Victorian & Edwardian

Fashions for Women

1840 to 1919

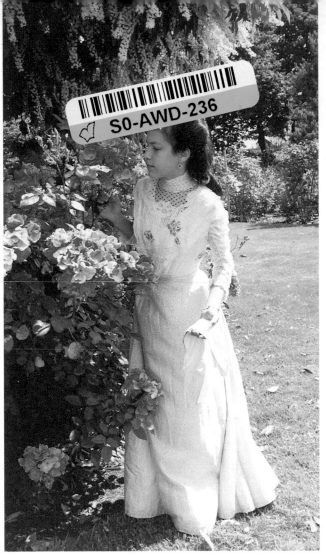

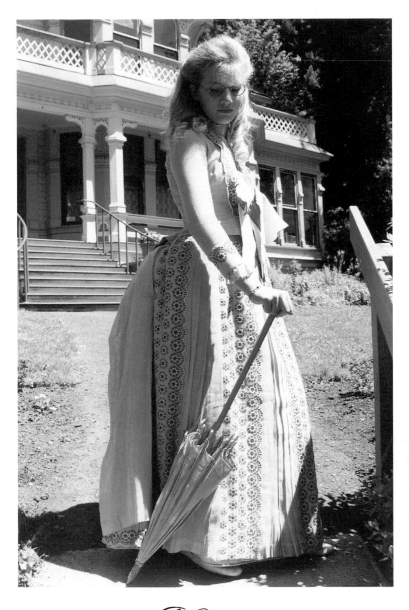

Kristina Harris

Schiffer Publishing Ltd

77 Lower Valley Road, Atglen, PA 19310

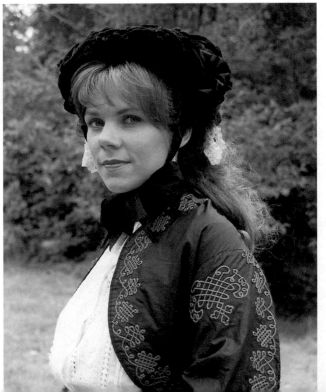

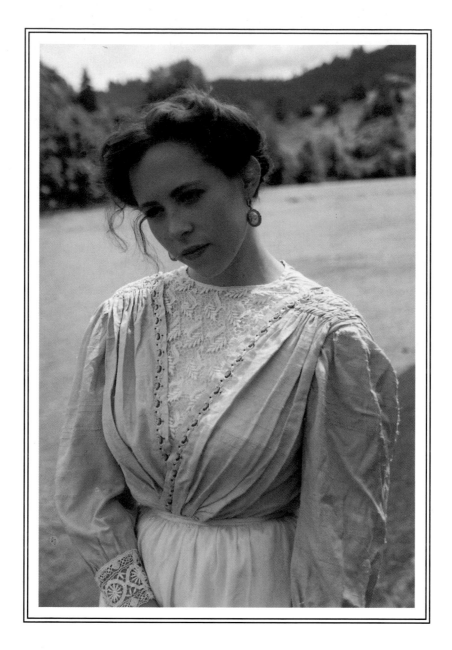

Printed in Hong Kong
ISBN: 0-88740-842-7

We are interested in hearing from authors
with book ideas on related topics.

Published by Schiffer Publishing Ltd.
77 Lower Valley Road
Atglen, PA 19310
Please write for a free catalog.
This book may be purchased from the publisher.
Please include $2.95 postage.
Try your bookstore first.

Library of Congress Cataloging-in-Publication Data

Harris, Kristina.
 Victorian & Edwardian fashions for women / by Kristina Harris.
 p. cm.
 Includes bibliographical references and index.
 ISBN: 0-88740-842-7 (pbk.)
 1. Costume–History–19th century. 2. Costume–History–20th century. 3. Costume–Collectors and collecting–United States. I. Title. II. Title: Victorian and Edwardian fashions for women.
GT595.H37 1995
391'.2'09034–dc20 95-11839
 CIP

Contents

of clothing squeezed onto any person. No garment was worn by any model unless proper, protective undergarments were worn beneath the garment. All models were instructed about the fragile state of all garments photographed before every photo shoot. No surroundings (indoor or outdoor) were allowed to stain, rip, or harm the garments photographed in any way; garments were always carefully protected.

In fact, because the garments were only modeled for a few minutes, the garments modeled for this book were probably in less danger of harm than garments mounted on mannequins and displayed for an exhibition.

Finally, for those who are reading this *Note* and wondering what all this fuss is about, please be sure to read *Chapter One* for more information.

Kristina Harris
Springfield, Oregon
November, 1994

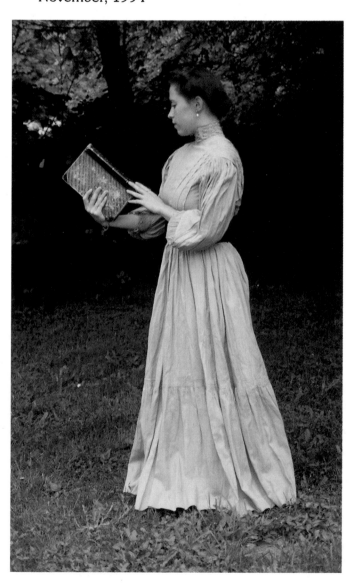

Author's Note

As I prepare to send this book off to the publishers, already I know that some people in the antique clothing world will have a concern about the manner in which numerous garments in the book were photographed. Like many thoughtful people in the antique clothing field, I believe in the conservation of clothing as artifacts. However, as with any artifact, clothing is best appreciated if it is well presented. Rarely do we see antique furniture presented in a museum under a glass case, solitary from other furniture and decor. And just as a Rococo settee seems less influential without a decorated room as its companion, so clothing somehow seems less adequate hung on a wall or set atop a mannequin.

There is no better way to appreciate the value, craftsmanship, and beauty of antique clothing than to view it as it was intended to be seen—on a live figure.

But for those, like me, who are concerned that placing antique clothing on a live model can be hazardous to the clothing's health, let me ease your concerns. No article of clothing was worn by any model if it was in an extremely fragile state, nor was any piece

Acknowledgments

It is truly amazing how many people it takes to make a book possible. I happily thank everyone who has cooperated.

Thank you, Mother, for all your support whenever I undertake any project; your time, energy, and helping hand has been greatly appreciated during the making of this book, in particular.

Another big thank you is due to the Schiffers, who have been a great joy to work with. From the first inklings of an idea for this book, to our meeting in person, to this book's final stages, you couldn't have been more positive and enthusiastic. Do you realize how much this means to a writer? Thank you!

Thanks to my father, also, who—though he's gotten much too picky to find things in antique shops for himself—somehow managed to surprise me with several pieces of antique clothing which he thought I'd like to include in the book. They were good additions, Dad!

I also thank the entire board of Eugene, Oregon's Very Little Theatre for allowing me to borrow and photograph a large number of antique clothes from their marvelous collection. Thank you Mary Mason for putting me in touch with the costume department. Special thanks is also due to Lucy and Darwin Sullivan for putting up with my many visits that always lasted longer than anticipated because I always discovered yet another treasure. You often performed above and beyond the call of duty—thank you.

My gratitude is also extended to the people who graciously allowed me to borrow items from their collections in order to photograph them; a big thanks to: Joanne Haug of Reflections Of The Past in Bay Village, Ohio; Rosetta Hurley of Persona Vintage Clothing in Astoria, Oregon; Priscilla Washco of The Victorian Lady, in Waxhaw, North Carolina; and Nancy Fishkoff of Reincarnation in Pacific Grove, California.

Appreciation also goes to Jan Alberg and Eugene, Oregon's historic Shelton–McMurphy–Johnson House Board for allowing me to photograph on location.

I also thank all the models, who couldn't have been more enthusiastic if they had wistfully sighed even once more "I wish we could dress like *this* today." The book wouldn't have been the same without you! Thank you: Andrea Bush, Brianna Rose Cole, Anna Kristine Crivello, Clinton McKay Crivello, Lisa Ann Crivello, Jocelyn Jones, Darcie Jones, Stephanie Jones, Krystyn Kuntz, and Alicia Wray. I offer additional thanks to Jocelyn Jones for enthusiastically uncovering many models for me.

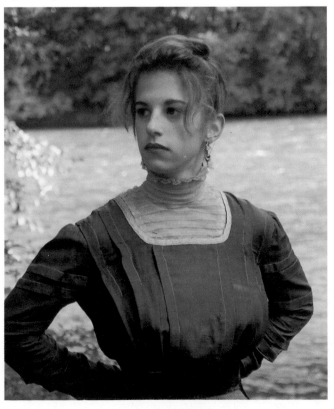

Introduction

I'll never forget the first Victorian dress I met in person.

My parents were ardent antique lovers, and my mother owned a small antique shop. And though, at the presumptuous age of eleven, I vehemently proclaimed that I'd never clutter *my* house with "old stuff," I sneakily visited my mother's shop on a regular basis in order to feed my secret antique passion. I'd spy gorgeous cut glass, exquisite engravings, and velvet covered settees—always with a bored look in case anyone noticed me.

Then one day, I casually entered my mother's shop only to be struck absolutely dumb by a magnificent turn-of-the-century gown hanging on the wall—a soft peach silk dress, trimmed with delicate coral *fleur de lis* braid, the tiniest of pink buttons, and fluid ecru lace. My heart fluttered with love at first sight.

After a few visits where I did little more than swoon over the gorgeous gown, I persuaded my mother into letting me take the dress home. There, I held it up to myself. Immediately I was taken back to all the movies I'd seen with beautiful ladies costumed in rustling, flowing Victorian gowns. Suddenly I was Judy Garland in *Meet Me In St. Louis*, and Ava Gardner in *Show Boat*.

Most every collector has a similar story. That rushing, exhilarating feeling you get when you spot the melon sleeve of an 1890s dress poking out from the racks of a vintage clothing shop (or your grandmother's attic trunk) has no comparison. And as you collect, the experience of collecting grows.

Personally, I love not only the look and feel of antique clothing; I also love the history behind it—what it tells me about our ancestors. I like imagining myself in their place (usually without all the tough parts of their life, like unbearably bumpy coach rides and unsanitary outhouses). I love the idea that a woman—an individual—chose to make or buy a certain dress, and that it was probably special to her, since it managed to survive all these years.

But the reasons for collecting are as varied as collectors are. Whatever your reasons, you have picked up this book—and I hope that it will enhance your collecting experience.

I have tried to make the book an interesting read-through, in addition to organizing it for easy reference. I have combined the Victorian and Edwardian eras for a single reason: they are so heavily intertwined. The general looks, style, and feeling behind clothing remained much the same when Queen Victoria took her throne in 1839 as when her son King Edward took her place in 1901.

I have also tried to make the book as practical as possible by picturing garments within the average collector's arm-reach. This being a collector's guide and not specifically a tour of fashion history, I felt it important to concern this book primarily with garments that the average collector can both *find* and *afford*. Every garment pictured is from a private collection or is readily available to collectors through dealers. You will also notice that some eras are represented with more photos of existing garments than others. Let this be a general guide to availability.

Both the publishers and I have tried to make the book as aesthetically pleasing as the Victorian and Edwardian clothes it features. Not only do I hope you will gain much collecting and historical information, but I hope you will find yourself drawn to gaze through the book on a lazy afternoon.

Oh, and one last thing. I still cherish that dress from my mother's antique shop; you'll find it pictured in *Chapter 9*.

Chapter *One*

Collecting Victorian and Edwardian Fashions

In 1839 a young, pale, dark–haired girl became Queen of England. Her sense of style and morality was fresh and sometimes innovative—and ladies everywhere wished to emulate her. As she grew older, the women of the Western World grew with her—beginning in girlish dresses, graduating to more mature (and heavier) fashions that slowed them down and no longer permitted them to bounce about, and finally adopting a mature, smart style of wearing tailored suits. When King Edward took over the throne in 1901, it seemed that though women were now mature in their fashions, they were in need of more variety—and more variety they got. First came the ultra–feminine, lacy, pigeon–fronted dresses of the early 1900s, quickly followed by a mish–mash of styles like no other period in history had ever seen, until, finally, around 1920, women completely dispelled the look and feel they had cherished for eighty–some years and adopted the new 'modern' look of the Roaring Twenties.

The entire Victorian and Edwardian period is one unlike any other. Nowhere else will collectors find clothing as opulent, frivolous, or beautiful as they will in the years 1840 to 1919. But like anything else, a collection of antique clothes will be considered much more valuable and noteworthy if it is handled well.

Avoiding "Mistakes"

It is nearly impossible for the beginning collector not to buy a few "mistakes" before she or he gains more experience. For instance, my very first acquisition was a silk turn-of-the-century dress. Beautiful though it is, unfortunately over the years it has disintegrated considerably. (Read *The Importance of T.L.C.* for the reasons why.)

New collectors also typically buy items that are in poor condition. While its certainly smart to pick up inexpensively priced garments whenever possible,

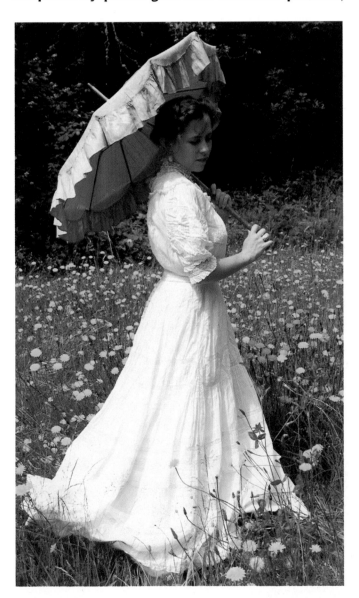

A 'lingerie' dress and parasol, both typical of the early 1900s. *Courtesy of The Very Little Theatre.*

care should be taken that their condition is reasonable. A few small holes are acceptable and to be expected, but any large rips or holes are definitely to be avoided. Collectors should also avoid garments which have been altered by modern hands. It is interesting and enlightening to own a garment that has been re-styled several times in the nineteenth or early twentieth century, but a garment with a rip repaired with iron–on tape was obviously repaired by a modern collector. Such repairs and alterations reduce the value of your collection.

As in every field of antiques, reproductions can be seen displayed in antique stores and markets, priced and marked as though they were authentic. Unfortunately, there is no reliable way for new collectors to spot reproductions; it takes an eye that is thoroughly familiar with the real thing. However, most reproductions are actually theatrical costumes, and as such, clues to their background can often be found. If a garment seems hastily sewn, if it has what appear to be modern notions (such as a zipper), if the fabric looks and feels modern, you should avoid the garment. Unfortunately, however, with the advent of historical fairs

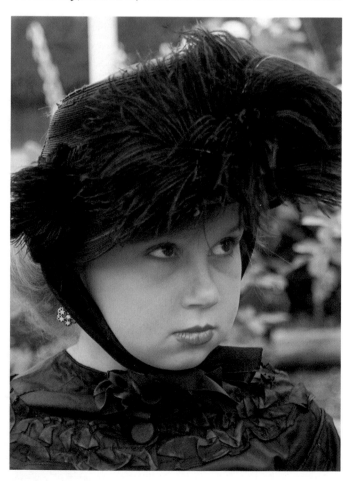

A feathered hat and taffeta bodice from the 1870s. *Courtesy of The Very Little Theatre.*

and re–enactments, extremely authentic–looking reproductions are also on the market. Here, again, only an experienced eye can spot a fake. Yet another variation to this confusing scenario is that sometimes authentic garments are used in the theatre or for re-enactments with the addition of some modern lace, a zipper, and similar notions; such garments can sometimes be carefully restored and be a boon to a collection. Once again, a careful eye is necessary.

The best advice for beginners is to trust your instincts. Study the photographs in this book. Get familiar with authentic period garments. Then, when shopping, use a careful eye and your best judgment. If something tells you the fabric a certain dress is made of just seems too modern to be from 1880, then walk away.

The Importance Of T.L.C.

If antique garments are cared for properly, not only will their value increase, but they will remain in a condition that future generations can enjoy and learn from. Only so many Victorian and Edwardian clothes were ever made, and perhaps half of those have survived to this day. No more will ever be created. Thinking of your collection in these terms, you'll quickly realize that proper care is essential.

Every garment in your collection needs a home. Unlike your everyday clothes, antique garments should rarely be hung. Occasionally, if space is at a premium, hanging a very lightweight dress or blouse on a padded hanger is all right, but all other garments should be stored flat. Find a trunk, a dresser, or some boxes; line them with a clean white sheet, and then layer your garments (heaviest on bottom), separating each garment with acid–free tissue. (No, regular tissue paper won't do. Go to your local art supply store for acid–free tissue—which won't cause yellow spots to appear on antique clothing.) Pad all folds well with acid–free tissue to prevent permanent wrinkles and fold lines from appearing. Shoes, purses, and hats should also be gently stuffed with acid–free tissue, then wrapped in muslin for protection. It will be necessary to replace your acid–free tissue paper about once a year. Because fabrics need to breathe in order to remain healthy, you should *never* place any antique garment in a plastic bag. If you think extra protection from dust and dirt is necessary, use a cotton cloth bag. (Be certain not to use bleached muslin, however, since the chemicals in it are said to wash out only after many years of use.)

During the late Edwardian period, sleek, sophisticated evening gowns were the height of fashion. *Dress at right courtesy of The Very Little Theatre.*

Silk fabrics require special care. Every antique fashion collector needs to know that silk can be an iffy investment; many silk garments from the nineteenth and early twentieth centuries already have worn-out spots (referred to as "shattering") where it appears a cat has torn a section of the garment to shreds. But don't blame the cats; silk is generally an unstable fabric and eventually destroys itself, even with very careful care. If you buy any silk garments, purchase them simply because you love them and bear in mind that their value may decrease with further age. If you already own a silk garment, keep it in the best condition possible by never allowing the fabric of the garment to touch itself. This is best accomplished by padding the entire inside of the garment with acid-free tissue; any folds made in the garment for storage should also be padded. If the silk is especially fragile, but the lining is still strong, turning the garment inside-out while in storage will also help protect it.

Whenever you acquire any garment, be certain to ask the previous owner if the garment was recently cleaned. If their answer is yes, do not clean the garment again; cleaning is very hard on old fabrics—which are always more fragile than they appear. In fact, unless the garment is noticeably dirty, cleaning should be avoided altogether.

Musty-smelling clothes can be aired either on a bed or table in a room where all the windows have been opened, or, less preferably, outside on a white cotton sheet. In either case, the garment should be kept out of direct sunlight, which can cause irreparable harm to old fabrics. If the garment is persistently bad-smelling, try steaming it. Using a hand-held fabric steamer (available for a reasonable price at most drug stores), carefully steam the garment while it hangs on a padded hanger. Be prepared for the pungent odor. After steaming, remove the garment from the room and air it.

Cotton garments can often be carefully washed at home. Whites are your safest bet, but colored garments may be washed also, if first tested on an inside seam for colorfastness. To wash an antique garment, place a pillowcase at the bottom of a sink (or a large sheet at the bottom of your bathtub), and fill it slowly with lukewarm water. Add cleanser to the water. Never use the same detergent you use on your everyday clothes; even "gentle" products such as Woolite are much too harsh for antique fabrics. Instead, either use Orvus (a special product used by museum curators; you can probably find it fastest by looking for the brand name "Quilt Care" in your local fabric store), or liquid Neutrogena (available in the face wash section of drug stores). Add only enough to give gentle bubbles; too many bubbles will just make your job more difficult.

Next, gently lower the garment into the water and agitate by hand. Do not allow the garment to sit in the water for more than a half hour, since any dirt that has fallen off the garment will tend too seep back into the fabric after thirty minutes. Remove the garment from the water by lifting up two edges of the pillowcase or sheet. Drain the sink or bathtub. To rinse the garment, lower the pillowcase or sheet back into the basin and fill it slowly with lukewarm water. Gently press bubbles out of the garment (do not squeeze or twist). Repeat this process until all the bubbles have been removed.

Dry a hand-washed garment by placing it on a clean screen (either the kind created for sweaters or, for larger items, a piece of fiberglass screening purchased at a hardware store). Be sure any rough edges are covered well with masking tape, and keep the garment out of direct sunlight.

If handwashing is out of the question, dry cleaning is the next best bet. Take your antique garments to a dry cleaner who specializes in bridal wear. If you're lucky, you may even be able to get a local museum's recommendation on a good local dry cleaner. Ask the

cleaner to place your garment in a mesh bag, and be sure he runs the garment through his machinery only *after* he adds fresh solvent to it. It should be noted, however, that dry cleaning can be a risky proposition. In many cases, the chemicals used in the process make old fabrics more brittle and more likely to rip and tear.

To Wear Or Not To Wear

Some collectors feel that the only real way to appreciate a collection of antique clothing is to wear it. While this may be all right with garments that are in very poor condition, I strongly suggest (as do many authoritative historical institutions) that you do not wear your antique garments. By wearing antique clothes, you run a high risk of staining, ripping, tearing, or otherwise damaging the condition of the piece. Not only does this drastically affect the value of your collectibles, but it also affects the historical significance of the piece. If you wish to enjoy your collection more than is possible by storing them in trunks and cases, try displaying them in archive–quality display cases and frames with ultra–violet light protectors. (However, it is wise to rotate displayed items frequently, since light, heat, and humidity are great destroyers of old textiles.) Another option is to lend pieces of your collection to local museums for their rotating display.

If you wish to dress in period attire, reproductions are available in a variety of places. Patterns for historical clothes abound, and ready–made reproductions are advertised in almost every antique–fashion–related magazine.

Certainly, if we wish to preserve history's fashions for future generations to enjoy, these seem reasonable precautions.

I do realize, however, that no matter how much I wish no one would wear antique garments, there will always be those who do. For those people, please allow me to make a request or two. First, I would ask that you never alter any antique garment; this destroys both the monetary and historical value of the piece. Second, I would ask that you avoid garments which are in good condition. Many times, garments with rips, tears, and other faults can be purchased very inexpensively at antique stores and markets. Once repaired and donned, no one will be able to tell they once were in such poor shape. One last thing: When you do wear antique garments, please be certain to wear appropriate undergarments. This includes not only bustles and crinolines (since these help support old, fragile fabrics), but also proper modern undergarments. A slip or chemise with sleeves and underarm shields is absolutely essential in protecting garments from perspiration and other body chemicals.

Documentation And Value

There are many rewards for documenting your collection. Any collection that is well documented tends to be perceived as more valuable by others—including those who many eventually acquire it or a piece of it. A well documented collection is also easier to appraise and will please your insurance agent. And documentation can *increase* the actual value of your collection—sometimes as much as ten percent. Perhaps most importantly, a well documented collection will help you to focus on what direction your collection is headed and what you may wish to focus on in the future.

If you already have a large collection, taking the first few steps to documentation may seen daunting—but it doesn't take as long as you may think. And once your existing collection is documented, it won't take much time at all to document newcomers.

If your collection is not yet large, or if you're a fairly new collector, documentation has the further advantage of teaching you a great deal about antique fashions; no other approach will teach you as much as the "hands on" method.

A 'teens 'lingerie' dress. *Courtesy of The Very Little Theatre.*

Creating A "Brag Book"

The first step toward good documentation is labeling and coding. This is easily done with garment labeling cloth tape (available through a conservation supply company). If this convenient product isn't readily available, you can create your own with strips of unbleached muslin. These can then be marked with a permanent-ink pen and tacked into the garment (usually at the center-back neckline of dresses and blouses, or at the center-back waistline of skirts). If you prefer, you may instead use stringed tie-on paper tags (available at office supply stores), but these are less preferable, since the paper such tags are made of is not acid-free.

Next, code each garment with its own individual number. Over the years, museums have developed a simple, yet effective way to do this which private collectors can easily adopt. If, for instance, I had a turn-of-the-century shirtwaist that I had purchased in December of 1994, I would code that garment: 94.12 (that is, the year 1994, the month of December). If you are a heavy-duty purchaser, you may wish to also add the *day* to your code. For example: 94.12.15 (1994, the month of December, the 15th day). Another important part of coding is adding some indication of where you purchased the garment. For example, the addition of the initials PVC to the end of any code in my collection indicates that I purchased the item from a local shop called Persona Vintage Clothing. Keep a list of these initials (and the names, addresses, and phone numbers of the dealers). Finally, add an acquisition number to your code. If, for example, that turn-of-the-century shirtwaist was the twentieth garment I had purchased for my collection, its code would be: 94.12.PVC.20.

While labeling you collection, its also a good idea to make a rough sketch of where every item in your collection lays within your storage area. This will prevent needless rummaging when you're looking for a specific piece.

Now you can get down to actually creating you documentation book (what I affectionately refer to as a "brag book"). This can be as simple or elaborate as you wish. Probably the most functional brag book consists of a three–ring binder with 8.5 by 11 paper inserted into plastic protective sheets. Type (or neatly write) all pertinent information about the item onto your sheet. Add a photograph of the garment, plus photocopies from any relevant value guides, magazines, or books.

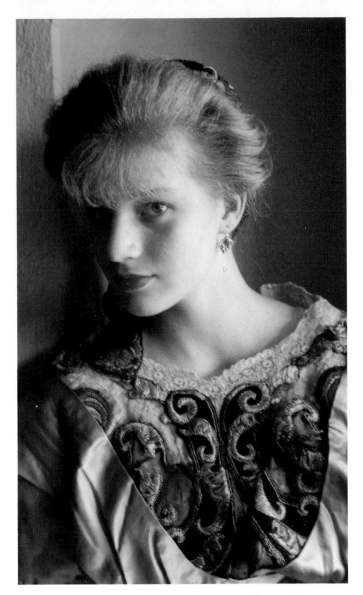

An embroidered 'teens evening gown. *Courtesy of The Very Little Theatre.*

Add the sketch of your storage area to your brag book, in addition to your dealer coding and addresses. This is also an ideal place to keep your insurance information, appraisals, bills of sale, or any other papers pertinent to your collection.

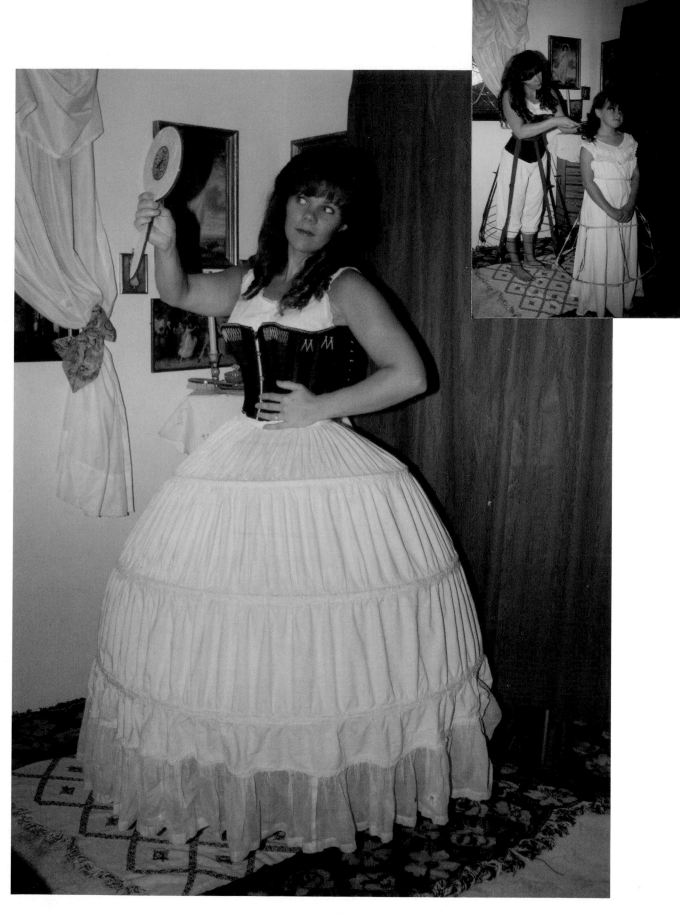

Victorian women wore layers of underclothing—including shape-forming corsets and absurdly wide hoopskirts.

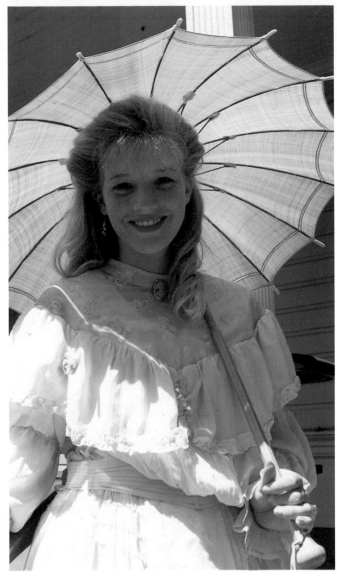

Accessories were important to every fashionable woman; parasols not only gave an air of grace, but also helped to shield the face from the tanning affects of the sun. *Courtesy of The Very Little Theatre.*

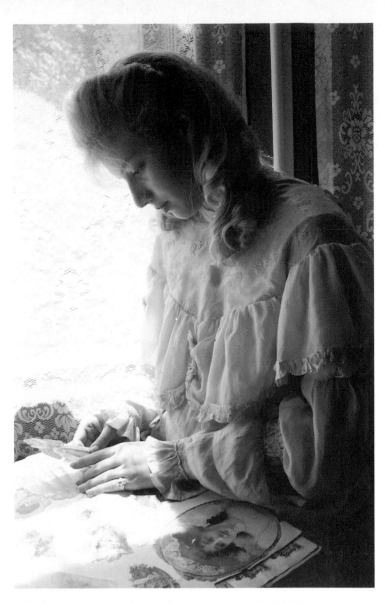

Soft, flowing garments were favored in the early 1900s. *Courtesy of The Very little Theatre.*

The type of silk deterioration most often seen looks like this and is called 'shattering'.

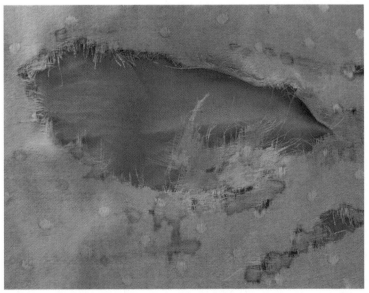

Sometimes silk deterioration looks like holes 'rusted out' of the fabric.

White dresses were a staple in the early 1900s. *Courtesy of The Very Little Theatre.*

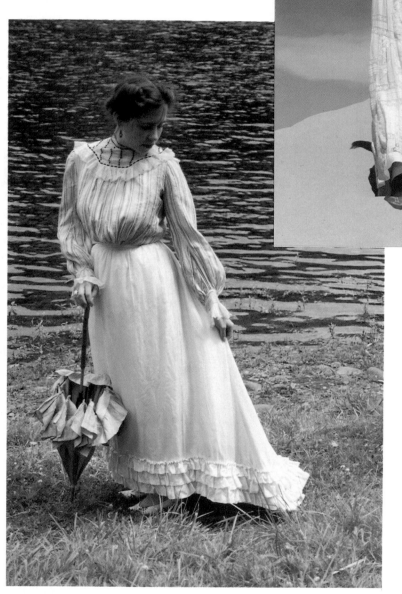

An early 1900s ensemble featuring a white silk skirt and a woven, striped bodice. *Bodice and parasol courtesy of The Very Little Theatre.*

An early 1900s silk parasol. *Courtesy of The Very Little Theatre.*

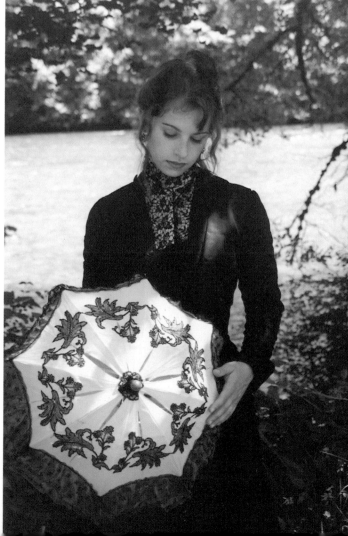

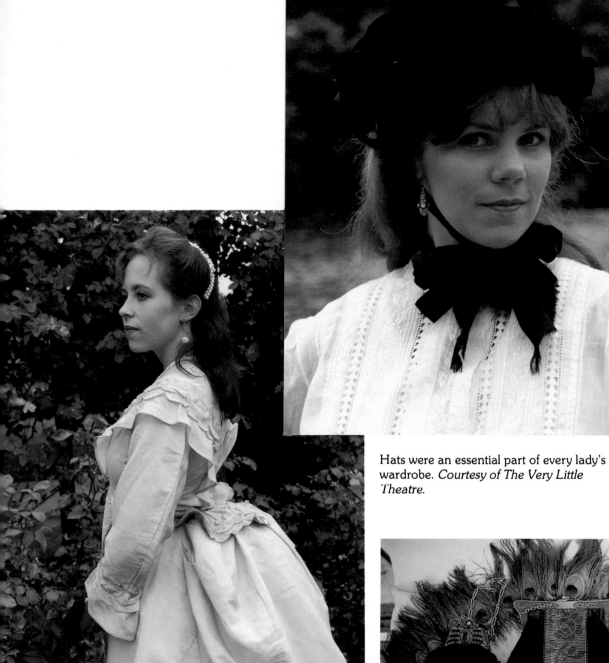

Hats were an essential part of every lady's wardrobe. *Courtesy of The Very Little Theatre.*

An 1870s wedding gown. *Courtesy of Reflections of the Past.*

Three turn-of-the-century handbags. *Courtesy of The Very Little Theatre.*

A page from the author's 'brag book'.

A modern 1880s lady on the steps of a befittingly 1880s Victorian home. *Courtesy of The Very Little Theatre.*

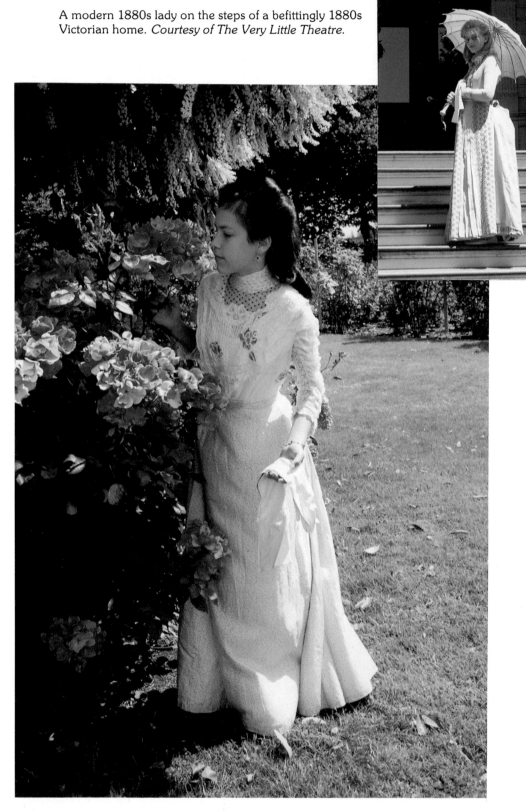

A late 1890s ensemble.

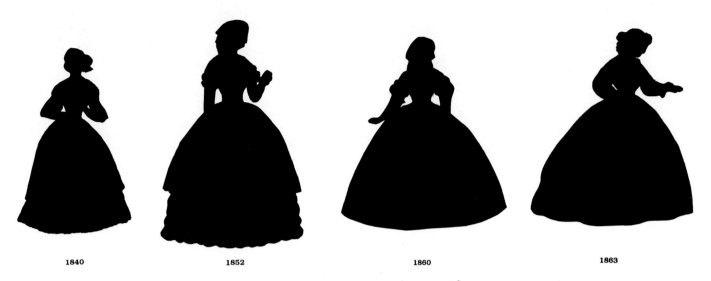

1840 1852 1860 1863

Chapter *Two*

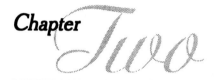

Identification and Dating

Some collectors go through their entire collecting careers without ever knowing exactly *what* they are collecting. I've never understood this, since learning about the history behind my collection has great appeal to me. At the very least, I think, all collectors should know how to date garments within the eras they collect—if for no other reason than to make sure they know exactly what they are purchasing.

This book guides you step by step through the Victorian and Edwardian eras, helping you to identify and date your collection through descriptions and illustrations of both the *exterior* and *interior* of period garments. Though this book contains photos taken from period fashion magazines and photographic portraits, this should not keep you from amassing your own collection of them. You can never have too many illustrations of period fashions—you never know which one will match a garment in your collection most closely. In fact, a good collection of fashion plates, photographs, and magazines can, in itself, be quite collectible and valuable.

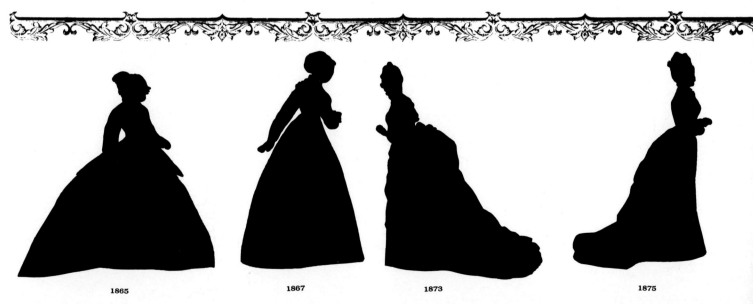

1865 1867 1873 1875

1877 1883 1885 1890 1896

Silhouette

The general shape of women's clothes is a good place to begin your identification. Using the timeline given here, you can easily identify the general era of any Victorian or Edwardian garment, then turn to that era's chapter in this book to uncover more details. Though it shouldn't be the *only* method used to date garments, its a great place to begin. For best results, place the garment on a mannequin (for a three–di-mensional look) and then compare its silhouette to those on the timeline. If no mannequin is available, lay the garment *completely flat* on a clean table or floor. Also remember that if proper undergarments aren't worn under some period garments, the silhou-ette will be altered; a skirt or blouse with a great deal of excess fullness in the back was probably worn with a bustle, and a skirt hem that seems to drag all around was probably worn with hoops.

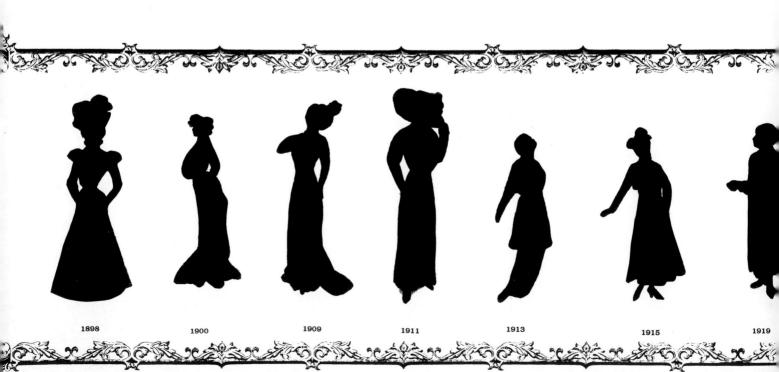

1898 1900 1909 1911 1913 1915 1919

It's In The Details

Once you have an idea of the general period of the garment, study it for details as described and pictured in each chapter. Examining the *inside* of garments is just as important as examining the outside, so don't skip over information about construction and craftsmanship. Remember too that you'll probably never find an *exact* picture or description of any garment in your collection; most antique clothes are one of a kind. Instead, look for strong similarities in sleeve styles, waistlines, necklines, et cetera.

There are also some other, more general, guidelines to keep in mind:

• While the sewing machine was invented in the 1840s, most experts agree it wasn't in widespread use in American until the late 1850s. All through the Victorian and Edwardian eras, however, many dresses contained both machine and handstitching, so examine a variety of seams. If you are not very familiar with the various methods of sewing, study the seams under a magnifying glass. If adjoining stitches seem to come out of the same hole, the seam was machine-stitched—*unless* the stitches on the underside overlap, in which case the seam was handstitched with a technique called backstitching. Also bear in mind that around the early 1900s, a number of very fine lingerie dresses were sewn entirely by hand, and throughout the nineteenth and twentieth centuries, some special occasion dresses were also almost entirely handstitched.

• Anything with a zipper probably isn't authentic. The zipper was patented in 1893, but wasn't used in women's clothes until the 1930s (and even then, it was primarily used by only a few high-fashion designers).

• Black clothes aren't necessarily mourning clothes. Black was just as much a fashion color in the Victorian and Edwardian eras as it is today. It was also eminently practical for clothes that could not be washed.

• Occasionally, you'll run across a garment that has elements from several eras. At such times, look for signs of alterations; the original nineteenth century owners may have re-styled the garment several times in order to keep up with ever–changing styles.

THE FASHIONS
Expressly designed and prepared for the
Englishwoman's Domestic Magazine

1840

Chapter *Three*

1840s: Little Woman

"The modern stay extends not only over the bosom but also all over the abdomen and back down to the hips;" *The Handbook of the Toilet* informed its readers about the new 1841 style of corset. "Besides being garnished with whalebone, to say nothing of an immense wooden, metal, or whalebone busk...they have been growing in length...the gait of [women] is generally stiff and awkward..." It was not just an encompassing corset that made it difficult for ladies to move, however; the child–like garments Queen Victoria helped bring into fashion were built in such a way that their wearer's were virtually useless: Sleeves and shoulders were fitted so snugly women could hardly raise their arms, and skirts were so long and full they weighed their wearers down. Dresses—and even corsets—fastened up the back, making the help of a sister, maid, or husband absolutely necessary in order to get dressed. (Thankfully, informal clothes created to be lounged in at home allowed ladies to dress themselves with front fastenings.)

Fashion was making some improvements, however. Stylish clothes were extending to all classes, for instance; period fashion magazines regularly com-

plained that "even housemaids" were able to wear the new style of bustle with the aid of old dishtowels, and that dressing maids wore nearly as many petticoats as their mistresses.

The art of creating clothes also progressed; as skirts grew wider and heavier, new innovations were necessary. Because the new wide skirts appeared so unwieldy when gathered to the bodice, dressmakers employed the new method of "cartridge pleating," which created the regular, flat, and tubular pleats which were so prevalent in the Forties. Another new technique, called "gauging" (a method of gathering which required four to eight rows of handstitching), made its premiere in the Forties and would continue to be used throughout the nineteenth century. In the early part of the decade, another new technique was created: the insertion of an inner-waistband. Made up of a piece of grosgrain ribbon tacked to several inner seams and secured around the waist with a hook and eye, this simple device was a great aid in keeping the bodice from shifting upwards with movement. "No one who has not tried this simple improvement can imagine what an advantage it is to the figure," *Miss Leslie's Magazine* proclaimed in 1843.

An 1849 fashion plate featuring dresses with highly fashionable scallops.

Skirts

Why women of the Forties thought shaping themselves like bells made them more graceful and attractive is dubious. But in order to achieve the bell look, skirts were usually heavily lined, small bustles were often built into skirts, and dresses of heavy fabrics frequently had pads at the hip and derriere, sandwiched between the dress and its lining. By the end of the Forties, skirts grew so heavy and the extreme bell shape was so desired that skirts were often lined with stiff crinoline.

By 1843, skirts were sometimes trimmed to look as though they exposed a matching petticoat, or had a few flounces or frills near the hem which were often pinked or scalloped—but very plain skirts were most favored.

Bodices

The bodice of the Forties featured the essential diagonal line from shoulder to waist, which gave women a helpless, childish appearance. Whether created by seaming, trimming, or striped fabric, this diagonal line is typical of the period. Also typical of the Forties is an elongated, pointed waistline that reached well below the waist. To keep this line smooth, bodices were usually lined in muslin and had three bones placed in a fan-like position at the center front, plus a bone under each arm, and sometimes bones in the back seams. Bodices cut on the bias of fabric also helped the fabric cling to the figure, as did piping, which was often placed in all seams.

Necklines were generally low, but were often filled in with the help of a chemisette (what we today call a dickey). Bertha collars were especially popular cover-ups, and were frequently made in fabric matching day dresses, or in lace for evening.

The first few years of the decade saw 1830s sleeves that were re-shaped to conform to the new 1840s styles. This often meant that the fullness of the past decade's sleeves were held down with fabric or trim bands and sewn up tight to the upper arm. The rest of the fullness was then allowed to puff out at the elbow.

After 1843, sleeves were long, straight, fitted, and frequently cut on the bias of the fabric; when made up in striped fabric, this made the stripes appear to wrap themselves around the arms like serpents. By 1844, sleeves started to become a little fuller and Bishop sleeves were commonplace. Fitted

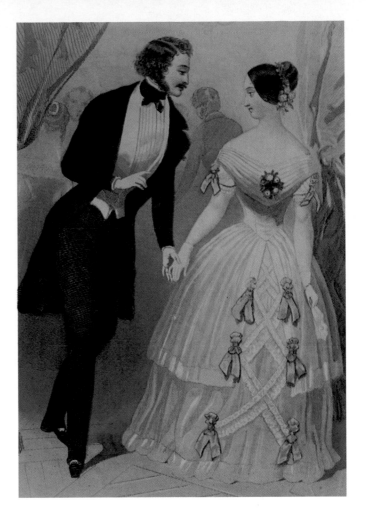

An 1846 fashion plate featuring a 'low corsage' dress.

undersleeves, worn under shorter, fuller upper sleeves, also made their appearance around 1846, and continued to be popular throughout the decade; these were one of the few practical aspects of women's clothing, since the undersleeves could be removed for easy cleaning. Occasionally, bodices also had two separate sets of detachable sleeves that could be interchanged for day or evening wear.

Dresses

Economical and practical ladies created for themselves dresses with two matching bodices—one appropriate for day wear and one designed for the evening. The only real difference between these two bodices was that the day bodice had long sleeves and a higher neckline or matching Bertha collar, and the evening bodice had a low decolletage nearly falling off the shoulders, and minuscule sleeves.

Watch pockets were common in the bodices of day dresses and large skirt pockets can be found in both day and evening gowns. Dresses for day or night were sometimes trimmed to look as though they fas-

tened up the front, but garments from the Forties always fasten up the back. (The exception to this rule was the dress designed for mothers who were nursing, which, of necessity, fastened in the front.) Toward the end of the decade, waistlines rose and rounded off and skirts had slight trains, though dresses from 1840 to 1847 followed the same general lines as separate bodices and skirts.

Stripes were the most notable fabric type used in the 1840s; damasks and silks were also eminently popular. Pink, light blue, lavender, and pea green dominated most of the decade, though deeper reds, purples, greens, and greys were favored in the latter part of the Forties. Tone-on-tone was the style of ladies of taste—but unusual color mixtures were worn by many; one period magazines described an average outfit thus: "A crimson opera-dress, worn with a light blue mantle, and pale green velvet leaves in hair."

Detail of a skirt gauged to a bodice. Notice that while the stitches are prominent on the inside, they are barely visible from the outside of the garment.

Undergarments

Petticoats were the most important undergarments of the decade. In the 1840s, petticoats were layered to create wide, increasingly bell-shaped skirts; five to ten petticoats could be worn by fashionable ladies—the undermost often made of stiff horsehair or crinoline fabric. But while layers of petticoats gave

ladies the fashionable look, they had their problems; not only were petticoats extremely hot, they wrapped themselves around ladies legs and made walking nearly impossible.

Drawers, though criticized by some as being "too masculine," were now being worn by more and more women. The drawers of the Forties were possibly the most simple garments ladies wore, basically consisting of two tubes attached to a waistband. Though they were always open-crotched, they were cut full enough to conceal.

Small fabric bustles composed of several layers of stiffened fabric tied to a waistband were often worn over layered petticoats, even when bustles were built into dresses. These bustles, unlike similar bustles used later in the Victorian period, extended all the way across the derriere and to the sides of the hips.

Corsets (often called "stays" at the time) were long, heavily boned, and uncomfortable. Unlike corsets worn in the following decades, they had only one opening—in the back—and had to be re-laced each time a lady wished to get in or out of it. However, the most common complaint about corsets of the decade was that their busk was too large and therefore too uncomfortable. This "busk," or wide piece of boning placed at the center front of the corset, was designed to keep ladies' stomach's as flat as possible. An ankle-length, nightgown-like chemise was worn under the corset (to help keep the corset clean), and a camisole was often worn over the corset (to protect snug-fitting bodices from sharp corset bones). Vests—usually made of wool—were sometimes worn over the camisole (or in place of the camisole) for added warmth, as they were through much of the Victorian and Edwardian period—but many ladies went without them because they added girth to the figure.

Fancy Dress

Occasionally, antique clothing collectors will run across garments that don't seem to fit into the general style lines of any particular period; at least two possibilities should then be explored. One is alternative dress (see Chapter Six); the other is fancy dress.

The Victorian and Edwardian eras saw a revival in interest in masquerades and costume balls; the trend-setters of the era—including Queen Victoria and Alva Vanderbilt—were well known for their elaborate fancy dress parties. For the most part, however, collector's will find that fancy dress is rare; often, cos-

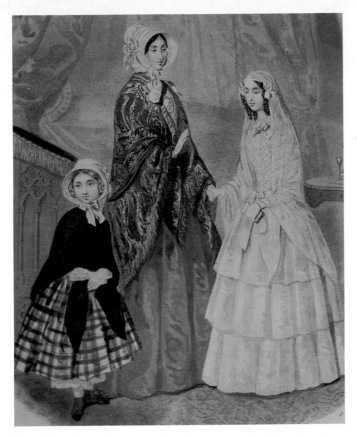

A wedding gown featuring deep flounces and a long, shawl–like veil. The mother of the bride also wears a full shawl and bonnet, giving her a demure appearance.

Other Important Garments

Bonnets were extremely popular in the Forties, and had a great deal to do with the demure look of fashionable ladies. They sometimes had cane hoops inserted into them horizontally to help them stick straight out, and they were almost always trimmed with flowers and ribbons *inside* the brim. Bonnets and evening headdresses reached far down the sides of the face and bonnet brims nearly met at the chin.

Mittens and wrist-length gloves were also extremely fashionable, and would be through the 1860s. Often found made up in lace, they were not only reserved for evenings, but were worn by day, as well. Soft, flowing shawls—like gloves—were almost always worn by ladies.

So-called "Miser" purses were much favored by the middle and upper classes. These odd-shaped purses separated different types of coins in each of their rounded ends, and were held in hand at the center. Purses heavily decorated with hanging beads were also popular, as were reticules made in fabrics to match specific outfits.

tumes were re–made until they wore out completely.

Several important details will help you to discern whether or not you have uncovered a piece of fancy dress. First, it is important to realize that while fancy dress often depicts fashions from earlier times, it almost always follows the silhouette of whatever era it was worn in. Take for instance the women's fancy dress costumes pictured here. Though this fashion plate pictures "Greek Costumes," it clearly follows the silhouette of the 1840s, with drooping shoulders and bell-shaped skirts. In the same vein, an 1880s costume depicting Joan of Arc would be worn with a bustle, and an 1860s costume depicting Mary Queen of Scots would be worn with a crinoline—even though Mary never wore a cage crinoline and Joan never even lived to see the invention of the bustle.

Not all fancy dress costumes depicted historical (or even fictional) characters, however; many costumes may be difficult to discern from other types of evening wear because they depicted abstract themes such as "Spring," "Music," or "Love." Such costumes can be recognized by shorter skirts and unusual color combinations or decorations. For instance, one period costuming book suggested that an abstract costume be made of cotton batting flecked with black ink.

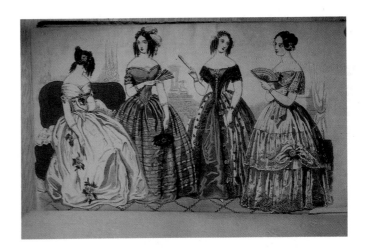

An 1845 fashion plate featuring off-the-shoulder evening gowns.

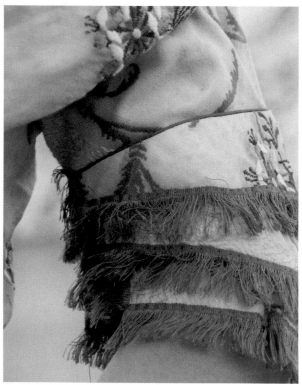

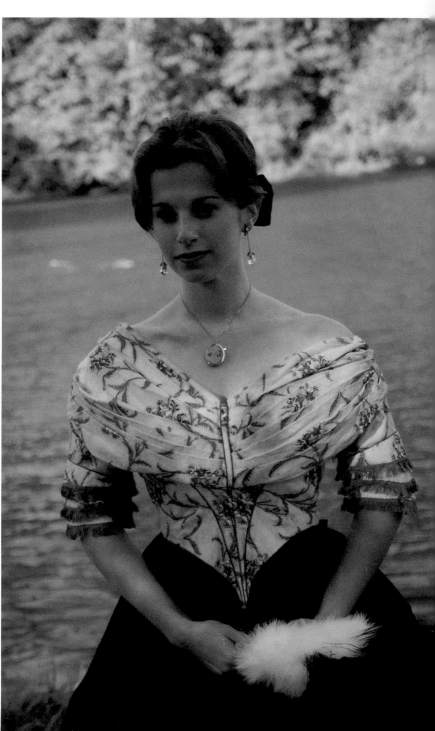

A circa 1841 silk and wool evening bodice from Norwich (an English weaving center) with an all-over embroidered design and sleeves edged with silk fringe. *Courtesy of Reflections of the Past.*

An embroidered and painted picture taken directly from an 1845 fashion plate.

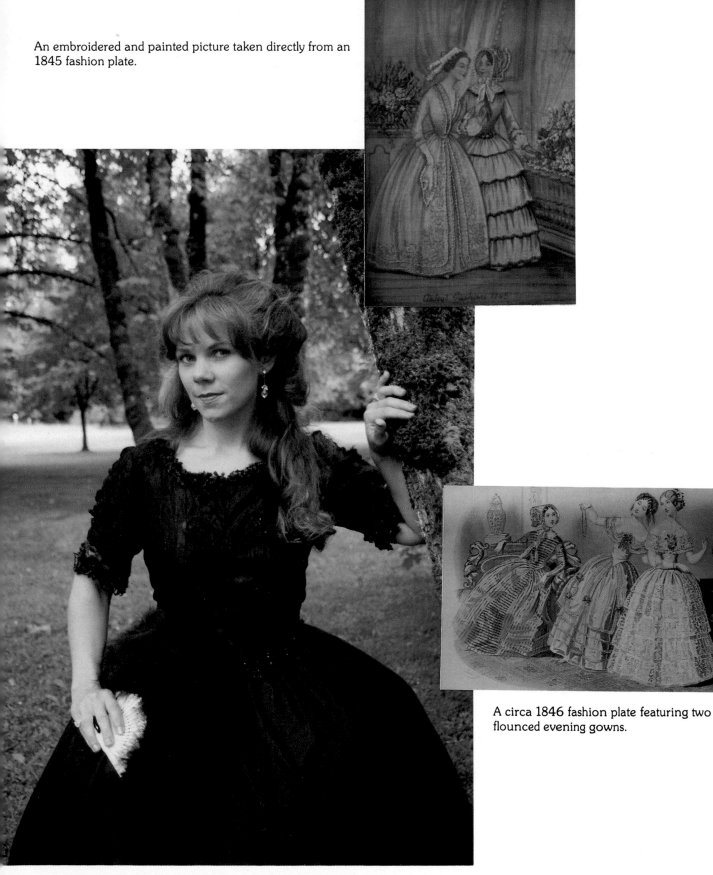

A circa 1846 fashion plate featuring two flounced evening gowns.

An evening bodice from about 1849. The pointed waistline is accentuated with jet passementerie; ruched gold faille accents the sleeves and neckline. The buttons in front are fastened with separate, removable straight pins. *Courtesy of The Very Little Theatre.*

A circa 1848 dress of pastel purple shades, a shaped and smocked waist, and a moderately bell-shaped skirt. *Courtesy of Reflections of the Past.*

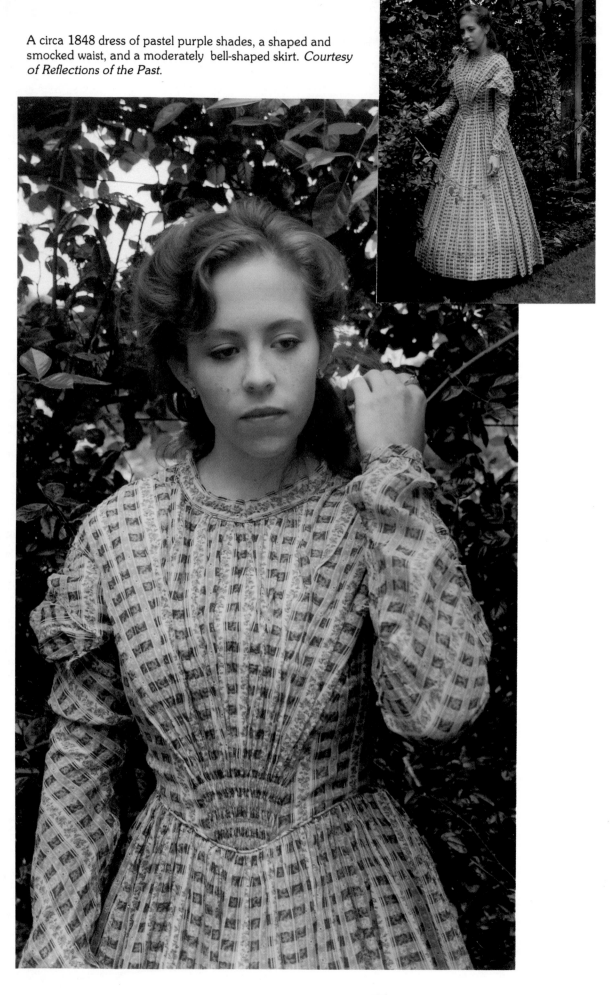

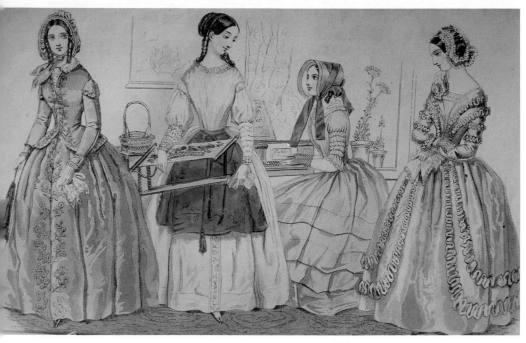

An 1845 fashion plate featuring a white muslin dress. Notice how the sleeves on all the dresses are in the stitched-down style.

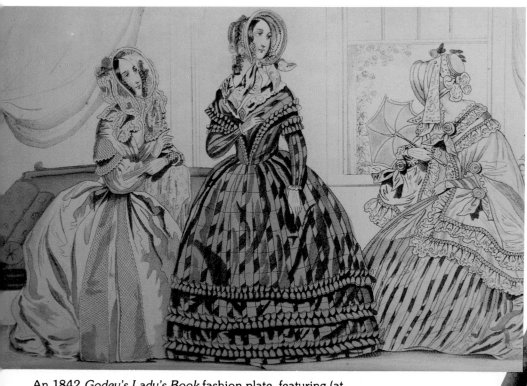

An 1842 *Godey's Lady's Book* fashion plate, featuring (at center) a dress of "a new style of plaid." Notice how rounded the waistlines are.

An 1848 fashion plate.

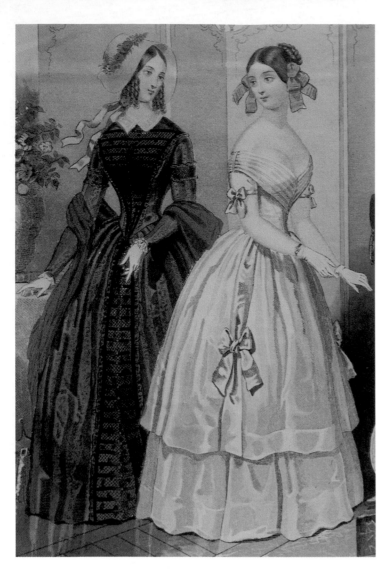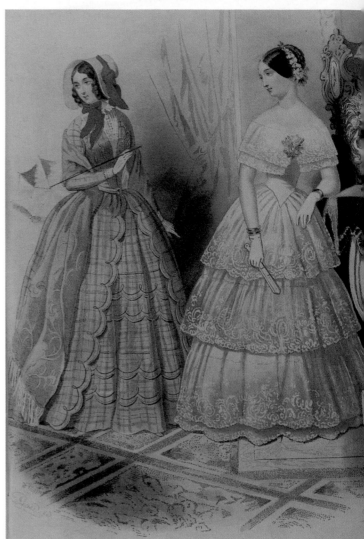

Two 1846 fashion plates.

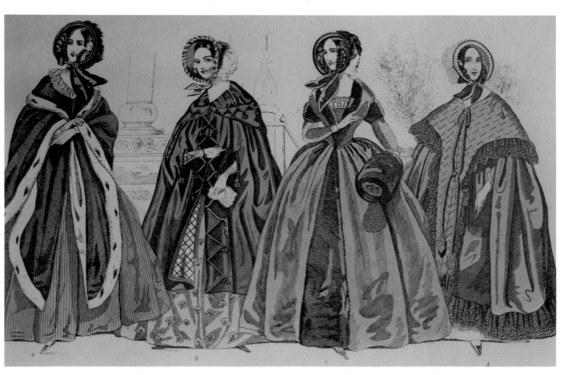

A circa 1849 fashion plate featuring widening skirts.

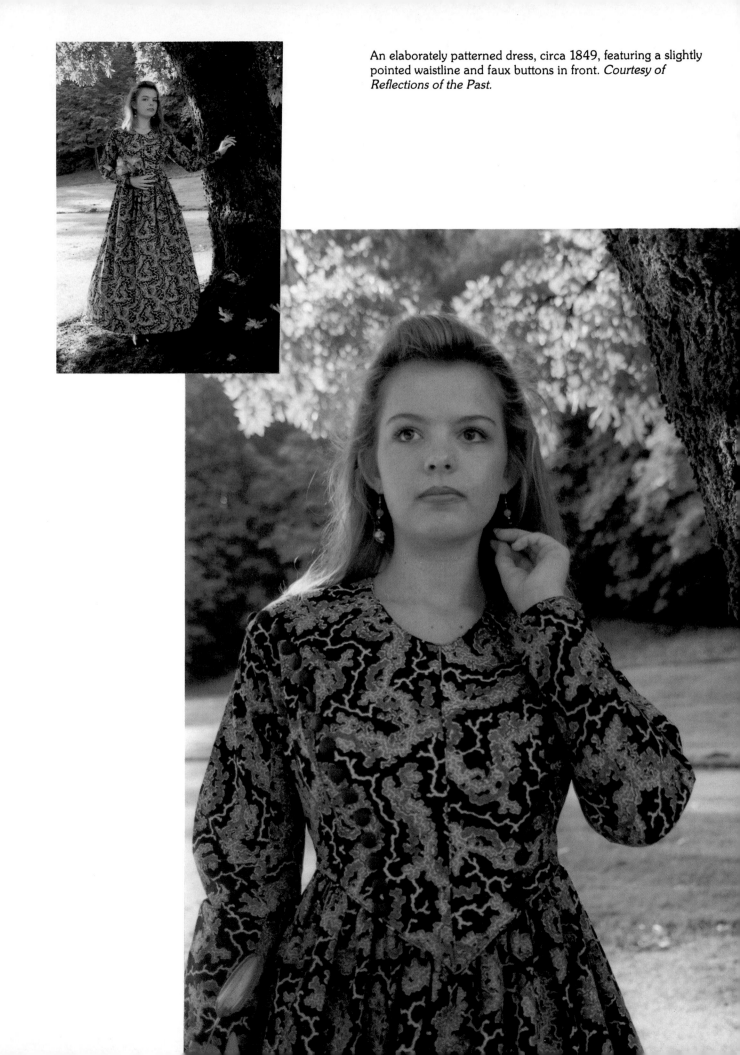

An elaborately patterned dress, circa 1849, featuring a slightly pointed waistline and faux buttons in front. *Courtesy of Reflections of the Past.*

An embroidered picture taken from an 1848 *Godey's Lady's Book* fashion plate.

An early 1900s shepherdess fancy dress costume.

A circa 1899 fancy dress costume of an unusually short length.

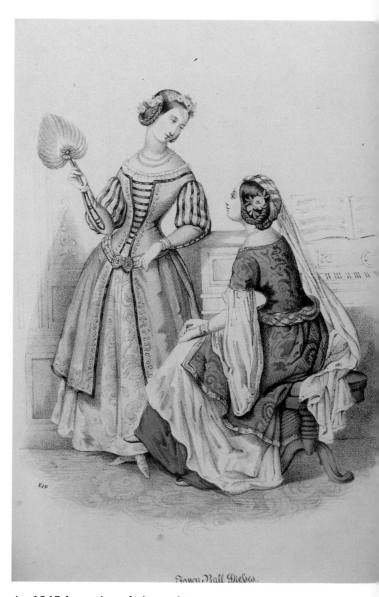

An 1845 fancy dress fashion plate.

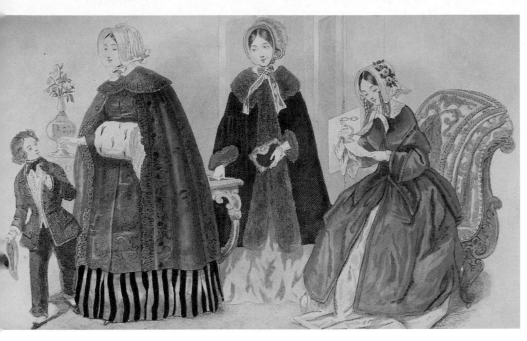

An 1845 fashion plate featuring cape and coat styles.

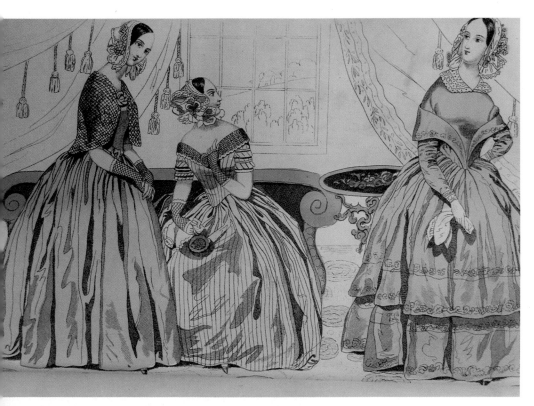

An 1842 *Godey's Lady's Book* fashion plate illustrating how mittens, scarves, and headdresses were coveted by fashionable ladies.

An abstract "field of flowers" fancy dress costume from 1913.

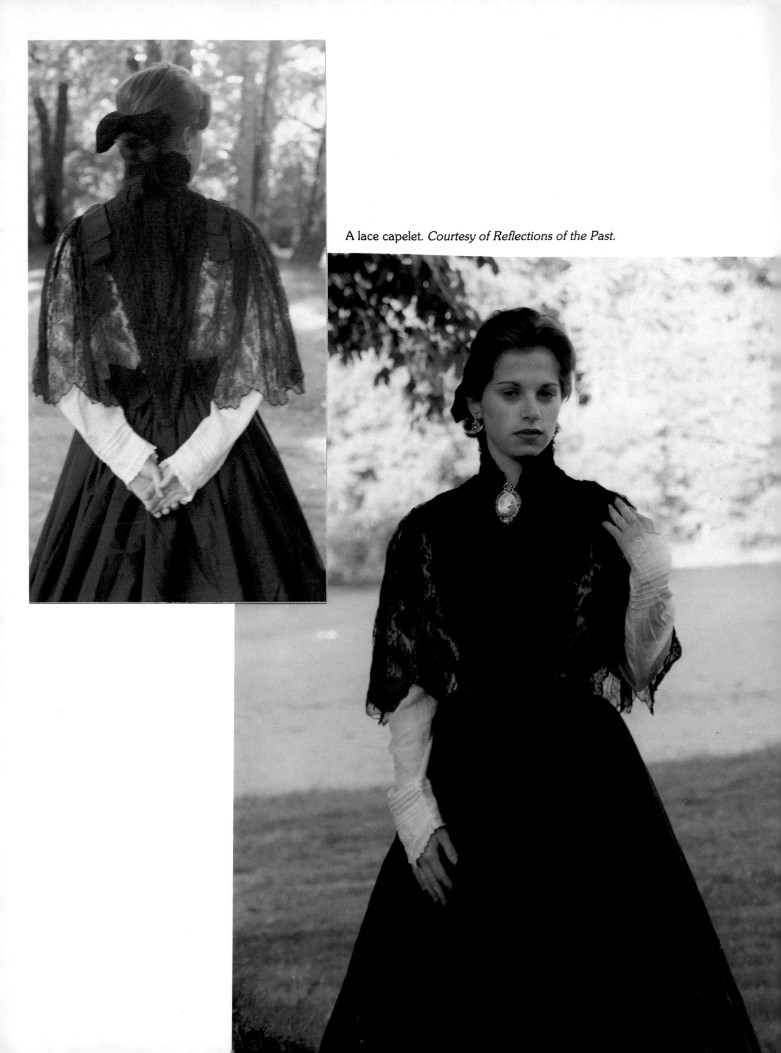

A lace capelet. *Courtesy of Reflections of the Past.*

1852

Chapter *Four*

"Captain Lucust, of the Metropolitan Force, having chased two notorious Burglars to a house in Water Street, proceeded to search the premises," *Harper's Weekly* reported in 1857, "but...he obtained no trace of them till he entered a closet which the lady of the establishment used as a Dressing Room. There, at infinite risk, he succeeded in dislodging fourteen Herculean Brigands from the inside of a Fashionable Hoop." And so it was that in the 1850s hoopskirts became the favorite subject of newspapers and magazines—both on and off the fashion pages. Despite the possible criminal implications of hoops, *Harper's* also reported that a fashionable lady and her husband got caught walking in a violent thunderstorm; "The gentleman," they reported, "received a severe shock, but the lady escaped uninjured, the steel hoops which expanded [her dress] proving a perfect lightning conductor. She was terrified and fainted away, however; but here the hoops proved their utility in another direction, and supported her, so that it was impossible for her to fall to the ground." Therefore, *Harper's* concluded, hoops had at least one good purpose.

While certainly such accounts were told tongue-in-cheek, there is little doubt that increasing skirt sizes and hooped petticoats did take their toll on society. In New York City, for instance, women wearing hoopskirts took up so much extra space on omnibuses that higher fares were charged for them. And on the opposite side of the nation, where pioneers were settling, hoops had become so utterly impractical for ladies that a woman who wore them was in danger of being thought a prostitute.

The 1850s also saw the rise of another important invention: the sewing machine. Though at first dressmakers were skeptical of the machine, by 1857 it was in regular use and was making an impact on fashionable clothing; because the time involved in creating clothes was now considerably shortened, the average woman could now afford to use more trimmings. It would take nearly another decade for the sewing machine to make its full impact upon American society, however.

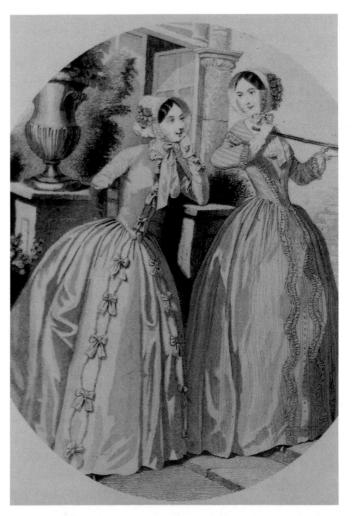

A circa 1850 fashion plate depicting simple, but soft and feminine, styles.

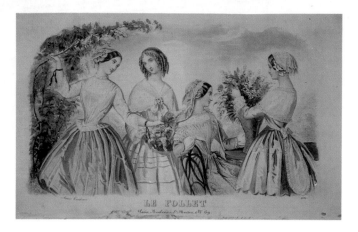

A fashion plate from 1858, showing 'everyday' clothes.

Skirts

By the Fifties, a skirt three yards at the hem was not unusual, and ultra-fashionable ladies sometimes wore skirts taking up five yards at the hem. During the first half of the decade, before hoops were worn, skirts were frequently lined with stiffened muslin or crinoline. Hems were sometimes also trimmed with braiding to help add stiffness. One period magazine even reported that some of the better dressmakers were placing "slight whalebones" in skirts in order to give "the ample fan-like form which is so graceful and so rarely obtained;" this technique, though by no means in standard use, was usually used in skirts of lightweight fabric. Because of the growing width of skirts, gathers were very rarely used, and pleats—especially flat pleats—became the norm.

Perhaps the most easily distinguishable feature of 1850s skirts were flounces. Though not all skirts from this decade featured them, a large number showcased two to four flounces, and the most elaborate garments had up to twenty. Fabric manufacturers took advantage of this trend by printing specially designed border prints which could be lined up along each flounce. By 1854, in the constant effort to achieve the bell shape, flounces were frequently stiffened with the likes of muslin, crinoline, or even straw. The last years of the decade saw the end of fashionably flounced skirts.

Occasionally, skirts featured a strip of fabric or a string about one-half the length of the skirt which was sewn to two sides of the waistband and could be matched up with buttons on the lower part of the skirt; the skirt could then be lifted on the sides to reveal a lavishly decorated petticoat. Skirts worn in the evening frequently had a looped-up look, usually trimmed with bows and ribbons.

Bodices

In the Fifties, women stole several articles of clothing from men. By 1851, ladies were wearing both waistcoats and vests—usually embroidered and decorated as lavishly as possible. But fashions were still quite feminine: snugly fitted bodices revealed curvy figures, and a profusion of ruching, braids, bows, and ornamental buttons covered ladies from head to toe.

Bodices were still lined and well boned, but now front fastenings were also fashionable. Sometimes bodices were even left open above the waist to show off an embroidered or cut-work chemisette or collar. With this new style also came a number of bodices that extended well past the waist and were gathered at the waistline in a peplum fashion.

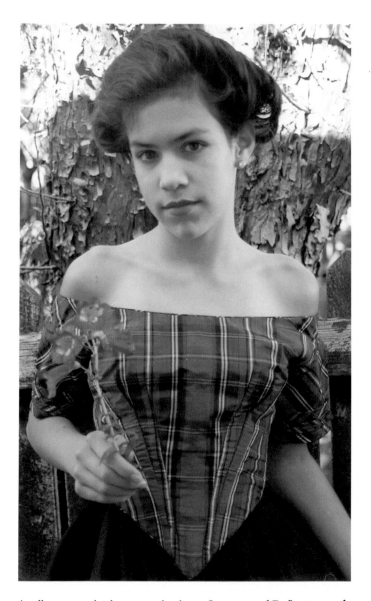

A silk tartan plaid evening bodice. *Courtesy of Reflections of the Past.*

Two-piece sleeves that were fitted on top, loose at the bottom, and featured an undersleeve remained popular. By 1857, sleeves had widened considerably and the upper sleeve was often slitted to accommodate the fullness of the undersleeve. One-piece Bishop sleeves were also fashionable. Usually, all sleeves of the Fifties had a single seam, placed on the underside of the arm.

By 1854, necklines generally were ending at the base of the neck—though bodices worn in the evening still featured décolletage and often exposed the shoulders.

Paletots—draped, cape-like garments—saw a continual rise in popularity until their pinnacle in the 1860s. Jackets also became increasingly important to ladies and can be distinguished from those from some later decades by their lack of boning.

Dresses

Dresses from the 1850s were usually made up of a separate bodice and skirt; two bodices—one for evening and one for day—were still coveted by practical ladies. In almost every case, the skirt was fastened in the back, and the bodice in the front. This new trend of front fastening garments may have been due in part to new strides in button making. Pearl buttons, for example, are commonly seen on garments after 1855 because they could then be manufactured instead of being made painstakingly by hand. Advances in manufacturing also made ornamental buttons within the budget of most ladies—and with the invention of "split pins," they could easily be pinned onto one dress in the morning and then transferred to another in the evening; this explains why some dresses of the period lack buttons or any evidence that they ever had buttons.

The 1850s also saw the introduction of "the short dress," created for ease in walking; the dress was ankle-length—and not readily accepted by most ladies.

The use of trimmings on day dresses increased dramatically in the Fifties; ribbons, ruches, and braids were used as extensively on day dresses as they were on evening gowns. Jet became *the* trim for mourning clothes. Silk was the fabric desired by all ladies, but because so much fabric was necessary to create popular fashions, most women had to settle for brocades, challis, taffetas, velvets, and cottons. The "invisible" look was fashionable in summer evening gowns; gauzes, laces, nets, and mousselines were frequently chosen by fashionable ladies. Tartan plaids—a favorite of Queen Victoria—were worn extensively, both in this decade and the one to follow. Mauves, purples, and browns were favored colors. "Check materials," one upper-class period magazine claimed, "are not worn by the ladies, being entirely given up to the nether integuments of the sterner sex." Nonetheless, checked dresses are often found from this period.

A basic bodice from the 1850s, showing the essential V-line. *Courtesy of The Very Little Theatre.*

Undergarments

By far the most important undergarment of the 1850s was "the artificial crinoline," or hoops. When the first hoops appeared around 1856, they were hailed as marvelous inventions because they eliminated layers of petticoats that wrapped around women's legs and made walking difficult. These early versions of the crinoline were usually petticoats with cane inserted into them horizontally. In 1850, *Godey's Lady's Book* also featured a petticoat with reeds inserted in it—but unlike most hoops, it was one-half the length of the skirt. Another variation shown was a corset with a hip-length peplum with hoops inserted through it. The "cage" crinoline was also available, which was made of a series of metal bands. Yet another variation was a combination of fabric strips and flexible steels extending from a waistband.

Though crinolines were much praised for lightening the load of clothes ladies wore, they certainly had their drawbacks. Most dangerously, they made it nearly impossible to save ladies from burning, and in fact, thousands of women were reported to have died because of the crinoline. On the lighter side, many gentlemen complained that American women weren't graceful enough to walk in hoops without wobbling; only ladies who took tiny steps could avoid this humorous gait.

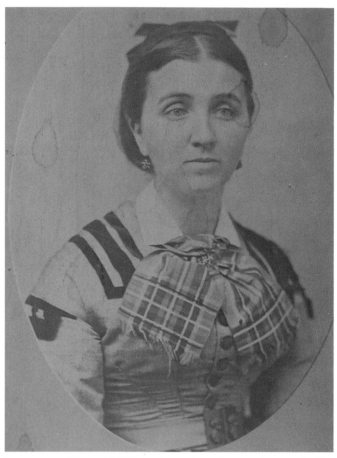

A woman of the mid-1850s, dressed in plaid, velvet, and silk.

Hoops, unfortunately, can be very difficult to date. One might think you could date hoops by the size of their circumference, but this measurement varied greatly according to personal preference. The average middle-class woman might wear a 50" hoop for day, but a 90" hoop for evening; while it would seem likely that a working woman would wear a moderate 45" hoop, many period photographs show maids and factory girls wearing 60" to 70" hoops. And while 1858 fashion magazines claimed "the hoop has reached its utmost extent unless our doors are to be made wider," the pinnacle of the width of hoops was 1860. However, just because one lady wore a 118" hoop in 1859, doesn't mean every lady did; according to period photographs, many ladies preferred 60" and 80" hoops in that year.

Some hoops will have manufacturer's labels attached to them; these hoops can sometimes be dated by locating the manufacturer's original ads in period magazines. It is important to point out, however, that crinolines from the 1850s were always perfectly circular; unlike crinolines from later decades, Fifties hoops placed their wearer in the absolute center of the crinoline.

Crinolines also brought about the regular wearing of another piece of underwear: drawers. The reason for this is told perfectly in a story about the Duchess of Manchester. According to Queen Victoria's lady-in-waiting, in 1859 the Duchess "caught a hoop of her cage in a stile and went regularly head over heels lightening on her feet with her cage and whole petticoats remaining above, above her head. They say there was never such a thing seen—and the other ladies hardly knew whether to be thankful or not that a part of her underclothing consisted of a pair of knickerbockers (the things Charlie shoots in)—which were revealed to the view of all the world in general and the Duc de Malakoff in particular." Indeed, though drawers may have been thought masculine, most ladies decided they were better than the revealing alternative.

A single petticoat, usually tightly gathered or pleated in back to accentuate the derriere, was now worn *over* the crinoline.

For some time having being virginally white, petticoats suddenly became popular in scarlet red when Queen Victoria was reported to have switched to the color "to reawaken the dormant conjugal susceptibility of Prince Albert." Another traditional garment—the corset—was still part of women's repertoire; however, because the width of skirts naturally made the waist appear smaller, it wasn't thought as necessary to lace up tightly, and corsets had a tendency to be larger. To the appreciation of many ladies, corsets could now be hooked open or closed in the front, in addition to being cinched up in back.

Underclothes, with these exceptions, remained virtually the same in the Fifties as they had been in the previous decade. Tucks and laces tend to be a little more prevalent in Fifties underwear, though the new ready-made undergarments were generally quite plain. There was also a trend in the summer months for so-called "invisible underclothing." Almost as intriguing as their name, these garments were created in the finest gauzes.

In keeping with this practicality, jewelry was often functional; chatelaines were a prime example. Though often elaborately decorated, these belt-like chains carried housekeys, scissors, and sewing tools.

A delicately printed lightweight wool dress, circa 1858. *Courtesy of Reflections of the Past.*

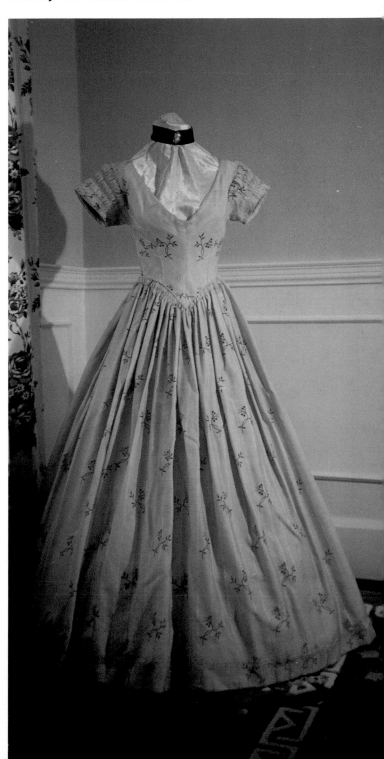

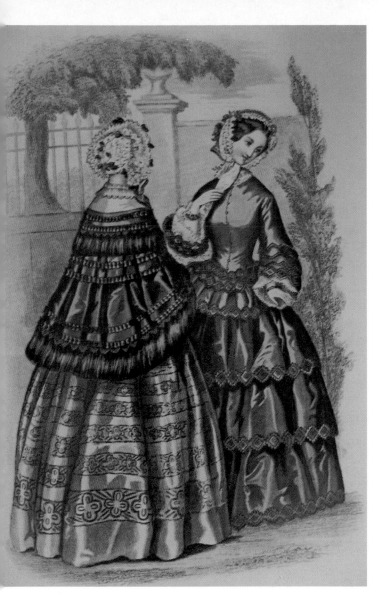

An 1855 fashion plate featuring sleeves worn over white undersleeves.

Other Important Garments

Bonnets, the darlings of the Forties, gradually became less and less obtrusive. Gradually, the face began peeking out from the bonnet's brim, and by 1855, the face could easily be seen in a lady's profile. After 1855, hats gradually began replacing bonnets—though bonnets would not go entirely out of fashion for some time.

But while "old fashioned" bonnets were slowly being ushered out, "old-style" pockets were once again coming into favor. Having been worn frequently in the early years of America, in addition to being worn by some in the early decades of the 1800s, detachable pockets that tied around the waist with string were once again being worn—this time, under the crinoline.

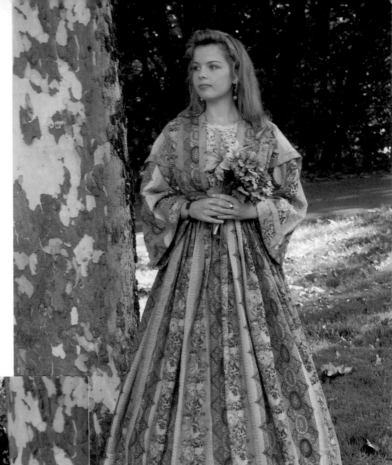

A rose and paisley printed dress, circa 1852. The wide sleeves would have been worn over full, separate undersleeves. *Courtesy of Reflections of the Past.*

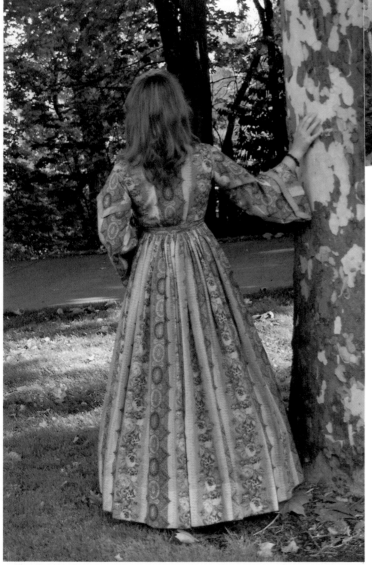

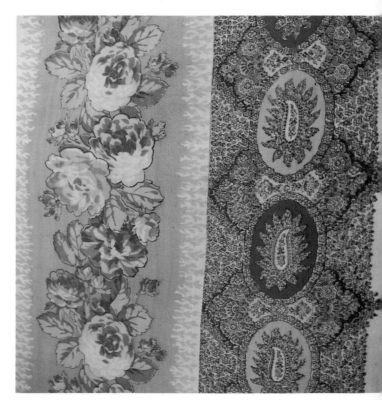

Detail of the beautifully printed fabric shown in the previous two illustrations.

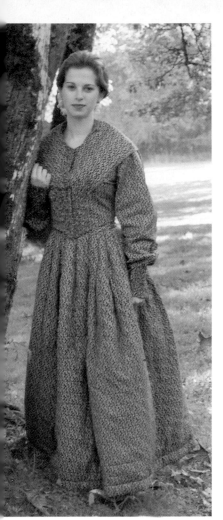

A finely quilted two–piece dress, circa 1850. *Courtesy of Reflections of the Past.*

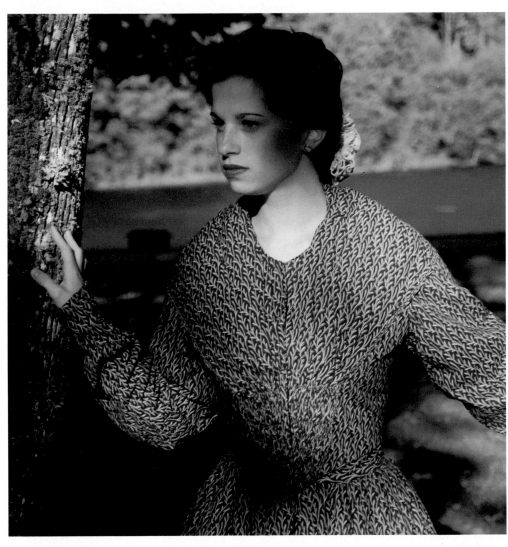

A circa 1859 fashion plate featuring a bride in a blushed pink wedding gown with a looped-up overskirt. The mother of the bride wears a simpler costume in shades of green and gold.

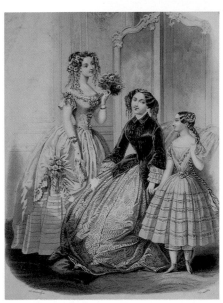

Detail of the inside of the dress pictured in the previous illustration. The fine quilting stitches are barely visible.

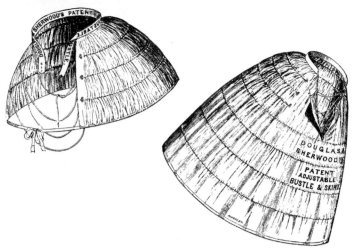

A hoopskirt much like the one from 1859, pictured in the photograph below, in addition to a much shorter version.

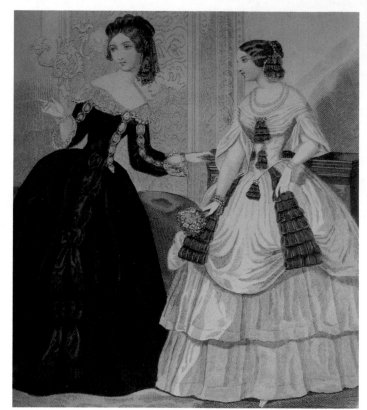

An 1850 *Peterson's Magazine* fashion plate featuring two exquisite evening gowns.

This hoopskirt made of cotton and cane is an amazing 116" in circumference; perfectly circular, it dates to 1859. The child's hoopskirt, which features an elastic waistband and snaps on the hoops (enabling it to be easily adjusted in length as the child grew) also dates to the same period. *Child's hoopskirt courtesy of The Very Little Theatre.*

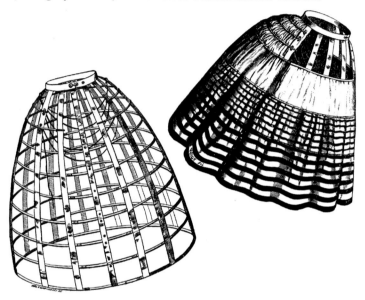

Two types of crinolines from 1858. The hoops on the left consist almost entirely of metal, while the hoops on the right feature decorative fabric.

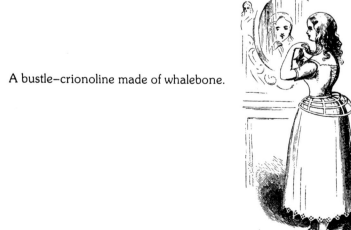

A bustle–crionoline made of whalebone.

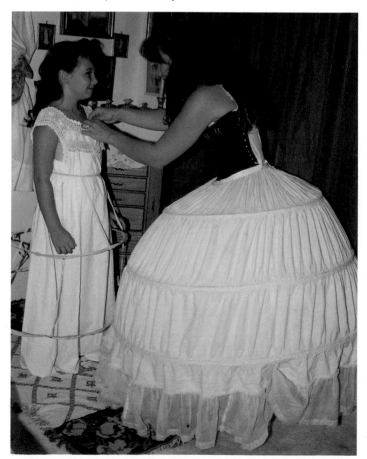

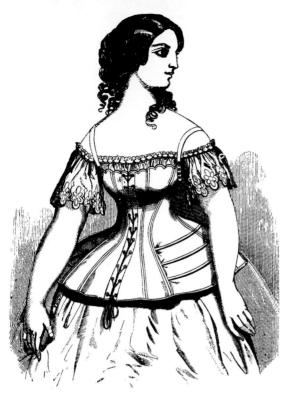

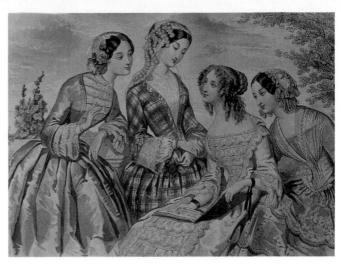

A *Graham's Magazine* fashion plate from 1859, depicting contemporary fashions as soft and flowing.

A "Douglas & Sherwood Tournure Corset," as featured in *Godey's Lady's Book*. This unusual item attempted comfort by combining the corset and hoopskirt into a single garment.

A delicate pair of soft and silky kid leather shoes, circa the late 1850s. *Courtesy of Reflections of the Past.*

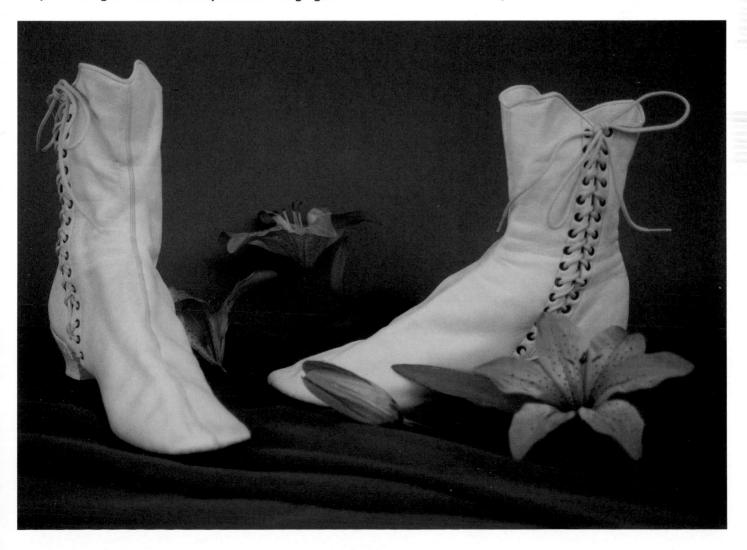

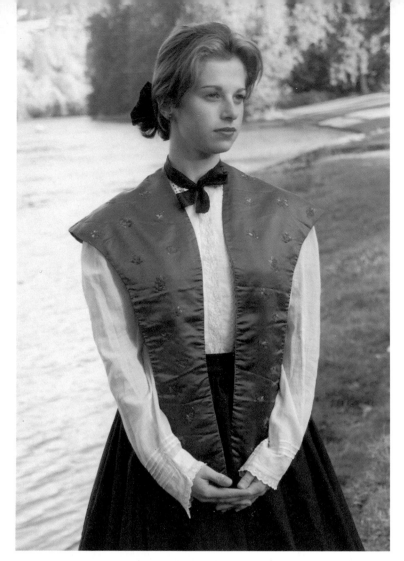

A silk embroidered shoulder cape. *Courtesy of Reflections of the Past.*

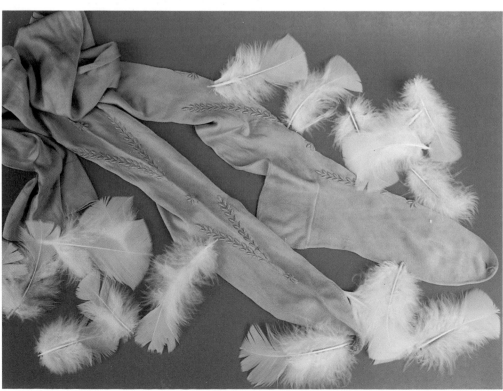

A pair of delicately embroidered silk stockings. *Courtesy of The Very Little Theatre.*

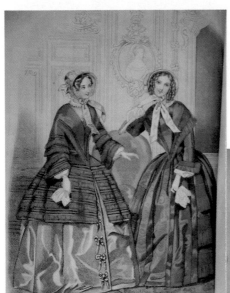

An 1850 *Peterson's Magazine* fashion plate featuring a fitted and flared jacket.

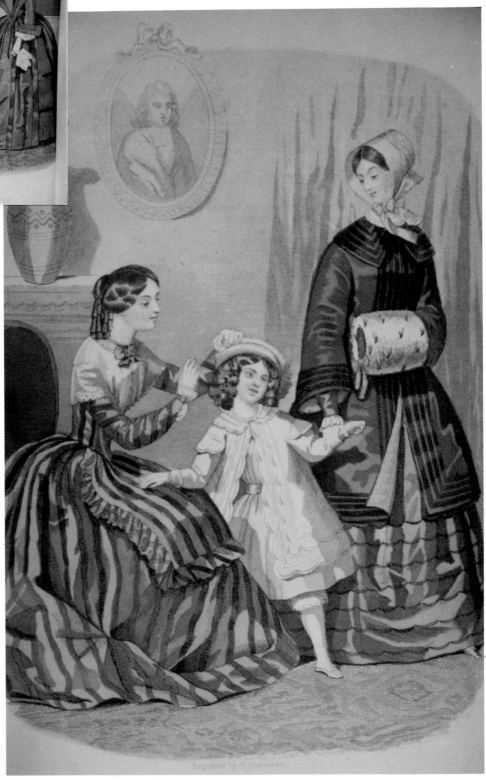

An 1850 fashion plate illustrating the clothing thought necessary for outings.

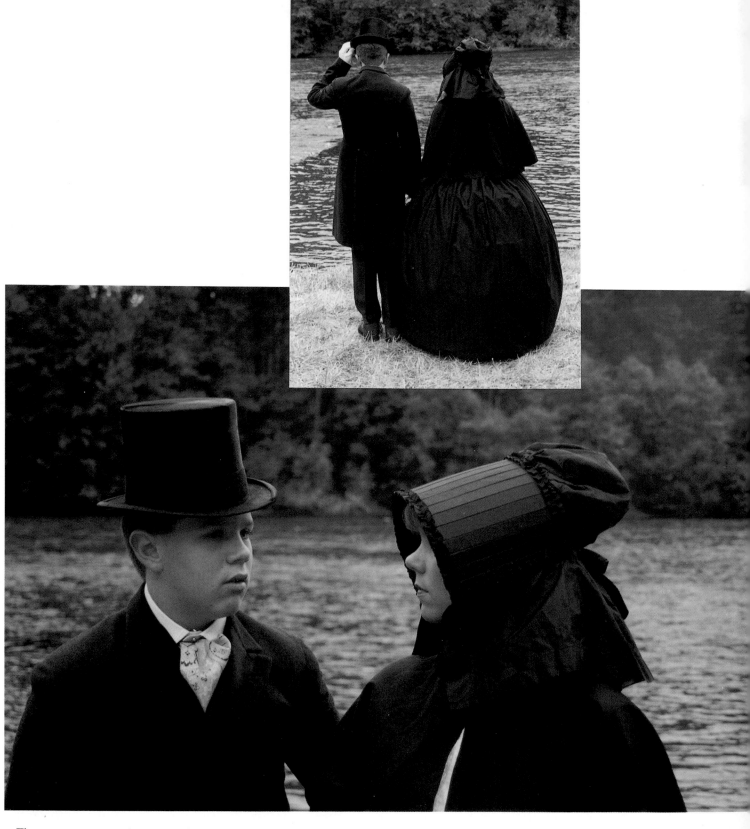

The woman wears a bonnet and cape, circa 1859. Originally worn by a widow while traveling from St. Louis, Missouri to Eugene, Oregon along the Oregon Trail, the bonnet features wooden slats in its stiff brim. The man's ensemble is also typical of the era, though the top hat was actually worn at the signing of the Treaty of Versailles (1919) by Solicitor General of the United States Fred Neilson. *Man's ensemble courtesy of The Very Little Theatre.*

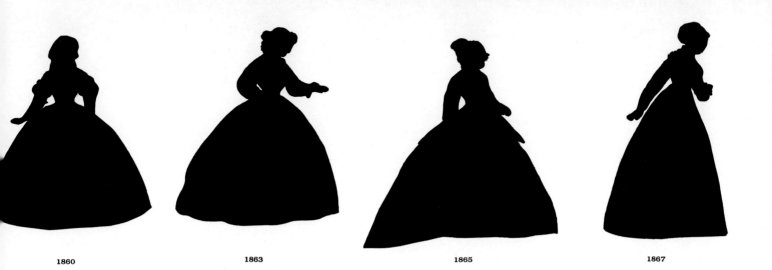

1860 1863 1865 1867

Chapter *Five*

1860s: Transitional Years

The sewing machine's effect took its hold on women in the 1860s. Though not every woman could yet afford the machine, the majority of new clothes were sewn with it, and nearly every lady wished to own one—and with good reason, as *Godey's Lady's Book* pointed out. "Mrs. Mary R. Hubbard..." *The Lady's Book* praised, "earned with a Wheeler & Wilson [sewing machine] in 1868, $731.47, stitching 31,092 shirt fronts, equal to 886,122 feet of seam. At 20 stitches to the inch, this would give 212,669,280, an average of 708,891 per day, 88,612 per hour, and 1,477 per minute, or sixty times as fast as hand sewing...Sixty years in one!" This meant clothes made by dressmakers took far less time to sew, and were therefore less expensive—which may account for the increase in the average woman's wardrobe in the Sixties. Where once one or two dresses would be appropriate for a single day, now each day required a dress for morning, afternoon, visiting, walking, and evening.

By reading ladies' magazines of the period, one would hardly guess that a far more significant factor was affecting the way women dressed in America: the Civil War. America's most popular ladies' magazines spoke of matters of beauty and the toilet, marriage and etiquette, offered stories, poems, fashion plates, art engravings, and songs—but no mention of the war that was daily affecting every American's life. There was at least one exception to this, however; in 1864, a *Peterson's Magazine* reader wrote a letter that hinted at wartime: The fashions, they claimed, were becoming much too masculine. Though such a claim may be difficult for modern women to understand after gazing at period fashion plates filled with billowing skirts and petticoats, upon close examination the age-old tendency for women to dress in a more masculine fashion during periods of war is certainly evident. Jackets and vests were worn together in a suit-like fashion, decorated with rows of gold and silver buttons and stripes, and many blouses resembled men's shirts.

The war had other effects on women's clothing, also; in the South many items—including new fabrics and findings—were scarce. Just think of Scarlet O'Hara's ingenious dress made of old draperies. Fashion magazines (also scarce—remember Scarlet's complaints that she could no longer receive *Godey's Lady's Book?*) regularly featured designs created for "the hard times," from which old carpets, drapes, and utility fabrics could be fashioned into clothes. Similarly, in the North, though there wasn't as much of a scarcity of new fabrics, there was often a lack of information on new fashions, since mail was extremely slow, and often lost altogether.

Skirts

1860 was the pinnacle of width in skirts, seeing measurements of up to 120" in the hems of some skirts; however, while fashion plates of the era regularly feature skirts of this proportion and larger, the majority of women chose less dramatic widths.

Dresses

In the Sixties, though most dresses were one-piece, the bodice and skirt were usually sewn into a waistband one to two inches wide. Sometimes the waistline of dresses was raised slightly, allowing the bulk of petticoats, drawers, and hoops to remain at the natural waistline. There was also a fleeting attempt around 1864 to revive the high-waisted Empire look of the early 1800s, but it was not widely accepted.

Trends in dress decoration remained much the same as in the previous decade, though the mid-Sixties saw very little trimming; by the end of the Sixties, dresses were more heavily decorated. Throughout the decade, braided hems, piping, puffing, ruching, and fringe were popular trims.

Plaids remained popular, and large stripes and geometric prints became a new favorite. Reds, bright royal blue, emerald green, olive, silver-grey, mauve, gold, and magenta were used extensively throughout the decade. Taffetas and velvets remained popular, and satins, moires, alpaca, and sateen were also used frequently.

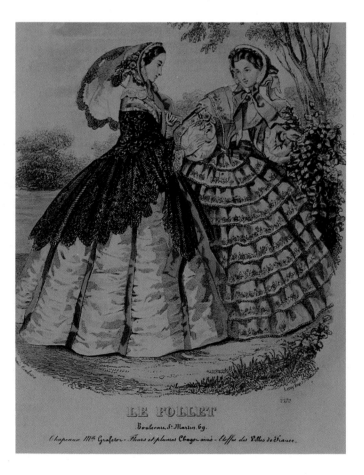

A fashion plate, circa 1860; the woman on the right wears a flounced dress featuring a border-print manufactured specifically for such designs.

After 1860, skirts evolved into an oval shape; around 1863, skirt fronts flattened; shortly after, the skirt's sides also flattened out; finally, the fullness of the skirt centered at the back, and included a slight train—giving the distinct impression that ladies were in constant, gliding motion, even when standing still. By 1869, the rear of skirts became larger than life and the bustle appeared. Indeed, the skirt was in a constant state of flux from the beginning of the Sixties; such a large amount of fabric was needed for fashionably wide hems that gathering—or even pleating—circular skirts was out of the question. So gored skirts appeared.

By 1868, skirts with flounces were definitely out of fashion. The new style was bands of contrasting fabric appliqued to skirt hems in geometric shapes. Pinked and scalloped edges also increased in popularity, and border prints remained fashionable.

At the end of the decade, when the bustle came into fashion, strings were usually sewn inside the back of skirts to control the fullness of the derriere. In fact, older, trained skirts are frequently found with strings which were attached in the late Sixties to help bunch up the old-style trains into new-style bustles.

Walking skirts from the Sixties often have loops of elastic on each side of the underside of the skirt, which allowed the skirt to be buttoned-up to the petticoat just below the waist. Author Gyp wrote in her book *Souvenirs d'une Petit Fille* about "short" walking skirts in 1863: "As they required less material and did not get dirty, everyone was wearing them. Day dresses that were not of the new fashionable length had *tirettes*, that is to say, cords sewn underneath to the bottom of the skirt which came out at the waist and were caught together with a button. One pulled the button and the dress rose like a tent over the petticoat which was held out by a cage [crinoline] and was always very elegant..."

Throughout the Sixties, skirts were often unlined—but hems were frequently stiffened with muslin about ten inches from the bottom. Some skirts from this decade are also totally lined with stiffened muslin or crinoline, and were probably worn by those who refused to adopt the cage crinoline.

Bodices

Bishop sleeves continued to be fashionable in the Sixties, and two-piece sleeves with detachable undersleeves became essential to the fashionable look—though by 1866, sleeves shrunk close to the

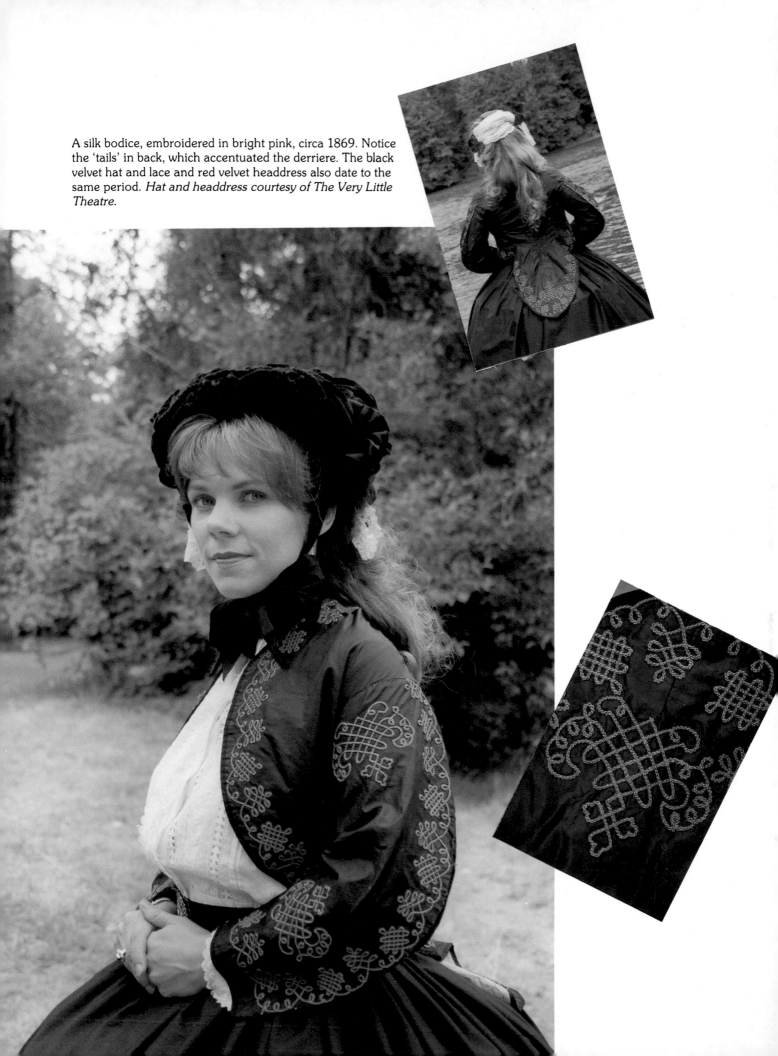

A silk bodice, embroidered in bright pink, circa 1869. Notice the 'tails' in back, which accentuated the derriere. The black velvet hat and lace and red velvet headdress also date to the same period. *Hat and headdress courtesy of The Very Little Theatre.*

entire arm. To look as though one had delicately drooping shoulders was once again the aim of ladies. This was achieved in the 1860s by placing the seam (where the sleeve and shoulder met) at the top of the arm; the shoulder seam was then stitched diagonally *behind* the shoulder near the neck, and several inches below the natural shoulder at the sleeve seam.

Necklines varied from the base of the neck to just slightly up the neck. Waists, in turn, were usually rounded and were frequently belted. Long, draped sashes were often worn around the waist up until about 1866. From 1866–68, bodices frequently included a peplum—especially if they were designed for evening wear. Watch pockets are often found in bodices of all types.

In the Sixties, boning in bodices usually consisted of two to three bones (only a few inches long) in the center front, and two bones four to six inches long on each of the bodice sides. Bodices which were pointed (in this decade, almost never seen except on evening gowns), usually relied more heavily on boning.

Undergarments

Crinolines were still a lady's most important undergarment—even some Catholic nuns wore crinolines under their habits; most ladies went without hoops only while horseback riding, swimming, or sleeping. At the beginning of the decade, crinolines usually had up to nine hoops in them—though some fashionable evening gowns were worn over crinolines containing up to eighteen hoops. From 1860 to 1866, crinolines varied in circumference from about 70" to 118"—according to their wearer's personal preference. Like skirts, hoops naturally changed in shape throughout the decade; for the first eight or so months of 1860, they were circular, then the front subtly flattened. By 1863, their sides flattened, also. Finally, in 1864, crinolines were shaped so that nearly all fullness was in the back. Crinolines worn in the day were often flatter in the front than those worn under evening gowns. By 1868, if a lady chose to wear a crinoline, it usually consisted of only three or four hoops suspended by fabric bands from a waistband, and wasn't more than six feet at the hem.

By 1868, however, the bustle had almost completely taken the place of the crinoline. In these early years of the bustle, it often looked like a modified version of the crinoline, usually consisting of a straight-fronted petticoat with a few steels or canes creating a fashionable hump at the back.

A middle-class woman of the Civil War era, wearing a simple ensemble.

Petticoats, still worn over the crinoline or bustle, remained virtually unchanged in the 1860s—though they were often made sleeker by goring. Petticoats were sometimes created especially to be worn under walking dresses and featured a profusion of scallops, tucks, lace, and ribbon. Sometimes the hems of these specially created petticoats were lined with oilcloth, for easier cleaning. Drawers were worn by most women in the Sixties; these either ended at or just below the knee and were still cut quite full. Sometimes they were also secured just below the knee by elastic or a buttoned band. "Those who are fond of gardening will find these most judicious things to wear," *Godey's Lady's Book* praised.

The snug, but not tightly cinched, corset remained important to ladies throughout the 1860s. Early in the decade, ladies learned a much shorter corset (usually ending just a few inches below the waist) suited their needs—and their comfort—much better than the long corsets of previous decades. While new types of corsets were almost constantly being thrust into ladies' laps, only a few caught women's attention. The "Thompson's Patent Glove-Fitting Corset" was one that had some lasting power. Manufactured with snaps in front—in additional to the traditional hooks—it was praised for preventing accidental openings.

The chemise was still worn in the Sixties and usually measured about one yard at the hem. Corset covers were also still worn. Undergarments in general were only occasionally made up in bright colors, white (and the intermittent red petticoat) remaining the most popular.

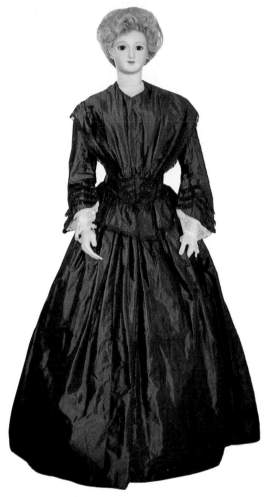

An iridescent dress trimmed with cobalt blue fringe. *Photograph courtesy of Reflections of the Past.*

Sportswear

The 1860s saw the genesis of a new kind of women's clothing: sportswear. Before this time, if a lady wished to partake in sports, she either did so in men's sporting clothes (if she was particularly brave), or in her everyday attire. Shorter skirts (usually reaching the top of the ankle) and sets of hoops which could be drawn up to the thigh or collapsed entirely were created for walking, hiking, and mountain climbing. But by far the greatest advances seen in women's sportswear in the Sixties were in bathing attire.

Before the 1860s, if a woman wished to swim, she either did so in the nude or in a long, shapeless, nightgown-like garment. But in the Sixties, much ef-

fort was made to make swimming an activity that men and women could enjoy together without being scandalous. Thus, the bathing suit was born. By 1863 fashion magazines wrote such things as: "The loose blue gown like a bottomless sack is no longer considered the right thing for a bathing costume and a little more attention is paid by fair bathers to avoid looking like down-right frights...Very pretty costumes are [now] made; trousers long and straight to the ankle in the shape of knickerbockers, and a long half-fitting casaque; or else a blouse-tunic with trousers; these are made in flannel of red, black with blue or red worsted braid; white is to be avoided for obvious reasons."

Other Important Garments

Small hats were preferred over bonnets by ladies of fashion. Other essential accessories included: paletots, square-toed shoes, mitts (instead of gloves), and snoods (which were little more than glorified hair-nets).

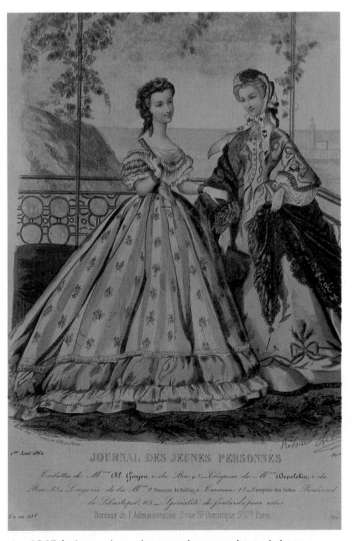

An 1865 fashion plate, showing the new eliptical skirt.

A shirtwaist from the 1860s, featuring lace insertions in front.

An 1876 fashion plate showing slightly raised waists and slimming skirts.

Glorious fashion plates aside, the average 1860s woman looked like this.

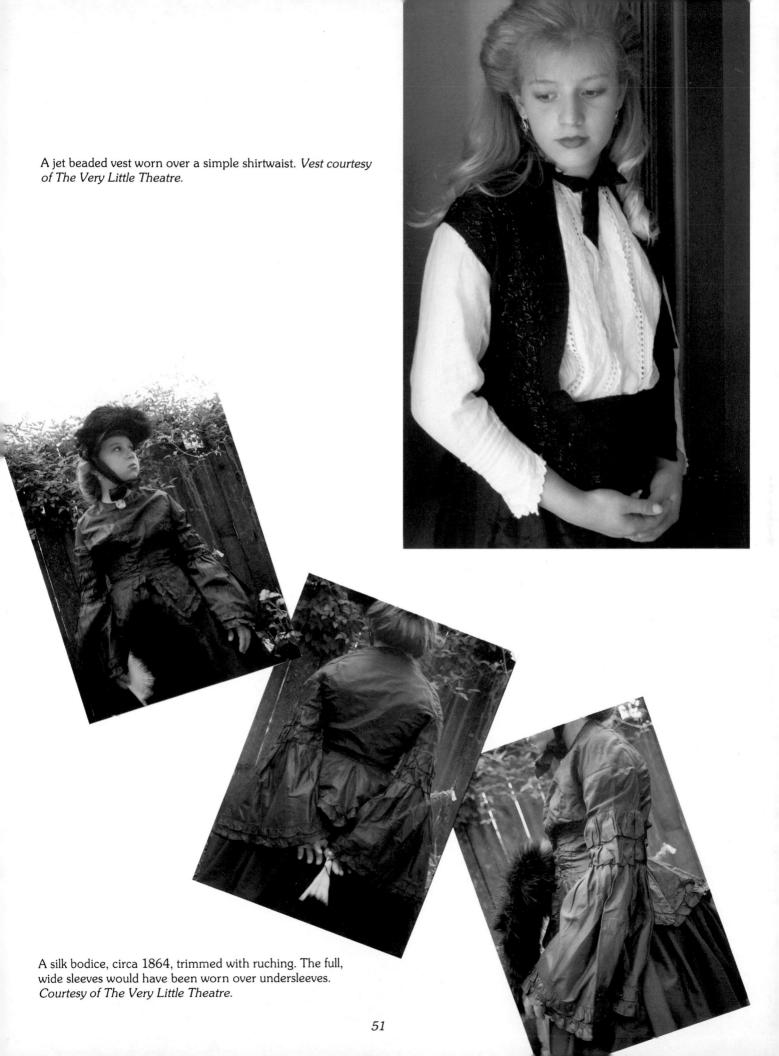

A jet beaded vest worn over a simple shirtwaist. *Vest courtesy of The Very Little Theatre.*

A silk bodice, circa 1864, trimmed with ruching. The full, wide sleeves would have been worn over undersleeves. *Courtesy of The Very Little Theatre.*

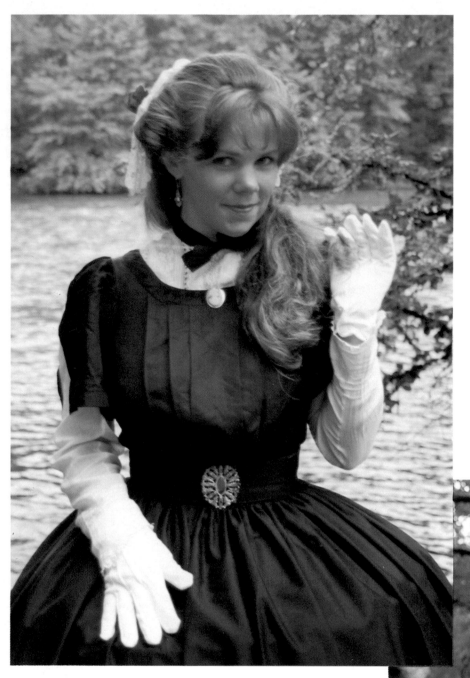

A bodice of tucked fabric, circa 1866. It could have been worn over a long–sleeved blouse, as pictured; it is more likely, however, that the split sleeves featured full, separate undersleeves. *Courtesy of The Very Little Theatre.*

This blouse, vest, and belt ensemble date to about 1862. Notice the black grosgrain ribbon–tie on the blouse. The belt consists simply of a wide grosgrain ribbon attached to a decorative metal buckle.

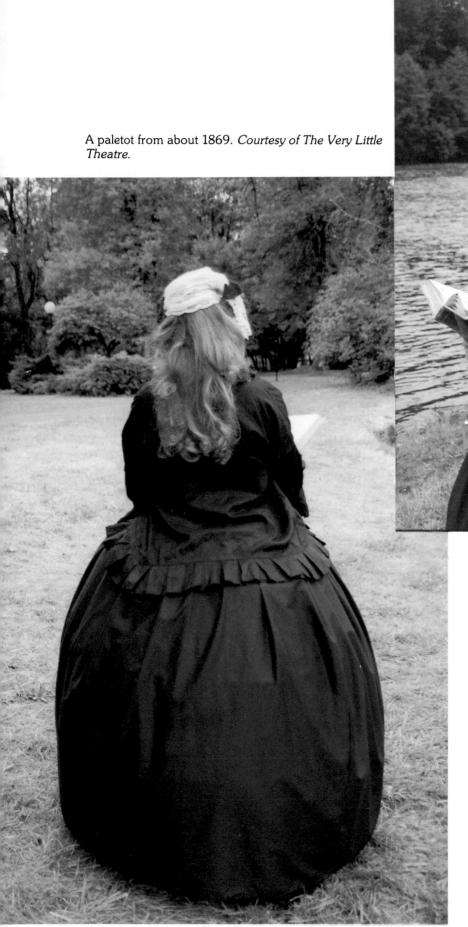

A paletot from about 1869. *Courtesy of The Very Little Theatre.*

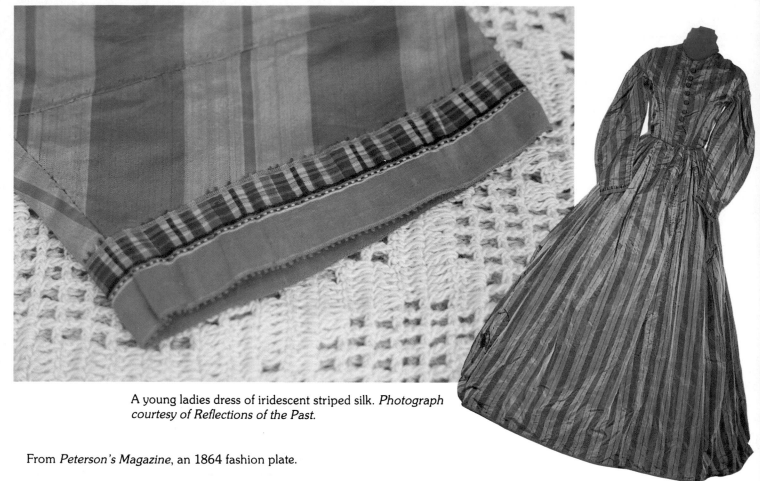

A young ladies dress of iridescent striped silk. *Photograph courtesy of Reflections of the Past.*

From *Peterson's Magazine*, an 1864 fashion plate.

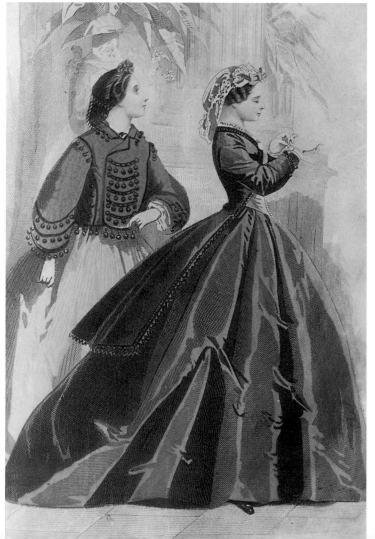

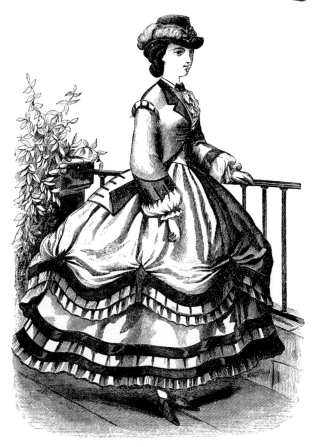

An 1864 'seaside' costume, featuring a skirt with a looped–up affect.

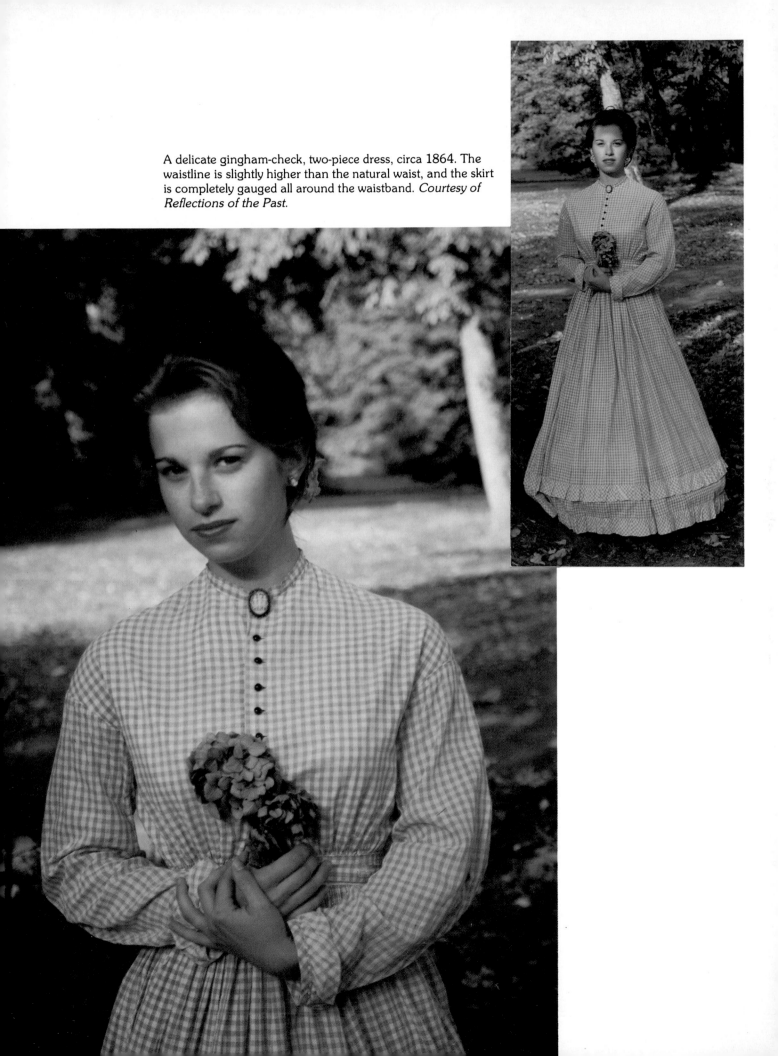

A delicate gingham-check, two-piece dress, circa 1864. The waistline is slightly higher than the natural waist, and the skirt is completely gauged all around the waistband. *Courtesy of Reflections of the Past.*

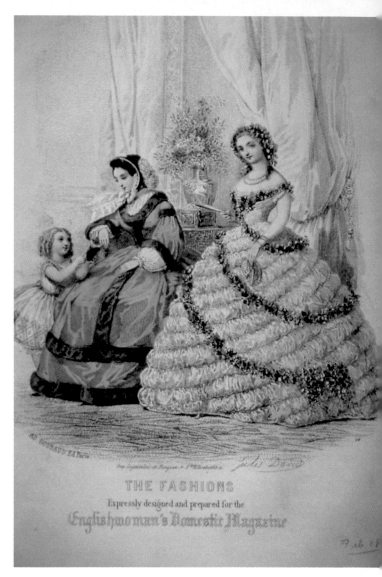

A soft, feminine dress, circa 1868. *Photograph courtesy of Reflections of the Past.*

An 1861 *Englishwoman's Dometic Magazine* fashion plate, featuring an 'invisible' evening gown.

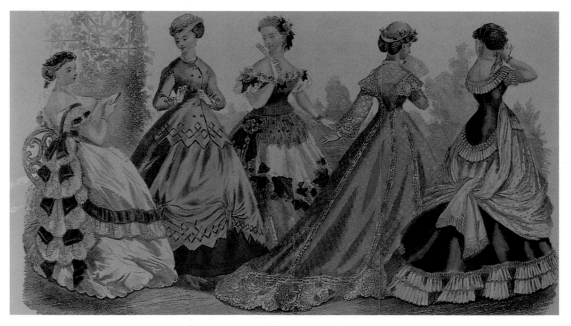

A circa 1867 fashion plate illustrating the new style in evening and visiting attire.

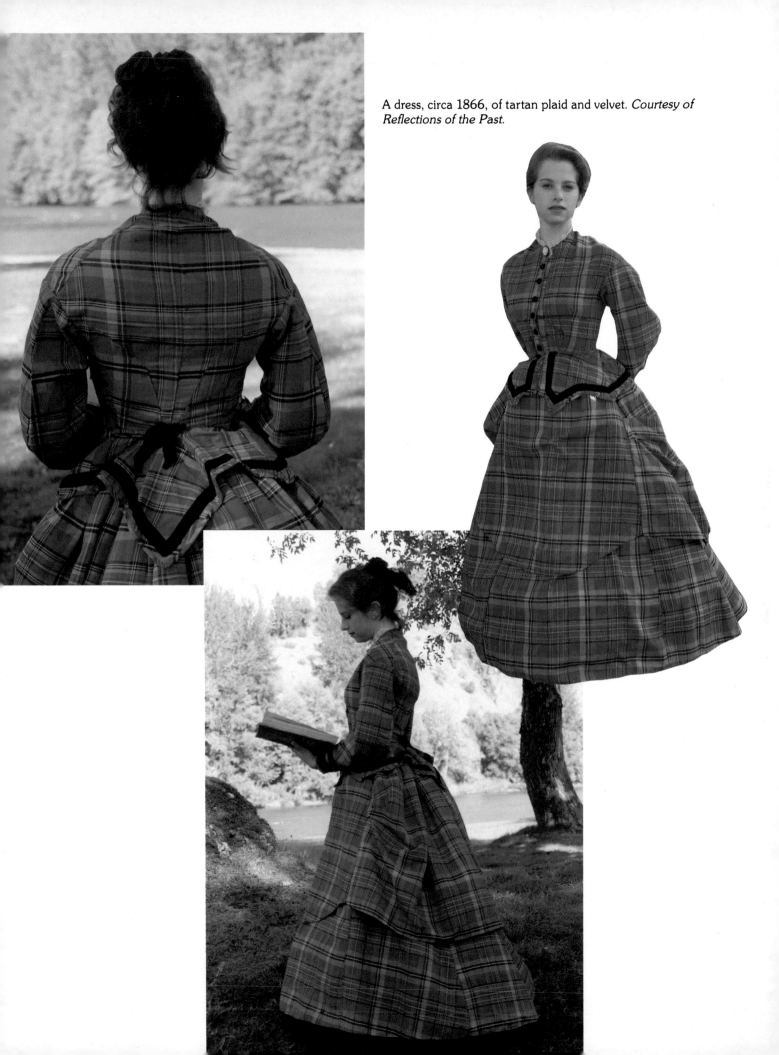

A dress, circa 1866, of tartan plaid and velvet. *Courtesy of Reflections of the Past.*

Detail showing the technique of gauging. Notice how two rows of stitching (here, in brown thread) are visible.

A fashion plate, circa 1865, featuring geometric designs.

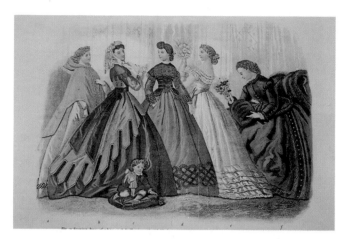

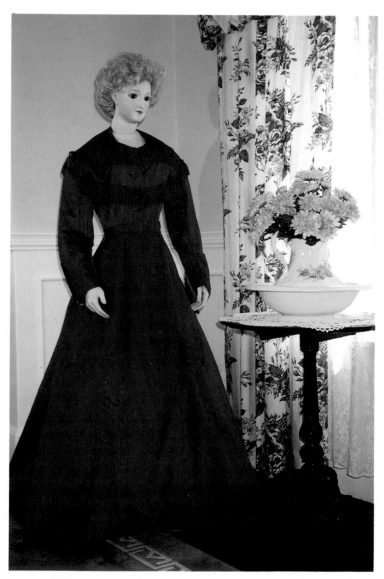

A stunning red gown, circa 1863. *Photograph courtesy of Reflections of the Past.*

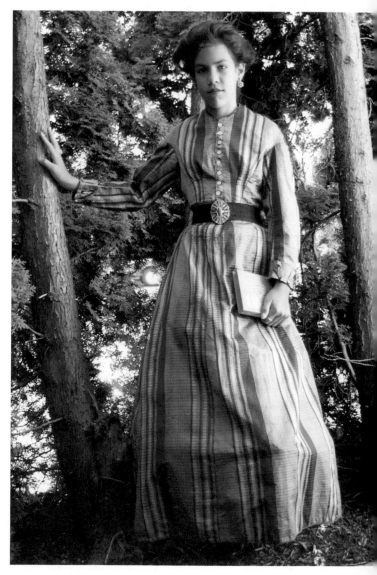

A young lady's dress of iridescent striped silk. *Courtesy of Reflections of the Past.*

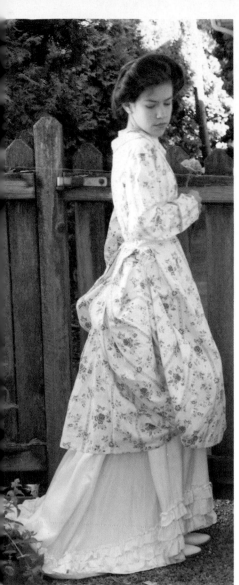

A circa 1869 dress with looped up sides which are held in place with tiny elastic loops and inconspicuous buttons. *Courtesy of Reflections of the Past.*

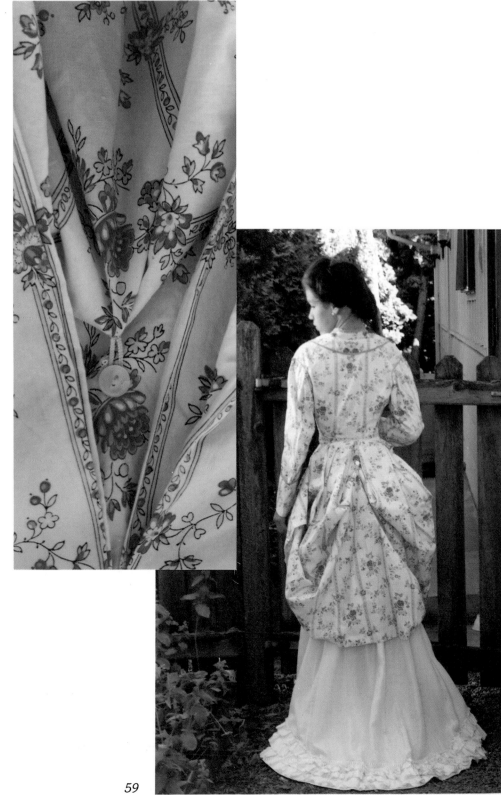

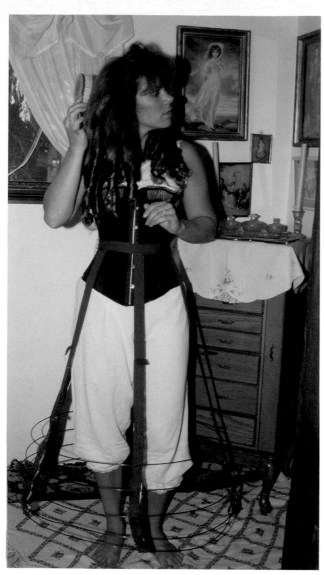

A circa 1862 hoopskirt made up of tape ties and metal hoops, and measuring 92.5" in circumference. *Courtesy of The Very Little Theatre.*

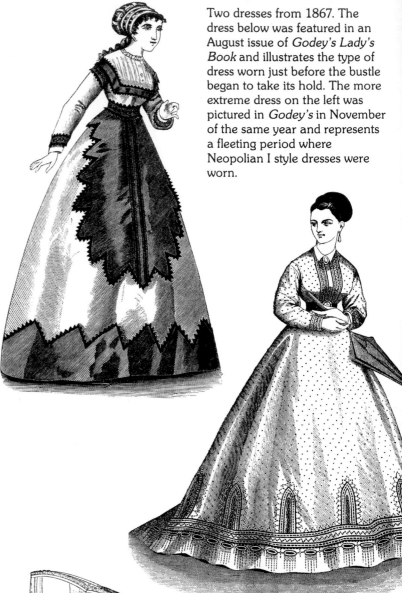

Two dresses from 1867. The dress below was featured in an August issue of *Godey's Lady's Book* and illustrates the type of dress worn just before the bustle began to take its hold. The more extreme dress on the left was pictured in *Godey's* in November of the same year and represents a fleeting period where Neopolian I style dresses were worn.

A corset from the early 1860s.

This 1860s woman wears a typically Civil War Era snood in her hair.

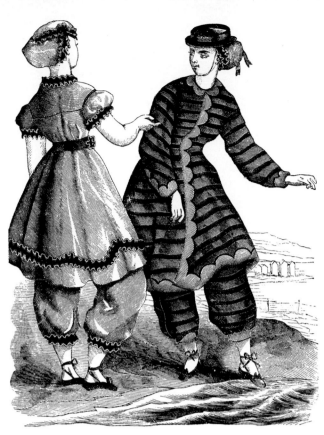

Two flannel bathing suits in shades of red, as featured in an 1865 *Godey's Lady's Book*.

A fashion plate from 1865.

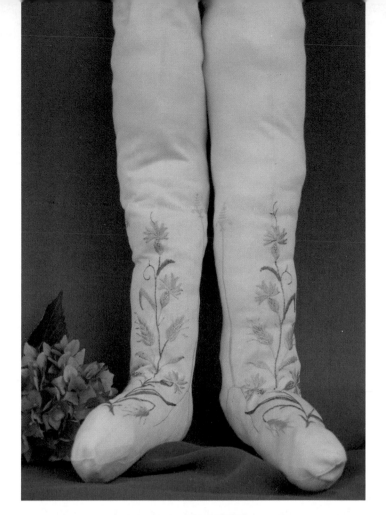

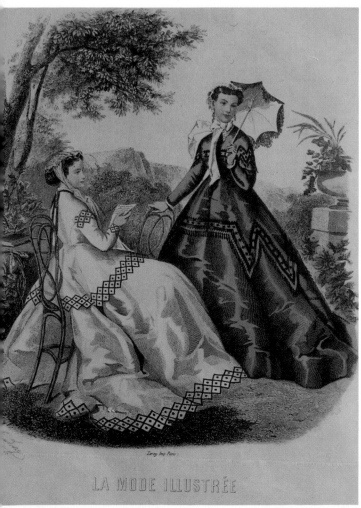

LA MODE ILLUSTRÉE

A pair of stockings, probably dating to the 1860s, embroidered in soft, natural tones. *Courtesy of Reflections of the Past.*

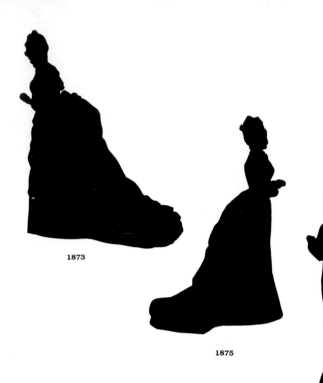

1873

1875

1877

of the mass-produced trims that had once been out of reach of their budgets. The result was often gaudy; with typical Victorian flair, ladies decided that if a little trimming was good—more was better.

Skirts

The typical skirt of the early 1870s was nearly straight in front (though not fitted), and flared toward the back, where pleats, gathers, or an apron-like peplum rested atop a bustle. Trains were worn on all but walking skirts. Long pleats, ruching, or other decorative trims were favored at the hems of skirts for both day and evening wear.

Chapter Six

1870s: Mermaid's Tale

"A Pittsfield feminine Sunday-school teacher recently...lost her Bible and didn't know where to find it," *Godey's Lady's Book* reported early in the 1870s. "When she got home, the book of books was found wagging along on the bustle behind her, where it had been placed by a member of her class." In the Seventies, the bustle took almost as much flack as the crinoline had in the previous decade. Supposedly created to help women with tightly cinched waists comfortably hold up the mass of material designers placed at their rears, bustles created for ladies a large shelf-life derriere.

In 1873, however, one fashion magazine claimed the bustle was not the most outstanding feature of fashion. "What will characterize the present epoch in the history of Fashion," they wrote, "is the amount of trimming with which we have found it possible to load every separate article, from the slipper to the monument we have agreed to call the bonnet." Indeed, by the Seventies, ladies were definitely taking advantage of the sewing machine's cost-effectiveness. Now that dressmaker-made clothes were more quickly created (and therefore, less expensive), ladies took advantage

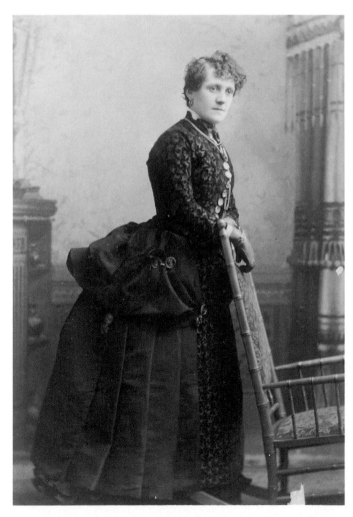

A photograph taken circa 1872 of a fashionable lady dressed in rich velvets and brocades.

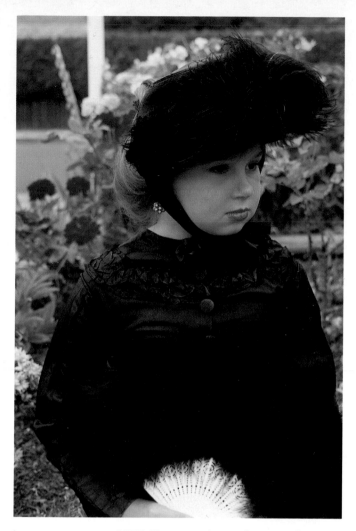

A waist worn to an 1875 Christmas dance, featuring large buttons and ruching. The straw hat trimmed with feathers also dates to the same period. *Courtesy of The Very Little Theatre.*

By 1871, the apron-like peplum that had once only covered the derriere, could now also cover the front of the skirt, giving the appearance of an over-skirt. In 1873, the "Polonaise" skirt firmly took its hold on fashion. Designed to look like an over-skirt that opened in a ∧ shape in front, many underskirts were designed to look like lavishly decorated petticoats.

"Skirts are worn much closer to the figure..." one period magazine reported. "In order that the skirt may cling closely in front, it is usual now to border them with a fringe or to lead them." This snugness in skirt continued until, by 1874, ladies stood in front of a draped ellipse. By 1875, the bustle became much smaller. This trend toward slimmer skirts continued, and by 1879, skirts were nearly straight except for their trains. Ultra–fashionable women followed the look of fashion plates and wore dresses that outlined every curve of their figure. One fashionable lady wrote that if it weren't for women's "mermaid's tails" (their trains, that is), they would look as though they had "a towel wrapped 'round" themselves. At this time, also, fashionable ladies often swathed scarves or bands of fabric around their knees—which gave them a curious waddle and made walking upstairs nearly impossible.

All through the Seventies, skirts frequently contained strings sewn into the side seams—which were tied to the rear to control fullness and keep the front of the skirt flat. Skirt trains—much discussed as filthy things that swept the street—now had a new feature: *The balayeuse*, or "dust ruffle." Made of durable, washable fabric, these heavily pleated or gathered strips of fabric could be easily untied, unbuttoned, or, if tacked in place with loose stitches, ripped away from skirt hems to allow for easy cleaning.

Bodices

While rounded waists were still sometimes worn in the early Seventies, waistlines that came to a point at center front were most favored. Bodices were frequently created to look like jackets which opened in front and had a wide peplum in front and back. By 1874, bodices reached well beyond the waist, often extending over the belly.

In 1875, one period magazine complained that "bodices fit the figure as though they were glued there." Often corset-like in design, the chief variation in bodices was decoration; however, sleeves also added some variety to fashionable bodices. In the early 1870s, long sleeves, straight (but not too tight) above the elbow, and very full below it, were fashionable. Straight sleeves were also fashionable and usually featured lace, pleating, or tucks at the wrist. Melon puff sleeves appeared around 1872, and continued to be worn until about 1875. From 1875, straight, fairly plain sleeves were fashionable, sometimes featuring large, decorated cuffs.

Squared necklines were a strong feature during the Seventies, but rounded and V-shaped necklines were also worn. After 1875, necklines were generally high, rounding off at the base of the neck and sometimes topped off with a standing or falling collar.

Dresses

Beginning in the early 1870s, dresses were once again frequently made in two pieces—this time because the weight of bustled skirts pulled uncomfortably at bodices if the two pieces were attached.

One of the new and notable styles of the early Seventies was the so-called "Dolly Varden" dress, named after a Dickens character. Consisting of a full, bustled skirt worn over a polonaise-style bodice with a peplum, the dress was ridiculed by the upper class, but frequently worn by the average woman.

"The ideal at present," *Harper's Bazar* reported in 1875, "is the greatest possible flatness and straightness: a woman is a pencil covered with raiment." Though this report was greatly exaggerated, it did predict the loss of the cumbersome bustle around 1876. By 1879, Lilly Langtry—actress and ideal Seventies beauty—made fashionable the jersey dress. As the name suggested, the outfit consisted of a mid-thigh length bodice made of clingy jersey fabric (usually in red or blue) with a serge or flannel pleated skirt worn beneath it. Unfortunately, it was terribly unflattering to all but the trimmest, curviest figures.

Princess-style dresses—also clinging to the figure—were eminently popular between 1875 and 1881. Lined to the hips and boned fully in the bodice, princess dresses served to accentuate the hourglass figure. Unfortunately, however, their draped bustles and long trains gave women a definite mermaid appearance.

For evening, styles were virtually the same as for day; however, evening saw more cleavage than day dresses, and—as in the past—sleeveless styles were permitted at night. Though trains were also seen on day dresses, for evening they were most extravagant, measuring up to 70" in length.

Heavier fabrics were most favored in the 1870s, as were darker colors. Heavy silks, foulards, alpacas, and velvets were prescribed by fashion magazines; greys, black, maroon, plum, emerald, browns, and sapphire blue were recommended colors.

Undergarments

Occasionally bustles—hoops and all—are found sewn into dresses; this, however, is rather unusual. More often found are small pads or layered ruffles sewn to the rear at the waistband. Even so, separate bustles were worn by all fashionable ladies. Around 1872, stiffened fabric bustles made up of several ruffles and tied to the waist with a string were regularly featured in fashion magazines. Under these, a full-fledged bustle was usually worn. These often consisted of strong cotton in the shape of a straight (often frontless) skirt; inside the skirt, several strings were sewn to side seams and could be tied toward the rear in order to

control fullness. Some more severe bustles also contained flexible hoops at the derriere.

As the decade progressed, these awkward bustles were gradually replaced by lighter, smaller "wire baskets," made of pliable metals. By 1876, the bustle virtually disappeared until the early years of the next decade.

A jacket of midnight blue velvet, trimmed with silk ribbon, circa 1875. *Courtesy of The Very Little Theatre.*

The corset remained virtually the same until about 1875, when the new long, sleek look became fashionable; at this time, the corset grew in length, in order to help flatten the stomach. The Seventies also saw a new optional feature to the corset: suspenders. At first worn over the shoulder, then gradually attached to the corset, these new contraptions made their first marked appearance at Paris' *Grande Opera Bouffe.* Here, period newspapers tell us, the dancers appeared with "naked thighs" and suspenders holding up their stockings. Though it caused quite a row at first, it wasn't long before many ladies were wearing them daily—finding them much more comfortable than garters.

The chemise also took on a slightly new look by adopting the princess–cut, which allowed it to cling close to the figure. Drawers, now sometimes fastening closed with buttons, had a new rival: combinations. These new garments, designed to reduce bulk, combined the chemise and drawers all in one. The popularity of combinations was limited in the Seventies, however.

Around 1875, when dresses began growing more snug, some women abandoned the bulk of petticoats altogether. Such women then buttoned their skirts to the waistlines of their corsets and sewed a simulated petticoat ruffle to the hem of their skirt. More often, however, ladies wore one or two petticoats cut in gores for ultra-slimness.

Alternative Dress

Since 1800, a fleeting variety of fashion reform societies had existed. Either complaining that women's clothes were unhealthful, uncomfortable, or just plain ugly, these societies had varying impacts upon fashions worn by the masses.

The first alternative fashions to have any impact on contemporary fashions were 'bloomers', introduced around 1849 and named after a woman who greatly encouraged their use: Amelia Bloomer. These full, Turkish-style pants were frequently mocked, however, and were only adopted by a small number of brave women. Still, their long-term impact was great, and in the 1860s women adopted bloomers for swimwear; by the 1890s, they were also widely worn for bicycling, gymnastics, and hunting.

The 1860s also saw a small group of women wearing full trousers under knee–length skirts. Mostly worn by doctors and other scientists, such women were mocked for 'wearing the pants'.

It was in the late 1870s, however, that a more widespread form of alternative dress appeared. Unlike past dress reform movements, successful Seventies and Eighties alternative movements touted clothes more closely resembling contemporary fashion plates— except they were looser, lighter, and free from bonings and bustles. Though some women (mostly wealthy) choose to wear so-called "aesthetic" Grecian-robe-style reform dress, it was less radical styles—like those shown in Annie Jenness Miller's magazine *Dress*—that won the most favor. Such fashions varied from contemporary fashions in varying degrees. Some were no more than contemporary fashion plates, loosened for uncorseted waists; others were made up of less fashionable style lines.

This type of alternative dress had the strongest impact upon fashion. Most obviously, it made negligees (or teagowns) a more acceptably seen garment (many wealthy women wore these almost exclusively while resorting in the summer). 'Prairie' dresses of the 1850s through 1890s, also—of necessity—followed the general principals of alternative dress. By the early 1900s, a great many women choose to be entirely corsetless, and by 1910, looser dresses were widely worn everyday.

Alternative dress does pose particular problems for collectors, mostly because it can be difficult to identify and date. For instance, the difference between maternity and other types of alternative dress is largely undeterminable; only sack–like gowns with very little adornment can be called "maternity gowns" with much certainty. Then there are dresses like the one pictured here, which has fashion elements from several decades; the sleeves resemble the 1860s, but the skirt is definitely in the style of the late 1870s. Was the dress worn in several decades? Or was it simply styled without contemporary fashion held strongly in mind? Fortunately, studying alternative dress fashion magazines proved the latter to be most likely. However, not all collectors have access to such rare publications.

Still, the average collector *can* usually discern alternative dress from fashionable dress—and can keep their eyes open for more information which will aid them in dating these rare additions to their collection.

Other Important Garments

As corsets and dresses grew tighter in the second half of the decade, women increasingly favored the wearing of teagowns. Once only worn in the boudoir, it became more and more popular to wear them to the breakfast table and before morning outings. As more friends and family were apt to see the garment, it also became more and more elaborate, made up in silk or faille, and trimmed with laces, tucks, and trims.

Similarly, as clothes grew increasingly uncomfortable, house dresses became more important. Looser, more simplified, and washable garments, house dresses were largely frowned upon by elite fashion magazines, but certainly, a large number of women favored their practicality.

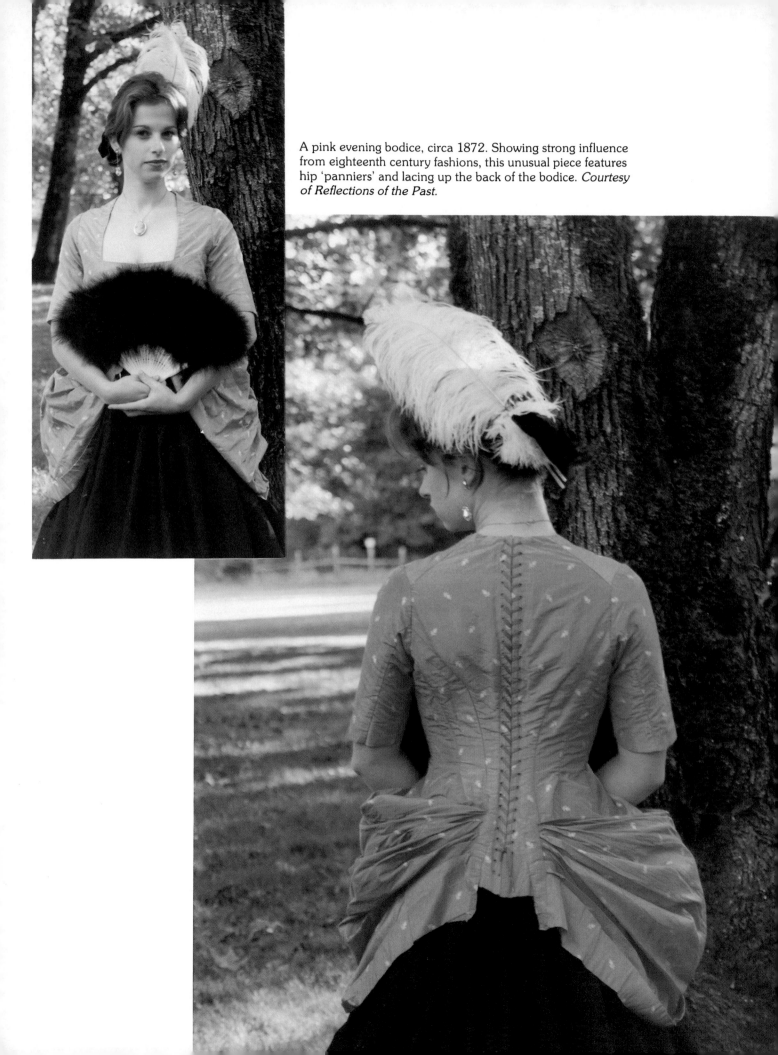

A pink evening bodice, circa 1872. Showing strong influence from eighteenth century fashions, this unusual piece features hip 'panniers' and lacing up the back of the bodice. *Courtesy of Reflections of the Past.*

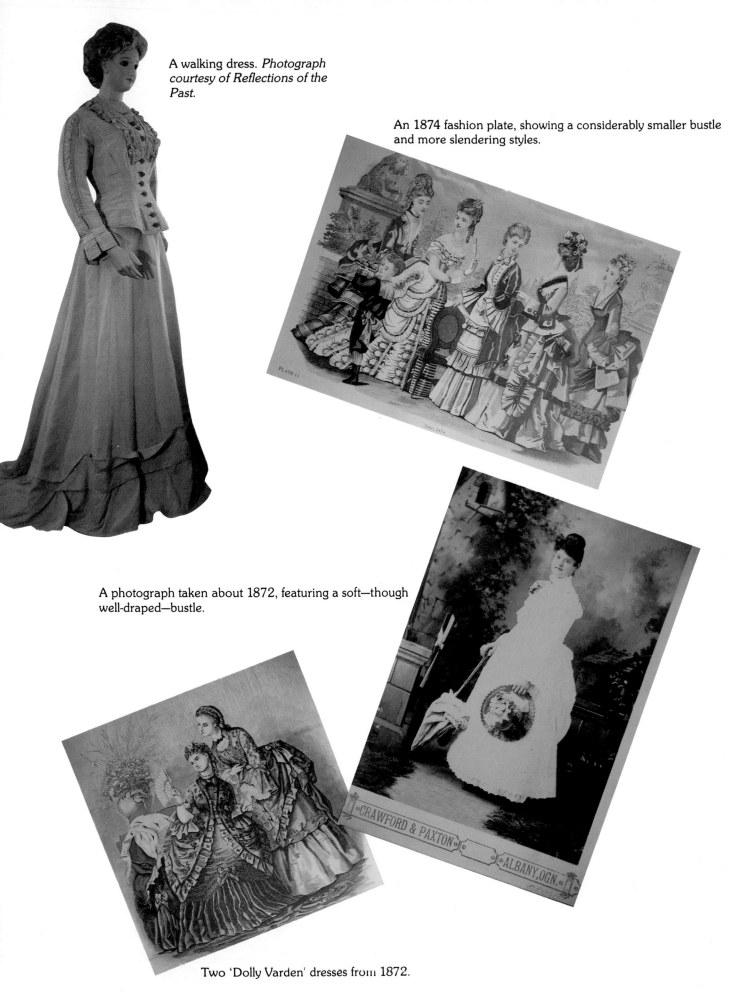

A walking dress. *Photograph courtesy of Reflections of the Past.*

An 1874 fashion plate, showing a considerably smaller bustle and more slendering styles.

A photograph taken about 1872, featuring a soft—though well-draped—bustle.

Two 'Dolly Varden' dresses from 1872.

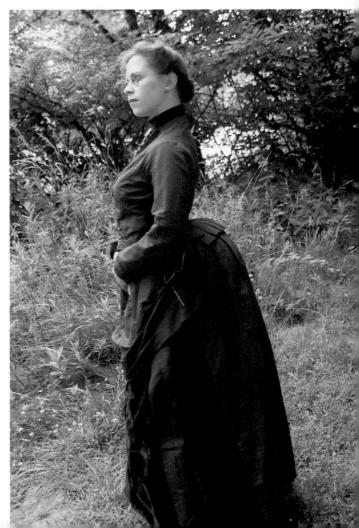

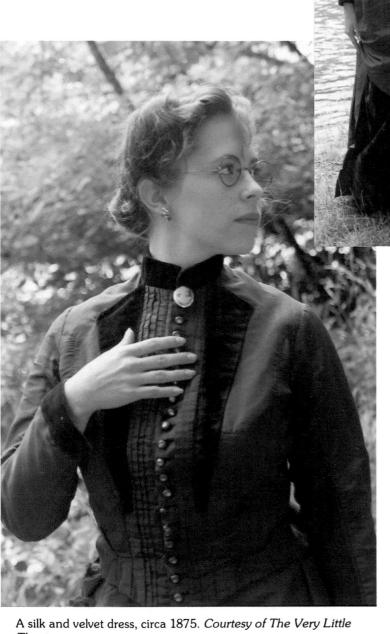

A silk and velvet dress, circa 1875. *Courtesy of The Very Little Theatre.*

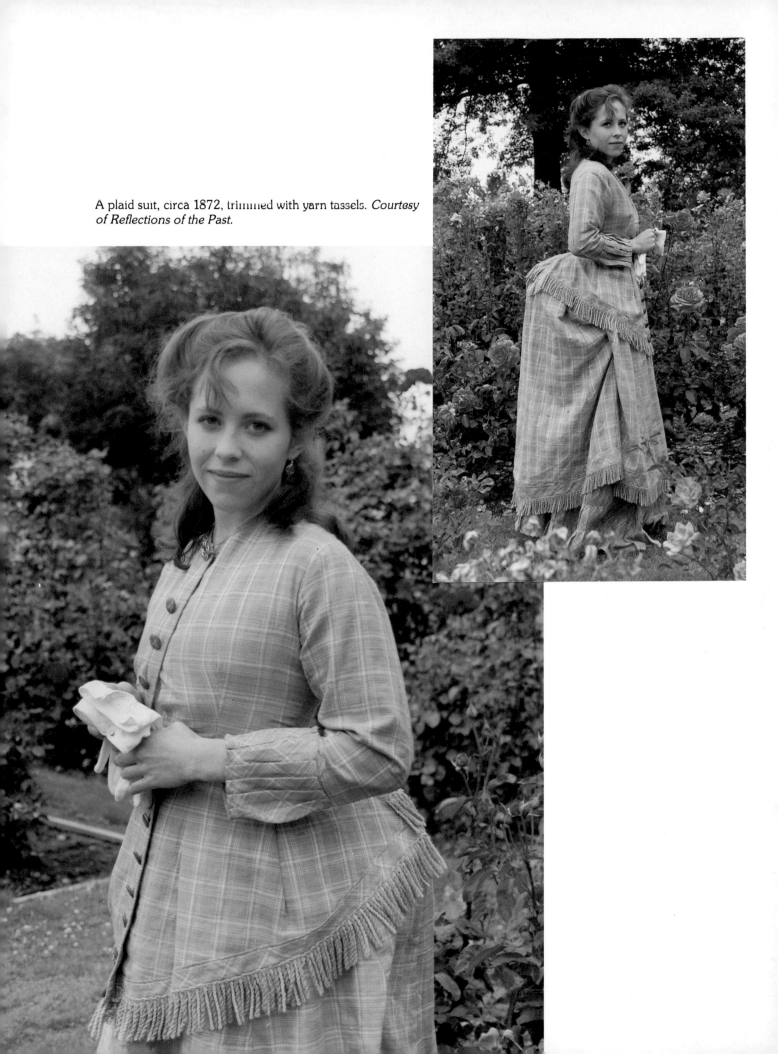

A plaid suit, circa 1872, trimmed with yarn tassels. *Courtesy of Reflections of the Past.*

A three-piece dress with a woven flower design, circa 1873.
Photograph courtesy of Reflections of the Past.

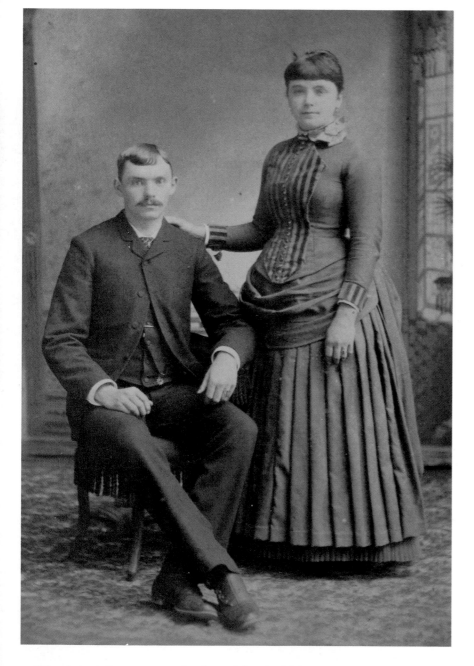

Kilt–pleated skirts worn under draped, bustle skirts were
considered a sensible style.

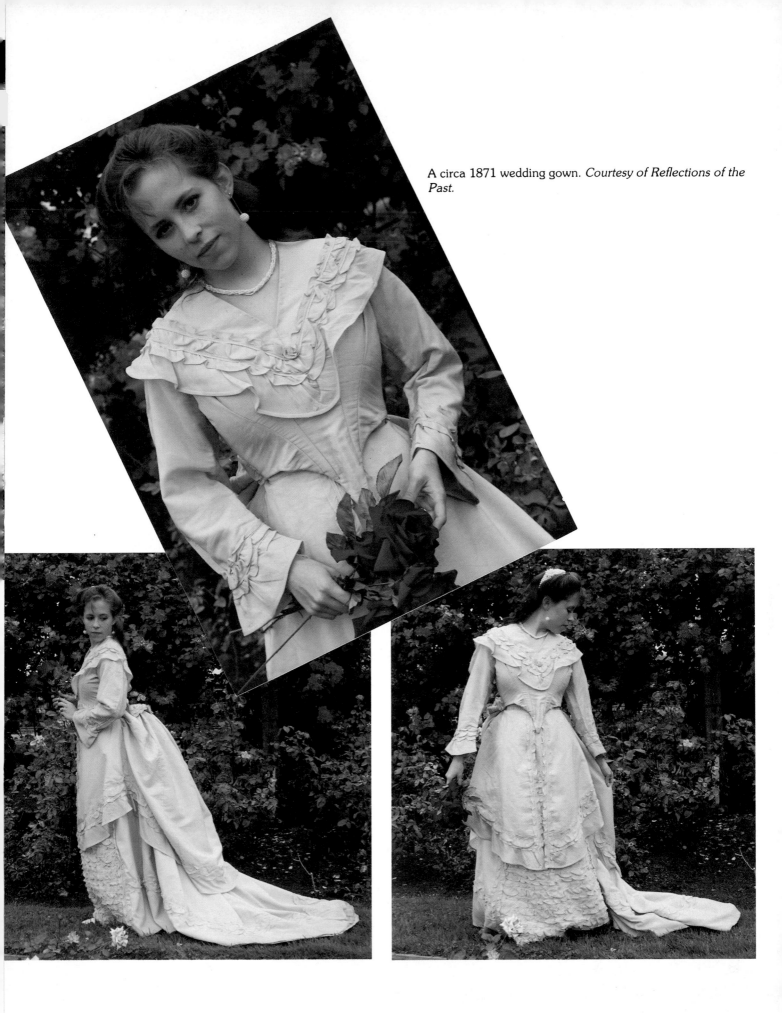

A circa 1871 wedding gown. *Courtesy of Reflections of the Past.*

A 'mermaid' style princess dress, circa 1876. Profusely ruched in front and tucked along both sides, this dress hugs the figure closely.

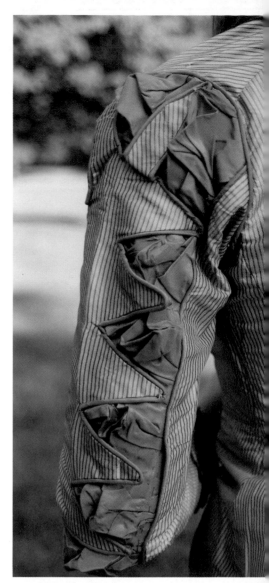

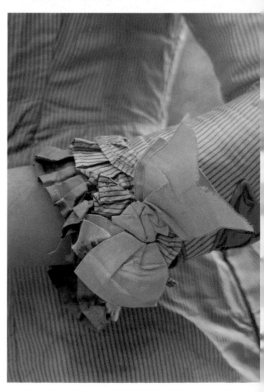

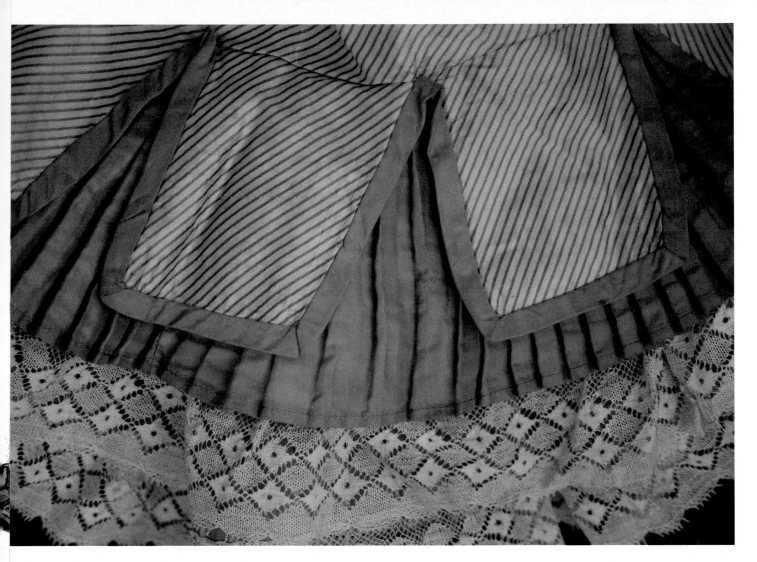

A hem detail from the previous dress.

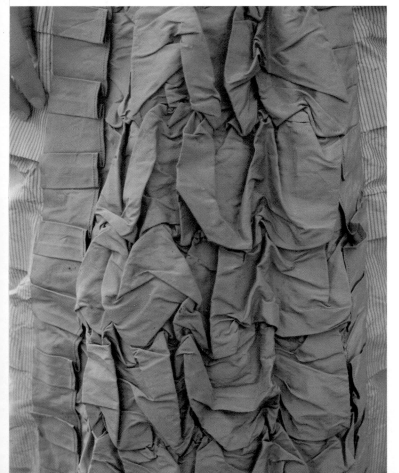

A detail of the ruching on the previous dress.

When bloomers were first intro-
duced, they were widely ridiculed,
though some brave, forward–
thinking women did adopt them,
as illustrated in this fashion plate.

An 1890s photograph featuring a woman in a maternity
dress.

An 1893 alternative dress fashion plate.

A reform dress of silk and corduroy, which contains style lines from several decades.

While mainstream fashion dictated that women wear 'everday' attire while playing tennis, this fashion plate from an. issue of *Dress* illustrated a more pratical outfit.

It was usually only the wealthy who indulged in the Grecian robe-style alternative dress.

An alternative dress which didn't stray too far from mainstream fashion.

Two alternative dresses as they appeared in Annie Jennes Miller's magazine *Dress*. The costume on the left takes its inspiration from Ancient Greece, while the garment on the right is based upon Napoleon I fashions.

An embroidered silk robe, circa 1876, lined in quilted silk and fastened with cord toggle. This princess-cut robe has never been worn-the tassels hanging from the waist are still wrapped in their original paper. *Photograph courtesy of Reflections of the Past.*

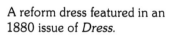

A reform dress featured in an 1880 issue of *Dress*.

Wire mesh bustles, as they were advertised in *Dress*. Designed to give ladies a fashionable look, these bustles varied from most others in that they did not extend down the legs and were made of lightweight materials.

A negligee, circa 1875, consisting of a trained underskirt and a slightly bustled over-dress. *Courtesy of Reflections of the Past.*

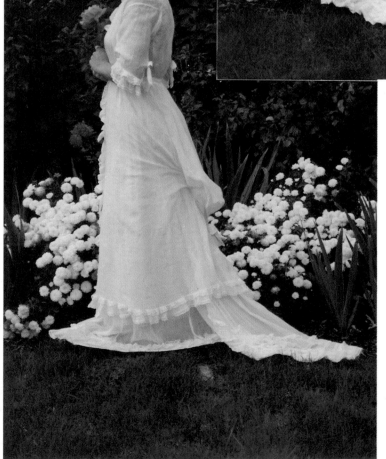

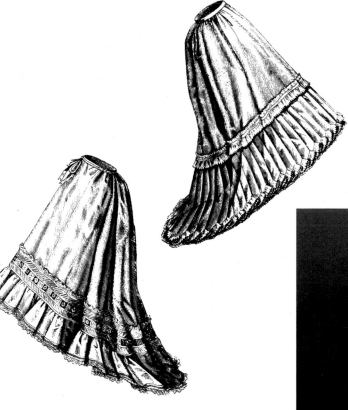

Two petticoats, as pictured in an 1872 issue of *Harper's Bazar*.

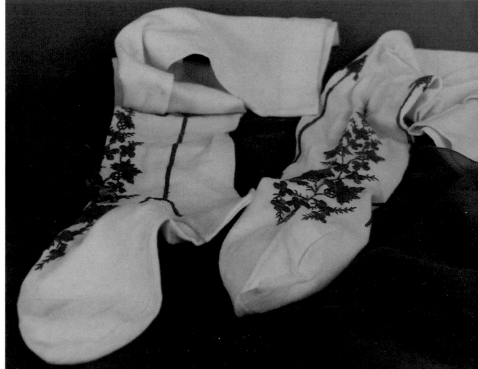

Stockings embroidered in brilliant red,
probably dating from the 1860s or 1870s.
Courtesy of Reflections of the Past.

Boas were used in a variety of unusual manners. Circa 1884.

A debutante of 1883, wearing a sleeveless evening gown trimmed with rosettes.

A 'chemisette' beaded heavily with jet, circa 1888.

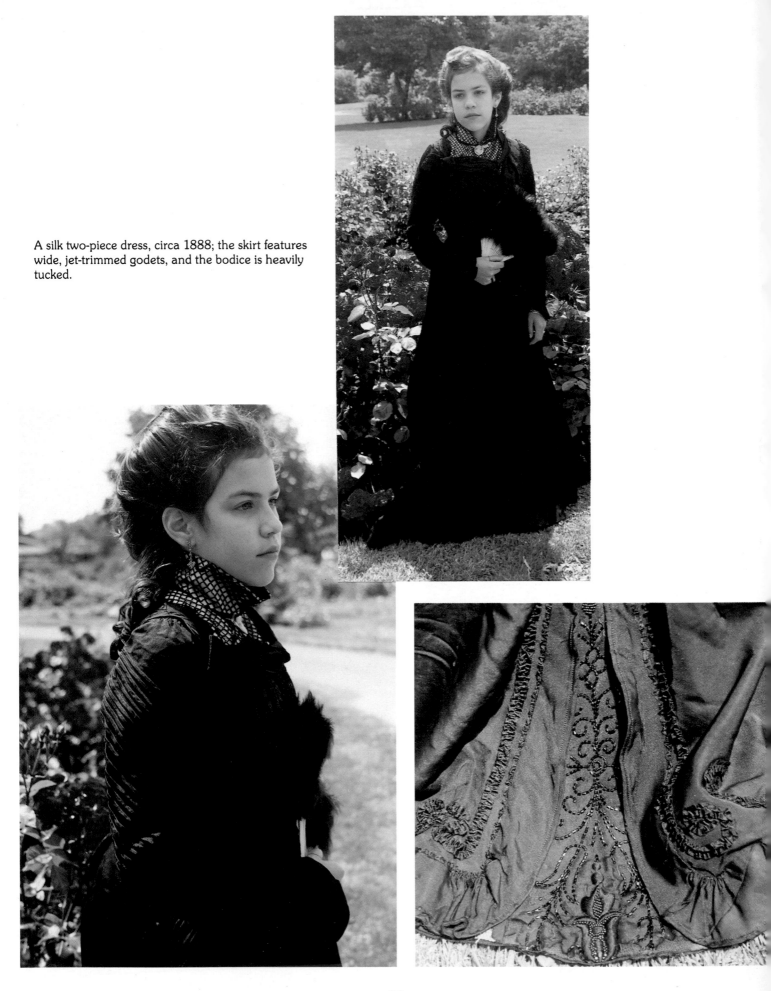

A silk two-piece dress, circa 1888; the skirt features wide, jet-trimmed godets, and the bodice is heavily tucked.

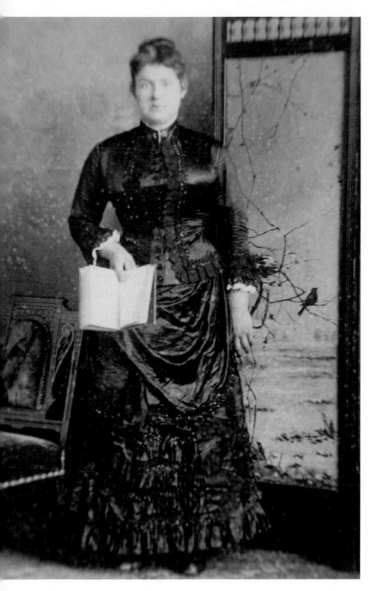

A rich silk dress, circa 1881.

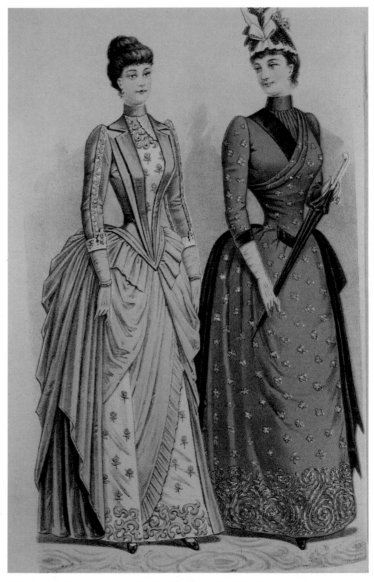

A fashion plate from an 1888 *Godey's Lady's Book.*

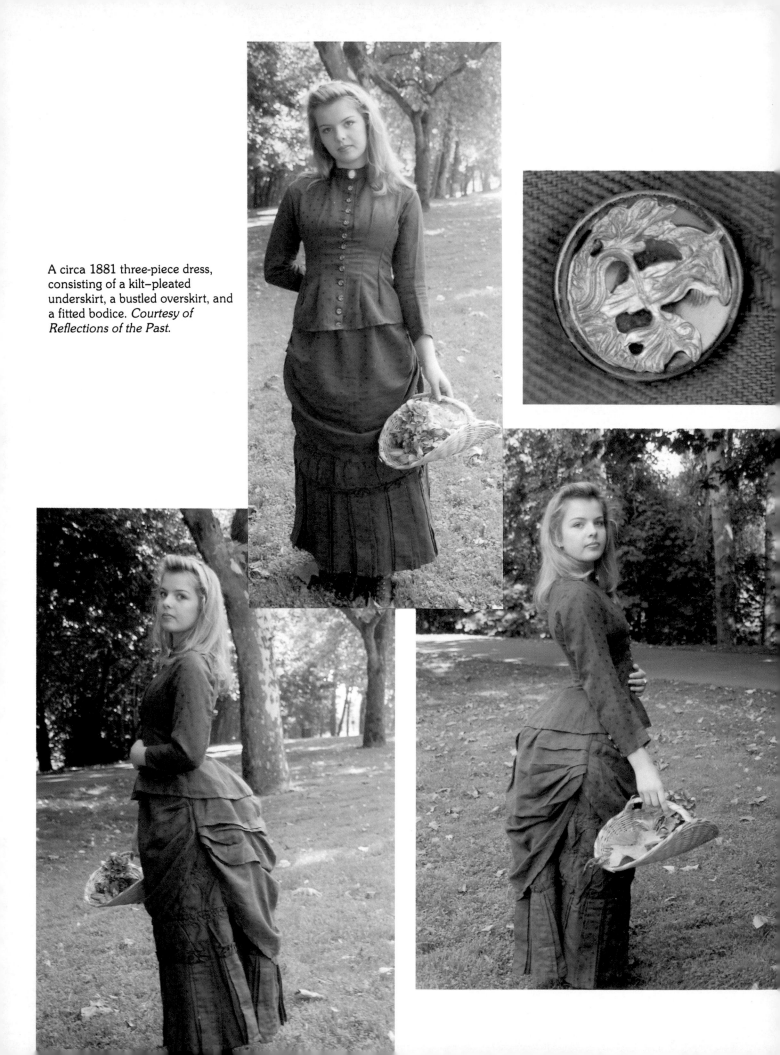

A circa 1881 three-piece dress, consisting of a kilt–pleated underskirt, a bustled overskirt, and a fitted bodice. *Courtesy of Reflections of the Past.*

A woman dressed in a sprightly print dress and a feathered hat. Circa 1882.

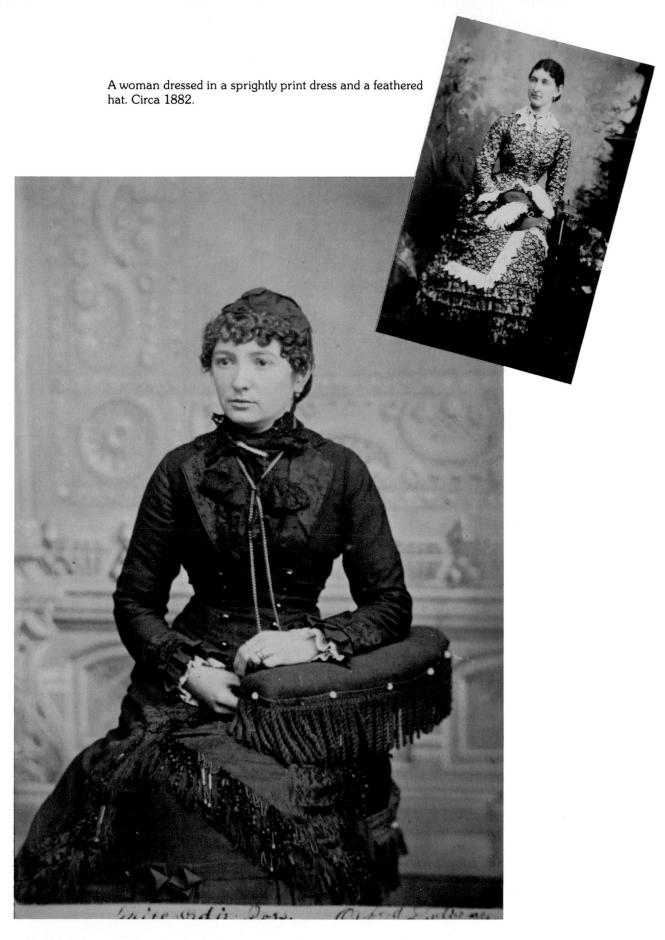

A wealthy woman wearing a dress lavishly trimmed with fringe, velvet, and jet. Circa 1881.

An angular suit of brilliant red and blue, circa 1889. *Courtesy of The Victorian Lady.*

A French fashion plate from 1889.

An 1888 French fashion plate, featuring heavy embroidery and a definite royal flavor.

A corset with golden embroidery, circa 1887. *Courtesy of The Very Little Theatre.*

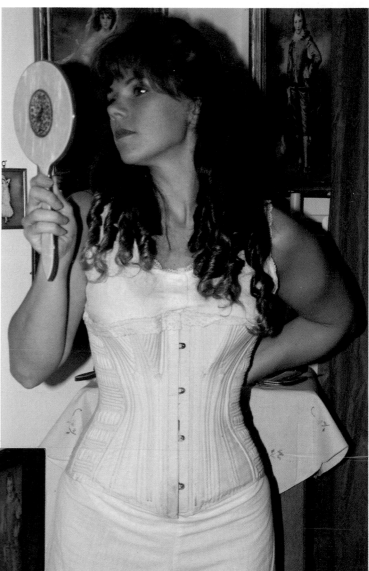

A corset featuring two panels of elastic, patented in 1881. *Courtesy of The Very Little Theatre.*

A fabric covered wire bustle with inner strings for shape control, circa 1887. *Courtesy of The Very Little Theatre.*

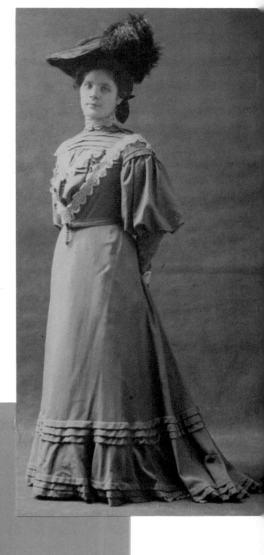

A photograph taken about 1899, featuring a home–made dress with a slight pigeon–front.

A French fashion plate from 1895.

A fashionable woman wearing typically huge sleeves. Circa 1896.

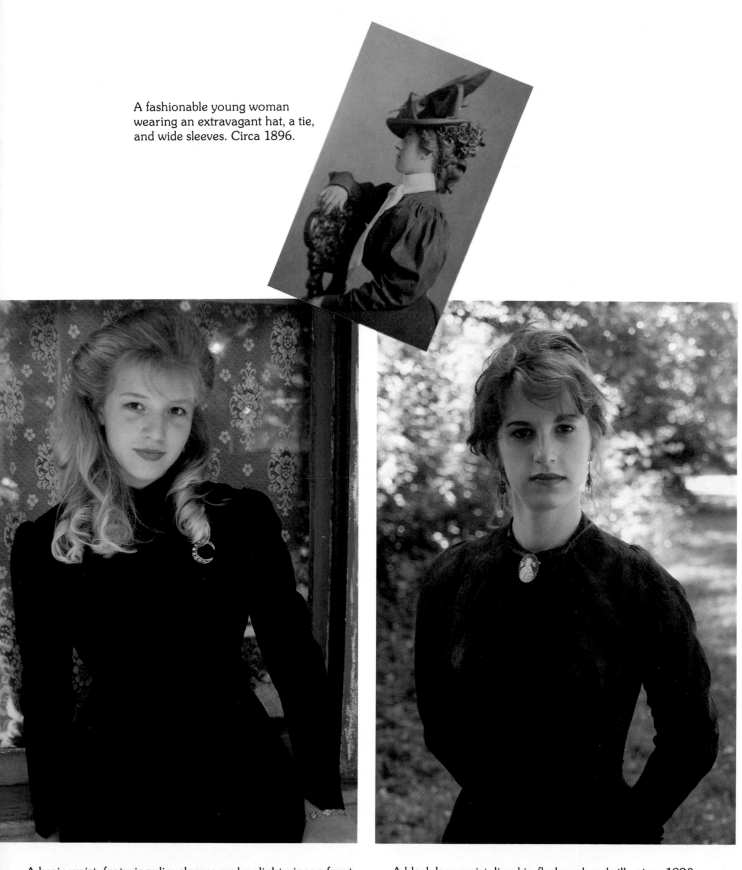

A fashionable young woman wearing an extravagant hat, a tie, and wide sleeves. Circa 1896.

A basic waist, featuring slim sleeves and a slight pigeon-front, circa 1899. *Courtesy of The Very Little Theatre.*

A black lace waist, lined in flesh–colored silk, circa 1890. *Courtesy of The Very Little Theatre.*

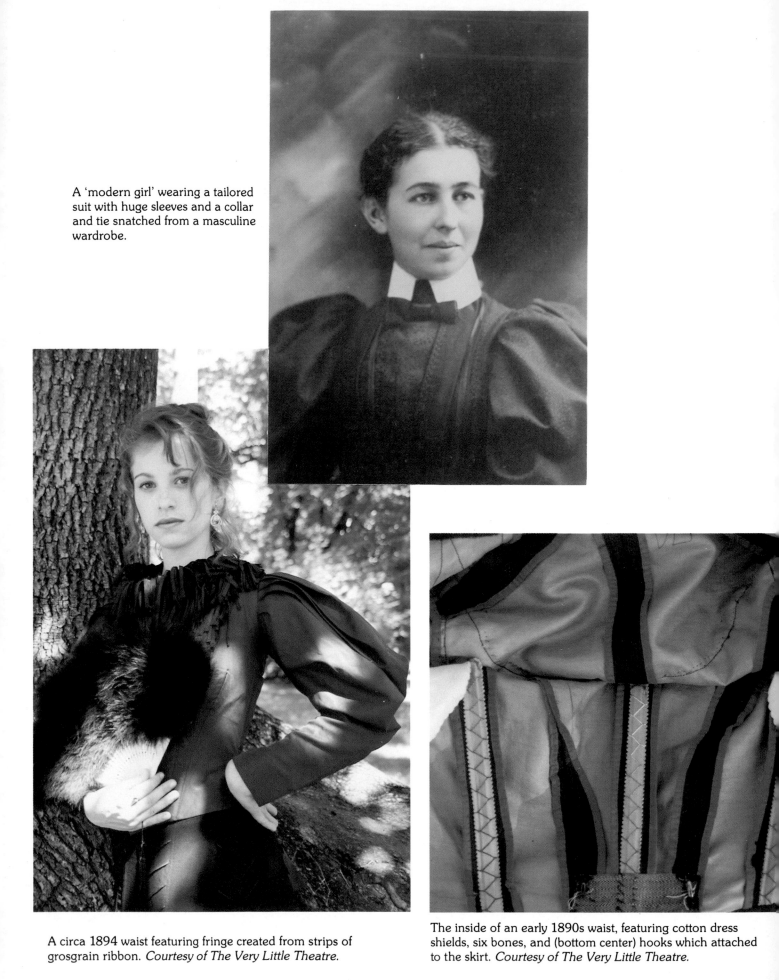

A 'modern girl' wearing a tailored suit with huge sleeves and a collar and tie snatched from a masculine wardrobe.

A circa 1894 waist featuring fringe created from strips of grosgrain ribbon. *Courtesy of The Very Little Theatre.*

The inside of an early 1890s waist, featuring cotton dress shields, six bones, and (bottom center) hooks which attached to the skirt. *Courtesy of The Very Little Theatre.*

An 1899 waist trimmed with jet. *Courtesy of The Very Little Theatre.*

An unusual waist, circa 1899. With ruched sleeves, black knotwork, lace insets, pintucks, and handpainted roses, little more could have been done to decorate this blouse!

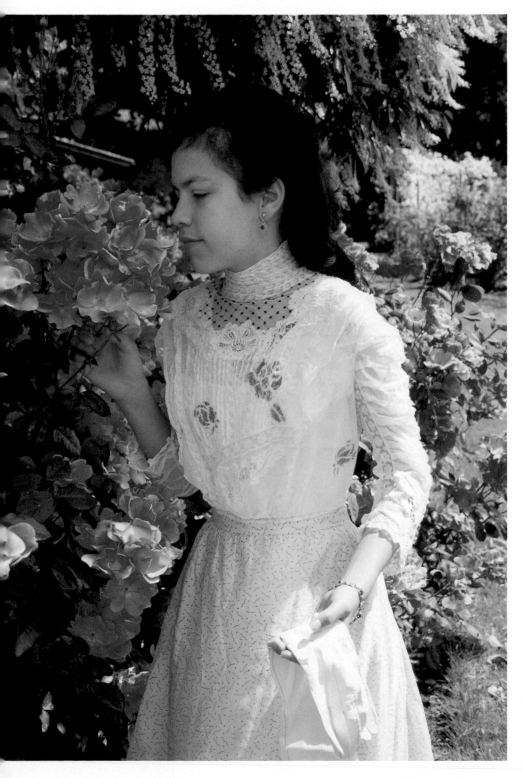

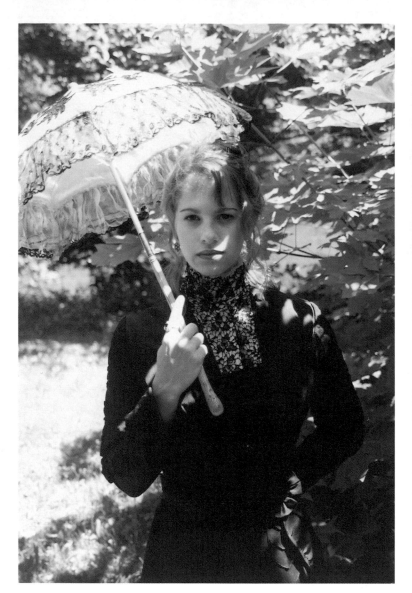

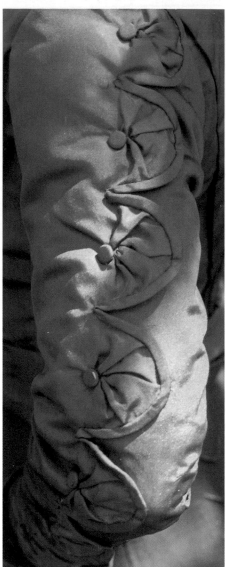

A circa 1891 waist, featuring a lace yoke and a scalloped sleeve. *Courtesy of The Very Little Theatre.*

Detail of a circa 1899 sleeve. The undersleeve is ruched along the inner seam, and the small, cap-like oversleeve is lightly gathered into the shoulder. *Courtesy of The Very little Theatre.*

Detail of a circa 1893 waist with a standing collar and a slimming sleeve. *Courtesy of The Very Little Theatre.*

A woman wearing an unusual vest-bodice over a white lingerie dress. Circa 1898.

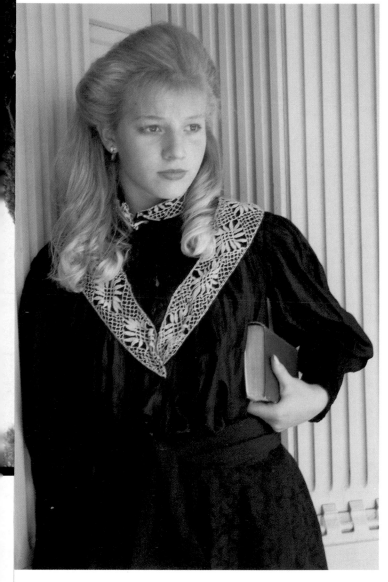

A taffeta and lace waist with a slight pigeon-front, circa 1899. *Courtesy of The Very Little Theatre.*

A circa 1899 silk blouse, featuring elaborate braid trim. *Courtesy of The Very Little Theatre.*

An unusual waist, circa 1898, featuring a great deal of ready–made trim.

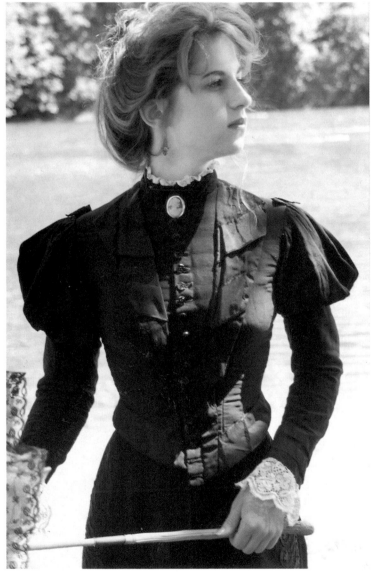

A black waist with pouffed and fitted sleeves, circa 1897. *Courtesy of The Very Little Theatre.*

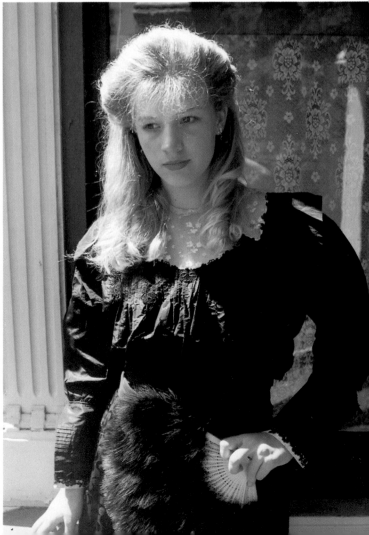

A lace-trimmed waist, circa 1898. *Courtesy of The Very Little Theatre.*

An elegant silk waist, circa 1893. The front is gathered down the center seam. *Courtesy of The Very Little Theatre.*

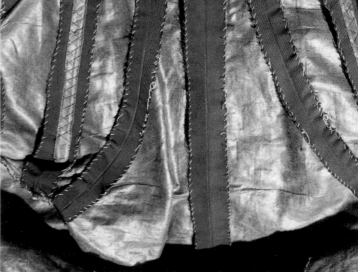

An evening bodice, circa 1899, made up of midnight blue velvet, netting, and iridescent beading. *Courtesy of The Very Little Theatre.*

The inside of a late 1898 waist, featuring four bones.

A two-piece dress of wool serge, featuring a multitude of lavender bows. Dress and parasol, circa 1892. *Courtesy of The Very Little Theatre.*

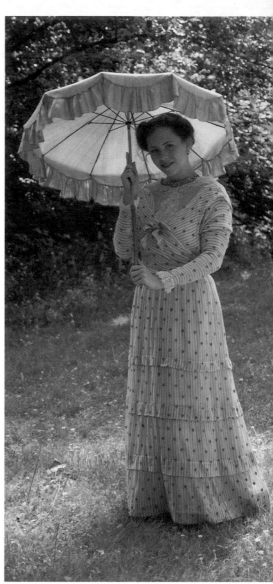

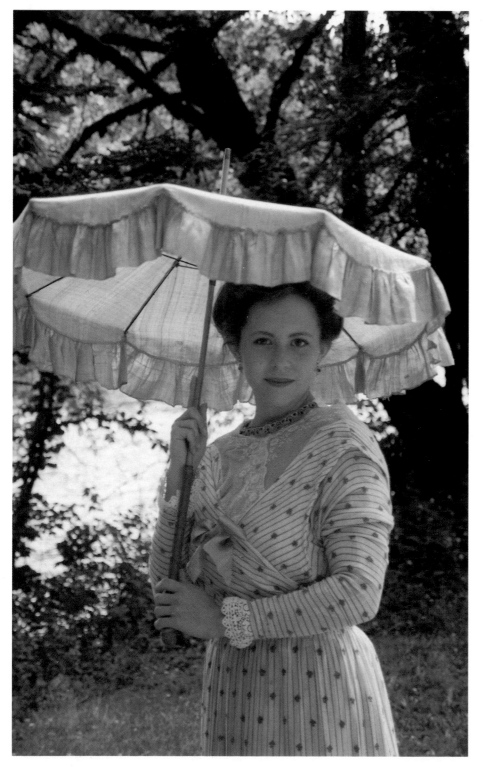

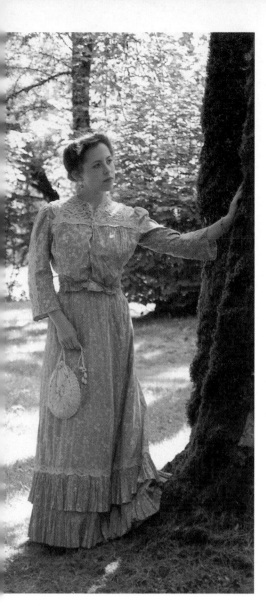

A simple two–piece dress, circa 1890. *Courtesy of The Very Little Theatre.*

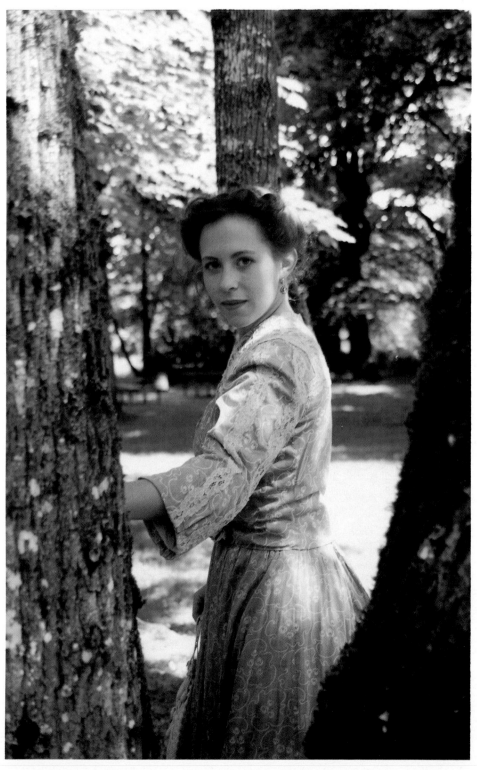

A black taffeta ensemble, circa 1899. *Courtesy of The Very Little Theatre.*

A homemade suit, circa 1891, featuring a wide corset-like waistband.

A two-piece dress with black lace trim, circa 1894. *Courtesy of The Very Little Theatre.*

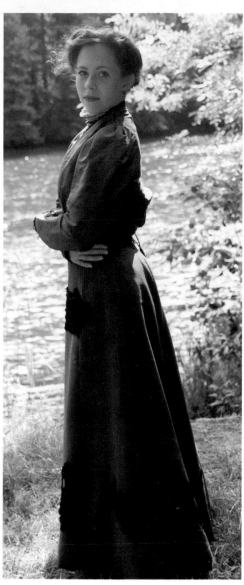

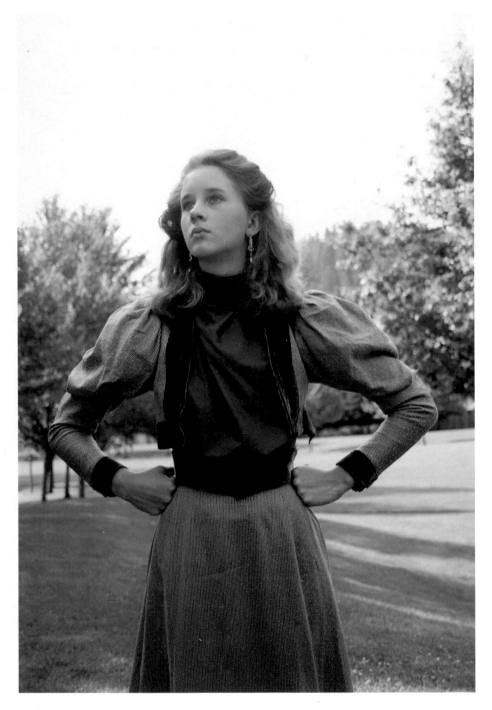

A velvet trimmed suit, circa 1891. *Courtesy of The Victorian Lady.*

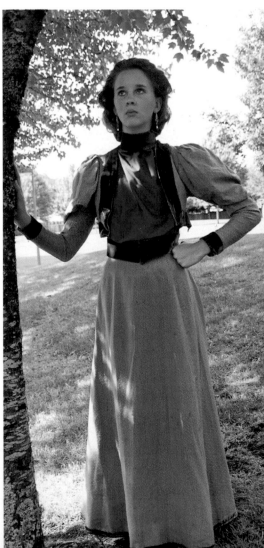

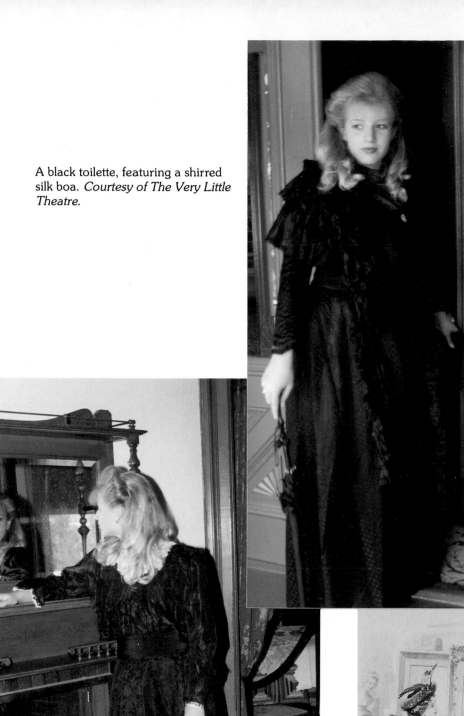

A black toilette, featuring a shirred silk boa. *Courtesy of The Very Little Theatre.*

A taffeta ensemble, circa 1899. *Courtesy of The Very Little Theatre.*

An 1895 fashion plate featuring dresses with excessively pouffed sleeves.

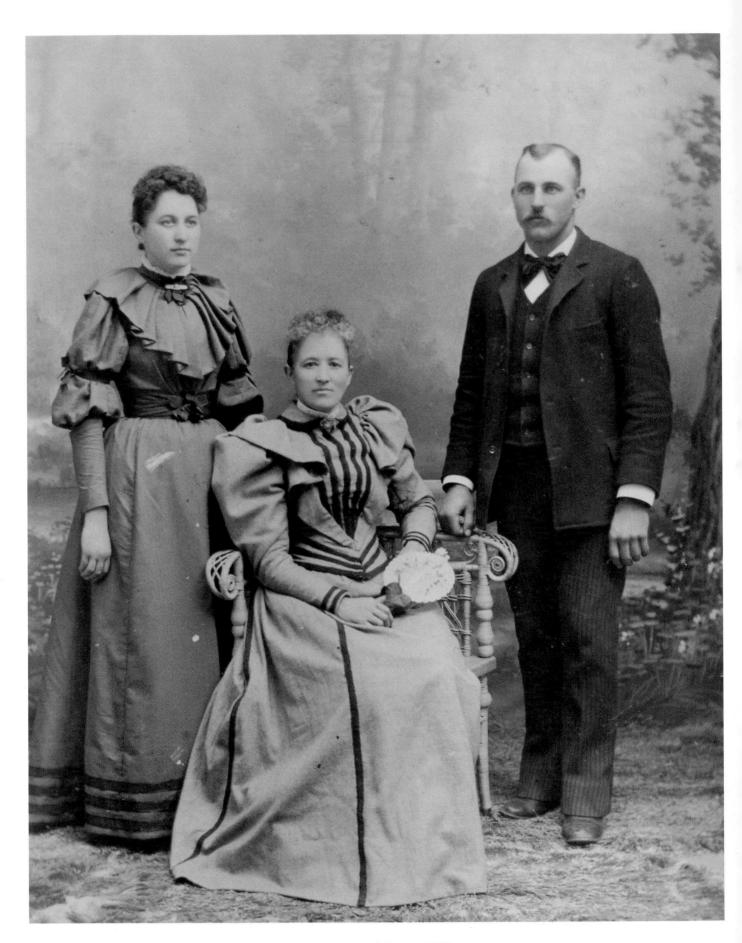

Two average women of the late 1890s.

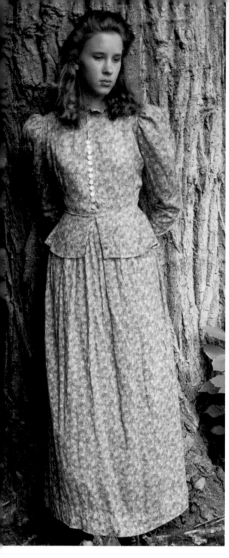

A 'prairie' dress, circa 1890.

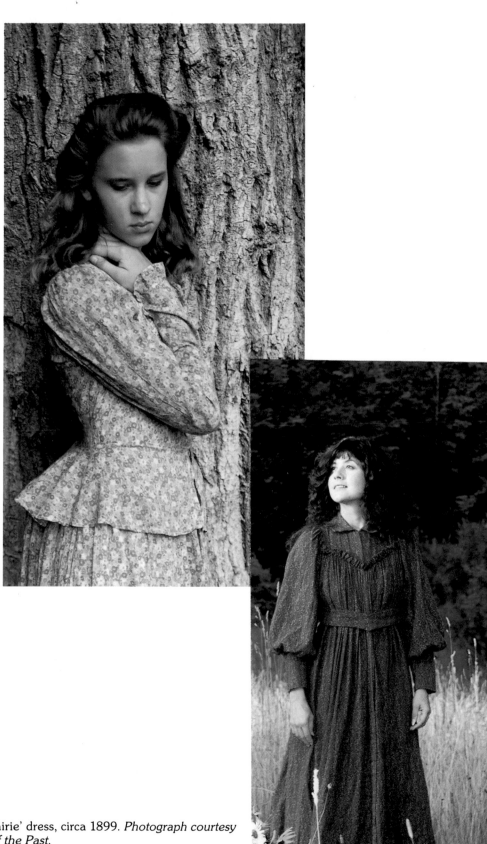

A two-piece 'prairie' dress, circa 1899. *Photograph courtesy of Reflections of the Past.*

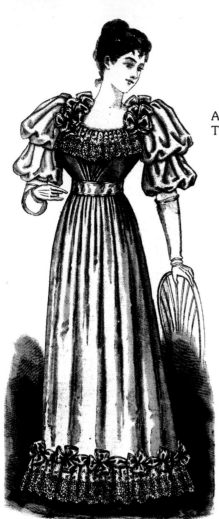

All through the Ninties, fashion flirted with Empire gowns. This one dates to 1893.

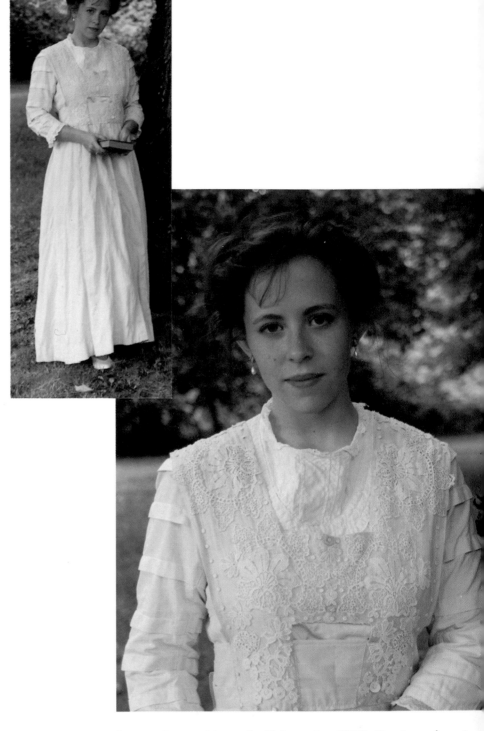

A cotton jumper trimmed with lace, circa 1898. *Courtesy of The Very Little Theatre.*

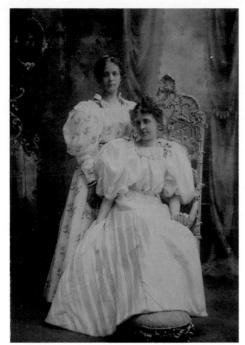

Two young ladies photographed circa 1893.

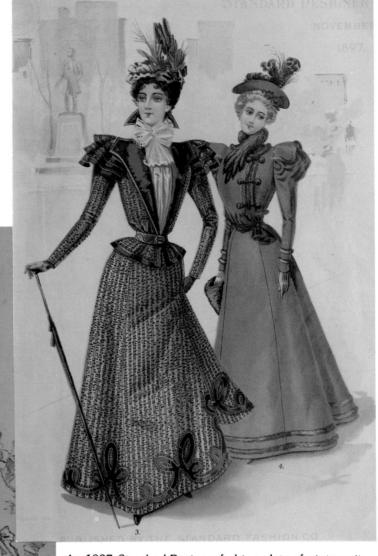

An 1897 *Standard Designer* fashion plate of winter suits.

An 1894 French fashion plate depicting novel sleeves.

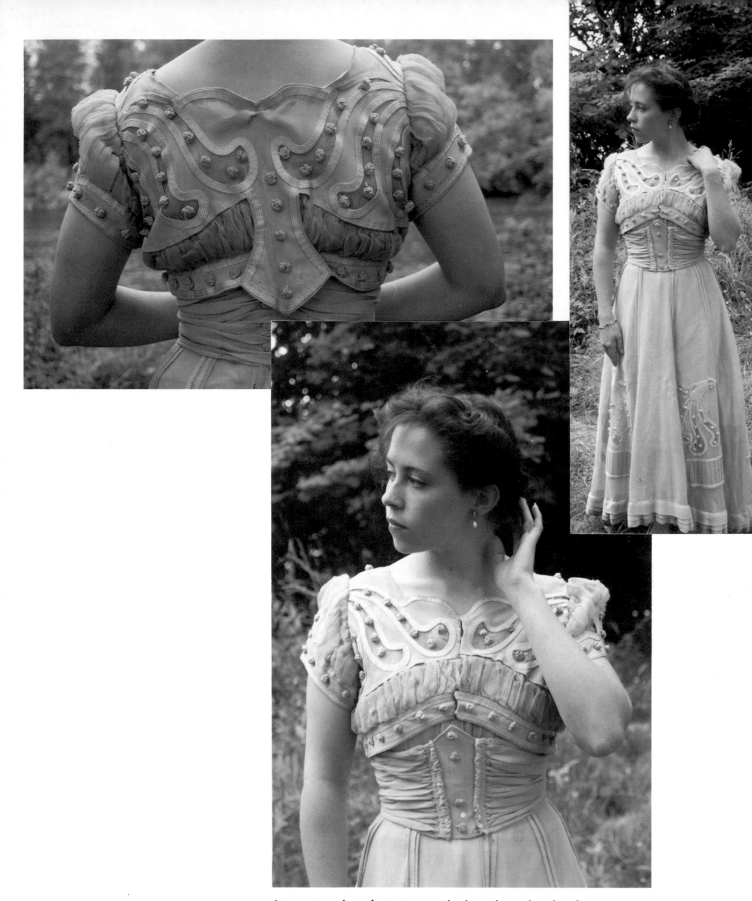

A two-piece dress featuring a wide shaped waistband and profuse ruching, knotwork, and braid trim. Circa 1899. *Courtesy of The Very Little Theatre.*

Detail of the inside of a circa 1899 waist.

Two types of combinations, from an 1893 *Standard Designer*. The garment on the left combines corset cover and petticoat, while the garment on the right combines drawers and corset cover.

Detail of a metal bone from an 1899 waist.

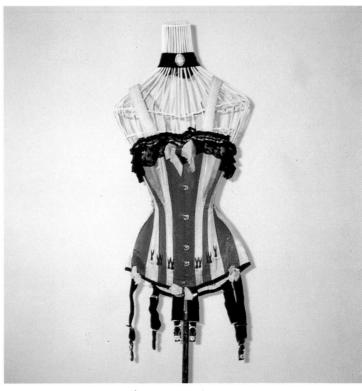

A brilliantly colored corset from the 1890s. *Photograph courtesy of Reflections of the Past.*

A typical 1890s bathing suit, as depicted in a period advertisement.

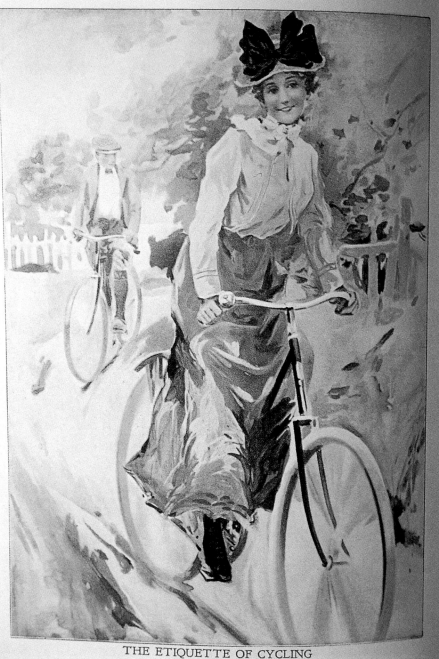

THE ETIQUETTE OF CYCLING

In the early 1890s, women simply wore shirtwaists and skirts while bicycling; it was not until the last few years of the Nineties that bloomer suits were widely adopted for this new pastime.

A French velveteen bicycling costume. American women did not widely adopt such cycling outfits until around 1897—and even then, few women were brave enough to wear such costumes without a skirt (usually knee-length) over their legs.

A fur cape. *Courtesy of The Very Little Theatre.*

A velvet and fur cape, labeled "Mme. Pouyanna, Paix, Paris." *Courtesy of The Very Little Theatre.*

A lace and jet caplet. *Courtesy of The Very Little Theatre.*

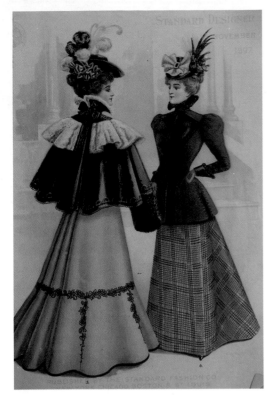

An 1897 fashion plate, featuring winter cape and coat styles.

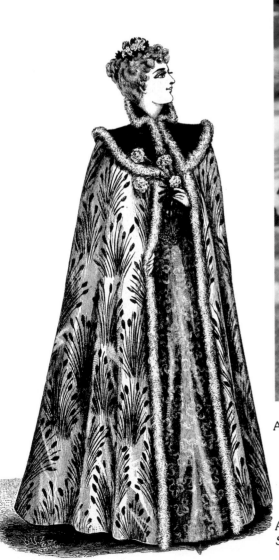

A velvet cape with a jet and braid design.

A rich silk, velvet, and maribou feather cape, from an 1897 *Standard Designer*.

A late 1890s jacket. *Courtesy of The Very Little Theatre.*

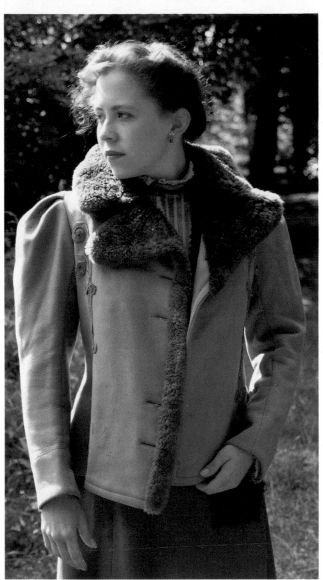

A capelet of lace, braid, and beading. *Courtesy of The Very Little Theatre.*

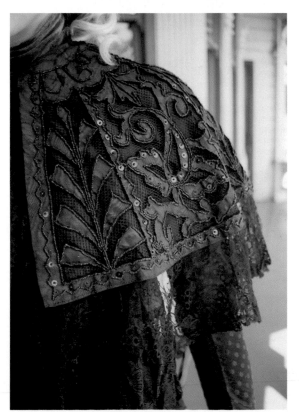

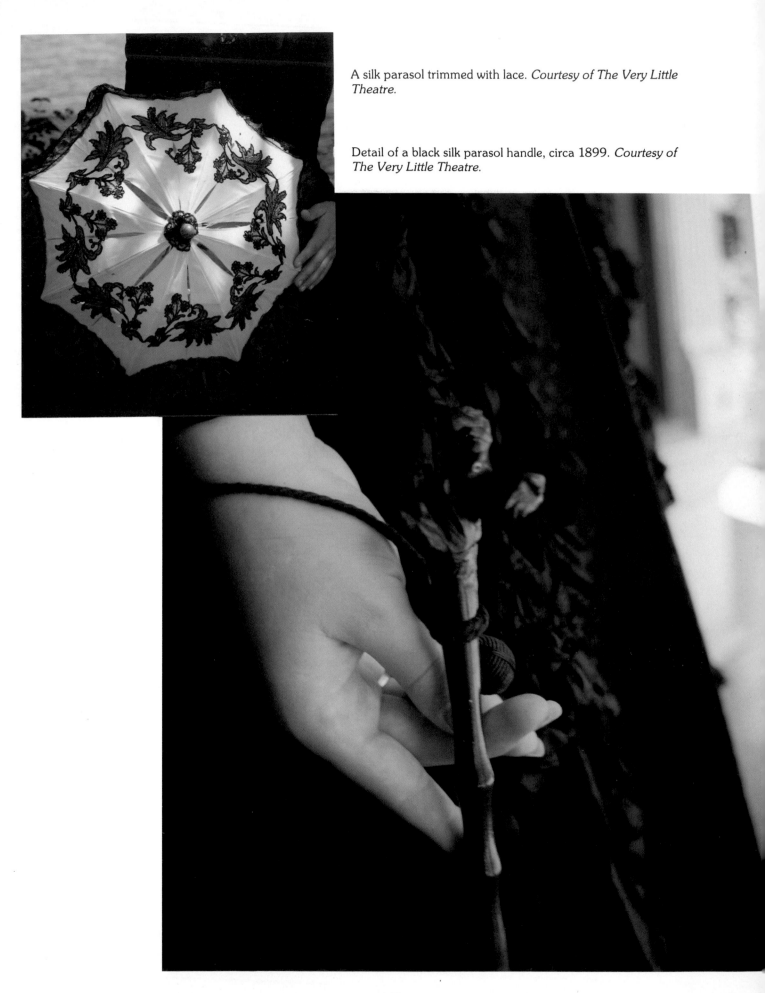

A silk parasol trimmed with lace. *Courtesy of The Very Little Theatre.*

Detail of a black silk parasol handle, circa 1899. *Courtesy of The Very Little Theatre.*

A feather-laden lady, circa 1899.

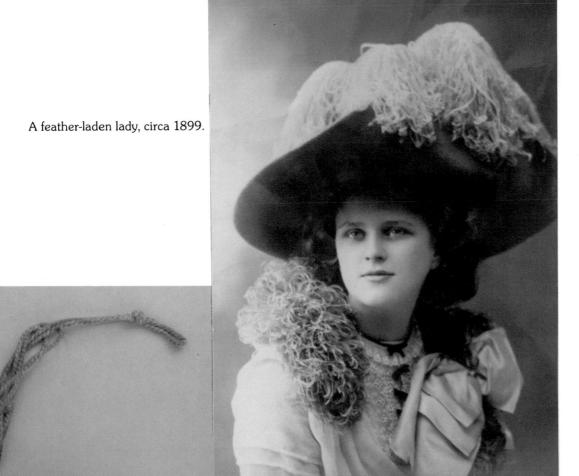

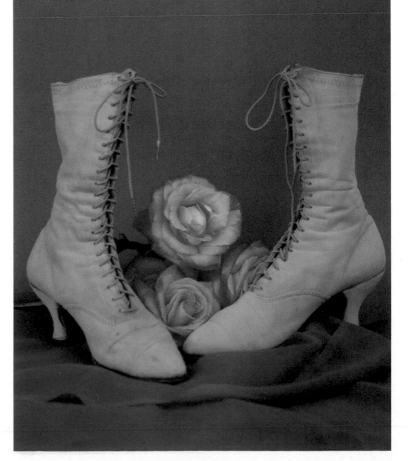

A glass-beaded purse from the late 1890s.

A pair of soft leather hightop boots. *Courtesy of Reflections of the Past.*

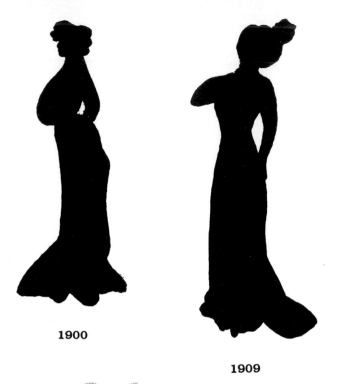

1900

1909

Now, however, they were readily available to nearly every woman, and the white and lacy lingerie dress that had become fashionable at the end of the nineteenth century became the staple of every woman's wardrobe.

A new style of corset also gave a new look to the 'New Woman', thrusting her bosom forward and throwing her hips back. A large, shelf-like bosom was favored, and the hourglass figure was considered a woman's most important asset. It was a very womanly look—and a far cry from the fashions of the beginning of the Victorian era. Women were growing up. Working to clean up poverty and alcohol abuse, and fighting for the right to vote, women were no longer the drooping, pale and thin wildflowers they once were.

Chapter *Nine*

Early 1900s: Woman Matured

"Why certain kinds of clothes are associated in the public mind with certain kinds of women is to me an amusing mystery," author Lilian Bell wrote in her book *From A Girl's Point Of View*, disparaging at society's typically turn-of-the-century way of creating hard–fast fashion and social rules. "Why are old maids always supposed to wear black silks?...[and] why are literary women always supposed to be frayed at the edges? And why, if they keep up with the fashions and wear patent–leathers, do people say, in an exasperating astonished tone, 'Can that woman write books?'...Little as some of you men may think it, literary women have souls, and a woman with a soul must, of necessity, love laces and ruffled petticoats, and high heels, and rosettes..." These attitudes all typify the early years of King Edward's reign in England. All women (even if only in their souls) were supposed to adore frilly, ultra-feminine styles—and, for the most part, all women of the early 1900s indulged in them.

The availability of machine-made laces, embroideries, eyelets, and cutworks had once only been within the budget of wealthy women—but had always been in the fashion dreams of the 'common' woman.

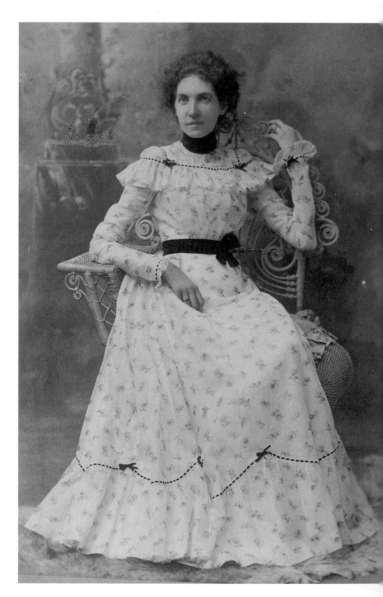

A lovely be-ribboned gown, circa 1900.

Skirts

"One thing is certain," *The Queen* dictated in late 1899, "the skirt must fit like wax at the top, and fall in full, graceful folds at the foot." Indeed, skirts from the early twentieth century were as slim as could be at the hips, but, with the help of gores, flowed with fullness at the hem. Light gathering or pleating still accentuated the derrière, as did trains in a variety of lengths. Skirts with very long trains usually also featured attached string loops at one edge near the hem, which allowed the train to be lifted gracefully by hand while walking.

Skirts were rarely lined—the light, flowing affect was now preferred. Instead, to help keep skirt hems from fraying and wearing out quickly, bands of velvet or velveteen were often sewn to hem edges. To help keep skirts full and away from the legs, many dressmakers sewed canvas or crinoline into the hems before adding this velvet binding.

Wide waistbands (which were often almost entirely hidden because women's bodices pouched so much), grew increasingly popular. Skirts made with narrow waistbands were usually worn with wide, shaped (and often boned) 'girdles' or belts. By 1907, however, the trend was banished by yet another revival of the Empire-style high waistline.

For day, skirts were usually very simple, with little or no decoration—but even walking skirts had trains. By evening, however, every tuck, trim, and frill was taken advantage of—usually at the skirt's hem.

Around 1909, skirts began changing drastically. Since about 1906, walking skirts were as short as four inches from the floor, and now this trend was beginning to show a bit in skirts worn everyday. Such skirts (increasingly tubular in shape) also grew slimmer at the hem and now had little or no fullness in the back.

Bodices

Collars reached an all time high in the early 1900s; boned and often reaching the earlobes, women were forced to carry their heads high, and sometimes looked as though their noses were in the air. Collars were sometimes detachable—which made for greater versatility in wardrobe, in addition to making collars more practical and accessible for frequent cleaning. It wasn't until 1908 that necklines for day wear could sometimes be worn at the base of the neck. Around 1909, a new style of collar appeared: the Dutch Collar, which was similar in shape to a Peter Pan Collar.

Bodices, though usually appearing very loose on the outside, were most frequently lined and fully boned on the inside, further adding to the rigidity of ladies. Inner-waistbands were also still used frequently—though by 1909, they were nearly obsolete. Bodice closures were the most versatile they had been in years, closing in the front, back, side, or a combination of the three. Often closures—especially those in the front—were concealed with ribbons and other trims.

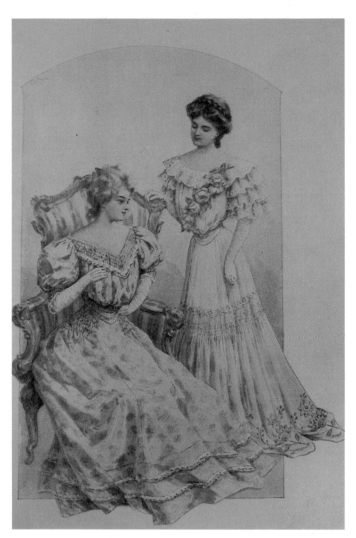

Two delicate gowns, circa 1901.

The shirtwaist was still in high favor, as were bodices decorated with rows of tucks. But the biggest variance in bodices of the early 1900s was sleeve styles. In 1900, sleeves frequently had small cuffs. An especially popular style (that continued until about 1908), was sleeves gathered along the under, upper, or both seams. Some sleeves from the era were given an extra puffy affect by making the sleeves about twice as long as the arm. Though a bodice created in this manner looks ridiculous off the figure, once put on, the extra length is attractively pushed up the arm.

Around 1908, women's clothes took on a decidedly less frilly look. Tailored garments were much in vogue and a favorite trim was buttons—functional or otherwise. One-piece dresses from this time often had a draped, Grecian appearance, with the waist often left unbelted (though fitted). The Empire line once more became trendy, always with a well-boned inner bodice.

Two gowns, circa 1900. *Courtesy of The Very Little Theatre.*

Around 1902, though sleeves were still slender, they usually had a ruffle at the wrist, rather than a cuff. About 1903, sleeves gained extra fullness from elbow to wrist, and by 1904, sleeve styles were in the true Bishop shape. By 1906, sleeves were full at the top, as well as at the bottom. Around 1908, when Oriental influence was strong in American design, kimono-style sleeves were also sometimes worn.

Dresses

For the first time in perhaps all of fashion history, competition between designer houses created experimentation and some diversity in the style-lines of women's clothes. While fashions were by no means distant from one another, dress styles reflected some diversity—and would increasingly do so through the next decade.

Women often followed the footsteps of Charles Dana's Gibson Girl and wore separate blouses and skirts—though one and two-piece dresses were still important. Hems were often only two inches from the floor, and trains were frequently worn—especially in the evening. Though by day women were extremely well covered, by night, sleeveless styles revealing décolletage were most fashionable.

The princess dress was a staple in the early 1900s, revealing every curve of the body. Lingerie dresses were equally important, usually made up in white or off-white, but also sometimes found in delicate shades of blue, pink, lavender, peach, and other pastels. Usually these dresses were sheer and meant to be worn with a separate slip; the practical woman had a variety of basic slips in white and various pastel colors, which greatly extended her wardrobe. Tailored suits were also favored, especially in shades of grey and trimmed with lace.

After a few years of focusing on impractical laces and sheers, around 1905, American fashion magazines began to focus their attention—at least partially—on washable fabrics. The search was also on for practical clothing designs. By 1907, jumpers were filling this void. Some jumpers consisted of only skirts with wide straps and a partial bodice, and were worn over a separate blouse. Others were only a sleeveless top, created to be worn over a separate dress or blouse and skirt. Worn even in the evening, jumpers continued to be an important fashion element until about 1911.

In 1909, the tailored look became increasingly popular, and skirts grew more slender at the hem. Tunic-style skirts were the newest style, giving the appearance of two separate skirts: one worn long and tubular under a shorter, slightly fuller over-skirt. The most fashionable evening dresses were still created in the Empire style and usually were heavily beaded.

"Not only are the fabrics of exquisite texture," *The Lady* praised in 1902, "but they are embellished with miraculously fine hand embroidery, applique, lace insertions, and trimmings of many kinds." Indeed, these were the choice fabrics for most of the early 1900s. Velvet crepe de Chine, moire, voile, silk, net, and lawn were also popular. Later in the decade, tailored styles were created primarily in linens and wools.

All pastel shades were fashionable—especially within the first few years of the 1900s. In complete contrast, royal shades of purple, blue, deep red, and emerald green were also fashionable.

Undergarments

The introduction of the straight-fronted corset had a tremendous impact upon early twentieth century fashions. Originally created with the intention of putting less force on women's bodies (and therefore, being more healthful), the corset's creators must not have understood turn-of-the-century women very well. In order to work as designed, the corset had to be fitted only lightly to the figure—but after decades of tight-lacing, women naturally cinched their new corsets as tight as ever. The healthy intentions of the corset were thus ruined and a peculiar S-shape silhouette became *the* look of the early 1900s. Reaching well past the tummy and contorting the back into a curve, corsets were as uncomfortable as ever. A woman's only relief was a corset created with elastic gussets, or the so-called 'ribbon corset', made shorter and more flexible and intended for housework and sportswear.

Around 1908, a forerunner of the bra could be purchased and worn instead of a corset—but it was by no means worn by the masses. These so-called 'bust supporters' were actually nothing more than boned corset covers.

Corset covers themselves were more important than ever in the early twentieth century, since sheer fabrics were popular and many corsets now left the bosom free. Women who were blessed with a much-admired ample bosom could purchase very snug-fitting, lace-up corset covers, designed to help support the bosom. Since a very large bosom was much to be desired, many corset covers of the early 1900s were layered with ruffles and frills. When even ruffles didn't produce the bosom desired, false bosoms were favored. Unlike the 'falsies' of previous decades, however, these bosoms usually were not made of stiff rubber, but of soft fabric pads or inflatable rubber.

Fabric pads were also sometimes worn on the hips to help achieve an hourglass figure, and while the large, cumbersome bustle had long since been out of fashion, small fabric pads were worn until about 1908 by some women. To add to this alarming array of 'falsies', *Harper's Bazar* recommended placing a small flat pad at the center front of the bodice in order to achieve as straight-fronted a look as possible.

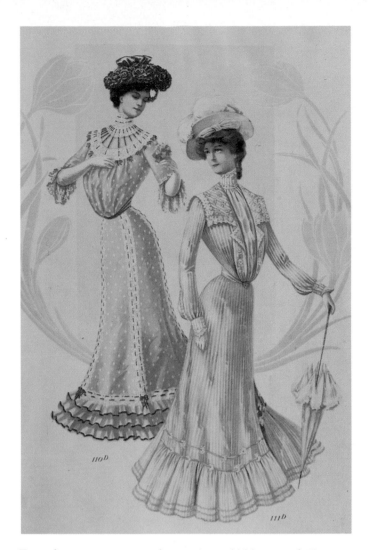

Two afternoon gowns, as featured in a 1902 issue of *The Delineator* magazine.

Combinations continued in their newly-found popularity, and new styles were often toyed with. One of the most popular alternative styles was a combination corset cover and petticoat, which was worn by some until 1908.

The rustle of silk and taffeta petticoats was of great appeal to early twentieth century women, though by 1908, petticoats abandoned their frills and furbelows and became quite simple. For the first time in decades, the wearing of only *one* petticoat became the norm.

From about 1900 to 1907, full-length slips were widely worn—mostly because of the popularity of sheer lingerie dresses. Usually made up in the close-fitting Princess style, these slips looked like very simple, sleeveless dresses, usually with a few flounces at the hem.

Sportswear

After great strides in women's sportswear in the 1890s, the genre came to a virtual standstill until the Edwardian period ended.

Bloomer costumes were worn by some turn-of-the-century women for nearly all forms of exercise. Consisting of a blouse (usually loose-fitting) and pleated or gathered bloomers, many women thought them ridiculous–looking and choose instead to wear traditional long skirts and snug bodices.

Swimwear also remained much the same—though now, occasionally, separate 'underbodies' consisting of a plain (usually sleeveless) top attached to bloomers were worn under a skirt or dress–like overbody.

Other Important Garments

Boas—though enjoying some popularity in the late 1890s—became truly fashionable in the early 1900s. Used as trim on dresses or as wide, fluffy stoles, nearly every fashionable woman tried her hand at them; but their popularity didn't last much past 1908. Huge hats decorated with every imaginable flower, fruit, and bird were worn by the most fashionable women, and from about 1908 forward, shoes decorated with rhine-stones, beads, and sometimes flowers, were especially favored for evening wear.

Housegowns became a more acknowledged gar-ment in the twentieth century. Designed to be worn for housework, they were carefully created with a snug-fitting inner bodice which could be laced up tightly, in case a corset was not worn. Teagowns (now fashion-ably called 'negligees') were still worn, but 'dressing saques' were quickly replacing them. Actually, the two were virtually the same, except saques only reached the thigh, whereas teagowns usually touched the floor.

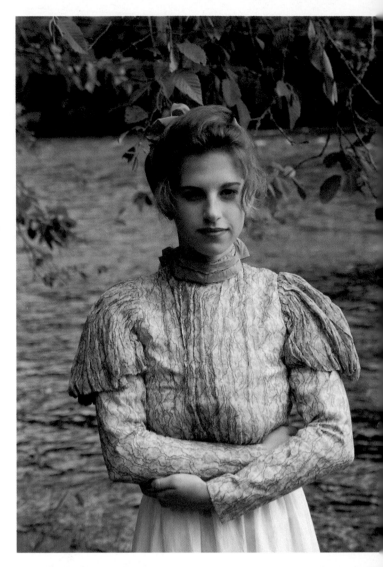

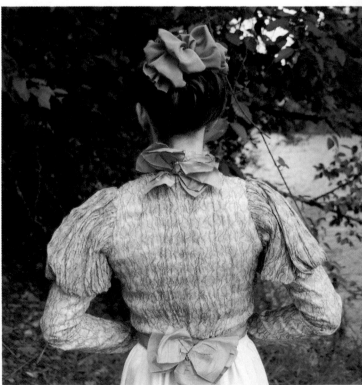

A girlish, pleated waist, featuring silk bows. *Courtesy of The Very Little Theatre.*

A lace waist lined with robin's-egg-blue silk, circa 1900.

Two waists, circa 1905. On the left, a heavy crocheted collar is featured, while the waist on the right features insets of lace. *Courtesy of The Very Little Theatre.*

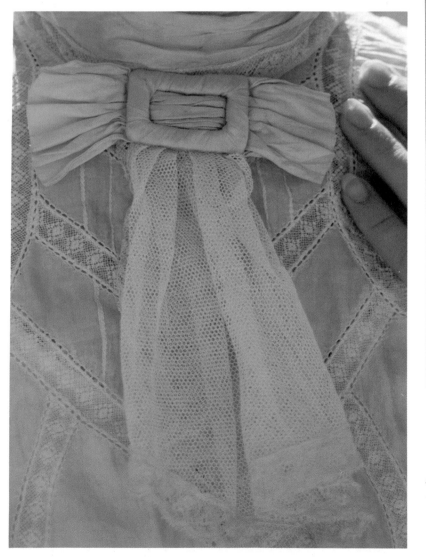

An eyelet blouse, circa 1909.

A detachable silk jabot, circa 1903. *Courtesy of The Very Little Theatre.*

A striped silk waist, circa 1902. *Courtesy of The Very Little Theatre.*

A typically pigeon-fronted waist, circa 1903. *Courtesy of The Very Little Theatre.*

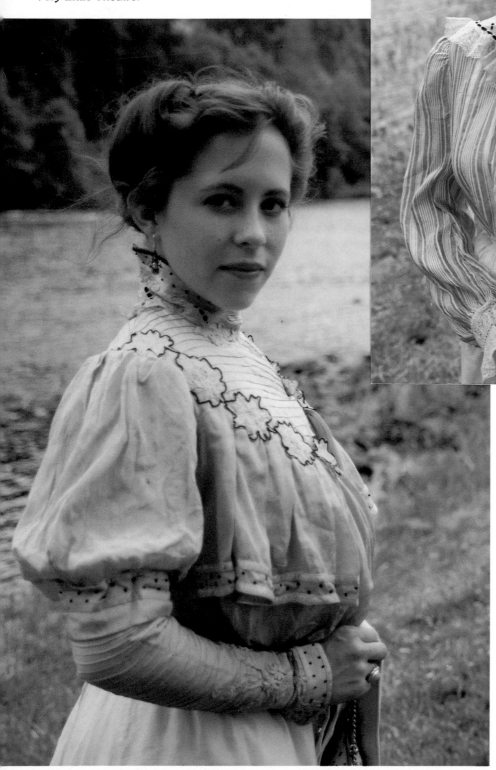

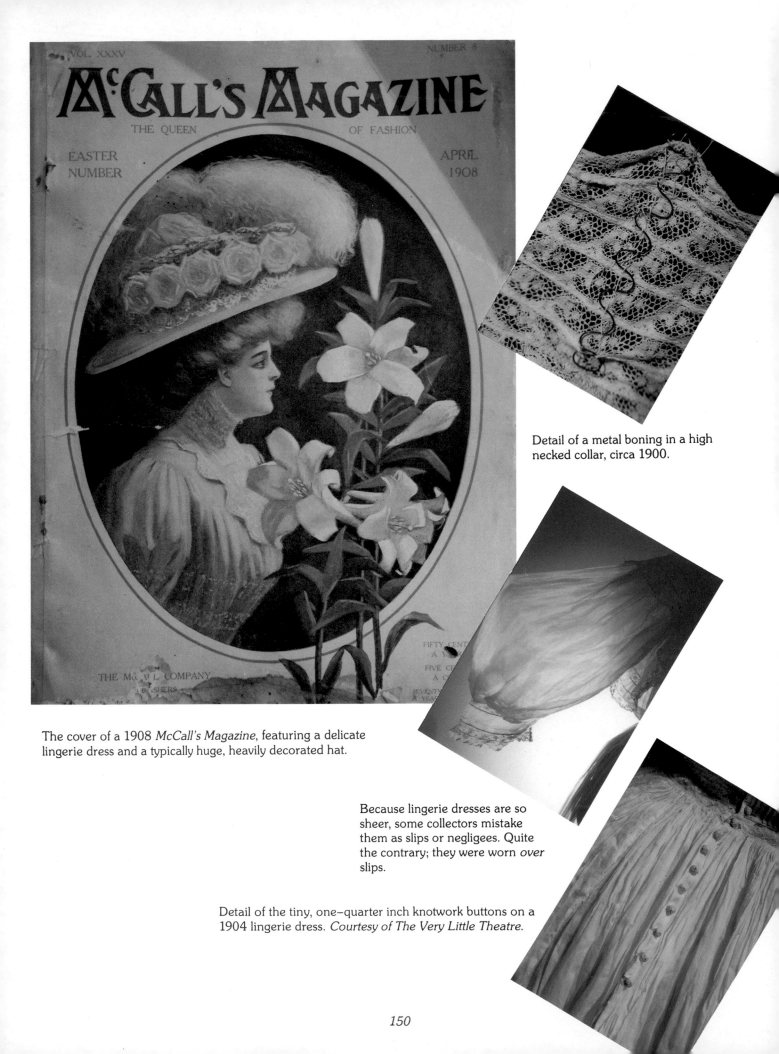

The cover of a 1908 *McCall's Magazine*, featuring a delicate lingerie dress and a typically huge, heavily decorated hat.

Detail of a metal boning in a high necked collar, circa 1900.

Because lingerie dresses are so sheer, some collectors mistake them as slips or negligees. Quite the contrary; they were worn *over* slips.

Detail of the tiny, one-quarter inch knotwork buttons on a 1904 lingerie dress. *Courtesy of The Very Little Theatre.*

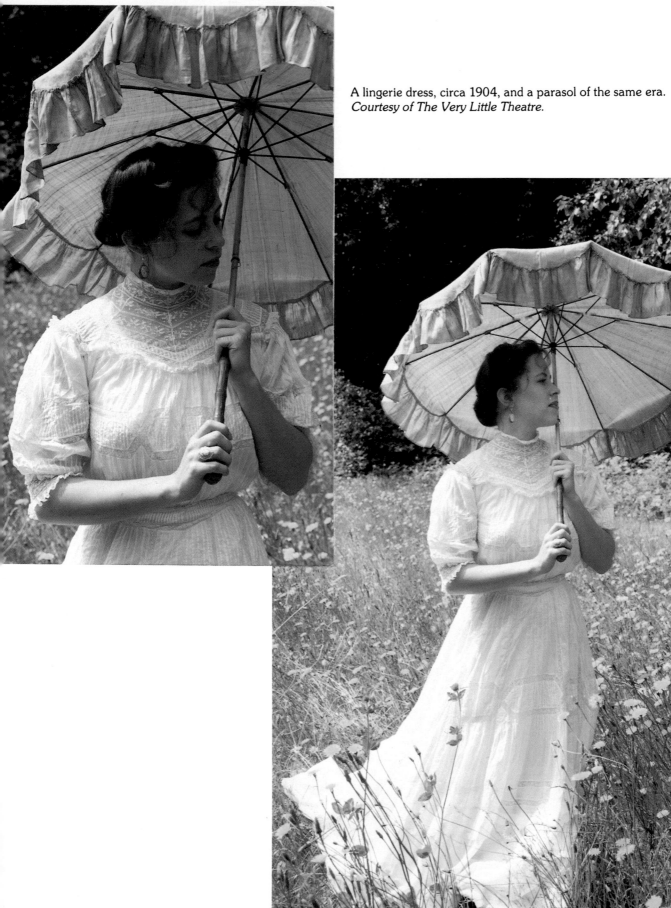

A lingerie dress, circa 1904, and a parasol of the same era.
Courtesy of The Very Little Theatre.

151

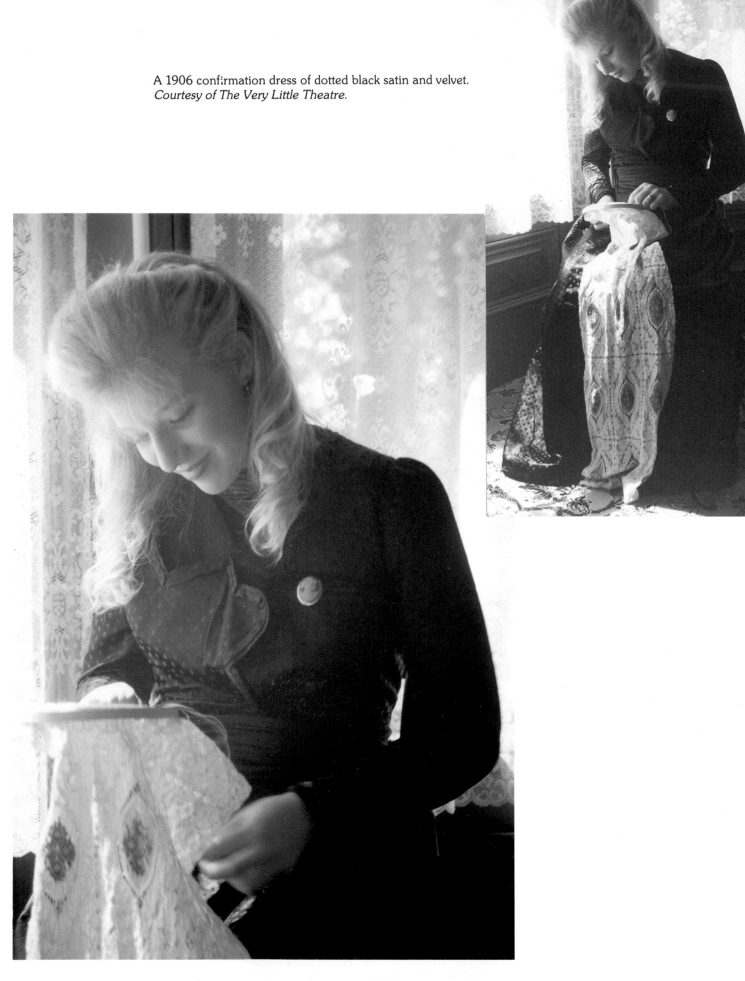

A 1906 confirmation dress of dotted black satin and velvet.
Courtesy of The Very Little Theatre.

Blissfully domestic, this Edwardian lady is dressed in a fashionable lingerie dress.

A lingerie dress, circa 1904. *Courtesy of The Very Little Theatre.*

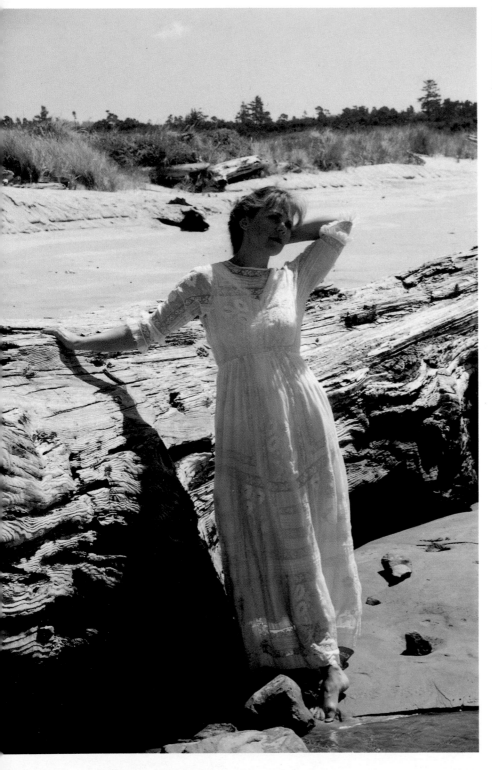

The cover of a 1906 French fashion magazine, featuring a tailored suit.

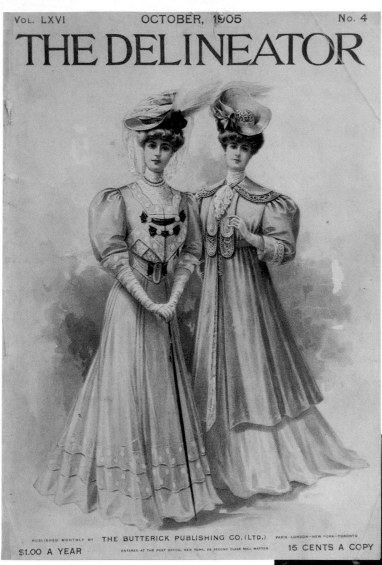

Vol. LXVI OCTOBER, 1905 No. 4

THE DELINEATOR

PUBLISHED MONTHLY BY **THE BUTTERICK PUBLISHING CO. (LTD.)** PARIS—LONDON—NEW YORK—TORONTO

$1.00 A YEAR ENTERED AT THE POST OFFICE, NEW YORK, AS SECOND CLASS MAIL MATTER 15 CENTS A COPY

The cover of a 1905 magazine, featuring tailored, but soft and well trimmed, dresses.

Detail of a circa 1903 lace-trimmed dress train. *Courtesy of The Very Little Theatre.*

A two-piece dress, circa 1903. The bodice has very long sleeves, which are pushed up the arm for a gathered affect. *Courtesy of The Very Little Theatre.*

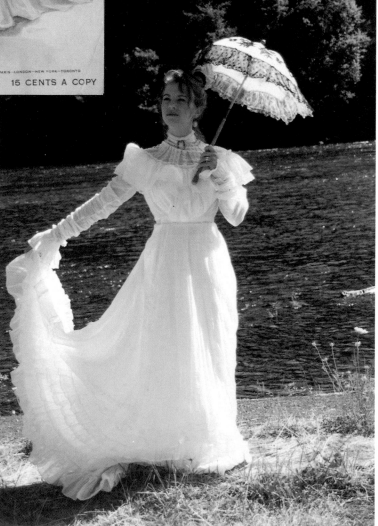

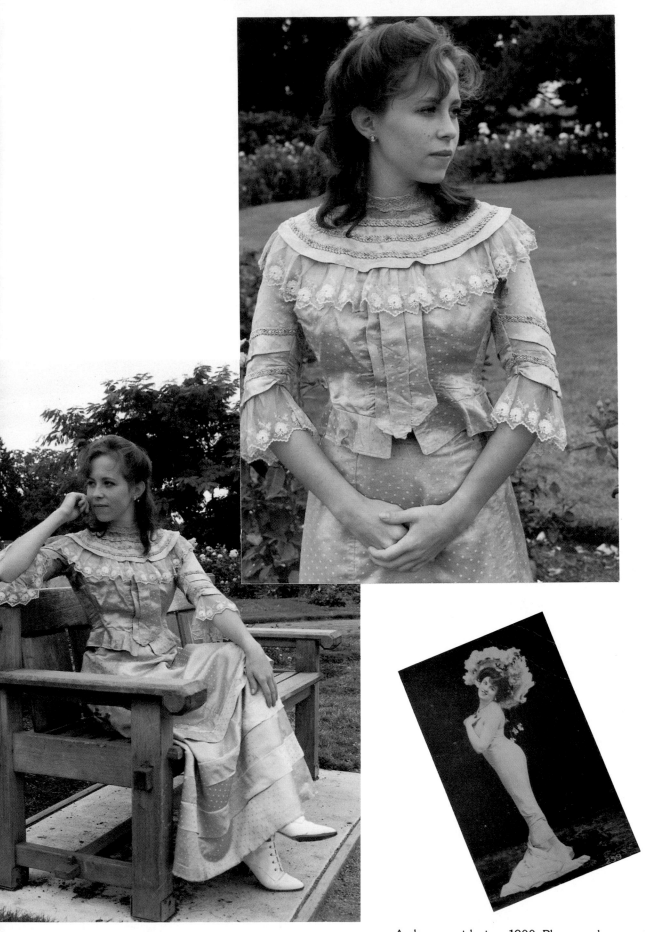

A silk two-piece dress trimmed with lace, tucks, and braid, circa 1900.

A glamour girl, circa 1900. Plump and curvy, she wears a princess-cut dress, with the long train wrapped about her ankles.

Detail of the lace-shaping, whitework, and tucks of two lingerie dresses. *Courtesy of The Very Little Theatre.*

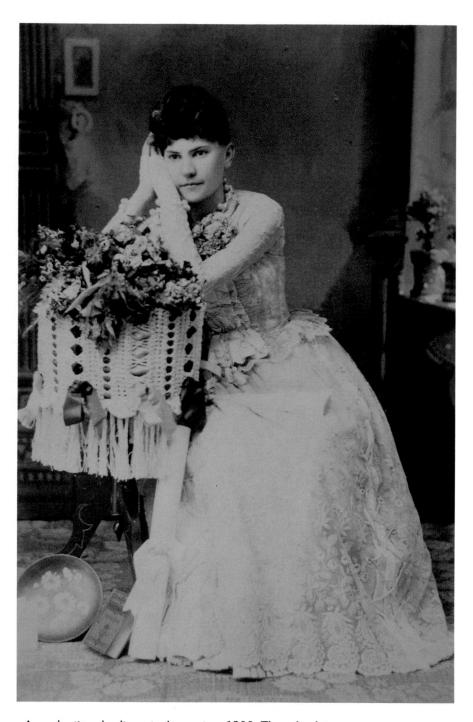

A graduation-day lingerie dress, circa 1900. Though white dresses were fashionable for every woman's wardrobe, they were considered absolutely essential for graduation day.

A tailored suit or a dress of frills and furbelows—two quintessential early 1900 styles.

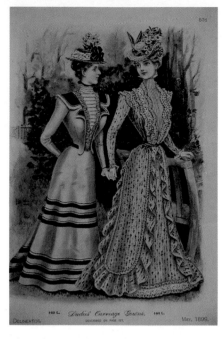

A lingerie dress with a wide, shaped belt, circa 1908.

A lingerie dress, circa 1903. *Courtesy of The Very Little Theatre.*

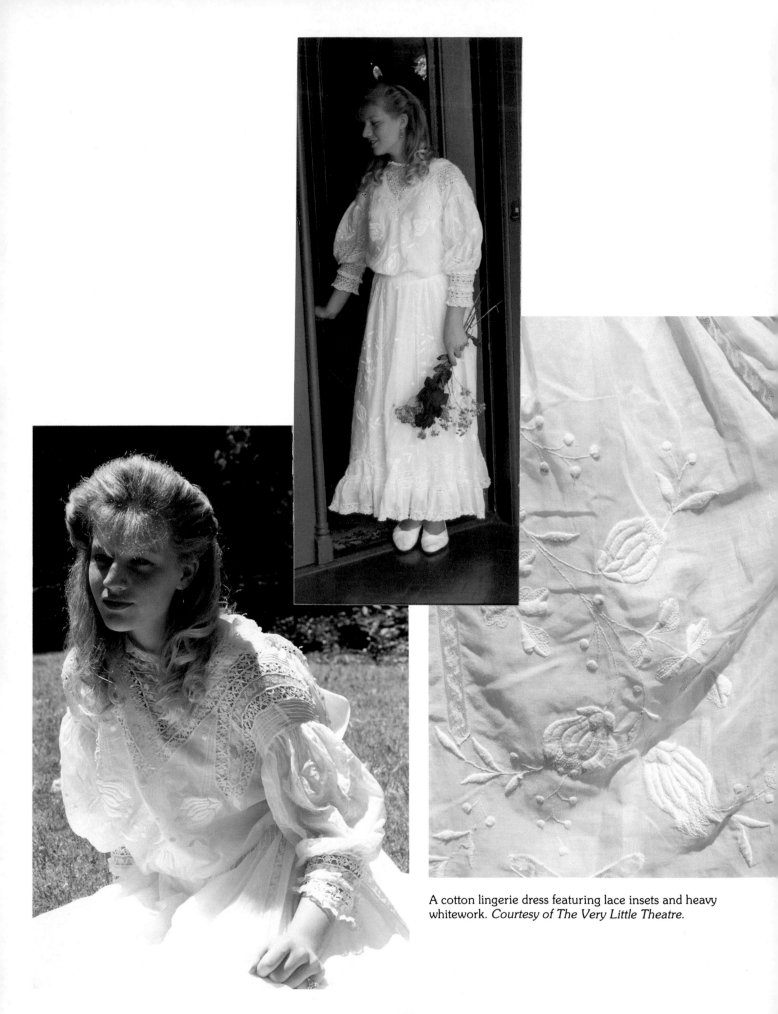

A cotton lingerie dress featuring lace insets and heavy whitework. *Courtesy of The Very Little Theatre.*

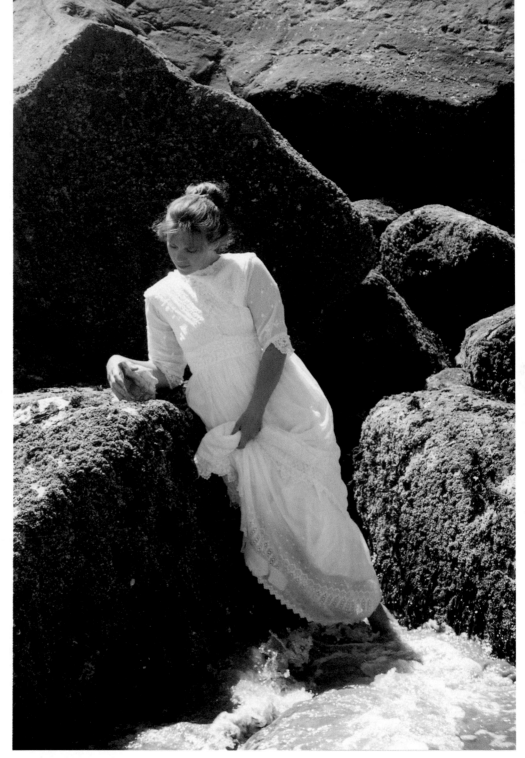

A lingerie dress featuring the more tubular lines of 1910.

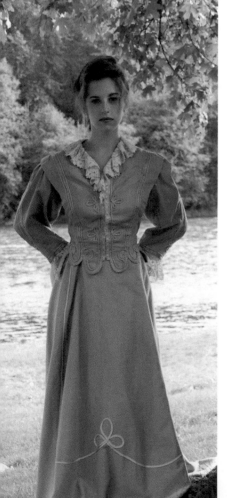

Grey suits dripping with lace were eminently popular in the early 1900s. This one dates to about 1905. *Courtesy of The Very Little Theatre.*

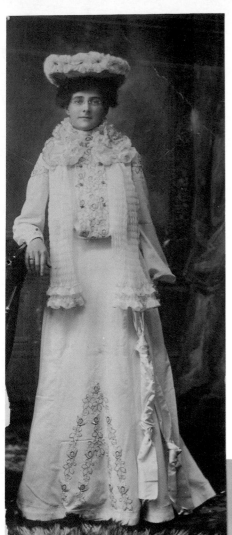

An atypical Edwardian lady, wearing a shirred boa and a white dress trimmed with lace, ribbon, and embroidery.

Two 'stylish toilettes' from a 1908 *McCall's Magazine*.

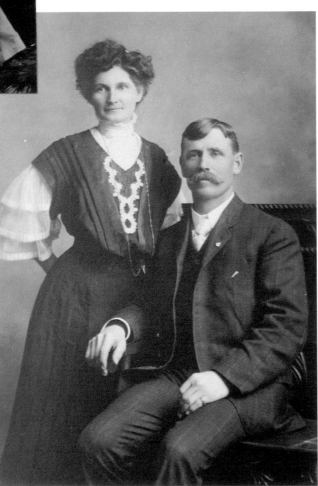

A tastefully dressed woman, circa 1906.

A delicate dress, circa 1903, trimmed with profuse 'drippery'. *Courtesy of The Very Little Theatre.*

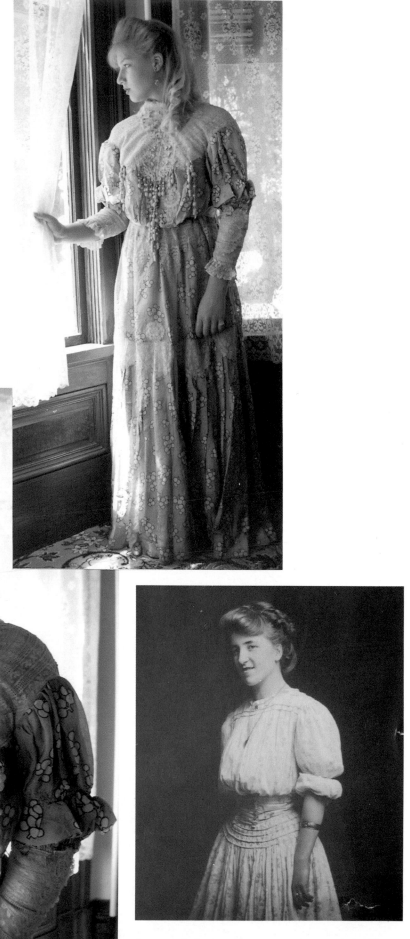

A young lady in a casual print dress, circa 1909.

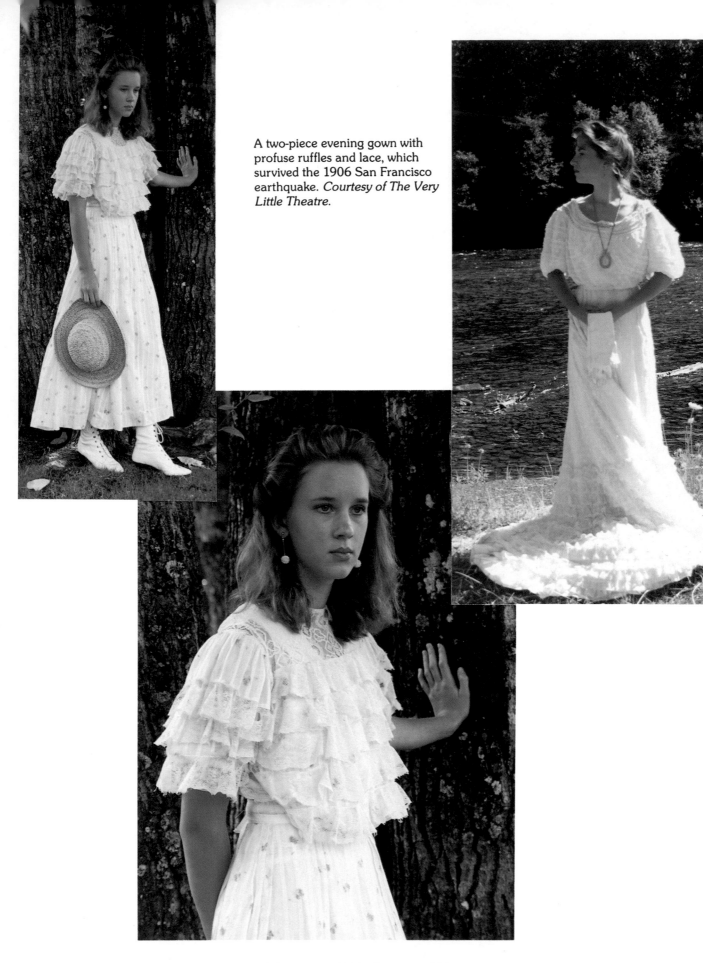

A two-piece evening gown with profuse ruffles and lace, which survived the 1906 San Francisco earthquake. *Courtesy of The Very Little Theatre.*

A two-piece rose-printed dress, circa 1905. *Courtesy of The Victorian Lady.*

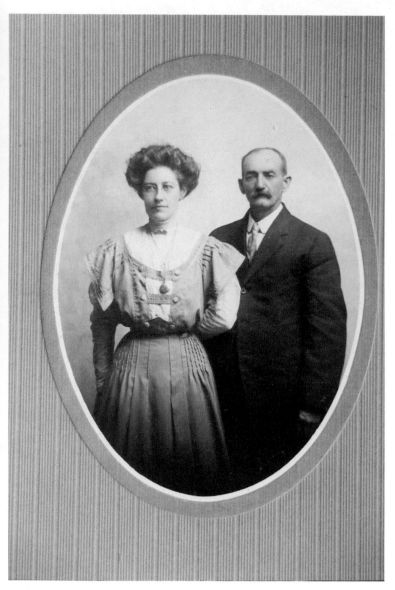

A woman wearing the more tailored suffragette look, circa 1904.

A wealthy Edwardian lady dressed in a lace and net dress, trimmed with beading. Circa 1901.

A 1908 fashion plate illustrating functional and practical jumpers.

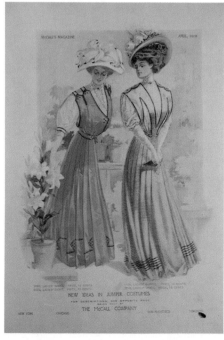

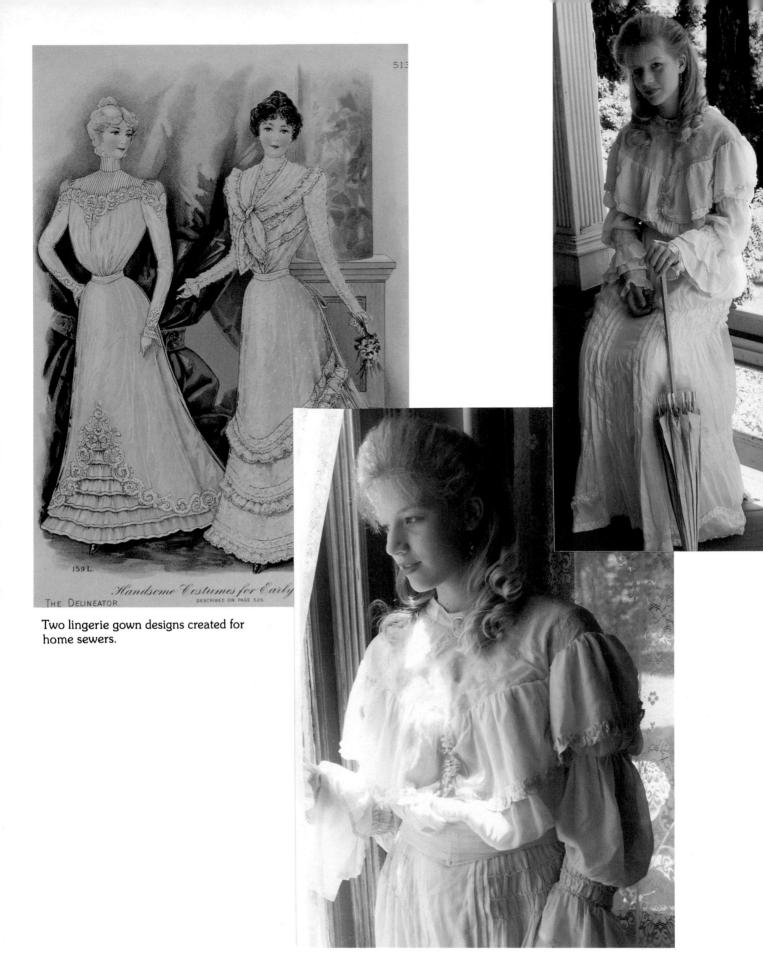

513

159 L.

Handsome Costumes for Early

THE DELINEATOR DESCRIBED ON PAGE 526.

Two lingerie gown designs created for home sewers.

A soft, poufy, two-piece dress with a matching shaped belt, circa 1903. *Courtesy of The Very Little Theatre.*

164

Two jumpers from a 1908 *McCall's Magazine*.

A 1908 fashion plate featuring tailored suits and large, feathered hats.

A working girl, circa 1909.

A suffragette suited in a sleek, minimalist toilette, resembling her husband's three-piece suit. Circa 1910.

Two dresses, circa 1905. On the left, flounces predominate, while on the right, tucks and ruching were favored. *Courtesy of The Very Little Theatre.*

A small, quilted bustle, circa 1900. *Courtesy of The Very Little Theatre.*

Two negligees from a 1908 fashion magazine. The gown at left is a traditional teagown, while the garment at right is in the shorter style

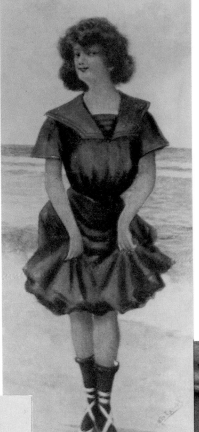

Bathing suits remained much the same as they had been in the previous decade, except now they were a bit more revealing.

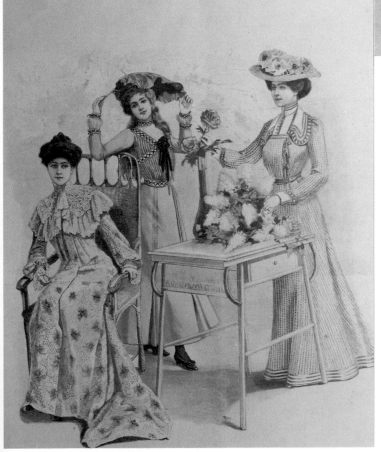

A 1901 fashion plate, featuring (on the far left) a teagown. *Courtesy of Reincarnation.*

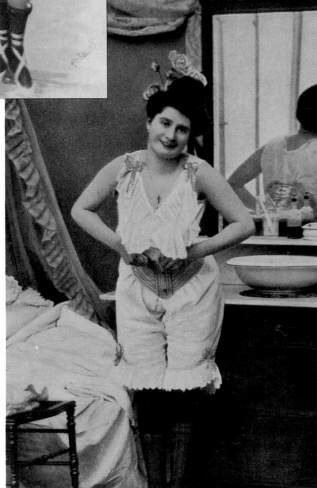

A 'naughty' postcard, circa 1900, showing a ribbon corset and combinations.

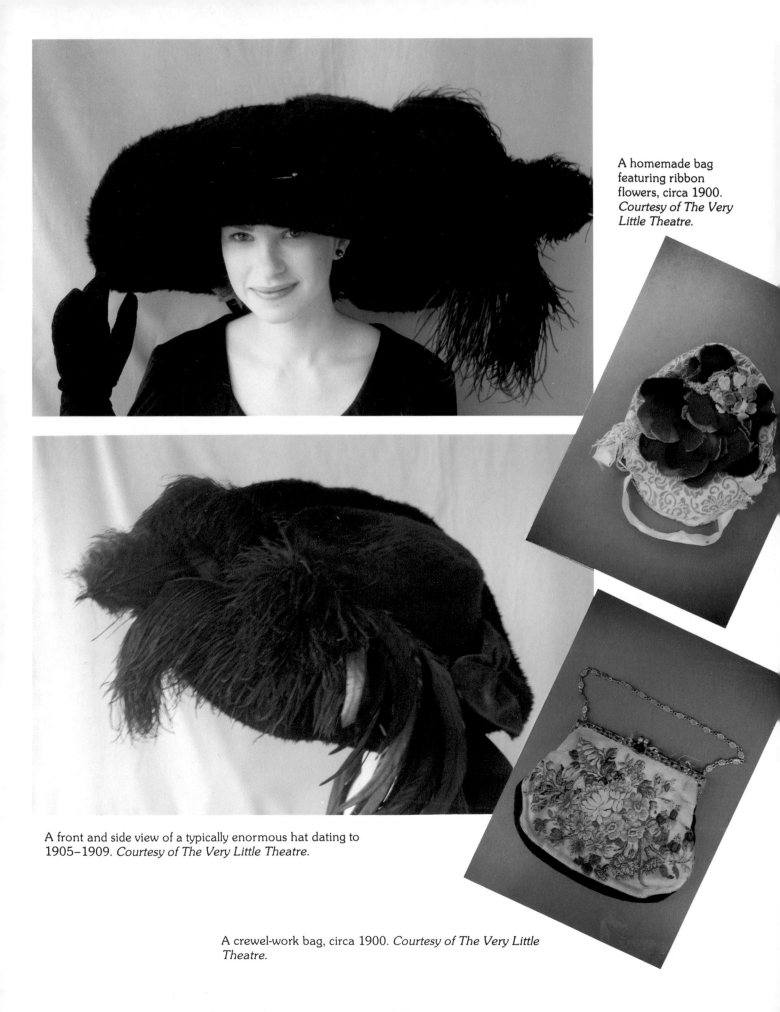

A homemade bag featuring ribbon flowers, circa 1900. *Courtesy of The Very Little Theatre.*

A front and side view of a typically enormous hat dating to 1905–1909. *Courtesy of The Very Little Theatre.*

A crewel-work bag, circa 1900. *Courtesy of The Very Little Theatre.*

Camille Clifford, striking a modern woman's defiant pose, circa 1905.

A humourous postcard, circa 1900, poking fun at fashion's latest invention.

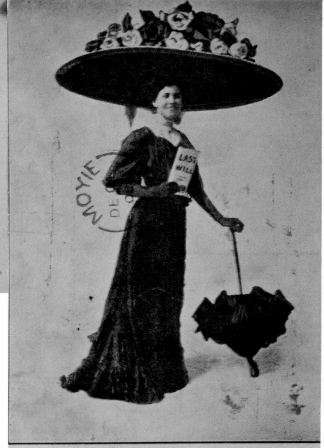

I've all the cash that I can use,
This will of Hubby's fixes that,
There's none to growl next time I choose
To get a MERRY WIDOW HAT.

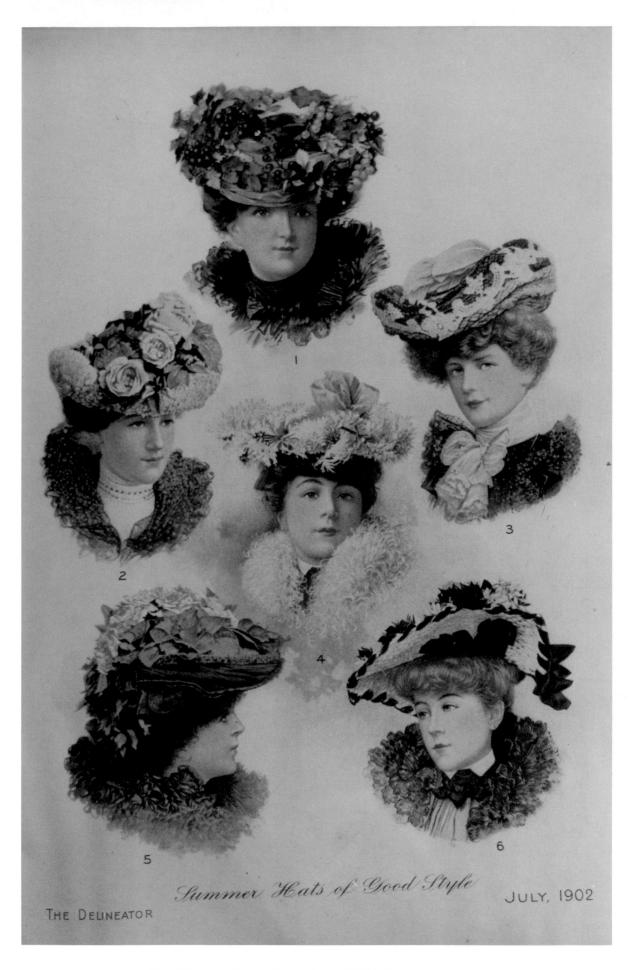

Six millinery styles, as featured in a 1902 fashion plate.

1913

1915

1919

1911

A parade of ever–changing styles, the 'teens have but one common denominator: though apparently 'modern' and more comfortable on the outside, on the insid, they were as uncomfortable and confining as ever.

Chapter *Ten*

'Teens: Hodge–Podge Years

"Anyone who wishes to look really smart and up-to-date must 'take heed to their corsets,' and see that they...are long—very, *very* long...It is quite *le dernier cri* to have the bodice 'floppy'...*but* under all that seeming freedom, there is a well cut, tight-fitting, and *boned* bodice lining," demanded *The Young Ladies Journal* in 1911. Indeed, though suffragettes were well on their way to political and social freedom, their clothes still kept them bound: long and tight corsets, hairpins and huge hats, and slim and snug skirts.

In 1913, *The Young Ladies Journal* complained about the restrictive fashions: "A human being's limbs...experience considerable difficulty in making an energetic stride, owing to the confining line in the region of the knees. It is, in fact, quite necessary nowadays to 'rehearse' an elaborately draped skirt before appearing in it in public, to realize the precise length of each pace to be taken, and calculate exactly how far it is possible to turn without the necessity of having to free ones ankles from the entanglement of the narrow tail-like train which most...gowns are now encumbered."

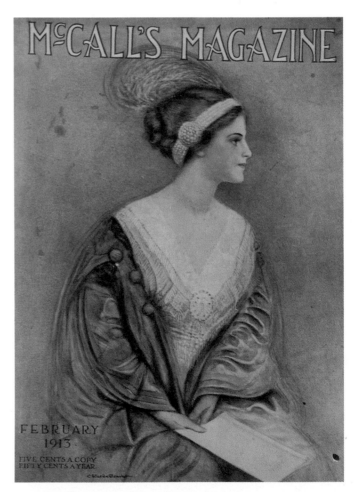

Coming closer to the vote, the women of 1913 preferred more sophisticated gowns.

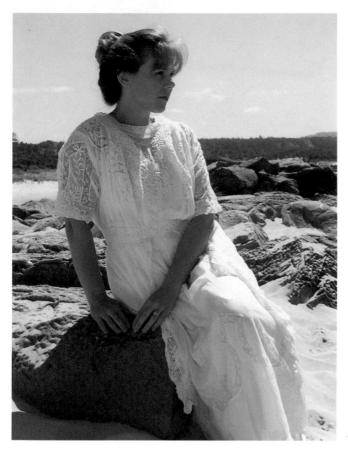

A lingerie dress, circa 1910. *Courtesy of The Very Little Theatre.*

Skirts

From 1910 to about 1914, skirts were slim through the hips—and if and when they were worn full, all fullness was below the knee. For evening, trains both slight and excessive were worn. By day, skirts were most often instep length. So-called 'hobble' skirts were at the cutting edge of fashion in 1910, though the excessively slim and crippling skirt was mocked by most. "Hobble, hobble little skirt," was the press's cry for the new style, often a mere thirty-two inches wide at hem. Around 1912, skirts began to feature side slits or wide pleats, which made walking considerably easier. Such slits were always worn with colored slips, however, so as not to reveal too much of the lady's limbs.

By 1913, all skirts featured Empire-style, high waistlines. In this same year, the 'barrel' or 'peg-top' skirt became fashionable. This new, draped style looked much like a wrap-around skirt, but featured full pleats, gathers, or open-ended darts at the waistline—which emphasized and exaggerated the hips. This emphasis on the hips took over completely in 1914. Puffs, panniers, peplums, tiers, and many other creative affects predominated.

In 1915, skirts took on an entirely new look. Circular and A-line styles offered greater freedom to their wearer's and were enthusiastically adopted. Skirts were also shorter, often three to five inches from the floor. This new freedom was short lived, however. As early as 1918, full skirts were going out of fashion, and by 1919, they were obsolete—though, thankfully, skirts did retain a length of five to seven inches from the floor.

Blouses

In the early 'teens, most bodices—now called 'blouses' or 'shirtwaists'—were cut low on the neck and were designed to be worn with a high-necked 'guimpe', or dickey. Occasionally necklines were also worn at the base of the neck. Tailored, tucked, and pleated shirtwaists were still worn frequently, as were net, embroidered, cutwork, eyelet, and sheer blouses.

By 1911, blouses started to take on new style. First, short peplums were added, then apron-like panels came into fashion. By 1912, raglan sleeves were sometimes worn, and by 1913, V-shaped necklines were becoming acceptable. Around this time, blouses also often featured a wrap-around look.

In 1914, raglan sleeves became extremely vogue, as were men's-shirtwaist-style collars. By 1916, blouses took on a structured, asymmetrical look. Long, tunic style blouses were sometimes worn outside the skirt, as were lightly gathered peplums.

In the years 1917 to 1919, blouses grew continually longer and were frequently worn outside of the skirt. By 1919, most blouses were quite simple and had a draped affect with wrap-around peplums, flounces, and long, loose sleeves.

Dresses

In 1910, dresses remained very similar to dresses worn in the past few years, with the exception that their skirts were slightly more slender. Most dresses were still two-piece, and most one-piece dresses were high-waisted. This new Empire style was slightly different than previous Empire styles, however; it was a few inches higher in the back than in the front.

In the evening, the fashion was still for light, gauzy fabrics, but necklines were more modest and did not feature décolletage. The most fashionable evening dresses still had trains, though now they frequently came to a sharp point in the back. Such trains were

also weighed down, usually with small, round, flat pieces of lead, which made humorous noises when their wearer walked across wooden floors or down staircases.

The 'lingerie' and tailored looks prevailed in the 'teens, and dresses followed all the trends of skirts and blouses, including the wrap-around look from 1912 to 1914, the peg-top look in 1913 and 1914, the A-line style from 1915 to 1917, and the draped, tubular look from 1918 to 1919.

Materials and colors varied as widely as the fashions of the 'teens, but in general, gauzes, eyelets, serge, velvet, silk, and satin (often delicately printed) were favored from 1910 to 1915, and light to medium weight cottons, georgettes, silk, satin, and wools in checks, stripes, and solids were favored from 1916 to 1919.

Undergarments

Perhaps it was the overwhelming popularity of the Tango and similar 'sinful' dances that prompted designers to create a new corset. Though still long and largely restrictive, corsets now featured insets of elastic that allowed for greater freedom of movement. By 1913, the corset had evolved even further; no longer was the corset designed to emphasize the waist, bust, and hips. Instead, it neglected them. The new look was straight, square, and curveless, and corsets controlled the hips to achieve this affect. Though still containing some boning, these corsets were largely made up of strong cottons, rubber webbings, and elastic. Because they often reached the knees, corsets were now laced instead of hooked up, in order to make movement easier.

In the 'teens corsets were gradually evolving into girdles, and by 1917, corsets were made almost entirely of elastic. Though now much more comfortable in nearly every respect, they had at least one major flaw: every time a lady sat, her corset rolled up her legs.

After decades of wearing impractical, immodest open-crotched drawers, by 1910, most ladies had discovered that closed–crotched knickerbockers or bloomers were preferable by far. Normally they were cut slim, sometimes featuring a hip yoke so more fullness could be allowed at the knees. By 1913, when the 'peg–top' look was fashionable, bloomers were often worn without petticoats in order to ensure a smooth, slender appearance; this trend continued into the next decade.

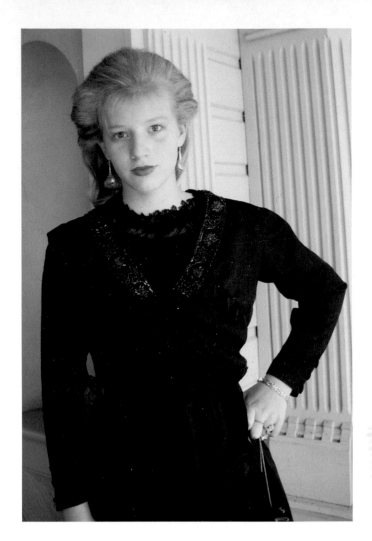

A circa 1910 bodice, trimmed with jet and lace. *Courtesy of The Very Little Theatre.*

'Bust supporters' were still being advertised in fashion magazines. Forerunners of the bra, the new-style supporters looked much like short corset covers, except that they were lightly boned, ended just below the bust, and often had fabric cups to hold the breasts. By 1913, the term 'brassiere' was being used to describe these supporters—but they hardly resembled modern bras.

Sportswear

Bathing suits, increasingly important to a world that was beginning to envy the suntans of the leisure class, looked more like everyday dresses than ever before. Box-like and loose-fitting, they always covered the knees. Around 1915, it at last became acceptable to wear a wider variety of colors and fabrics in bathing wear; checks, stripes, and polka-dots were favored by the most fashionable ladies. By 1917, knees were sometimes being seen on the beaches—a disclosure that rapidly led to more and more revealing styles.

Sportsclothes remained much the same, otherwise, until about 1917, when many women began choosing full trousers for activities such as fishing, golfing, and housework.

Other Important Garments

Capes continued in their popularity, and like many fashionable clothes of the 'teens, turned sophisticated and exotic. Wrapped around the body like a cocoon, draped, and created in opulent fabrics and trims, the new style in capes was definitely *couture*.

Shoes also took on a new face, now being created in a wide variety of shapes, and trimmed with everything from rhinestones to boa feathers (two trims that adorned *every* possible fashion accessory in the 'teens).

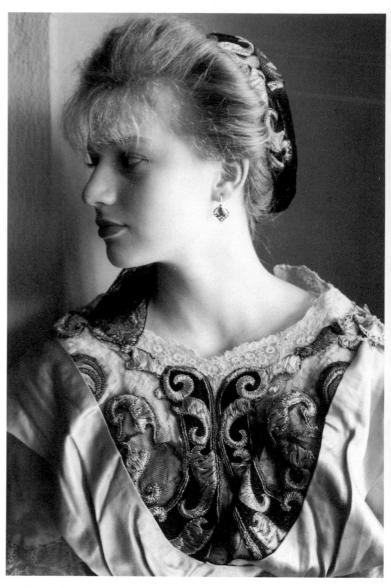

A satin embroidered evening gown with a matching embroidered net hat, circa 1913. The train, which comes to a point in back, is weighted. *Courtesy of The Very Little Theatre.*

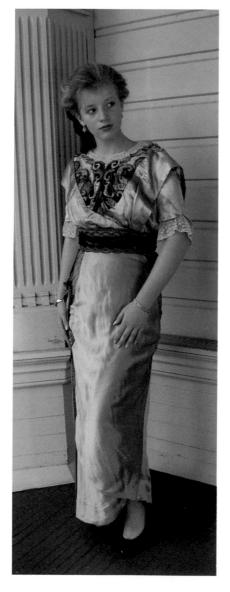

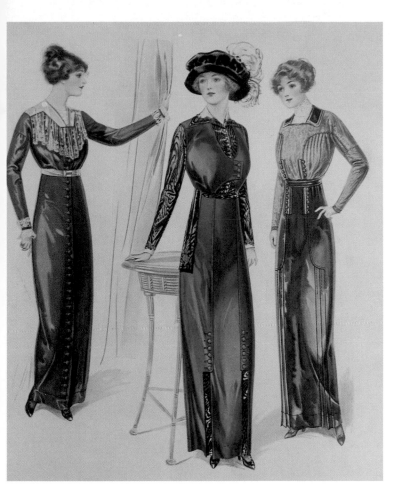

Three long, slim dresses from a 1914 fashion plate.

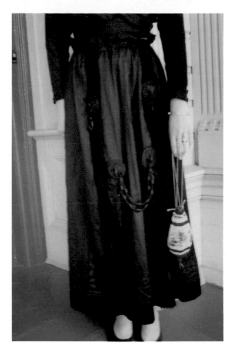

A circa 1910 skirt, trimmed with velvet and braided passementerie. *Courtesy of The Very Little Theatre.*

Detail of a celluloid bone inside a 'teens blouse collar.

The cover of a 1911 magazine, showing the new sleek and sophisticated style in evening gowns.

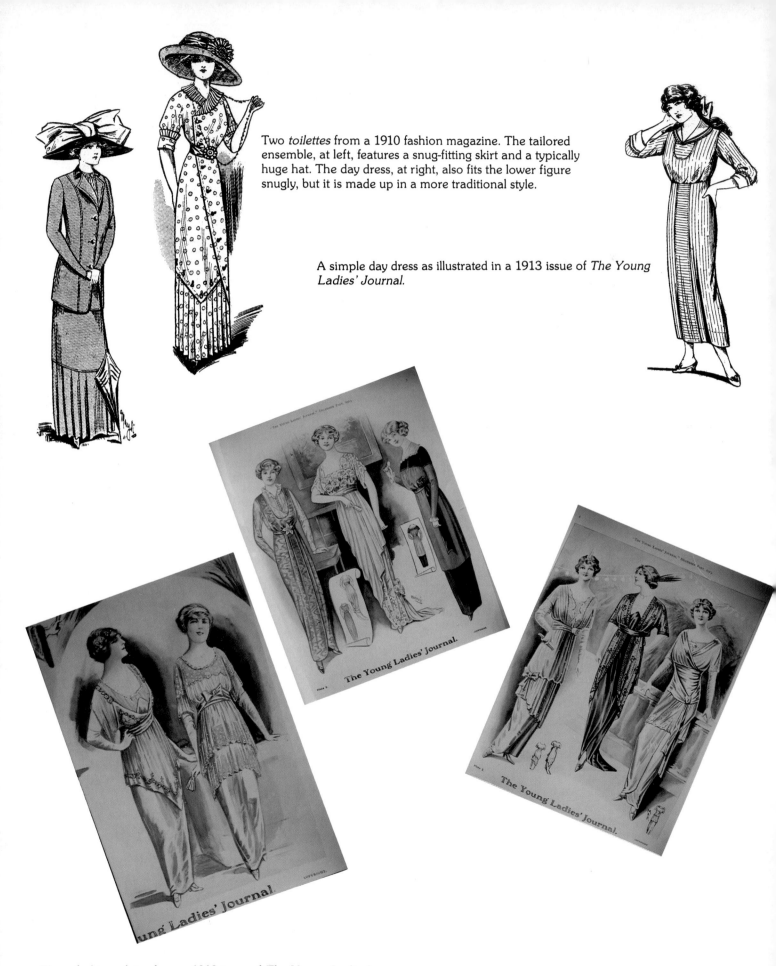

Two *toilettes* from a 1910 fashion magazine. The tailored ensemble, at left, features a snug-fitting skirt and a typically huge hat. The day dress, at right, also fits the lower figure snugly, but it is made up in a more traditional style.

A simple day dress as illustrated in a 1913 issue of *The Young Ladies' Journal.*

Three fashion plates from a 1913 issue of *The Young Ladies' Journal* illustrating evening and special occasion gowns.

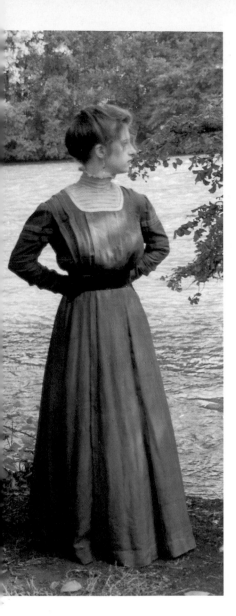

A tucked dress with a separate velvet belt, circa 1910. *Courtesy of The Very Little Theatre.*

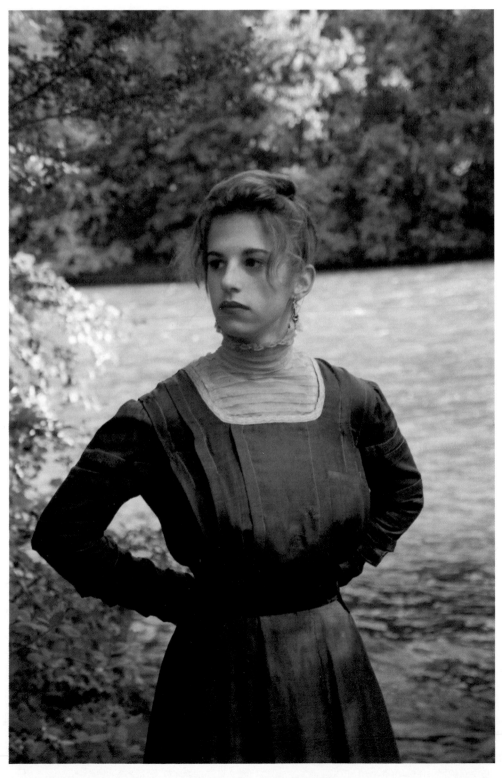

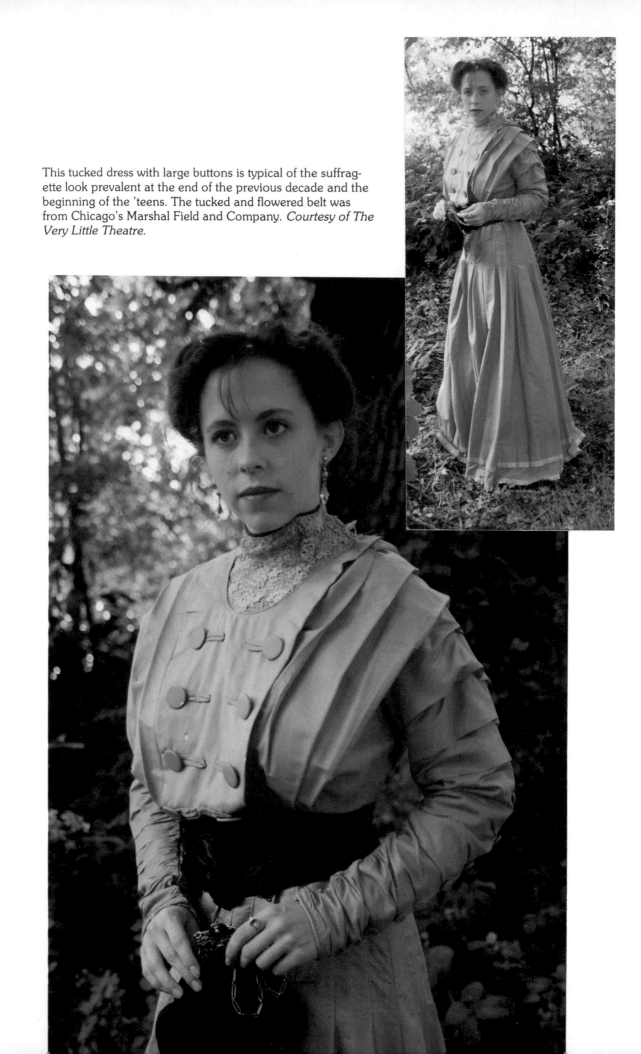

This tucked dress with large buttons is typical of the suffragette look prevalent at the end of the previous decade and the beginning of the 'teens. The tucked and flowered belt was from Chicago's Marshal Field and Company. *Courtesy of The Very Little Theatre.*

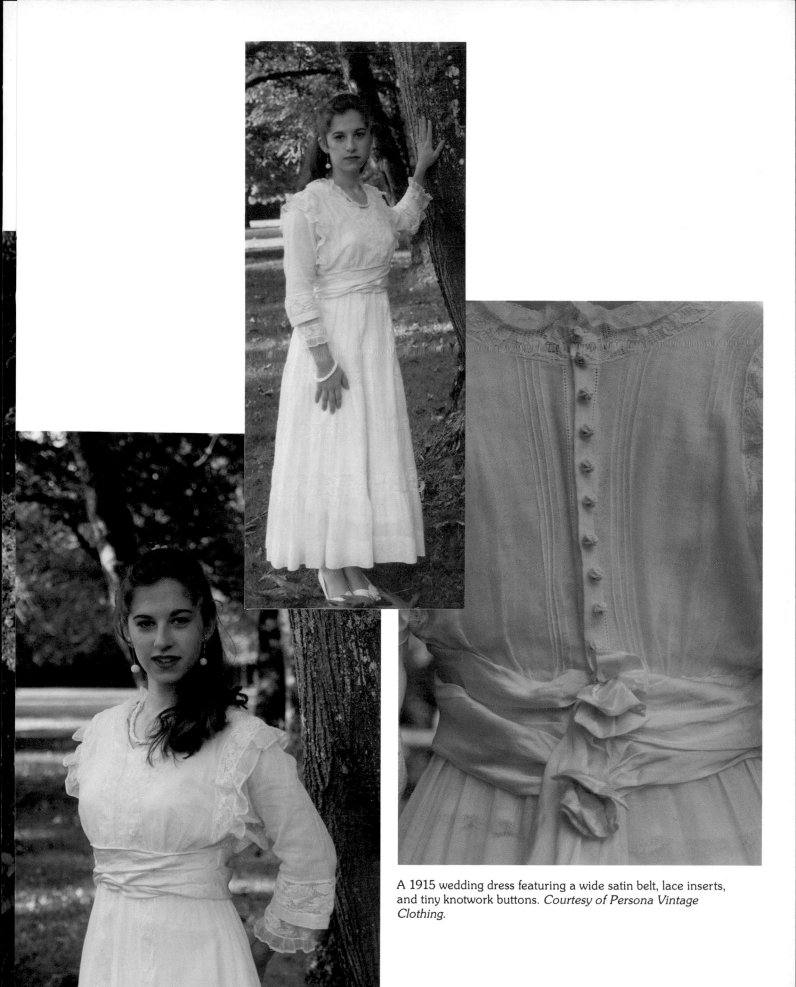

A 1915 wedding dress featuring a wide satin belt, lace inserts, and tiny knotwork buttons. *Courtesy of Persona Vintage Clothing.*

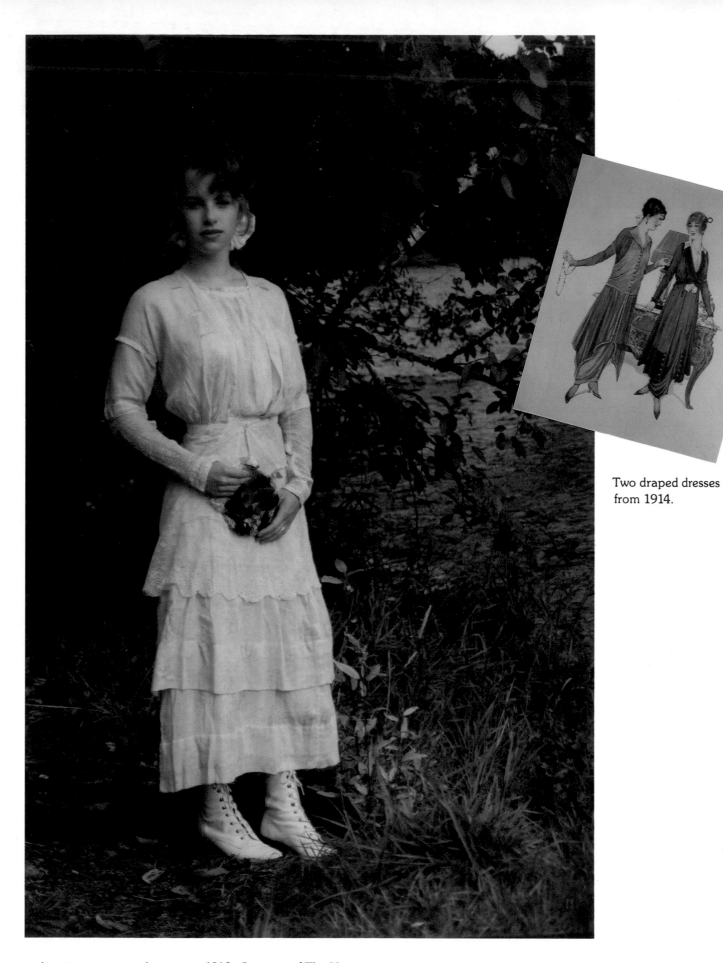

Two draped dresses
from 1914.

A cotton two-piece dress, circa 1918, *Courtesy of The Very
Little Theatre.*

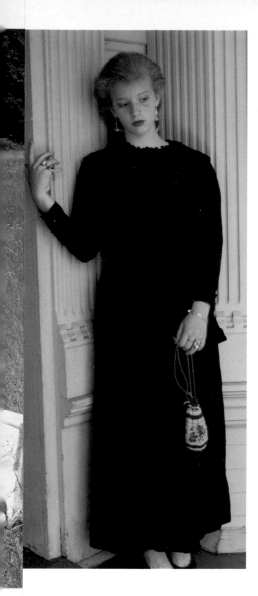

A two-piece dress, circa 1910. *Courtesy of The Very Little Theatre.*

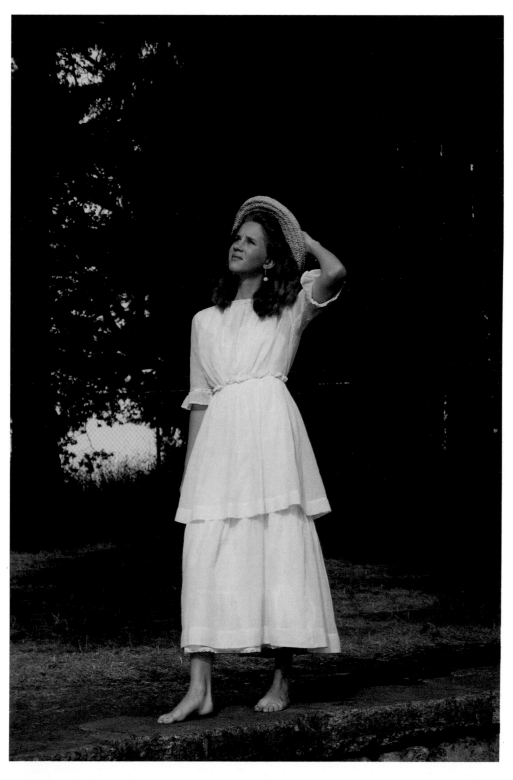

A two-tiered lawn dress, circa 1918.

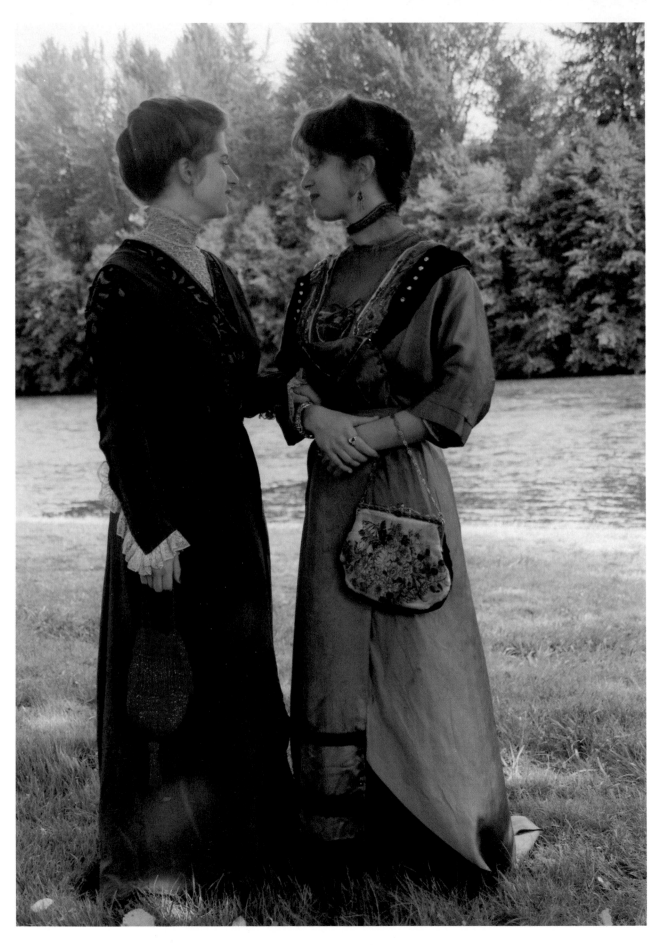

Two circa 1913 evening gowns. *Gown on right courtesy of*
The Very Little Theatre.

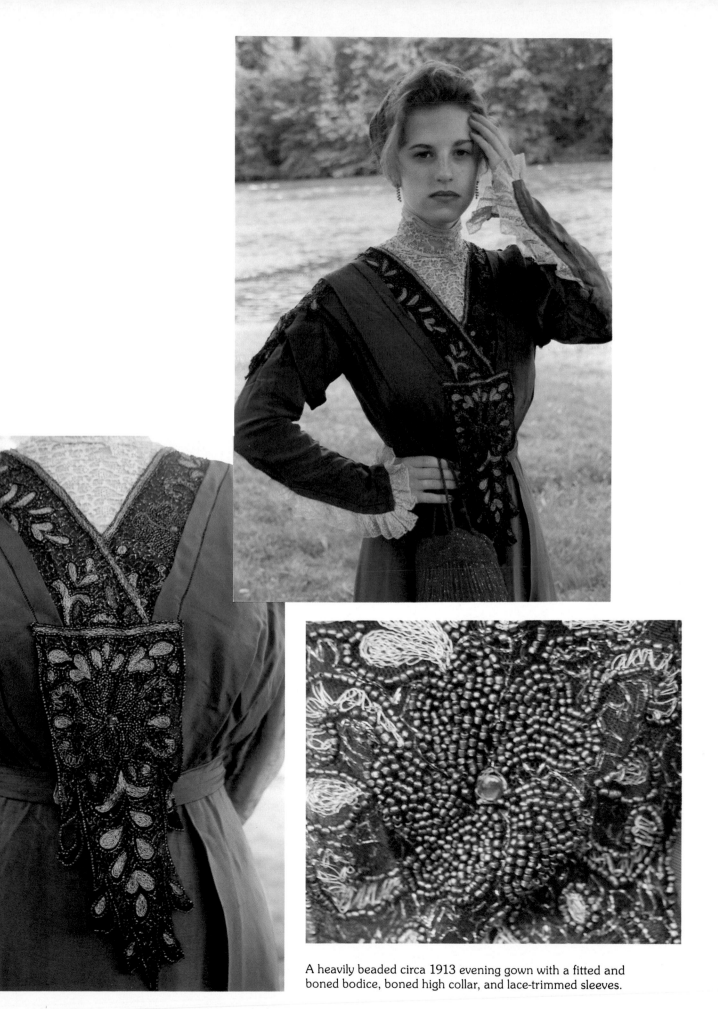

A heavily beaded circa 1913 evening gown with a fitted and boned bodice, boned high collar, and lace-trimmed sleeves.

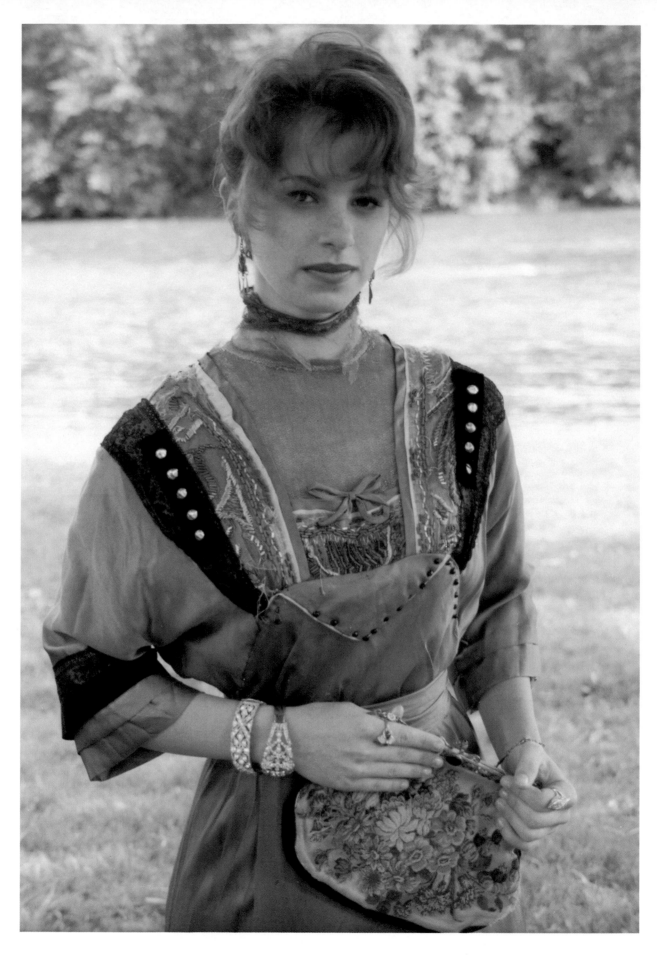

A circa 1913 gown, trimmed with velvet and embroidery.
Courtesy of The Very Little Theatre.

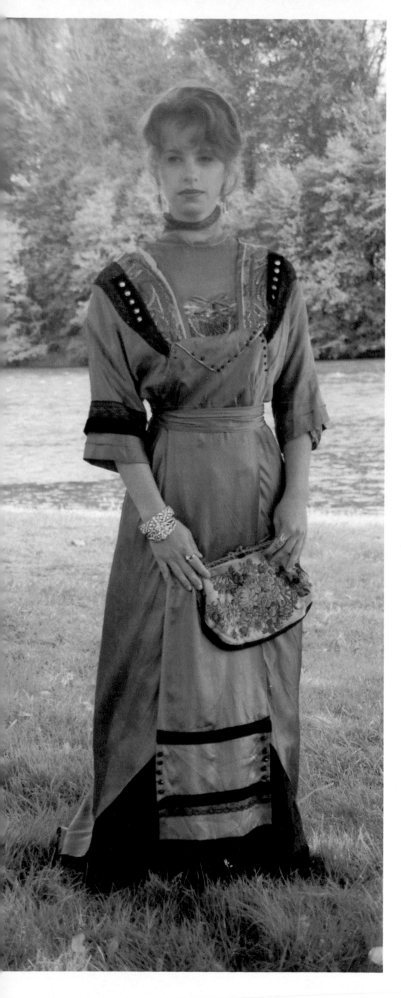
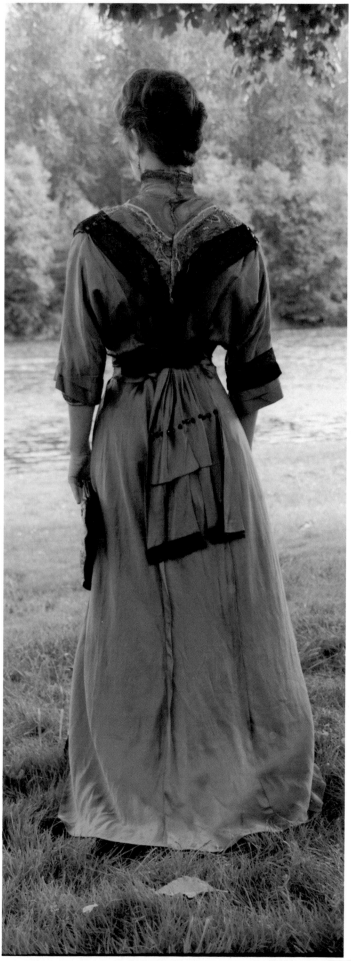

189

A heavy silk dress with a clear Oriental influence, circa 1913.
Courtesy of The Very Little Theatre.

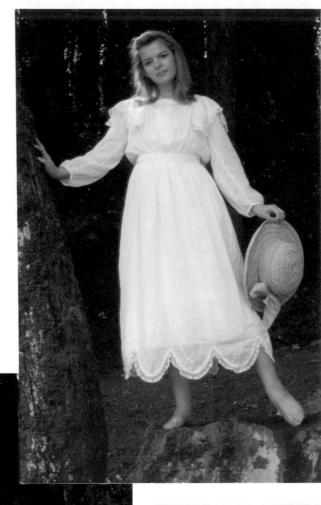

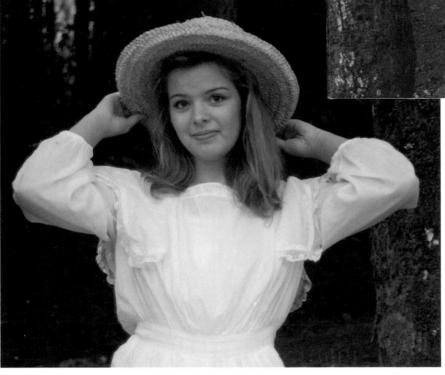

A circa 1919 cotton day dress with a small sailor collar and scalloped hemline.

A circa 1919 silk dress with a V-shaped lace insertion. The beginnings of the 1920s look is evident. *Courtesy of Persona Vintage Clothing.*

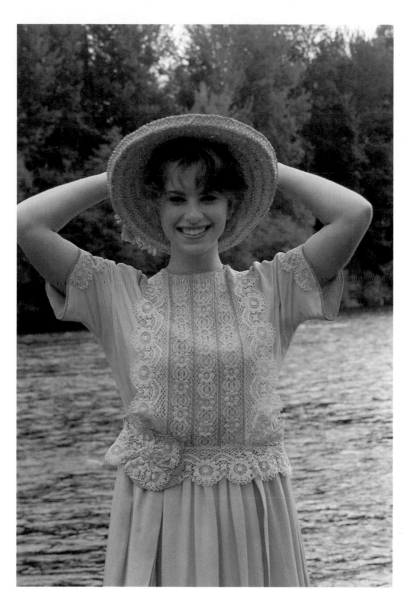

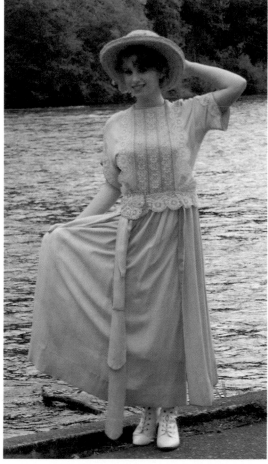

A day dress, circa 1919, nearly shaped in the 1920s tubular style. *Courtesy of The Very Little Theatre.*

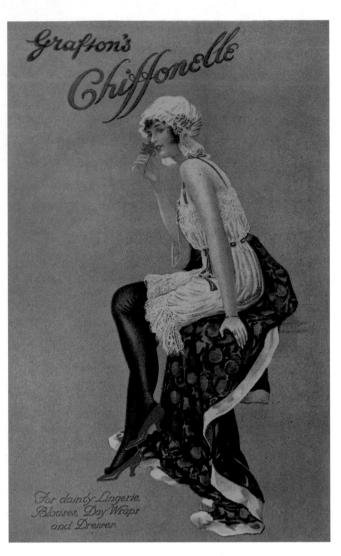

A 1918 advertisement featuring a pair of 'dainty' combinations and a nightcap.

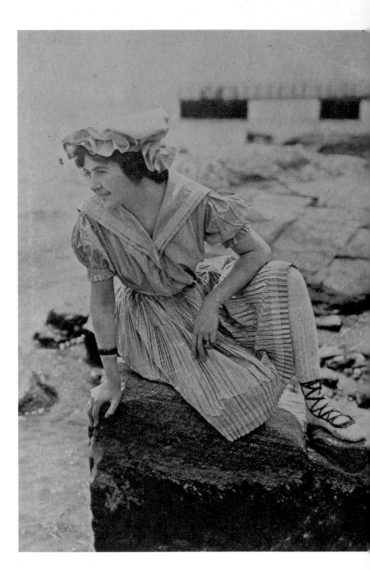

A modest bathing suit of 1910, featuring stockings, shoes, and a cap.

The 'modern' style bathing suit worn by only the most daring women in the early 'teens, but almost universally adopted by 1920.

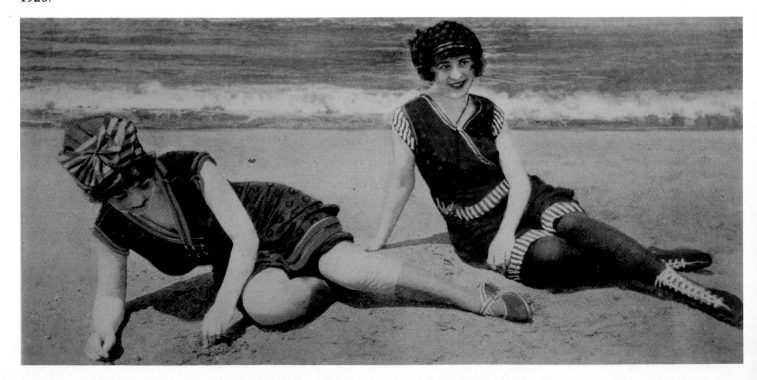

A 'teens corset with elastic garters. *Courtesy of Reflections of the Past.*

Two bathing suits in the style the majority of women wore in during the 'teens. These date to 1911.

A tucked coat from Boston's Jordan Marsh Company, circa 1910. *Courtesy of The Very Little Theatre.*

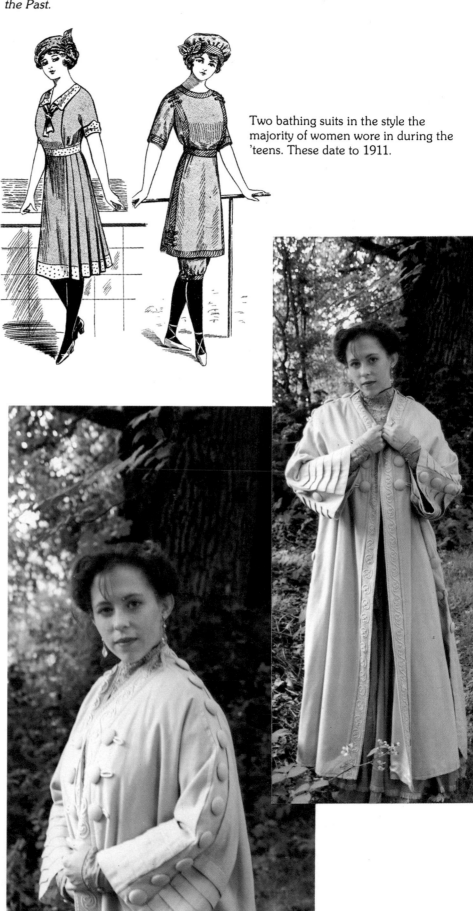

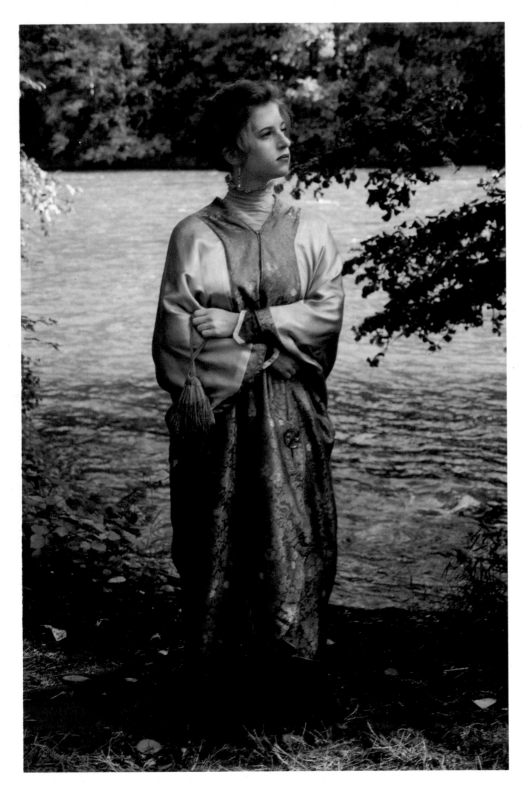

A magnificent, draped cape, circa 1913. Made up of satin, brocade, and tassels, this look was very modern. *Courtesy of The Very Little Theatre.*

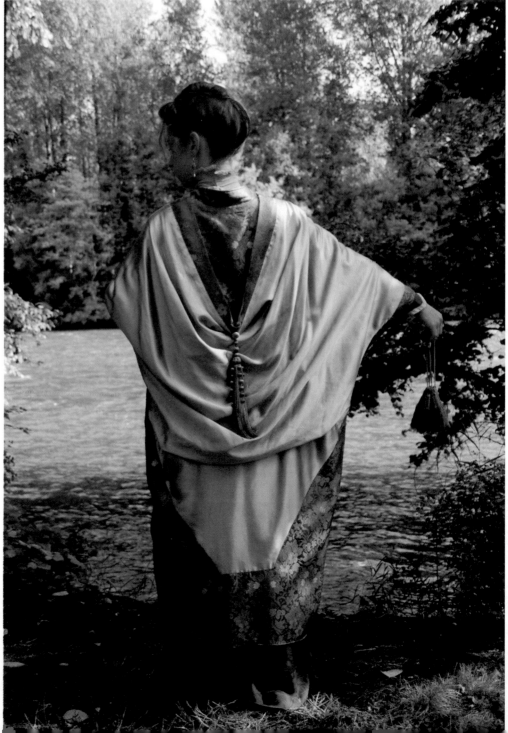

A pair of silk shoes with silver buckles, in their original box: "Costume Bootery of O'Connor & Goldberg at 23 Madison, East Chicago." Circa 1912. *Courtesy of The Very Little Theatre.*

A striking pair of cutwork leather shoes. *Courtesy of Reflections of the Past.*

A dramatic evening ensemble featuring a royal purple velvet cape. *Courtesy of The Very Little Theatre.*

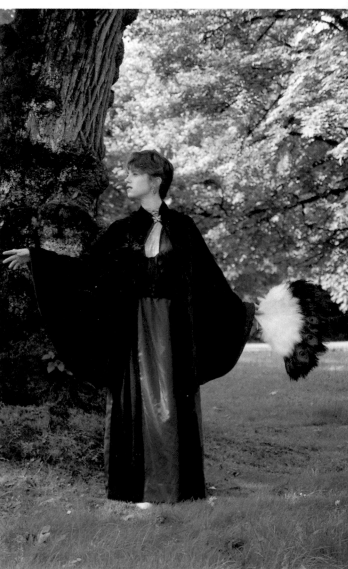

Two glass-beaded drawstring bags. *Courtesy of The Very Little Theatre.*

An iridescent beaded bag from the 'teens. *Courtesy of The Very Little Theatre.*

A ruched silk bag trimmed with faux gems. *Courtesy of The Very Little Theatre.*

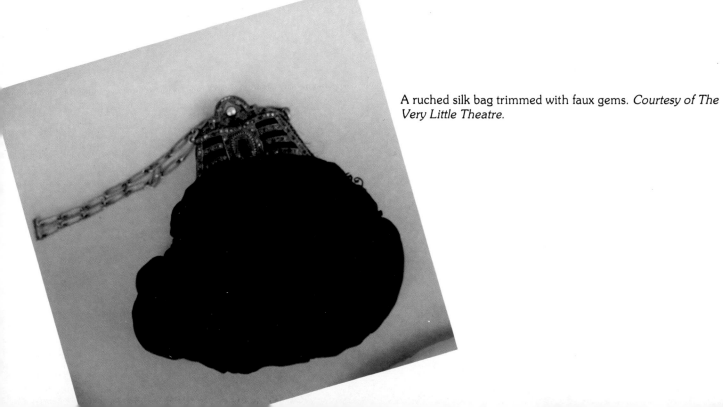

A dramatic velvet cloak, circa 1912. *Courtesy of The Very Little Theatre.*

Epilogue

The Victorian and Edwardian eras were years of great change. After the wild abandon of the Neopolian I years, the 1840s began with clothing and thought that was modest and moralistic. Change away from modesty may not have been easily discernible, but by 1919, women were well on their way to the radical attitude and attire of the 1920s flapper. True Victorian and Edwardian styles were but a brief (though glorious) spurt in time, never to be fully revived. Let us fully enjoy them, then, carefully conserving them for future generations to appreciate, learn from, and love. They are unique artifacts with wonderful tales to tell about our ancestors—how they lived, what their skills were, what they thought...Besides, as Dorothy Parker once astutely said, "Where's the man could ease a heart like a satin gown?"

Selected Bibliography

To cite every book or periodical that has influenced me in the writing of this book is an impossible feat; everything I have ever read on the subject of historical fashions has no doubt had a great impact on my work. Therefore, I list here only a few books and periodicals which I consider exceptional and particularly useful to me in writing this book.

Books

Bell, Lilian. *From A Girl's Point Of View*, Harper & Brothers, New York, NY 1897.

Blum, Stella. *Victorian Fashions and Costumes From Harper's Bazar*, Dover Publications, Inc. Mineola, NY 1974.

——— and Louise Hamer. *Fabulous Fashion*, The Metropolitan Museum Of Art, New York, NY (nd)

Black, Alexander. *Modern Daughters*, Charles Scribner's Sons, New York, NY 1899.

Bradfield, Nancy. *Costume In Detail: 1730–1930*, Plays, Inc., Boston, MA 1968.

Burgess, Janet. *Clothing Guidelines For The Civil War Era*, Amazon Dry Goods, Davenport, IA 1985.

Coleman, Elizabeth Ann. *The Opulent Era*, Thames and Hudson, New York, NY 1989.

Cunnington, C. Willett. *English Women's Clothing in the Nineteenth Century*, Dover Publications, Inc., Mineola, NY 1990.

———————. *The History of Underclothes*, Dover Publications Inc., Mineola, NY 1992.

Ewing, Elizabeth. *Dress and Undress*, B.T. Batsford, Ltd., London, England 1978.

Ginsburg, Madeleine, Avril Hart, Valerie D. Mendes. *Four Hundred Years Of Fashion*, Victoria And Albert Museum, London, 1984.

Hall, Carrie A. *From Hoopskirts to Nudity*, Caxton Printers, Ltd., Caldwell, ID 1946.

LaBarre, Kathleen and Kay. *Reference Book of Women's Vintage Clothing: 1900–1919*, LaBarre Books, Portland, OR 1990.

Tarrant, Naomi. *The Rise And Fall Of The Sleeve*, Royal Scottish Museum, 1983.

Thieme, Charles Otto, Elizabeth Ann Coleman, Michelle Oberly, and Patricia Cunningham. *With Grace and Favour*, Cincinnati Art Museum, Cincinnati, OH 1993.

Waugh, Nora. *Corsets and Crinolines*, Routeledge, New York, NY, 1993.

————––. *The Cut Of Women's Clothes*, Routeledge, New York, NY 1993.

Periodicals

Delineator, The
Dress
Englishwomen's Domestic Magazine, The
Godey's Lady's Book
Graham's Magazine
Harper's Bazar
Home Book Of Fashions, The
Lady, The
Ladies Cabinet, The
Ladies Home Journal, The
McCall's Magazine
Miss Leslie's Magazine
Peterson's Magazine
Queen, The
Standard Designer, The
Young Ladies Journal, The

Andrea Bush: 16 (C), 34, 58, 59, 88, 91, 94, 113 (BL), 120

Brianna Rose Cole: 11, 13, 16 (TR), 51 (TR), 93, 111 (BL), 113 (TR), 115, 118 (BR), 119 (BL), 123, 126, 129, 137 (BL, BR), 139 (C, BR), 147, 152, 158, 161, 164, 173, 174, 180, 183 (TL) 190, 191

Anna Kristine Crivello: 8, 12 (TR, R), 40 (L), 51, (C, BR), 63

Clinton McKay Crivello: 44

Lisa Ann Crivello: 10, 12, 14 (TC), 15 (TR), 25, 40, 44, 47, 50, 52, 53, 60, 99, 153, 157, 159, 172, 203

Jocelyn Jones: Cover, 4, 7, 14 (CL), 15 (CL), 26, 64, 68, 69, 71, 73, 77, 79, 89, 116, 124, 125, 127, 132, 134, 137 (TR), 139 (TR), 149, 151, 155, 178, 185, 195, 196, 202

Darcie Jones: 5, 9 (L), 14 (BR), 101, 103 (R), 111 (BR), 114, 118 (CL), 119 (TR), 144 (L), 146, 148 (LR), 159 (BL), 162 (TR), 166 (R), 177, 179, 186 (R), 187, 192 (BR), 197, 198, 199

Stephanie Jones: 9 (R), 24, 32, 39, 42, 55, 57, 66, 82, 103 (L), 112, 117, 121, 144 (L), 148 (L), 154, 166 (L), 168, 181, 182, 186 (R), 188, 189, 193, 200

Krystyn Kuntz: 29, 38, 74, 96, 184, 192 (TR, C)

Alicia Wray: 98, 128, 131 (TL, C), 138, 162 (TL, C), 183 (BR)

Value Guide

The following is intended to be a general reference for collectors and dealers who want to know what they can expect to pay for various items in the antique clothing field or what they can sell them for. The actual prices listed come directly from antique fashion dealers throughout the United States. All values listed presume the item is in mint or excellent condition. When trying to evaluate items, every bit of damage and every flaw must be taken into consideration, and the items must be depreciated accordingly. There is no such thing as a garment in "good condition for its age"; either it is in good condition or it is not. Mint and excellent condition items from 1840s do exist, as do terribly torn-up garments from the 'teens. Bear in mind that prices vary from state to state and region to region. Demand in your own area and current collecting trends also affect values.

Page	Item	Value
20	Fashion Plate	$45
21	Fashion Plate	$29
23	Fashion Plate (right)	$30
23	Fashion Plate (left)	$25
24	Bodice	$180
25	Bodice	$150
25	Embroidered Picture	$50
25	Fashion Plate	$30
26	Dress	$395
27	Fasion Plate (top)	$20
27	Fashion Plate (bottom center)	$35
27	Fashion Plate (right)	$19
28	Fashion Plate (top left, right, & bottom)	$30 ea.
29	Dress	$695
30	Embroidered Picture	$45
30	Fashion Plate	$60
31	Fashion Plate (top)	$15
31	Fashion Plate (bottom)	$20
32	Capelet	$175
33	Fashion Plate	$33
34	Fashion Plate	$41
34	Bodice	$120
35	Bodice	$67
37	Fashion Plate	$15
37	Dress	$495
38	Dress	$295
39	Dress	$575
39	Fashion Plate	$30
40 &12	Hoopskirt, cotton	$170
40 &12	Hoopskirt, child's	$75
40	Fashion Plate	$40
41	Fashion Plate	$45
41	Shoes	$225
42	Shoulder Cape	$195
42	Stockings	$115
43	Fashion Plate (top)	$20
43	Fashion Plate (bottom)	$29
44	Bonnet & Cape set	$325
44	Hat, man's	$160
46	Fashion Plate	$42
47	Bodice	$95
47 &15	Hat	$100
47	Headdress	$27
49	Dress	$650
49	Fashion Plate	$30
50	Fashion Plate	$15
50	Shirtwaist	$60
51	Vest	$180
51	Bodice	$85
52	Bodice	$90
52	Blouse, Vest, and Belt ensemble	$230
53	Paletot	$67
54	Dress	$200
54	Fashion Plate	$39
55	Dress	$295
56	Dress	$150
56	Fashion Plate (top)	$20
56	Fashion Plate (bottom)	$30
57	Dress	$575
58	Fashion Plate	$22
58	Dress (left)	$475
58	Dress (right)	$210
59	Dress	$395
60 & 12	Hoopskirt	$80
61	Stockings	$95
61	Fashion Plate	$35
63	Bodice	$69
64	Jacket	$125
66	Bodice	$150
67	Dress	$145
67	Fashion Plate	$27
68	Dress	$350
69	Suit	$295
70	Dress	$650
71 & 15	Wedding Gown	$195
72	Fashion Plate	$45
73	Dress	$295
74	Dress	$650
77	Dress	$110
78	Fashion Plate	$65
79	Dress	$170
81	Robe	$1,110
82	Negligee	$475
83	Stockings	$110
84	Shoes	$65
84	Gloves	$25
84	Mantel	$1,000
86	Fashion Plate	$30
88	Bodice	$180
89	Bodice	$37
91	Chemisette	$210
92	Fashion Plate	$25
93	Dress	$398
93	Parasol	$160
94	Dress	$310
95	Fashion Plate	$15
96	Dress	$190
98	Suit	$210
98	Fashion Plate (left)	$60
98	Fashion Plate (right)	$56
99	Corset, black	$230
99	Corset, white	$184
99	Bustle	$50
100	Petticoat	$70
101	Cape	$115
103	Bodice (left)	$125
103	Bodice (right)	$55
105	Fashion Plate	$12
107	Skirt (right)	$115
107	Skirt (left)	$120
108	Skirt	$125
109	Skirt	$96
110	Fashion Plate	$45
111	Bodice (left)	$34
111	Bodice (right)	$90
112	Bodice	$89
113	Bodice (top)	$90
113	Bodice (bottom)	$145
114	Bodice (top)	$170
114	Bodice (bottom left)	$30
114	Bodice (bottom right)	$56
115	Bodice (top)	$29
115	Bodice (bottom)	$45
116	Bodice	$50
116	Parasol	$90
117	Bodice	$70
118	Bodice (right)	$40
118	Bodice (left)	$35
119	Bodice (top)	$50
119	Bodice (bottom)	$130
120	Bodice	$60
121	Mantel	$300
122	Fashion Plate (top)	$40
122	Fashion Plate (bottom)	$35
123	Dress	$60
124	Dress	$280
124	Parasol	$80
125	Dress	$70
126	Dress	$120
127	Dress	$100
128	Suit	$299
129	Boa	$39
129	Ensemble (top)	$100
129	Ensemble (bottom)	$83
129	Fashion Plate	$30
131	Dress (top)	$90
131	Dress (bottom)	$195
132	Jumper	$60
133	Fashion Plate (top)	423
133	Fashion Plate (bottom)	$30
134	Dress	$515
135	Corset	$1,700
137	Cape, fur (top)	$90
137	Cape, fur (bottom)	$70
137	Cape, lace	$50
138	Fashion Plate	$15
138	Cape	$69
139	Jacket	$110
139	Capelet	$85
140	Parasol (top)	$200
140	Parasol (bottom)	$180
141	Purse	$160
141	Shoes	$150
143	Fashion Plate	$21
144	Dress (right)	$290
144	Dress (left)	$260
145	Fashion Plate	$12
146	Bodice	$45
147	Bodice	$109
148	Bodice (left)	$40
148	Bodice (right)	$30
148	Jabot	$30
149	Bodice (top)	$50
149	Bodice (bottom)	$66
150	Magazine	$15
151	Dress	$400
151	Parasol	$185
152	Dress	$225
153	Dress	$130
153	Magazine	$30
154	Dress	$430
154	Magazine	$10
155	Dress	$290
157	Fashion Plate	$10
157	Dress	$100
158	Dress	$90
159	Dress	$85
159	Suit	$280
160	Fashion Plate	$12
161	Dress	$510
162	Dress (left)	$325
162	Dress (right)	$620
163	Fashion Plate	$13
164	Dress	$149
165	Fashion Plate (left & right)	$10 ea
166	Dress (right)	$430
166	Dress (left)	$620
166	Bustle	$20
168	Hat	$135
168	Purse (top)	$25
168	Purse (bottom)	$69
170	Fashion Plate	$10
171	Magazine	$10
172	Dress	$70
173	Bodice	$35
174	Dress & Cap set	$515
175	Skirt	$45
175	Magazine	$12
177	Dress	$82
178	Dress	$89
178	Belt	$30
179	Wedding Dress	$160
180	Dress	$135
181	Dress	$365
182	Dress	$115
182	Fashion Plate	$10
183	Dress (top)	$89
183	Dress (bottom)	$65
184	Dress	$300
185	Dress	$70
186 &187	Dress (left)	$115
188 & 18	Dress	$125
190 &191	Dress	$525
192	Dress (top)	$65
192	Dress (bottom)	$95
193	Dress	$67
195	Corset	$190
195	Coat	$125
196	Dress	$165
197	Dress	$185
197	Fashion Plate	$12
198 &199	Cape	$415
200	Shoes (top)	$160
200	Shoes (bottom)	$200
200	Ensemble	$385
201	Purse, red	$160
201	Purse, small green	$70
201	Purse, iridescent	$115
201	Purse, ruched	$46
202	Cape	$370

Index

Balenciaga

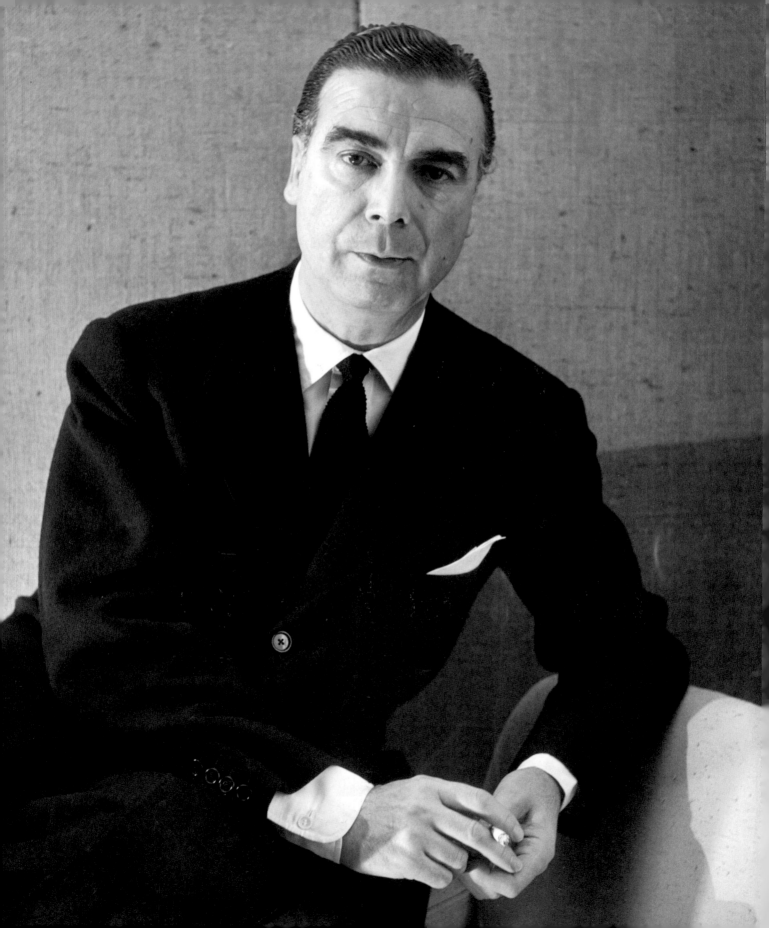

Cristóbal

Balenciaga

(1895-1972)

The Couturiers' Couturier

Lesley Ellis Miller

V&A Publications

INTRODUCTION

*If Dior is the Watteau of dressmaking –
full of nuances, chic, delicate and timely
– then Balenciaga is fashion's Picasso.
For like that painter, underneath all of his
experiments with the modern, Balenciaga
has a deep respect for tradition and a pure
classic line.*[1] Cecil Beaton

Cristóbal Balenciaga Eisaguirre (1895–1972) was perhaps the best-known Spanish fashion designer of the twentieth century, and his career has been outlined in many books and articles. It is thus common knowledge that his life comprised three phases: between 1895 and 1935–6 he lived in Spain, training as a tailor in San Sebastian (Donostia) and Madrid and setting up his own dressmaking establishments in these cities; in 1937 he made his mark on Paris by opening the House of Balenciaga, which he ran for the next 31 years; and from 1968 he lived in retirement, until his death in 1972 at the age of 77. The bald facts are clear and simple, but there is a dearth of material on his preoccupations and views, and on the motivating forces behind his very successful career. Balenciaga's own obsession with privacy – a most unusual concern in the annals of a profession renowned for its proclamations, exaggerations and love of self-publicity – is partially responsible.

Little systematic historical research has taken place since Balenciaga's death, although several retrospective exhibitions and their catalogues and several books have begun to put his career and work into perspective. They all owe much to the dedicated cataloguing and research of Marie-Andrée Jouve, archivist at the House of Balenciaga from 1980 until 2003. An expert on his life and designs, she has visited and documented not only the large collections of his clothes and drawings preserved in Paris, but also those in other major cities of the world. The collection of which she was curator is considerable in its own right, comprising some 600 garments by Balenciaga and 400 accessories (hats and jewellery), some *toiles* (1960–68), 40,000 workshop sketches (1930–68) and 15 films of mannequin parades (1960–68). This particular archive is now a living one, used by the current designer both for inspiration and for the creation of a new 'Edition' collection. It is in the process of being digitized. In brief, there is no shortage of material evidence of Balenciaga's expertise in his chosen profession, and, no doubt, even more to discover through future research.

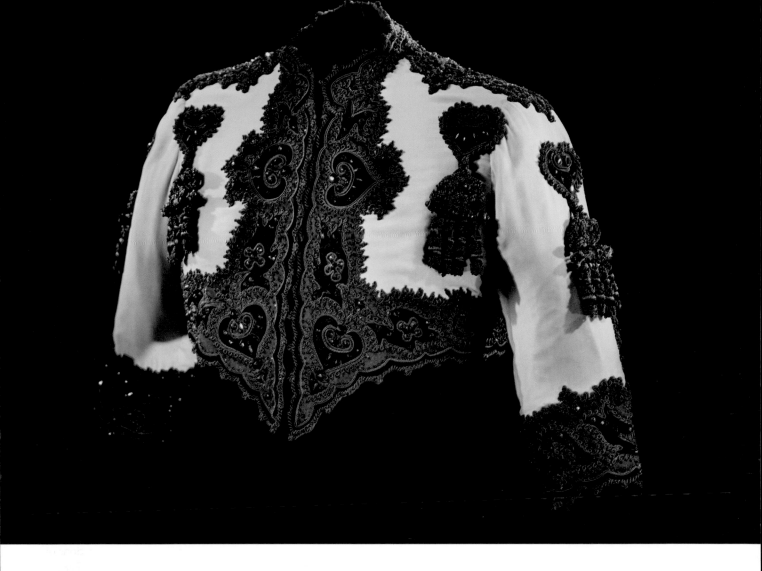

As yet, no exhibition has taken place in
Britain, and this book represents the only
British attempt to discuss the life and work of
Balenciaga since that of Cecil Beaton in the
1950s. Beaton had a particular affection for his
subject, having struck up a lifelong friendship
with Balenciaga in New York, at a time when
they both felt rather homesick. Some of the
most intimate portraits of the couturier and his
family and friends resulted from this friendship
with Beaton, a friendship that spanned two
continents and decades – and led to the first
donations of Balenciaga to the Victoria and
Albert Museum. This book is similarly
international in its scope. Based on research in

2. **Bolero of blue velvet with
appliqué decoration in black felt and
velvet, with jet beads, 1947.** Worn by
the Marquesa de Llanzol. Llanzol
Collection. This bolero is one of
Balenciaga's interpretations of one
component of bullfighting dress that
draws on the contrast in colour
between the base fabric and the rich
embroidery, and on the weight of jet
beads and intricate braiding for its
effect. In fashion, Balenciaga was
translating the use of the bolero from
male to female dress, from sporting
to evening wear. The quintessential
feature of each context was drama
and performance.
Courtesy of the Fundación Balenciaga,
Guetaria.

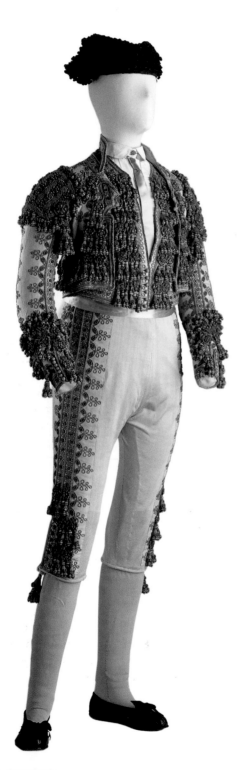

3. **Suit of lights, late 19th century.** Balenciaga drew inspiration from a range of sources, including the colourful and omnipresent popular entertainment and sport of bullfighting. Commercialized in the late 18th century, bullfighting retains certain highly adorned traditions, among them the bright suits of lights (*traje de luces*) worn by matadors and toreadors. This example dates from the late 19th century, when Balenciaga was born.
Courtesy of Museo del Traje, Madrid.

France, Spain, Britain and America, it uses a variety of sources to construct a fresh view of the designer and his work.

Cristóbal Balenciaga arrived in Paris in the 1930s, when nationalism was an important issue in European politics. It was also becoming important in Parisian couture, since out of the total of 40 designers who practised as couturiers, the most prominent were foreign: Schiaparelli was Italian, Molyneux was Irish, Piguet was Swiss and Mainbocher was American.[2] Balenciaga, not surprisingly, became the 'Spaniard' in Paris almost immediately and benefited from the attention of the fashion press, which rallied to support him from 1938 onwards after only his second collection. Alluring captions ensued: 'Inspirations from Spain! Balenciaga is young, Spanish and new to Paris. His beautiful clothes have the warm, colourful drama of his country.'[3]

Balenciaga was one of the few foreign designers to remain in practice in Paris during the Second World War, and to follow up his initial success with his post-war collections. His reputation for leading fashion by several seasons grew as the 1940s and '50s passed. Allusions to the Spanish nature of his work, however, remained prominent in both the fashion and the trade press. For example, in November 1949 the trade journal *Silk and Rayon* reported on his autumn collection, remarking that this 'dextrous use of braiding' on a 'pale grey taffeta dress with loose side panels' revealed Balenciaga's Spanish blood.[4]

Not only was Balenciaga able to survive the war, he also maintained his position as one of the few Spaniards ever to attempt to infiltrate the Paris fashion scene. His contemporary Pedro Rodriguez, who had left Spain at about the same time as Balenciaga, went back home at the end of the Spanish Civil War in 1939. Antonio Canovas del Castillo, from the next generation, worked for the French house of Lanvin from 1950. His achievements gained recognition in the new composite name of the house, Lanvin-Castillo, and he figured in most fashion magazines of the 1950s and early 1960s. He became less prominent, however, after his

4. Ignacio Zuloaga, *Bullfighters in Turegano*. Oil on canvas, c.1915.
The spectacle of the bullfight drew the attention of many artists, both natives of Spain and foreigners. For Spaniards, it was part of their heritage, often scheduled into the annual calendar at particular times of year. In San Sebastian, the nearest cosmopolitan centre to the home towns of both Balenciaga (Guetaria) and the painter Zuloaga (Zumaia), the month of August was the main season for fighting. Spaniards from other provinces and many French tourists flooded into the city for these events. Zuloaga himself was so fond of the spectacle that he deliberately followed the trail of bullfights from one town to the next during the summer months.
Museo Zuloaga, Zumaia. © DACS 2007.

departure from Lanvin, and his own house, Castillo, survived for only four years (1964–8). Ironically, he retired in the same year as Balenciaga. Many of the characteristics noted in Balenciaga's work were also those of his compatriot: skill in the use of braiding and lace, and strident colour combinations.[5]

Thus, for 31 years between 1937 and 1968, Balenciaga was, to all intents and purposes, the only Spanish couturier in Paris. In 1973, a year after his death, his relationship with Spain was immortalized in Diana Vreeland's retrospective exhibition of his work at the Metropolitan Museum of Art in New York. She hung important works of Spanish art beside his garments and provided a backing of castanet music. In her autobiography she again insisted on his debt to Spain, writing: 'Balenciaga's inspiration came from the bullrings, the flamenco dancers, the loose blouses the fishermen wear, the cool of the cloisters.'[6] She was not the last to emphasize his Spanishness. As late as the 1990s, the House of Balenciaga was carrying on the tradition in its advertising of new products. The promotion of a new men's fragrance reinforced the message in 1990: 'Another couturier, another perfume, the third for Balenciaga, called quite simply "Balenciaga Pour Homme". A matte white bottle, topped with a turquoise and gold cap to bring back memories of sea and sun. Balenciaga, with Mediterranean (and Spanish) roots, acknowledged, famed and glorified!'[7]

Beyond the façade that saw no contradiction between Balenciaga's nationality and his obvious comfort in Parisian couture lie many questions. The following chapters focus on different aspects of Balenciaga's long and varied life: his background and his allegiance to Spain; the characteristics of his fashion design; the form and management of his business; the identity and loyalty of his clients; and finally, as a postscript, the survival and revival of the House of Balenciaga to the present day.

1

A SPANIARD IN PARIS

His voice was very low, and often you had to concentrate to hear it. His first name was Cristóbal. His inspiration came from the bullrings, the flamenco dancers, the loose blouses the fishermen wear, the cool of the cloisters . . . and he took these models and colors and, adapting them to his own tastes, literally dressed those who cared about such things for thirty years.[1]

Diana Vreeland

Prudence Glynn achieved the ultimate fashion journalist's coup in August 1971, some seven months after the funeral of the legendary French couturier Coco Chanel: she gained permission to interview Cristóbal Balenciaga. The Spanish couturier was the longest-lived contemporary, rival and friend of Chanel, and perhaps the most elusive yet pervasive influence on international fashion in post-war Paris.[2] *The Times* billed Glynn's article a 'World Exclusive', as befitted the first and only interview accorded by Balenciaga throughout his career.

Early on in her interview Glynn naturally approached the question of Balenciaga's avoidance of the press, eliciting two main reasons for his silence. First, he told her 'passionately' how impossible he found it to explain his *métier* to anyone. This first reason was particularly relevant by the date of the interview, since fashion design was undergoing a radical change. Explaining his *métier* before the youth explosion of the 1960s would have been simpler, and it would have delighted the receptive audience that avidly purchased the many biographies and autobiographies of old-style couture designers in the 1950s and early 1960s. Such publicity, however, would have involved Balenciaga in renouncing a certain amount of discretion – a fact that he highlighted as his second reason for avoiding the press. He felt a natural reticence about being drawn into discussion and, almost inevitably, into criticism of other designers. By 1971, though, some three years after Balenciaga's own retirement, interviews were less likely to receive acrimonious responses. By then, Paris – and the world – regarded Balenciaga as the 'grand old man of couture', whose influence was deeply felt, but who was no longer an active participant. Even in this one interview he managed to avoid criticizing his former rivals.

Interestingly, Balenciaga's silence rewarded him, since it led his contemporaries to concentrate on the perfection of his work rather than sniping at his personality or at the attention paid him by the press. Dior, his main rival in the post-war years, paid him this tribute:

5. **Cecil Beaton,** *Photograph of cerise flamenco-style evening dress,* **taken in 1971.** Designed by Balenciaga in February 1961, this evening dress makes reference to Spanish flamenco dress in its dramatic colour and its flounced skirt, but not in its straplessness. Both Spanish customers, such as the Marquesa de Llanzol, and foreign customers, such as Mrs Stavros Niarchos, to whom this dress belonged, chose this model. It required a certain confidence and presence to work to full advantage, and a social calendar that suited this kind of exuberance. Cecil Beaton, who initiated the first V&A exhibition on couture, took this photograph for the publication, *Fashion: An Anthology.*
V&A: T.26-1974. Courtesy of Sotheby's.

'Haute couture is like an orchestra, whose conductor is Balenciaga. We other couturiers are the musicians and we follow the directions he gives.'[3] Even Chanel, with whom Balenciaga quarrelled, acknowledged: 'Balenciaga alone is couturier in the truest sense of the word. Only he is capable of cutting material, assembling a creation and sewing it by hand. The others are simply fashion designers.'[4]

Other colleagues suggested further reasons for Balenciaga's silence. Percy Savage, who met him in the late 1940s and subsequently designed scarves and foulards for the house, mixed with Balenciaga socially and expressed the opinion that 'Balenciaga originally became a recluse because he had to work so hard. Then it was perceived to be rather a good ploy. This suited his Basque temperament – independent, determined, humourless.'[5] In conversation, Mr Savage went further, pointing out that the mystery surrounding Balenciaga, and his refusal to show his collections at the same time as the other couturiers after 1956, resulted in more, not less, press coverage. *Vogue* and *Harper's Bazaar* sent their journalists back to Paris to cover the collections at Givenchy and Balenciaga. All the other couturiers had to share an issue of each magazine in the month of the Chambre Syndicale de la Couture's carefully orchestrated shows. Balenciaga and Givenchy tended to figure all by themselves in the following month's issue. Thus, the two magazines sold extra copies, and the two couturiers won more than their fair share of editorial space. Anny Latour, author of a book on Parisian couture published in the late 1950s, confirmed the efficacy of this policy: 'The atmosphere of mystery which surrounds this Spanish individualist, the icy coldness with which every journalist is received, whether intentional or not, are just as effective as the loud beating of advertising drums.'[6]

Spanish Politics

While Balenciaga's silence may be attributed both to personal reticence and to calculated business practice, the timing of his arrival in France in 1937 may also have affected his attitude to the press. Spanish politics had been and continued to be in the European and American headlines for some years. The fall of the Spanish monarchy in 1931 was followed by the outbreak of the Spanish Civil War (1936–9), and the subsequent right-wing dictatorship of General Francisco Franco. This dictatorship was particularly repressive until the 1950s, and ended only with Franco's death in 1975. Censorship extended to all who overtly or covertly criticized the regime, and included Spaniards from all walks of life.[7]

Attitudes in Europe and America to Spain during and after the Civil War varied according to the political persuasion of particular states. Italy and Germany, both right-wing in their politics, supported Franco, while France, Britain and America unofficially contributed funds and volunteers to the International Brigade, which aided the Republican opposition. The end of the Civil War coincided with the beginning of the Second World War, during which Spain remained neutral, exhausted and devastated by internal strife. Initially, the rebuilding of the economy had to rely on scarce national resources. Not only was Europe at war until 1945, but the Allies imposed an economic and diplomatic boycott on Spain, and it was not until the 1950s that American financial loans fed economic growth. In other words, both ideology and war isolated Spain for some fifteen years, a fact on which French *Vogue* commented in 1951 in an early attempt to propose Spain as a holiday destination once more.[8] Only as the internal economic strategy changed and as America and Europe began to see advantages in a stronger and more internationally orientated Spain did Balenciaga's homeland begin to open up. In the 1950s Thomas Cook promoted the same cultural destinations as before the Civil War – San Sebastian in the Basque country, Madrid and Seville, while French *Vogue* thought the colourful events of Holy Week (*Semana Santa*) and the bullfighting season suitable fare for their readers.[9] In the 1960s Spain became the main tourist trap for northern Europeans, and the main provider of workers for the factories of northern Europe.[10] Its whole

MAKE IT SAN SEBASTIAN...

6. Advertisement of San Sebastian as a holiday resort. Thomas Cook promotional literature, 1936. This image dates from the period just before Balenciaga moved to Paris and shows British notions of Spanishness. Travel agents used British stereotypes of 'romantic' Spain to appeal to their audience; thus flamenco dancers featured in much of their literature even in that for the north, which was not the home of this type of dance or dress. Courtesy of Thomas Cook Archive.

7. Map of San Sebastian from Muirhead's *Northern Spain* (London, 1930). San Sebastian benefited from the destruction wrought during the Napoleonic Wars, being reconstructed into a fine modern city along a grid plan. The bay (La Concha) formed the focus for the many elite tourists who arrived there for the summer months, an esplanade affording access to the shopping streets. Avenida de la Libertad, where Balenciaga established and maintained business for 30 years, after being 'discovered' by the Marquesa de Casa Torres, is one of the two main boulevards that leads inland from the sea. Balenciaga's home was at Igueldo, a short distance from the city centre.

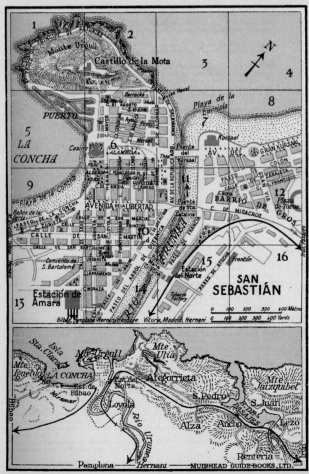

image abroad changed accordingly, an emphasis on the Costa Brava and Costa del Sol replacing the more traditional elite haunts of the north and south.

Spain was on the verge of bloody turmoil in 1935–6, when Balenciaga, a couturier whose business had already suffered as a result of the fall of the Spanish monarchy in 1931, decided to leave. He had lost his main clientele of the 1920s, the Spanish royal family and members of the court, who summered in San Sebastian and wintered in Madrid. His second branch in San Sebastian had to close not long after its opening in the early 1930s, and his house in Madrid seems to have closed during the Civil War.[11] Both Madrid and Barcelona were under siege from the early months of the war, while San Sebastian had fallen to Franco's forces by September 1936 and thereafter became the franquista capital of Spain, home to many supporters of the new order who were originally from Madrid and Catalonia. They helped the city develop its social and commercial structures.[12] Domestic unrest and uncertainty, as well as considerable deprivation and hardship, would not have improved Balenciaga's prospects. He departed for London, whence he continued to Paris. Madge Garland, fashion journalist and educator, suggests that he moved on because none of the court dressmakers or the large Oxford Street stores he approached offered him a job. Percy Savage, on the other hand, declares that he could not get a work permit to stay in Britain. Whatever the circumstances, Paris accepted him warmly and he established his business there in 1937, meeting with almost immediate success.[13]

The Nazi occupation of Paris in 1940 did not send Balenciaga back to Spain, probably because the Civil War there had created hardship. Such a move might also have meant the loss of the international clientele built up since his first collections of 1937 and 1938. The population of Spain in 1940 was relatively small considering the actual size of the country (some 25.9 million).[14] Only a tiny proportion of this number qualified as prospective customers of Balenciaga's business, possibly 2,000 women in

Madrid and the same in Barcelona.[15] In any case, whether he remained in France or not, his Spanish clientele was already a captive market.[16] On the insistence of the Marquesa de Casa Torres, his first patron, he reopened his houses in Spain; according to most accounts this was in 1939, although the only concrete evidence of his return suggests a date of late 1941 for Madrid and mid-1942 for Barcelona.[17] It seems likely that he was back in the Basque country well before this time, because he had a Spanish passport, which gave him freedom to move through Occupied and Free France into Spain; his family were there; and life in San Sebastian was already by late 1936 as it had been in preceding years. As a result, Balenciaga was able to clothe such Spanish women as the Spanish premier's wife, Doña Carmen Polo de Franco, Señora Satrústegui de Mata, the Condesa de Puebla del Maestre and the Marquesa de Llanzol throughout the Second World War. Although Spain was not active in the war, the Franco government basically supported the Germans.

The background to Balenciaga's move to Paris does not necessarily indicate his political persuasion. He apparently never voiced his views, although Spanish politics had obviously touched his life in the 1930s. Certainly, his devotion to his profession and his desire to see it prosper seem to have been of paramount importance. Once established in Paris, he was to command an international clientele accustomed to bi-annual visits to the French capital for the collections (even during the war, he had international clients who were resident in Paris for a variety of reasons: wealthy Spaniards still in exile, German officers' wives, and probably also the wives of French black marketers). Such people were most unlikely to abandon their visits to the houses of the experienced and high-class couturiers to follow a single Spanish designer to Spain. The only first-hand comment on Balenciaga's political inclinations comes from Percy Savage, who claims that Balenciaga was a monarchist.[18] This seems a logical assertion, considering the couturier's original professional contacts, his

aristocratic customers in Spain after the Civil War and his well-documented friendship with the Marquesa de Llanzol and Queen Fabiola of Belgium.

This résumé of the Spanish political and economic situation does suggest, however, that Balenciaga had a difficult tightrope to walk between the mid-1930s and the late 1950s. He was a Spaniard in Paris, with a largely American, French and British clientele. He also owned three couture houses in different parts of Spain. It was not politic to invite interrogation about his attitude to the Franco regime. Silence was one solution.

The Ambience of Paris

Paris also perhaps provided Balenciaga with the ideal environment for professional and personal development in a way that Spain did not. Balenciaga himself, looking back, stated in conversation with the fashion journalist Prudence Glynn: 'Paris used to have a special ambience for fashion because it contained hundreds of dedicated craftsmen making buttons and flowers and feathers and all the trimmings of luxe which could be found nowhere else.'[19] In the same interview, Balenciaga's secretary, Gérard Cueca, 'eyebrows properly raised at such barbarity', elaborated on the poor conditions outside Paris: 'When the Master went to New York once there was not a single hand-made rose to be found.' Balenciaga's reaction to Hitler's suggestion that French couture should be transferred to Berlin during the occupation of Paris was similarly incredulous. When confronted by 'six enormous Germans', Balenciaga 'said that he [Hitler] might just as well take all the bulls to Berlin and try to train bullfighters there'. Significantly, Balenciaga's analogy drew on an institution from his homeland.

The special ambience of Paris stemmed from more than the existence of hundreds of dedicated craftsmen, although they were part of a long tradition and an essential element in the success of French couture. From the government downwards, the French created favourable conditions to foster couture, which was regarded as an important national industry. Until the Wall Street Crash of 1929, fashion, or couture and its ancillary trades, was France's second largest export industry. A temporary decline to twenty-second place by 1939 was soon rectified, and in 1947 fashion had risen again to third place.[20] Government subsidies encouraged couturiers to use French textiles, thus promoting fabrics from well-established centres, such as Lyons.[21] In return, textile manufacturers produced short runs of rare fabrics just for the couturiers.[22] The Chambre Syndicale de la Couture Parisienne, the official body representing the couturiers, gave guidance on conditions of employment, provided training for prospective couturiers at its school, and organized the efficient coordination of the twice-yearly collections and their shows.

As a result of such nurturing, Paris was the uncontested Mecca of the international fashionable jet set until the 1950s. Thereafter, competition from Britain, Italy, America and Japan threatened its supremacy. Both private clients and commercial buyers made the trip to the Paris collections twice a year, in the knowledge that their programme had been carefully worked out in advance. They could fit in as many shows and couturiers as they wished in a short time, and be certain that they would miss nothing. After several years of making this pilgrimage to Paris as a young designer, and ten years working there, Balenciaga had assimilated this ambience completely. He chose to stay, nonetheless retaining his contact with Spain, and he evidently also travelled regularly to Switzerland, perhaps because of his firm friendship with the textile manufacturer Gustav Zumsteg.[23]

Once a Spaniard . . .

Balenciaga's links with Spain were both personal and professional, and contributed vitally to the Spanish themes in his fashion design. Outside Paris, Balenciaga's life centred on his family, who played a large part in his domestic and business affairs. His sister Agustina not only looked after his home in Igueldo in the Basque country, but also, from

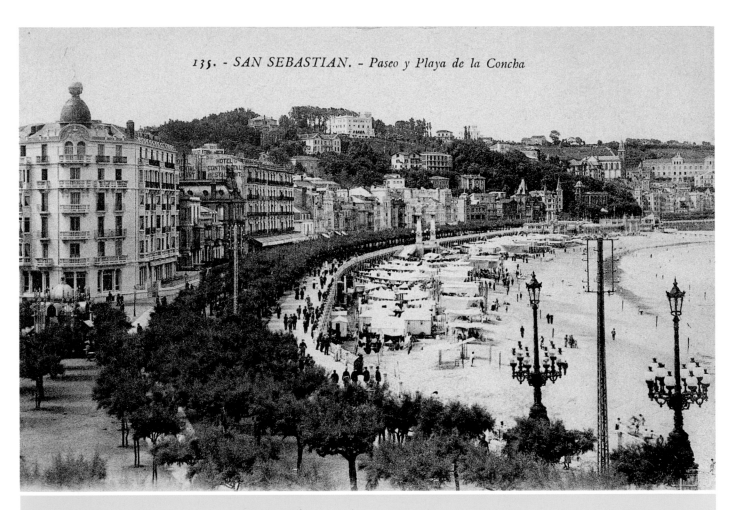

135. - SAN SEBASTIAN. - Paseo y Playa de la Concha

8. **View of the Paseo y Playa de la Concha, San Sebastian, early 20th-century.** This postcard shows the city at the time Balenciaga was first working there (around 1914). The harbour was some distance from the holiday beaches shown here and fully active. Impressive buildings, similar to those of neighbouring Biarritz, flanked the bay. It had gradually developed as a high-class resort from the 1860s, providing tourists with promenades, bathing amenities, a casino, bullfights, theatres and shops. Private collection.

1948 till her death, ran the couture house in Madrid. His nephew and godson José ran the business in Barcelona after its two-year refurbishment, and a nephew and a niece were in charge of the San Sebastian establishment by 1951.[24] Marie-Andrée Jouve suggests that the management of the San Sebastian branch was in the hands of the Crespo sisters in the late 1940s.[25] Elena Gurunchaga managed the house in Madrid in the 1930s, and Gloria Dorda had taken over by 1944.[26]

Even in Paris, Balenciaga had many Spanish contacts. He established his business at 10 Avenue Georges V in partnership with Vladzio Zawrorowski d'Attainville and Nicolas Bizcarrondo. D'Attainville, a Frenchman of Russian extraction, had an understanding of Spain, having worked with Balenciaga before accompanying him to Paris. Bizcarrondo, like Balenciaga, was a Spanish (Basque) émigré. Although the staff in Paris was mainly French, there was an injection of Spanish or Latin blood from time to time. After the death of d'Attainville in Madrid in 1948, a Spaniard, Ramón Esparza, joined the staff, taking over the designing of hats. Fernando Martínez Herreros arrived to help with designing other models, and drew many sketches to Balenciaga's specifications (many annotated in Spanish), whilst Salvador the tailor transferred from the house in Barcelona to work in Paris in 1948. Indeed, it is revealing that many of the principal positions were taken by Spanish speakers. Bettina Ballard, fashion editor of American *Vogue*, noted that much of the organization took place in Spanish. In February 1951 she observed Balenciaga taking leave of his colleagues at the Gare de Lyon: 'As the whistle blew, a figure stepped into the train calling a last stream of instructions in Spanish to someone on the platform',[27] and Pierre Ducharne remembered that during the ritual of selecting textiles, Balenciaga whispered to his associate in Spanish.[28] It seems that Balenciaga always found it easier to speak in his native tongue and retained certain elements of Spanish pronunciation when speaking French.[29] Salvador remembers how much more

comfortable he was with the tailoring workshop because he could express himself freely there, and this may be why promising up-and-coming talents, such as Ungaro, were sent to Madrid for several months of their training.[30] Janine Janet, the window-dresser, was disappointed that Balenciaga did not keep in touch regularly after his retirement, but knew that it was because he disliked writing in French. It is not surprising that he did not become completely acclimatized to Paris if he was able to consult with colleagues in Spanish on both sides of the French frontier.

Bettina Ballard was one of the few friends invited to Balenciaga's Spanish domain, where he relaxed after the stress and strain of creating his seasonal collections. By the end of his life he had three bases in Spain and two in France: his family base at Igueldo, three flats (one in Barcelona, one in Madrid and one in Paris) and an estate near Orléans. His final and elected resting place was the cemetery in Guetaria, the village of his birth. Bettina Ballard described the setting of Balenciaga's home, and his likes and dislikes. Struck by the Spanish quality of her surroundings after months in Paris, she remembered the kitchen where they ate after their train journey in February 1951: 'We set the massive, highly waxed table with beautiful Spanish silver, we ate strong Spanish food, drank strong Spanish red wine, and talked until we unwound our Paris tenseness and went off to our rooms to sleep.'[31] She was to find that Balenciaga retained the old custom of eating late, and simply – as Spaniards do, by French standards. Just as he never mastered the French language, he never changed his eating habits.

In this Spanish setting Ballard also identified other aspects of Balenciaga's character, such as his lack of sophistication in terms of the arts – although it must be remembered that she was not completely au fait with his every move:

The only sight-seeing trip he ever took was to Italy with the Spanish friend [presumably Bizcarrondo] and his wife who had provided the meagre financing for his first collection. They were knowledgeable, cultivated people who introduced him to the treasures of Italy, which left Balenciaga impressed but a little intimidated . . .

He knows little about his country or its art. I could never drag Cristóbal into the Prado with me, but . . . he has become a passionate antique hunter, and there is a collection of bronze Spanish keys, a collection of ivory *bilboquet* (a Spanish court game) that he has had for years . . . He spends much of his time while in Madrid antiquing in the Rastro (Madrid's Flea Market), piling up more and more pieces of furniture, antique Spanish rugs, and precious objects.[32]

Balenciaga had a passion for collecting black pearls, like his friend and compatriot Picasso.[33] He owned a substantial collection of costume and textiles, some 250 items of which are now housed in the Musée de la Mode et du Costume in Paris (Musée Galliera).

Much of Balenciaga's work contradicts Ballard's assumptions about his knowledge of native Spanish art, particularly of the seventeenth and eighteenth centuries. He was clearly familiar with Velázquez, Zurbarán and Goya – not surprisingly, given that his patron, the Marquesa de Casa Torres, had a fine collection, travel guides state that San Sebastian's main museum housed such Spanish artists, and he lived only a few miles along the coast from the museum devoted to the work and collection of his compatriot Ignacio Zuloaga (1870–1945).[34] Moreover, commissions for the theatre and for fancy dress required him to consult primary sources directly or through reproductions.[35] Perhaps, however, his knowledge of art was picked up from practical experience and curiosity rather than from formal book-learning or gallery visits in his youth. If it were based on personal untutored taste, then that might explain why some of his sources of inspiration were not immediately obvious to the non-Spaniard. Balenciaga preferred to collect those Spanish artefacts with which he was most familiar.

In Paris, his circle of acquaintances included a number of artists, many of whom he met in the house of Aimé and Marguerite Maeght, great patrons of modern art. They included Braque and Chagall, and his fellow Spaniards Picasso, Miró and Palazuelo. Photographs of Balenciaga's Paris flat reveal the presence of many large books, some possibly containing the fashion plates he collected, and also a few paintings. He enjoyed seascapes, and his Braque painting was of a grey sea with a small fishing boat, evocative of the Cantabrian coast, its inclement climate and Balenciaga's own roots.

Family Background

In the context of Balenciaga's untutored knowledge of the arts, his family background is relevant. It was relatively modest, but not indigent. He was brought up in a seafaring community; his father was a fisherman and also intermittently mayor of Guetaria until his death, when Balenciaga was only eleven years old. His mother, the young widow Martina Eisaguirre, supported her family of three through her work as a seamstress, including work undertaken for families on vacation in the vicinity. Her earliest surviving bill dates from the year of her husband's demise.[36] Her occupation perhaps explains her younger son's passion for sewing and his careful preservation of her sewing machine, as well as his meeting with his future patron. Having completed his obligatory elementary schooling Balenciaga began an apprenticeship as a tailor at the age of twelve. He had the basics of reading, writing, arithmetic and catechism under his belt, but it is unlikely that he had any formal tuition in art or art appreciation.[37]

Although Balenciaga's birthplace, Guetaria in the Basque province of Guipúzcoa, may not have provided immediate access to academic study, it did boast remarkable contact with a sophisticated world of international chic. It was a small seaside village with a population of approximately 1,300 in 1897, just two years after Balenciaga's birth. Located in a province whose inhabitants depended largely on traditional industries (textiles, paper, food and construction) for their livelihood, it relied on fishing and fishing-related industries – as it still did in the late 1950s, having grown slightly, and as it still does today.[38] Nonetheless, by the end of the nineteenth century the beauty of the coastline was attracting visitors and offering new employment opportunities. These visitors

9. **Juan Gyenes, *The Dining Room at Balenciaga's Home in Igueldo, Spain.*** The simplicity and austerity of the dining room with its low ceilings at Balenciaga's home in Igueldo contrasts with the sophistication of the Avenue Marceau. Bettina Ballard described eating in this room in Igueldo, noting the highly polished surface of the table and its decoration with heavy Spanish silver.
Biblioteca Nacional de España, Madrid.

10. **Juan Gyenes, *Balenciaga's Bedroom at Home in Igueldo, Spain.*** Rather more cluttered than Balenciaga's immaculate dining room, the bedroom was evidently a sanctuary, with objects of particular significance to its inhabitant: his mother's sewing machine and a painted wooden crucifix, flanked by two figures of saints or apostles.
Biblioteca Nacional de España, Madrid.

included many wealthy Spanish families, including the royal family, who contributed to the transformation of San Sebastian into a holiday spa town along the lines of Biarritz. One such family that had its roots in Guetaria was the family of Balenciaga's future patron, the Marquesa de Casa Torres, the family mansion dominating the village and sea from its hillside location. In the year of Balenciaga's birth, the church of San Salvador in Guetaria became a National Monument, thus putting it on the map for culturally inclined tourists. By the early 1920s it was a recommended destination on trips along the coast, being on a route that ran through Zarauz, a rapidly expanding holiday village, to Zumaya, where the painter Zuloaga opened his personal art collection as a museum in 1921, and thus to Deva.[39]

San Sebastian was the nearest large town to Guetaria with a still modest population of about 36,000 in 1897, which had risen to 113,000 by 1950.[40] It increasingly prided itself on its upmarket shops, hotels and entertainment, and when the royal family rebuilt the palace of Miramar in 1893, it became the official holiday resort for the court, with more than 116,000 outsiders arriving in the city in the summer months by 1900. While the city languished briefly after the fall of the monarchy, the imposition of a ban on betting under the Republic, the beginning of the First World War and then the Spanish Civil War, it flourished as virtual capital of Spain from late 1936, and after the war became the official summer residence of the Franco Government.[41] The town was used to an influx of tourists of different nationalities and social classes in the summer months (from June to October) throughout Balenciaga's life – French, British, Argentinian and Spanish (mainly from neighbouring provinces and Castile). Its proximity to France explains the presence of numerous French consumers – and even French shopkeepers, some of whom had seasonal businesses in the city. In 1913 it was only 20 minutes from the French border by train, and 11 hours from Paris; in other words, it was three hours closer to the French than to the Spanish capital.[42] Not surprisingly, therefore,

the Parisian department stores Au Louvre and Au Printemps were happy to advertise the presence of their Spanish 'branch' in travel guides and newspapers of the period, and some clothing suppliers used Castilian and French or English in their advertisements in the press.[43] Balenciaga's first apprenticeship was with Au Louvre, which provided him with further insights into French fashion and its practices. British tourists came by sea or rail, and they too found it to their taste both before and after the European disasters of 1936 and 1945. The travel agents Thomas Cook promoted the city consistently before and after the wars, as an up-market holiday resort, expensive in comparison with new destinations in the Balearics. It was accessible by sea from Southampton or Dieppe, or overland.[44]

The physical beauty, climate and leisure amenities of San Sebastian account for its popularity. One British guidebook of 1928 described it thus:

San Sebastian is a charming place, combining sea, mountains and town. The bathing is the best, and the Casino in the summer months, when the Court is in residence, provides a varied programme of entertainments. In fact one finds at San Sebastian first-class hotels, handsome shops, and the luxury of a great Riviera resort, with the added attraction of the charm and grace of the Basques, and facilities for studying some of the manners, customs and *cosas d'España* . . . The whole town meets in the evening, about seven, to stroll up and down the Alameda or promenade.[45]

This Basque environment of traditional craft skills, developing luxury consumption and international socializing informed Balenciaga's development. His family made their living from traditional crafts, and benefited from the holiday trade: his mother even undertook sewing tasks for the Spanish aristocracy who shopped in Paris.[46] Balenciaga was in a position to learn to appreciate international chic, good clothes and commercial success, and to learn the skills that enhanced them. He also had immediate access to patronage.

His appreciation of art was similarly formed. In all parts of Spain, painting and sculpture are

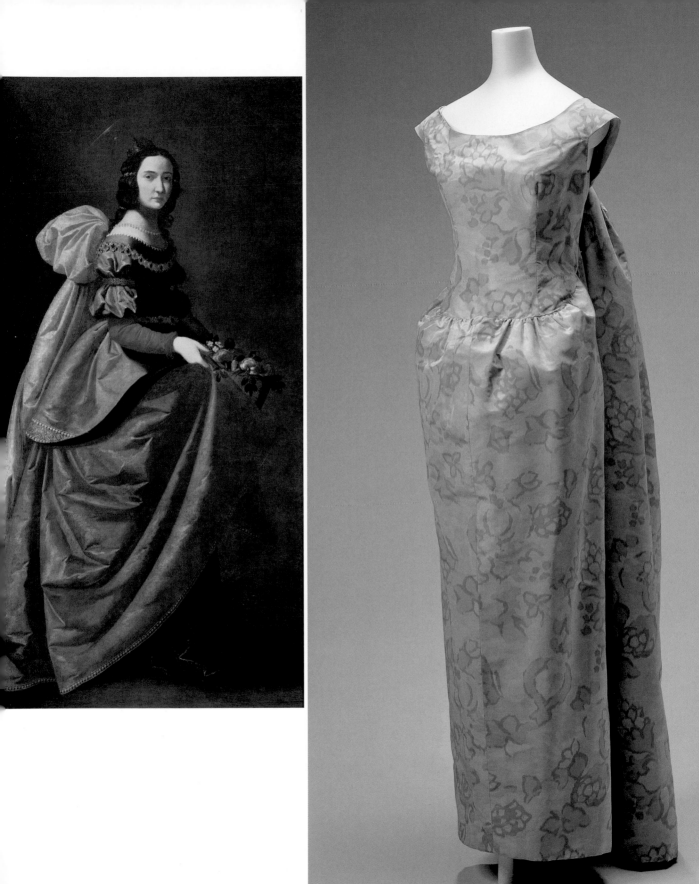

accessible to everyone in the churches and in the streets — as well as in art galleries and museums. Immense Baroque churches dwarf the tiniest villages, and their interiors often contain elaborate chapels and overpowering altarpieces. Even when the interior is fairly austere, images or paintings of the saints and the Virgin Mary abound. Some of the images wear expensive and highly decorative textiles, silks with metallic threads, very fine linens and laces. The altars are sometimes decked in similarly immaculate and well-laundered fabrics. The whole setting is heavy, dark and intricate. The clergy who inhabit this world habitually wear black, yet dress splendidly for Mass, adopting different colours according to the liturgical calendar — white, black, purple, green. Balenciaga grew up in this atmosphere and later introduced it to friends like Bettina Ballard. As an outsider, she noted the combination of sobriety and grandeur as Balenciaga drove her south from San Sebastian to Madrid. They passed though Burgos, stopping to appreciate the cathedral:

The wind sang in Burgos; only the cathedral had a warmth – not a physical warmth, but a hot sort of grandeur from the very number of purple and red-clad high clergy promenading under the stone protection of this most Catholic of Catholic cathedrals, as if they were in exile together.[47]

The church in Guetaria was the antithesis of the elaborate gilded cathedrals. According to Pauline de Rothschild, it was too big for the town, set at the opposite end of the main street from the seafront. Inside the church the most prominent image was of pain, Our Lady of Sorrows, enveloped in a long black hooded cloak relieved only by the brilliance of the seven silver swords planted in her heart. The atmosphere was very different from the grandeur of Burgos – a clue to its former altar server's sobriety.

Often the press invoked the 'shadow of the Spanish Inquisition' as a suitable image for the austere and unsmiling atmosphere of the House of Balenciaga.[48] The imagery is dramatic, exaggerated to appeal to the popular imagination and to preconceptions and

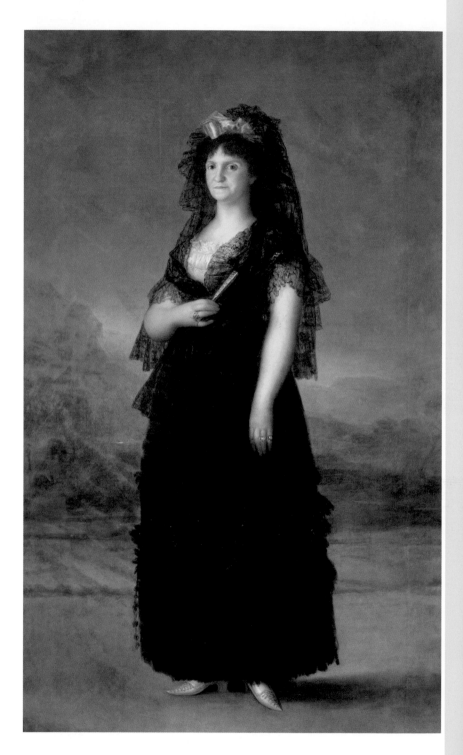

13. (LEFT) **Agustin Esteve y Marqués (after Francisco de Goya y Lucientes),** *Queen María Luisa in a Mantilla,* **oil on canvas, 1798–9.** The queen wears a dress of black lace, with a mantilla attached to a comb in her hair. The aristocracy had adopted this form of female dress from Andalusia in the south at the end of the 18th century as a sign of 'national' identity. Balenciaga was clearly familiar with the work of Goya, one of Spain's ubiquitous painters who had spent the end of his life in France. He created many different versions of black lace or transparent overdresses whose airiness was thrown into relief by a pale pink underdress or accessory.
Museo del Prado, Madrid.

14. (RIGHT) **Black and white cocktail dress of lace, 1956 and detail.** This dress comprises an under- and over-dress, both of which are made up of two layers of material: the first of black lining covered in black net, and the second of fine black organza covered with machine-made lace. The underdress has flesh-coloured straps which would not have been visible through the upper layer, its zip is sewn into the opposite side from that on the over-dress so that they do not cause unnecessary bulk or rub against each other. The lace of the overdress is white, the black being applied afterwards (printed or painted on). Its motif shows pastoral scenes reminiscent of the subject matter of Goya's late eighteenth-century cartoons for the Royal Tapestry Manufactures in Madrid. The dress was made in San Sebastian in 1956. While the design conforms to that of the model made in lace by Brivet in Paris in the same year, the lace is different and may well have been made in Spain.
Private Collection. Photo: Mike Halliwell.

stereotypes of Spain. Certainly, Balenciaga seems to have been a practising Catholic all his life, as well as a man with a vocation of his own. An enormous polychrome crucifix flanked by Our Lady and St John dominated his bedroom at Igueldo. According to his parish priest, confessor and friend Father Robert Pieplu, he was a 'haunted man: haunted by a great plan, a vision of the world and of the individual, and by a conception of his work'.[49] The designer Courrèges remembers the sound of the opening and closing of Balenciaga's office door at least once a day, as he left the atelier to go and pray in the church in the Avenue Marceau.[50] Balenciaga's active participation in the church services at Igueldo, his Spanish residence in the Basque country, extended to him making at least one soutane for the parish priest.[51] He also made a costume for a statue of St Roseline for a chapel in Haute-Provence on behalf of his friend Marguerite Maeght, and donated a Romano-Spanish figure of Christ, dating from the twelfth century, to the Maeght Foundation.[52] He thus used his own talents as couturier and antique collector in the interests of the Church, contributing to the religious art that he knew and revered. On a more anecdotal level, Balenciaga himself recounted with humour the story of his desire to meet Coco Chanel, renowned in her day as a 'scarlet woman'. His parish priest, he confided, warned him against such a meeting. He ignored the warning.[53]

A quasi-religious atmosphere permeated Balenciaga's workplace, as Ballard reported: 'The couture house on the Avenue Georges V has something of a convent atmosphere to it, presided over by Mademoiselle Renée, the directress, as the mother superior.'[54] Courrèges described the workshop as 'pure white, unornamented, and intensely silent. People whispered and walked on tiptoe, and even the clients talked in hushed voices'.[55] Percy Savage remembered:

He was, he was not very jovial, I mean he was a very, very quiet . . . Yes, he was rather stern, and rather monkish. And he always at the fashion house, he always wore a white smock. And he would hardly ever see any of the private clients,

they would just deal with the salesladies. He would see the private clients at dinner parties that he might give, or he might be invited to, as I said, the Spanish cultural attaché invited Balenciaga to that supper, where there were half a dozen different Spanish ladies or half a dozen different South American ladies and their husbands or boyfriends, but he would meet them there, but he wouldn't necessarily ever have anything to do with trying to sell them a dress. That wasn't his job. He just designed and made the clothes. And he himself was a master tailor, he could cut and sew impeccably.[56]

From photographs it is evident that the redesigned shop, opened in Paris in 1948, was more elaborate, but no less daunting, than the workrooms. Heavy red Spanish leather chairs with high, uncompromising backs, dark wooden tables and cabinets, gilded wall sconces and chandeliers, and a black and white tiled floor with the relief of an occasional Spanish rug, all conspired to give a taste of Spain within a quintessentially French building (see Chapter Four). Even the lift, remembered by all who ascended to the salon, was intimidating; in Alison Adburgham's words it was: 'Very austere. One was taken up (from the black and white tiled entrance with its heavy Spanish marble-top tables) in a very slow-moving lift which was lined with red leather, studded like a Victorian armchair.'[57] In fact, Bellos had taken the design from an eighteenth-century sedan chair.[58]

According to Ballard, all Balenciaga's homes were also 'simple, almost austere'.[59] Certainly, photographs of the house at Igueldo confirm such statements. The walls were white and relatively devoid of paintings. The few there were had heavy gilt frames. Again the furniture was of dark wood. Balenciaga's preference for three-dimensional artefacts is evident in the wrought-iron and silver candlesticks, and in heavy polychrome religious images. In contrast, his French dwellings and the couture salon on the first floor of 10 Avenue Georges V were totally French in taste. In short, his choice of surroundings was as ambiguous as his work. He assimilated both French and Spanish aesthetic models.

15. Midnight-blue cocktail dress of silk faille with soutache embroidery, 1953. The decorative three-dimensional embroidery is reminiscent of the embroidery of festive Spanish dress, an influence seen throughout Balenciaga's work. The shirtwaister dress has three-quarter-length sleeves, a stand-up collar and a tie belt. The skirt is gathered into the waistband. Only the front of the skirt is embroidered so that the wearer suffered no discomfort when seated and did not crush this exquisite craftsmanship. It belonged to Mrs Elizabeth Firestone (of Firestone tyres), one of Balenciaga's best clients, who was in the privileged position of being able to negotiate changes in styles with the couturier. She tended to choose blue, a colour that matched her eyes. Courtesy of Francesca Galloway.

Cecil Beaton, the society photographer, noted Balenciaga's pessimism: 'Behind his casual remarks about women, fashion and the modern world, one senses a firm but vital thread of pessimism. This may, indeed, be the basis of Balenciaga's unique creative abilities. For that which is rooted in pessimism can never die.'[60] Balenciaga's pessimism and religious devotion may also have led to the impression that he was humourless. Journalists and friends had differing views of his humour. Fernando Martínez Herreros indicated that he was a smiling man, but that his mood could change rapidly and that he was a hard taskmaster. Prudence Glynn was surprised to find how funny Balenciaga was, how readily he told stories against himself and how his eyes twinkled with spirit. His creations themselves, whilst often grand, reveal a quirky, sometimes grim, sense of humour. Nonetheless, as is apparent from a number of sources, he was a man dedicated to hard work, a serious figure to most. As the gradual evolution of his line and his ability to swim against the tide indicate, he was a man of great determination and independence.

This brief assessment of Balenciaga's Basque background highlights his continued debt to his native land and its traditions, and his awareness from an early age of a world beyond. His adjustment to Paris was perhaps not as radical as some writers have implied, and certainly did not mean a complete break with Spain, nor did it change his obsession with hard work or his progress in his chosen profession. In fact, his adaptability to new situations and his awareness of the age went hand in hand with the gradual development of his designs. The Basque country was not his only source of inspiration, nor was Spain itself. As 'The Universal Basque', Balenciaga looked far and wide in time and space.[61] In this exploration of different cultures, he followed the tradition set by Juan del Cano, the sixteenth-century explorer whose statue dominates the village of Guetaria. Both men benefited from the position of their home on the northern seaboard of the Iberian Peninsula. They looked outwards from Spain, towards the riches of the Americas and of northern Europe.

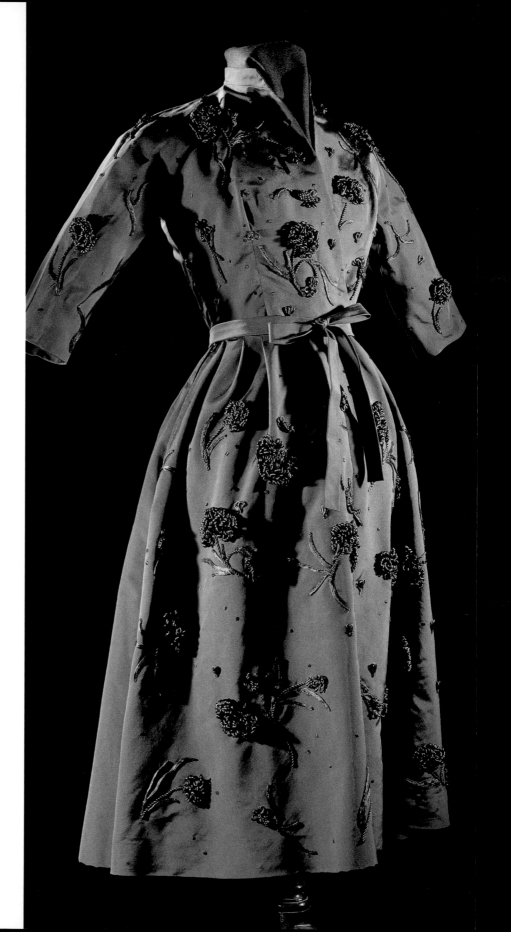

2

FROM CLOTH TO COLLECTIONS

The style of the Spanish couturier is that of a closed universe, without apparent connection with everyday life, without even much regard for Parisian forms and faces. It keeps always a little ahead of the prevailing fashion . . . From one collection to another, Balenciaga seems to be standing still. Each time, as you recognise and rediscover the continuity of his style, it is so impressive that at first you forget to look at what had changed. But he is sure to have advanced.[1] Celia Bertin

The task of the couturier, according to Balenciaga, was multi-faceted and required a range of skills. He often repeated to Gustav Zumsteg, the Swiss textile manufacturer, that a good couturier had to be an architect, a sculptor, a painter, a musician and a philosopher all rolled into one. Otherwise he would be unable to deal with the different problems of planning, form, colour, harmony and proportion.[2] In his own practice, Balenciaga involved himself in every aspect of his profession, producing sketches, choosing, cutting and sewing fabric, matching accessories, supervising the successful completion of every collection, and even training his live clothes-horses, the house mannequins. He insisted on perfection in proportion, fit, finish and presentation, and was not averse to unpicking and re-making garments that did not meet his exacting standards. The result of Balenciaga's immersion in every aspect of the design process was a gradual development of his line, rather than rapidly changing, headline-catching seasonal novelties. Over the period of thirty years in Paris, he pared away superfluous detail and achieved simple sculptural form. He moved from traditional nineteenth-century construction techniques to innovation and experimentation, reaching new heights with his one-seam coat of 1961 and the gazar wedding and evening dresses of 1967–8.[3] Both were based on clever cutting, minimal seaming and darting. Many innovations depended on textile technology, and as the early limp synthetics gave way to firm but suppler new fabrics, Balenciaga's designs altered. His work is stronger in the more substantial materials than in soft, floating, romantic chiffons and silks, perhaps because of his training in tailoring. Throughout his career, despite gradual change, certain features in his designs remained constant – his debt to French couture, English tailoring, Spanish regional dress, historic costume and ecclesiastical vestments. This chapter captures the principal developments in the evolution of his design through the innovations that fashion journalists appreciated, and then relates his fashion philosophy and

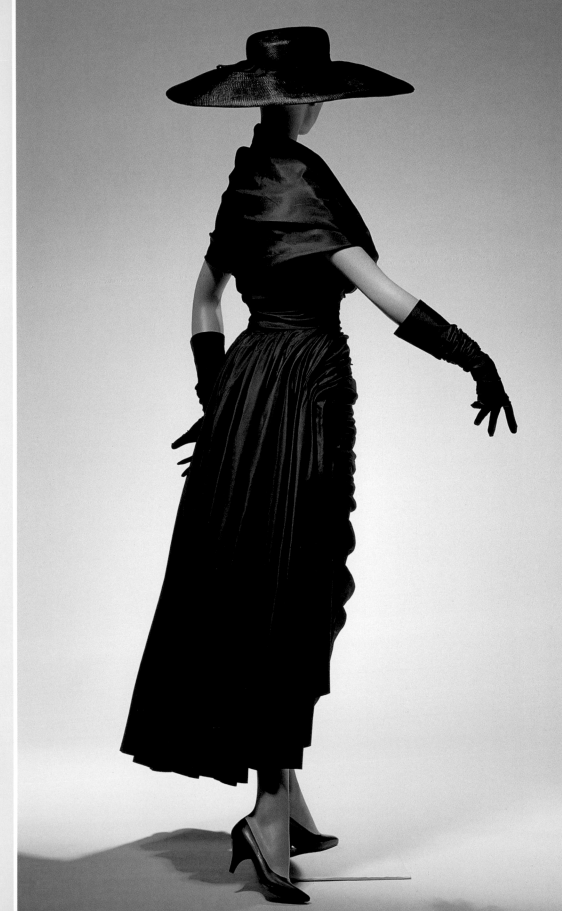

16. **Black silk cocktail dress, autumn–winter 1948.** This cocktail dress demonstrates Balenciaga's adherence to traditional forms of dress in the immediate post-war period, akin to Dior's 'corolle' line. Its line is based on the hourglass shape, with a corseted base that emphasized the bust, waist and hips. The skirt falls to below calf-length, a post-war reversion to pre-war extravagance in the use of material. This model was evidently popular with journalists, since it appeared in a now-famous sketch by Eric in British *Vogue* in November 1948 (56).
Courtesy of Kyoto Costume Institute, Tokyo, photo by Taishi Hirokawa.

design sources to this output. It does not chart collection by collection the gradual evolution or the extent of his œuvre.[4]

The Evolution of Line

Fashion journalists have the knack of reducing collections of more than 200 garments to a few highlights, styles considered revolutionary or saleable. They thought Balenciaga important but often found him difficult to classify, since his styles did not change radically from season to season, nor did he provide snappy names for them. In general, his dramatic colour combinations and textural effects attracted attention. In the late 1930s, and throughout the Second World War, his clothes show very similar characteristics to those of his contemporaries. For daywear the smart tailored suits and coats of his early collections, with their square shoulders and nipped-in waists, were in line with current styles, as were his full-skirted evening dresses, revivals from the Second Empire in France (1852–70), and his slinkier body-hugging models.

During and immediately after the war, Balenciaga continued to design classic daywear and striking evening attire, despite the Nazi occupation of Paris and restrictions on the use of fabrics and trimmings.[5] Photographs of his designs reveal practical tailored suits, square-shouldered, fitted at the waist, and skirts to just below the knee. The detail and differentiation resided in buttons and trimmings, contrasting sashes or belts. The shoulder line began to relax into a more sloping shape only from 1946–7, and his skirts began to lengthen at about the same date. The styles of the late 1940s presaged the division of Parisian couture into two camps in the 1950s. The first camp believed in the season-by-season lines of Dior, with their emphasis on moulding women's bodies into strange geometric shapes, defined by ever changing corsetry, to produce such lines as the Oblique (1950), the Tulip (1953) and the Spindle (1957). This camp was governed by increasing commercialism, a post-war development caused by the speed at which new technology enabled ready-to-wear

manufacturers to copy couture models. The second camp, epitomized by the day clothes of Chanel and Balenciaga, was happier to develop lines gradually and create classical, timeless models. Their clothes were easier to wear, moving with the body rather than dictating unnatural movement. The evening dress of these designers, however, often belied the more practical nature of their day dress and contradicted the notion that the two camps were totally separate. Balenciaga strove for comfort in his day clothes but gave rein to his imagination when designing evening dresses, quite happily using internal corseting and firm petticoats, and encrusting them with three-dimensional surface decoration.

Because Balenciaga did not introduce a new named line each season like Dior, the press had to invent their own suitably evocative names, and this they did every two or three years from the late 1940s. In 1947 Balenciaga provided the major competition for Dior's 'corolle' line, which assumed equal importance in magazine copy for the February collections. Later, the 'corolle' line appeared to have been unchallenged, but Balenciaga had questioned its supremacy at the time. In fact, *Harper's Bazaar* considered his sac or barrel-line jacket, loose and unfitted at the waist and touching the body all round only at the hem, to be more innovative than the 'long, nip-waisted, round-hipped jacket' launched in earlier collections by Balenciaga himself and then championed by Dior.[6] Although Balenciaga introduced the sac jacket, he did not renounce the fitted jacket completely, and his collections showed examples of both styles into the 1950s. Many of his suits had close-fitting, tight-waisted jackets with deep basques below the waist and were worn over increasingly long skirts from 1947 until 1951 or 1952. The cocoon-shaped jacket with full back that curved into the front opening (February 1947) and the box jacket of October 1949 followed the same principle. They were three-quarter-length casual jackets with a loose-fitting body, and heralded Balenciaga's major innovations of the 1950s: the middy line of 1951, the tunic line of 1955,

17. (RIGHT) Henry Clarke, barrel-line suit, *Album du Figaro* (1950). The barrel line that first made its appearance in 1947 continued to play a part in Balenciaga's collections for the next twelve years. This early example dates from autumn–winter 1950 and was described simply as: 'Balenciaga. The barrel line. Suit in cloth by H. Moreau'. Moreau was a consistent supplier of fine woollens to the couturier after the war. Courtesy of Henry Clarke, Coll. Musée Galliera, Paris, ADAGP, Paris and DACS 2007.

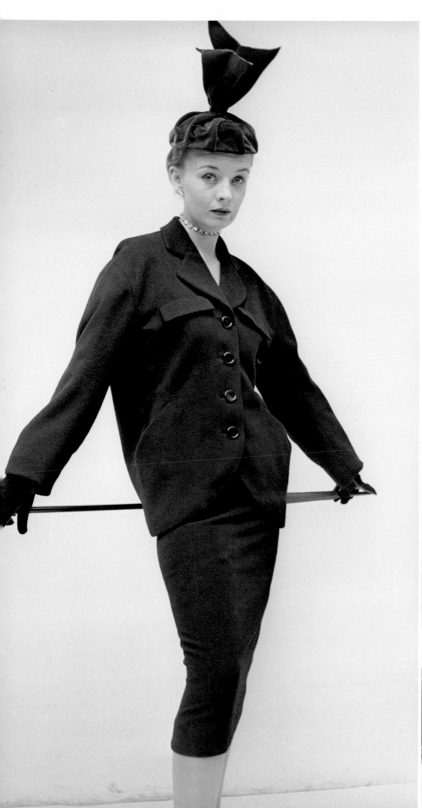

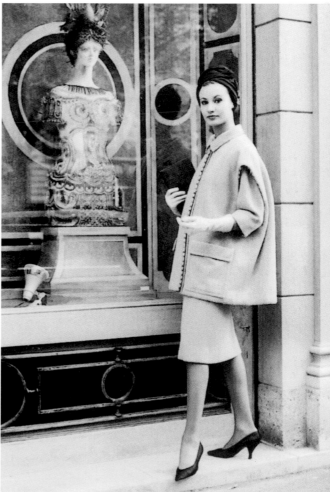

18. **Seeberger, photograph of suit posed outside 10 Avenue Georges V, autumn–winter 1962.** The loose-fitting back of this coat and its easy fit reveal how Baleniaga had developed his ideas from the barrel-line in the late 1940s and early 1950s, through the tunic and sac of the mid-1950s. This style has an almost Japanese feel in the construction of the shoulder and sleeve, which can be related to the Kabuki coat of the mid-1950s.
Bibliothèque Nationale de France.

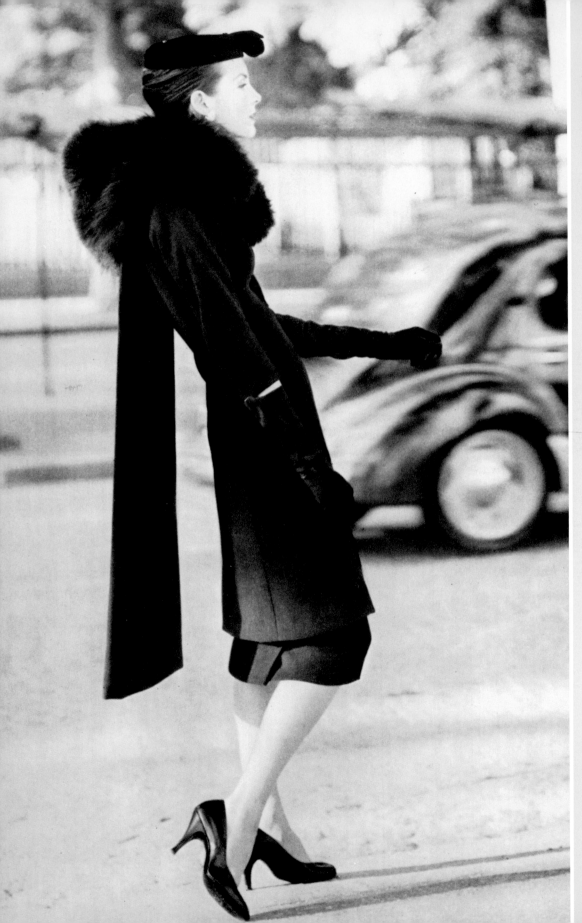

19. (LEFT) **Henry Clarke, tunic in black wool, French *Vogue*, (September 1955).** The tunic continued into autumn–winter 1955, this iconic photograph bearing testimony to an urbane manifestation with a large fox-fur collar. The caption in the magazine emphasizes that urbanity and superiority through reference to the vehicular equivalent to a Balenciaga outfit: 'The interest is situated in the back: from the large fox-fur collar a floating panel hangs. The narrow tunic is worn long over a straight skirt. Car: Mercedes-Benz 300 S.L.'
Courtesy of Clarke/*Vogue* © 1955 Condé Nast Publications Inc.

20. (RIGHT) **Henry Clarke, tunic in bright red linen, French *Vogue* (April 1955).** The tunic line made its debut in the spring–summer of 1955 in summer-weight fabrics. In the magazine the tunic was described thus: 'Balenciaga. In bright red linen, crossover and buttoning behind, a tunic that is plain in front. The skirt also crosses over giving unity to the light of the back. Bracelet and earrings in fine pearls and diamonds by Van Cleef & Arpels. Lips: "Bravo" by Revlon.' The slim outline with blousing at the small of the back and the three-quarter-length sleeves were typical of the style.
Courtesy of Henry Clarke, Coll. Musée Galliera, Paris, ADAGP, Paris and DACS 2007.

the sack or chemise of 1957 and the Empire line
of 1958. A quite clear progression is evident in
the development from one line to the next.
These styles all represented a departure from the
traditional emphasis on the waist. Instead of
indenting the female form at that level, they
shifted the focus to hip level in the case of the
middy, and bust level in the case of the Empire
line. The tunic and the sack eradicated the
waist altogether, recalling earlier tubular lines
from the 1920s, when Balenciaga was young.

The reaction of British fashion writers to the
tunic was instant. It delighted Jean Guest of
Draper's Record, who saw Balenciaga's collection
of August 1955 as a retention of 'the most
beautiful and austere line he launched last
season, but varied and loosened up a little'.[7]
However, it distressed immeasurably Jill Craigie
of the *Evening Standard*. To change the line so
dramatically from a tiny waist and wide skirt
was incomprehensible and required a quick
survey of some of the most influential fashion
personalities in London to establish their
reactions. She was mollified to find that only
Mrs Newton Sharp, Harrods' News Editor and
fashion consultant, was going to be tempted
into the latest fashion.[8] Nonetheless, the tunic
was adopted impressively quickly. *Vogue*'s
pattern book for October/November 1955
devoted a whole six pages to it and its
multifarious forms, a most unusual amount of
coverage for any new style.

By the end of the 1950s Balenciaga's suits
had developed into a number of shapes, some
with long bodies, others with short bodies; some
with fitted jackets, others with loose bloused
backs; some with full-length sleeves, others with
three-quarter or seven-eighths sleeves. Their
skirts by this time were usually slim-fitting, and
through the 1960s they lingered below the knee
or rose above it according to fashion and to the
age of the wearer. *Draper's Record* noted in
August 1950 that Balenciaga had won universal
recognition for his collection and that his
clothes were 'for those who wish to be not just
two, but three jumps ahead'.[9] At the end of the
decade, in July 1958, the *Daily Express*,
commenting on the impact of the Empire line

on fashion, pointed out that it had begun with Balenciaga's collection of the previous season: 'And it's the same old story. What is good enough for Balenciaga, is good enough for most of the other French designers.'[10] This was the year in which he received the Légion d'honneur, France's highest honour, for his services to the fashion industry.

In the 1960s Balenciaga's styles were on the whole a refinement of those introduced in the previous three decades. The innovation lay in their use of new materials, both synthetic and natural. New to Paris couture at the end of the 1950s was a range of mohair and mohair and synthetic mixes, launched by the textile converter Zika Ascher. In the British press, they caused uproar from as early as 1957, and Balenciaga was among the first to use them. His collections of February and October 1957 featured light, fluffy, high-waisted mohair dresses. American *Vogue* described a pink mohair dress as 'almost the equivalent of bubble bath in froth, in imperceptible warmth'.[11] In November 1964 Balenciaga hit the cover of

French *Vogue* in a coat of 'Papacha'. This fabric was a hand-tufted mohair and wool mix, very lightweight but bulky. On the surface it appears to comprise three different colours, but in fact each tuft is composed of at least two to three different colours of mohair yarns: the green tuft comprises light and mid-green yarns; the black tuft consists of black, deep pink and deep blue; the bright pink tuft comprises deep and mid-pink; the pale tuft is made of pale pink and white. Teamed with a black hat with a cockleshell and a white feather, it recalled the iconography of pilgrimage.[12] Whilst the mohairs of the late 1950s had been fine and easy to cut into dresses as well as coats, the bulkiness of 'Papacha' dictated a very simple tapering cut, as photographs in the Archives Balenciaga reveal. To a certain extent, in its bulkiness 'Papacha' was similar to some of the harsher synthetic mixes of the 1960s. Balenciaga even tried the rather less glamorous bonded fake fur fabrics, one of which survives in the collection of the Musée de la Mode et du Costume (Galliera). It is a cream-coloured mini coat in a hairy bonded fabric reminiscent of fake sheepskin rugs. It is tough and tubular and avoids the problem of buttonholes by fastening with gold clasps down the front. The neck is round and collarless.[13]

Balenciaga investigated the joys of wool and wool substitutes for daywear, as suited the etiquette of the era. He was equally punctilious in his attention to cocktail and evening wear. Luxury was evidently the hallmark of his collections, as *L'Officiel* commented, after the winter collection of 1938: 'the use of marvellous materials has created the atmosphere of luxury which makes its mark with Balenciaga. Among these we may quote: velvet in profusion, faille, lace and tulle, moiré, damasks, lames, satins.'[14] His little black dresses also aroused interest and were amongst the best of their type, according to *Harper's Bazaar*:

... at the new Spanish house, Balenciaga ... the black is so black that it hits you like a blow. Thick Spanish black, almost velvety, a night without stars, which makes the ordinary black seem almost grey ... Only Spanish and Italian women take naturally to black. This Spanish

21. House photograph of coat of 'Papacha', winter 1964, model no. 150. Balenciaga's in-house documentation photograph of the coat made from 'Papacha', a hand-tufted mohair from Zika Ascher, reveals the simplicity of style that the exuberant fabric demanded. No unnecessary seaming is used, the coat being t-shaped without collar or cuffs. Simple dark accessories disappear into the mass of colour. The textile is at once sophisticated and unruly, reminiscent of unkempt rags.
Courtesy of Archives Balenciaga, Paris.

22. Helmut Lang, French *Vogue* (November 1964). The choice of this model for the front cover of *Vogue* suggests its importance to the fashion cognoscenti. Helmut Lang used a mannequin external to the house for this cover despite Balenciaga's preference for his own house mannequins. His shot focuses on the textile rather than the garment, offering no hint of the cut or construction.
© *Vogue* Paris. The Helmut Newton Estate / Maconochie Photography

23. Sample of 'Papacha', developed by Zika Ascher and Balenciaga, 1964. This chunky tufted mohair sample (in shades of black, pink, green and cream) comes from the archive of Zika Ascher who was based in London after the annexation of Czechoslovakia. Ascher developed a range of different fabrics for use at the top end of the market, and had very close working relationships with a number of the French and British couturiers active in the 1950s and '60s. This fabric was the result of collaboration between textile manufacturer and fashion designer. The base textile is an open plain weave, made up with bouclé mohair yarn (the warp in light green and the weft in fawn). The tufts are large and at first sight single colour, but they are, in fact, made up of two to three different colours of mohair yarns.
V&A: T.219-1988.

6 F
NOVEMBRE

VOGUE

LA BEAUTE
AVEC DES PLANTES EN TUBES

OUI AU CUIR

NOUVEL AMOUR
LA BOUTIQUE KOSAK

PICASSO PAR ARAGON

LORD SNOWDON CHEZ MAX ERNST

BALENCIAGA

Inspiration from Spain! Balenciaga is young, Spanish and new to Paris. His beautiful clothes have the warm, colourful drama of his country. Like a lover's posy is this white chiffon frock, full skirt embroidered with violet bunches, and bodice of swathed green taffetas. The picturesque black Chantilly lace, posed over glistening white satin and veiled with grey tulle, takes the quality of a romantic dream. Of a contrasting fascination is the simple dinner frock of violet crêpe, long jumper, pink suède sash and slim pleated skirt.

There are no paper patterns obtainable of the French models on this or the opposite page.

B 17

24. 'Inspiration from Spain!',
Woman's Journal (September 1938).
This early magazine feature shows
many of the hallmarks of
Balenciaga's couture house: the use
of layers of black and white, and
striking combinations of pink and
purple. The evening dress (left)
closely follows the lines of regional
dress from the province of Granada
in the south of Spain, although the
bodice is more revealing and the
skirt longer.
Courtesy of *Woman's Journal*.

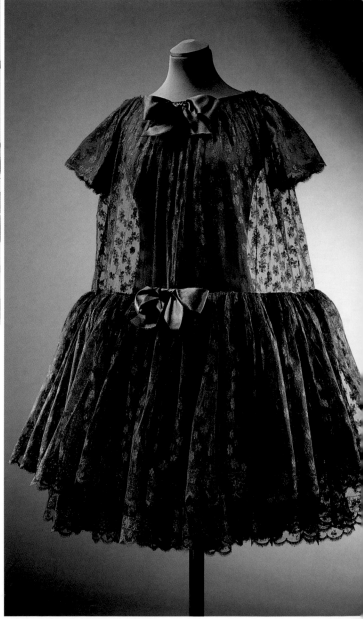

house abides by the great rule that elimination is the secret of chic.[15]

Although simplicity was the epitome of elegance, the more elaborate Spanish styles also caught the public imagination: the flounces and frills of black lace laid on a white or light-coloured ground, or alternatively the application of black braid or embroidery. *Woman's Journal* picked out three very different evening dresses in September 1938, two of which were particularly Spanish in their use of materials and colour: a 'picturesque black Chantilly lace, posed over glistening white satin and veiled with grey tulle' and a 'simple dinner frock of violet crepe, long jumper, pink suede sash and slim pleated skirt'. The third was more French in feel: a 'white chiffon frock, full skirt embroidered with violet bunches, and bodice of swathed green taffeta'.[16] Early on, Balenciaga used cottons as well as silks for his full-length dresses, as Chanel had done since about 1931.

In evening dress as in daywear, Balenciaga carried certain themes through consecutive collections in order to provide continuity. The black muslin sheath dress covered with small bands of ruched black lace, presented in August 1939, gradually developed into the black lace and muslin Second Empire dress of the 1940-41 collections. The fabric and trimming remained constant, and the large oval locket worn at the high round neck of the dress continued as the only relief to the black, but the cut from the waist downwards altered. From a simple sheath that flared out from below the knee, it developed into a bodice with a deep, almost Infanta-style basque, worn over a full crinoline-style skirt. In succeeding decades Balenciaga followed the same principle, developing certain themes from one collection to the next. Between the early 1950s and early 1960s it was the ballooning, bouffant taffeta evening and cocktail dresses; in the early 1960s it was his sari styles and simple, abstract shapes.

A range of simple black sheaths with contrasting coloured satin swathes offered an alternative to Balenciaga's more elaborate evening gowns in the late 1940s and early 1950s. The sheath was usually body-hugging

and totally plain. Attached to the neckline or the waist of the dress, a satin or taffeta drape contrasted with the body. The black wool crêpe sheaths in the Musée de la Mode et du Costume in Paris and the Museu Tèxtil i d'Indumentària in Barcelona have a gold swathe, but the house also showed examples with sea-green/turquoise drapes (colours favoured by Zurbarán). A more elaborate version appeared in the winter collection for 1951 and comprised a sheath dress of embroidered silk lace by Brivet and a drape of turquoise taffeta. This length of fabric or drape could be worn creatively – round the body, or over the head and shoulders. In each variation it clearly relates to the luxurious floating sashes and stoles of Zurbarán's saints. In contrast, Balenciaga's heavily draped gowns of the early 1950s appeared in various guises. Based on a fitted waist and boned bodice, with or without straps or sleeves, they followed traditional lines in their hugging of the female body, but were innovative in their gathered drapery. Bustles, swags, balloons and puffs all emerged in a variety of forms. A black silk cocktail dress of 1952 typifies the puffed and gathered look and seems to have been popular. It has a simple wrap-over bodice and slim-fitting sleeves, but the skirt and sash have added interest. The hemline and one edge of the sash are given body by gathering, which produces a puffed effect. A range of 'baby-doll' gowns from 1958 onwards combined these two strains: the outer layer was of lace, and appeared soft, loose and free from the body. Beneath this outer layer, however, was a figure-hugging sheath in the same colour as the lace; it clung to the body and was tantalizingly visible through the transparent lace.

Other gowns relied on heavy lace appliqué, beading, feathers or numerous flowers, hand-made from silk, to provide a note of impractical glamour. Such garments must have been damaged immediately the wearer sat down, yet they were a common feature of Balenciaga's evening wear throughout the 1950s and '60s. While Parisian embroiderers applied everything from sequins and paillettes, stones and plastics to Balenciaga gowns, Judith Barbier created the

26. (ABOVE) **Detail of the inside of Madame Alec Weisweiller's pink organdie dress, worn October 1960.** Balenciaga built foundations into some of his evening attire, presumably so that the gowns fitted the body of the wearer more snugly and enhanced it. This example, designed especially for Madame Weisweiller, had a front opening. An underdress with straps was attached at the waist to the overdress, small bust pads inserted between the layers (front right), and suspenders attached to the waistband. In other evening dresses, the body is boned (66).
V&A T.17-2006.

27. (LEFT) **Detail of the fabric of Madame Alec Weisweiller's pink and white organdie dress, worn October 1960.** The drama of this dress lay in its pretty textile – pink and white organdie embroidered with ribbons, lace and beads.
V&A: T.17-2006.

evening garments that most echoed the 'Papacha' mohair daywear. In 1964 she hand-sewed artificial silk flowers on to a net base, turning both an evening coat and a trouser suit into living gardens that must have been immensely easy to crush.

Fashion Philosophy

Behind Balenciaga's simple, easy daywear and his lavish cocktail and evening dress lay his philosophy of fashion, experience of materials and techniques, and experimentation with a range of recognizable design sources. Balenciaga relied on a number of guiding principles, which he discussed informally with Bettina Ballard and Cecil Beaton. His methods were based on practical experience and demanding personal standards. They revealed, however, sympathy with the needs of the women whom he dressed and the exigencies of the times in which he was living, as well as ideas about fashion in the abstract. Balenciaga felt strongly that the couturiers did not live in a vacuum but were part of a historical process that they had to interpret appropriately. A couturier could not battle against the times, but should rather, in Beaton's words, 'allow his expression to find its appeal through the temporal mode. He must sense what is needed and how women are to look at a given moment.' According to Beaton, Balenciaga himself always created a collection by starting from the indispensable rather than from his own personal inclination.[17]

Balenciaga believed that a fashionable woman could only be elegant if she knew herself sufficiently to patronize a single dressmaker, and not to seek out mere novelty, the fashion of the moment. This latter sentiment was an echo of Geneviève Dariaux's suggestions in A Guide to Elegance (1964). Balenciaga did not believe 'that women should vary their clothing often in order to be well dressed'.[18] After all, men wore the same suit over and over again and still achieved elegance and practicality. His own development of tailoring skills, which led to a variety of little suits over the years, testifies to his fascination with classical, practical garments and remains

one of his most influential contributions to fashion. His clothes were not unnecessarily difficult to put on and wear – and thus earned a reputation to which the press still alludes in phrases like 'the ease of Balenciaga'.[19] The fastenings on his dresses were seldom too complex for the wearer to deal with herself. In fact, by the mid-1950s he often created garments that simply slipped over the head and required few buttons, press-studs or hooks and eyes, having a simple fastening at the waist and the precaution of slip or bra-strap holders on the shoulders. Even his heavily structured evening dresses tended to fasten with a corset-type belt at the side and a zip set in the side seam. They did not involve the horror of dozens of buttons and loops, as did many of Dior's formal dresses. In fact, Bettina Ballard recounts

Lefaucheur pour Balenciaga.
Gaine très étudiée. Co-loris nouveau : bleu nuit.

28. **Sketch of Lefaucheur foundation garment made for Balenciaga and featured in 'L'Indispensable Maintien', French *Vogue* (March 1950).** Specialist lingerie and underwear suppliers created the underpinnings for couture garments. From the 1950s, however, some couturiers began to advertise their own brands. While Balenciaga lent his name to a brand of stockings by 1960 and was famed for the woolly tights he had made in the mid-1960s, he does not seem to have involved himself in the production of underwear. In 1950 this midnight-blue (a new colourway) foundation garment made by the house of Lefaucheur was made specifically for Balenciaga. In the same article in *Vogue*, Lefaucheur showed a bra and girdle of pink satin and latex made for Dior.
Denise Nicollet © *Vogue* Paris

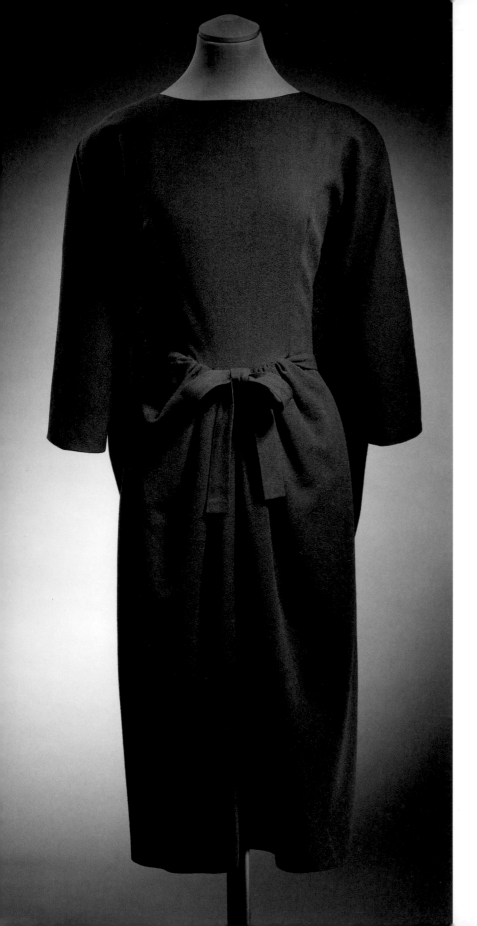

the day that Balenciaga helped her to fasten a Dior evening dress, which had buttons right down the back, virtually inaccessible to the wearer. He was appalled and kept muttering: 'But Christian is mad, mad!' ('Mais Christian est fou, fou!'), as he completed the buttoning.[20]

Balenciaga's styles were also practical from another point of view: they suited different female figures. The tunic, chemise (sack) and Empire styles, so favoured by Balenciaga, were simple, flattering both to the extremely slim and to those with curves and stomach, since they ignored the waist. The tunic was long and slim, worn to thigh level over a narrow skirt; the sack was a waistless dress that bloused slightly at the back; and the Empire line raised the waist to just below the bust. Other dresses also drew the eye away from the waist by using asymmetrical external drapery, which either swept upwards towards the bust or downwards into the skirt – away from the waist. Skirts also accommodated stomachs, since they were seldom cut completely straight but were slightly gathered into the waistband at the front.

Ease of movement and room for breathing were both important to Balenciaga (within the constraints of his times). Corseting was reserved for a few evening dresses in the pre- and post-war years. Three-quarter- and seven-eighth-length sleeves did not hamper movement or become dirty. Combined with the setting of the neckline away from the neck, the sleeves flattered older women because the eye was 'led . . . to the back of the neck and the curve of the wrist, both of which can be quite as graceful at sixty as at sixteen'.[21] Uneven hemlines on evening dresses, high at the front and ground level, or with a train at the back, avoided the hazards of the particularly pointed toes of 1950s stilettos. Finally, at various junctures, Balenciaga introduced warm clothing. Particularly noteworthy were the purple bloomers to be worn with red woollen stockings and a cycling skirt in war-stricken Paris in 1941, when fuel was limited and winter temperatures and cycling were an unhappy and chilly combination. A similar awareness of the weather lay behind Balenciaga's new developments in

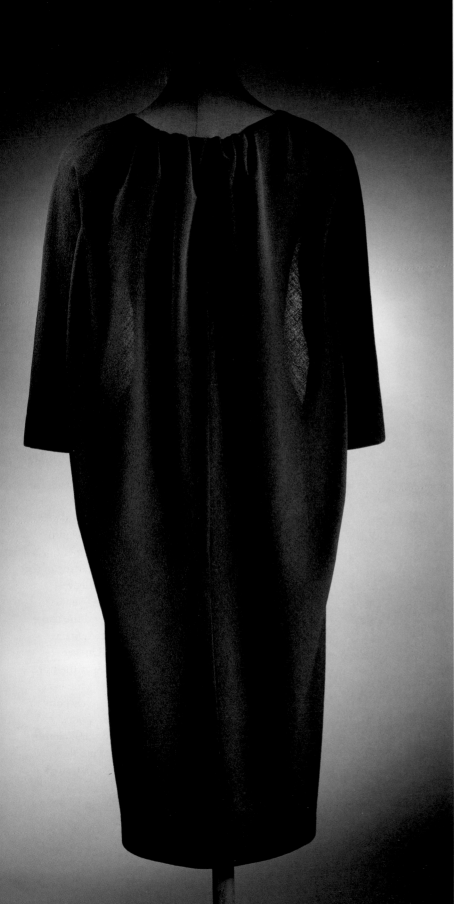

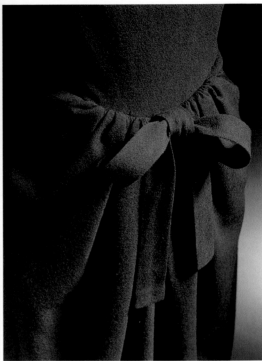

29-31. **Black wool sack (back, front and detail), autumn–winter 1957. Worn and given by Mrs S. Hammond.** Shown at Cecil Beaton's exhibition of couture clothes at the V&A in 1971, this black semi-fitted woollen dress is now in the Museum's collection. The garment carries a Spanish label and is one version of Balenciaga's many sack and chemise styles, which he developed from 1956 onwards. Semi-fitted, the gathering just above the waist takes the emphasis away from the wearer's waist (and odd bulges). The back is loose, but the front is fitted. The shapelessness of the sack met with such adverse criticism in 1956 that Balenciaga adjusted it in following collections. In later models the gathering is above the waist (chemise style).
V&A: T.234-1982.

the 1960s. As the mini skirt gradually exposed more and more flesh to the elements, he countered its perils with knee-length boots (1962) and woolly patterned tights (1965).

Many of Balenciaga's practical innovations indicated his recognition of the busy lives of his clients and their changing circumstances. After the Second World War, women increasingly worked outside the home. Balenciaga's clients included professional women as well as socialites, and even socialites worked for charitable or philanthropic organizations and therefore led active lives. Balenciaga lamented the fact that they did not have time to spend on their appearance, but he made life as easy as possible by producing clothes that catered for their needs while looking attractive. This sensitivity to the needs of a female clientele probably stemmed partly from his acknowledged debt to three notable couturiers of the 1920s and '30s – Chanel, Vionnet and Louiseboulanger. Chanel specialized in sporty, casual styles that catered for ease of movement, whilst Vionnet's famous bias cut allowed the female body to move and breathe without the restrictions of corseting. It is often said that women designing for women have a different attitude to the body, since they can wear their own garments. That Balenciaga studied and admired such women designers perhaps explains some of his own practical measures, and his aversion to the 'caged bird' attitude typified by Dior. The lines of the 1920s and '30s lingered on in his work well after the Second World War, and these were lines that particularly suited the tall, slim figures of two of his muses, his favourite mannequin between 1937 and 1954, Colette and his client the Marquesa de Llanzol (see Chapter Four). Neither woman was stereotypically hourglass-shaped in voluptuous Dior mode. Even though externally the styles suggested freedom, often the internal construction or the type of underwear required (armour-plated in comparison with today's scanty pieces) kept the body under control, or dieting and exercise were needed to keep the body in shape.

Balenciaga's practicality was relative to his

32. **Advertisement for stockings by Gui, French *Vogue* (June 1951).**
Before branding his own hosiery at the end of the 1950s, Balenciaga was happy to let his name be used in the advertising of stockings from the company Gui. This firm supplied many of the top couturiers in the 1950s and advertised the fact consistently in the front pages of French *Vogue*, in increasingly eye-catching images. Balenciaga's name appears on the right-hand side between Jacques Fath and Creed.

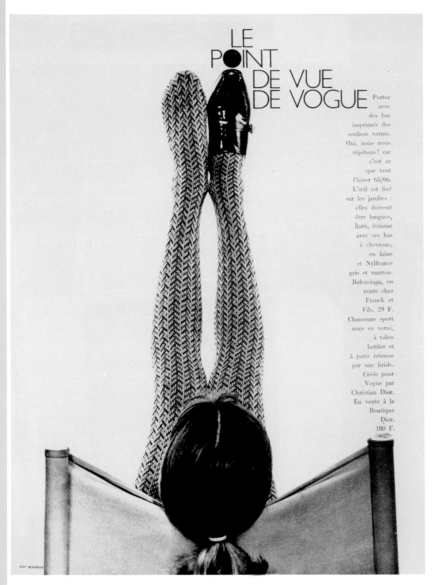

LE POINT DE VUE DE VOGUE

Portez avec des bas imprimés des souliers vernis. Oui, nous nous répétons! car c'est ce que veut l'hiver 65/66. L'œil est fixé sur les jambes : elles doivent être longues, fines, comme avec ces bas à chevrons, en laine et Nylfrance gris et marron. Balenciaga, en vente chez Franck et Fils, 29 F. Chaussure sport mais en verni, à talon bottier et à patte retenue par une bride. Créée pour Vogue par Christian Dior. En vente à la Boutique Dior. 180 F.

33. 'Le Point de Vue de Vogue', French *Vogue* (October 1965). In the mid-1960s, as the mini-skirt made its presence felt, Balenciaga innovated in hosiery, introducing woolly tights, much appreciated by the press and wearers. These tights featured in editorial space in French *Vogue* teamed up with a pair of shoes by Christian Dior, available at the boutique. The text indicates with regard to the tights: 'The focus is on legs: they must be long and slim, as with these tights with chevrons, in grey and brown wool and nylon [Nylfrance was the trade name]. Balenciaga, on sale at Franck et Fils, 29 francs'.
Guy Bourdin © *Vogue* Paris

times and to the requirements of the moment. While he strove for simplicity and practicality in day suits, dresses and even hats, his evening creations allowed room for frivolity and excess, usually in the form of large frills, elaborate embroidery, heavy beading, extended puffed skirts and cascading ostrich feathers. These models, whilst easy to put on, required certain deportment for maximum effect and were often problematic from the point of view of care and storage. The mere act of sitting down had disastrous effects on beaded or feathered dresses, which often needed repairs after only one wearing. The puff-ball cocktail and evening dresses of the 1950s needed space if they were to retain their three-dimensional grandeur.

Wearability and practicality apart, Balenciaga's fashion philosophy embraced ideas about colour. He believed that a couturier had to be 'virtually scientific in the choice of the colours', although he did not explain the actual process.[22] According to the fashion journalist and historian Marylene Delbourg-Delphis, his sense of colour was kinetic and conceived not merely within the geometric oppositions of different colour ranges, but also according to 'the physical or optical order of vibration'.[23] As a result, he made unusual combinations such as ginger with bottle green, greige with granite grey, black with reddish brown. His range of greys, blacks and browns was legendary.[24] These subtle combinations possibly derived from his Spanish background: the great variety of greys and blues seen in the Cantabrian sea; the reds, browns and blacks of the Spanish earth; Basque and Castilian regional dress; the deep mourning of Spanish widows; and the pinks and purples of ecclesiastical vestments. The choice of the 'sensational new "velvet tweeds"' created by Bernat Klein in 1964 was typical. Balenciaga selected 'a velvet ribbon in dark brown interwoven with uncut mohair loop threads in black'. The master's selection was, according to *Drapery and Fashion Weekly*, the ultimate accolade for the textile designer, who might have been surprised at how closely this combination related to certain forms of traditional Spanish dress.

The vibrancy of many of Balenciaga's Spanish colour combinations (noticeable, too, in the work of contemporary Spanish painters such as Zuloaga, Picasso and Miró) struck a chord. Such is the stereotype, even today, in external perceptions of Spanish taste. Courrèges affirmed that Balenciaga 'married a contrast in materials with a great Spanish violence, and the same was true for colours. You found Velasquez and Goya, Love and Blood. Often I thought that he worked, that he searched on the road to Death like the bullfighter in the ring.'[25] Other colours were less easy to define. The redoubtable Diana Vreeland tried to make sense of his purples, but failed in sheer ecstasy: 'Oh,

but violets. You should have seen Balenciaga's violets . . . My God, pink violets, blue violets! Suddenly you were in a nunnery, you were in a monastery.'[26] Not surprisingly, Balenciaga liked fabrics that mixed colours boldly or in which colours changed according to the way the light fell on them: striped fabrics, tweed, faille, taffeta, cloqué, moiré.

More prosaically, these decisions affected textile manufacturers, and the supplier of printed textiles, Pierre Ducharne, recalls that Balenciaga was one of the most demanding couturiers:

. . . from the point of view of colour, Balenciaga, Balmain were the two houses that I thought about most. I always had close to me the favourite colours of Balmain and the favourite colours of Balenciaga; it was this red not that one, this yellow not that one. There were colours that those couturiers didn't like: you learnt to know this, when you put down something else.[27]

Creation of a Collection

Balenciaga channelled his ideas about textiles and wearability into a minimum of two couture collections each year throughout his career in Paris. He also created half-season collections in the late 1930s and early 1940s. Each collection contained no less than 75 models, the minimum to qualify as a couturier, and usually between 200 and 250. Each collection observed the needs of the couture clients' social calendar, catering for the whole gamut of garments in appropriate materials: day suits, dresses, blouses, evening dresses, at-home ensembles, coats, raincoats, sportswear and, of course, hats.[28] The range of garments was far broader than that seen in the press, partly because Balenciaga censored what should appear in magazines. He tended to choose formal clothes, although examples of ski-wear and more casual sporty garments such as culottes did creep into magazines in the 1930s and '60s. He did not make the underpinnings (except those built into fitted gowns), but selected underwear from specialist couture suppliers such as Lefaucheur. In the 1950s Gui supplied stockings; by 1960 a range of stockings sold under the name of the house. These stockings were very fine in

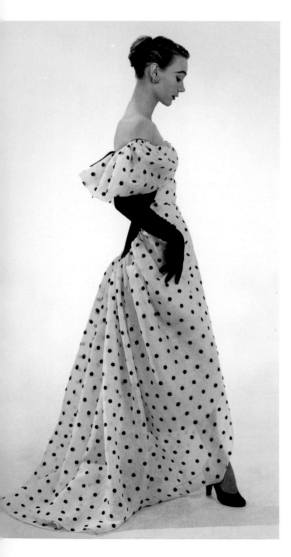

34. (LEFT) Seeberger, photograph of evening dress of white organdie with black spots, taken in February 1952 (Model no. 169). Balenciaga favoured spotted textiles of different types in many of his collections, perhaps a legacy from flamenco dress. This textile was expensive, having been embroidered with spots and supplied by one of the leading machine-embroidering firms in St Gall in Switzerland, Forster Willy. Bibliothèque nationale de France.

35. (RIGHT) 'La Perse', February 1946 (Model no. 113). This evening ensemble comprises a long dress of black silk crêpe and bolero jacket of off-white satin, embroidered in chenille, gold, glass beads and sequins is typical of the traditional collaboration of couturier and embroiderer, and the use of traditional materials for the embroidery. Once Balenciaga had chosen this design, Lesage, the embroiderer, would have reserved it exclusively for his use. Worn with a matching hat of embroidered satin, this outfit belonged to the Dutch concert pianist Else Rijkens (1898–1953), who was an elegant lady with a mannequin figure. The decorative top and plain skirt would have suited the needs of such a performer.
Courtesy of the Nederlands Kostuummuseum, The Hague.

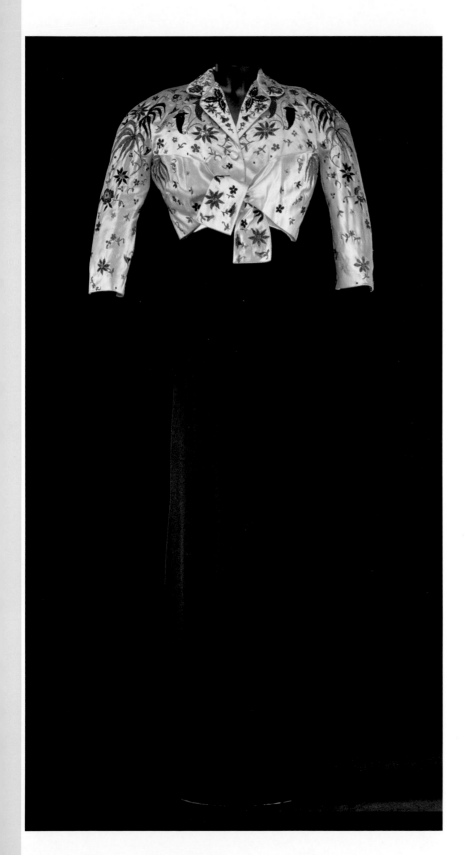

comparison with most on the market, and also quite expensive.[29]

Colours and, more importantly, fabrics were the initial inspiration for Balenciaga's collections, and the availability of rare fabrics in France was part of the joy of establishing a couture house in Paris. Paris gave access to a varied and flexible range of textiles and accessories, particularly important two months before the showing of the couture collections in July and January. Short lengths of fabric were available at short notice if a private client needed a dress urgently. *Prêt-à-porter* did not require these same conditions, and its increasing dominance brought about changes by the late 1950s. In 1971 Balenciaga lamented that few of the hundreds of craftsmen making luxury trimmings survived in Paris; that the textile people were no longer reliable in their deliveries; and that the escalating social-security payments, insurance and other costs were too high.[30]

Textile manufacturers courted Parisian couturiers throughout Balenciaga's career in the belief that the use of their fabrics in couture collections was a mark of approval that merited publicity and spread their name.[31] In Balenciaga, they found a discerning client who not only evaluated accurately the finer points of their products, but also experimented with new types and mixes of fibres, and even collaborated in the development of new ranges. Balenciaga chose to trade with whichever companies offered him the best wares, and thus forfeited the subsidy offered by the French government to all couturiers who used a minimum of 90 per cent native French textiles. The list of his suppliers thus encompasses all the highest-quality European manufacturers of the period.[32] The collections proceeded from this selection of colour and texture. Pierre Ducharne remembered his demands:

At Balenciaga's . . . Balenciaga was awful for his choice of textiles. He felt them for a long time before deciding. When he hardly touched the fabric and passed it to his neighbour, that meant that it didn't interest him . . . Givenchy was very careful, very difficult. But he liked fabric well, although less so than Balenciaga . . . [33]

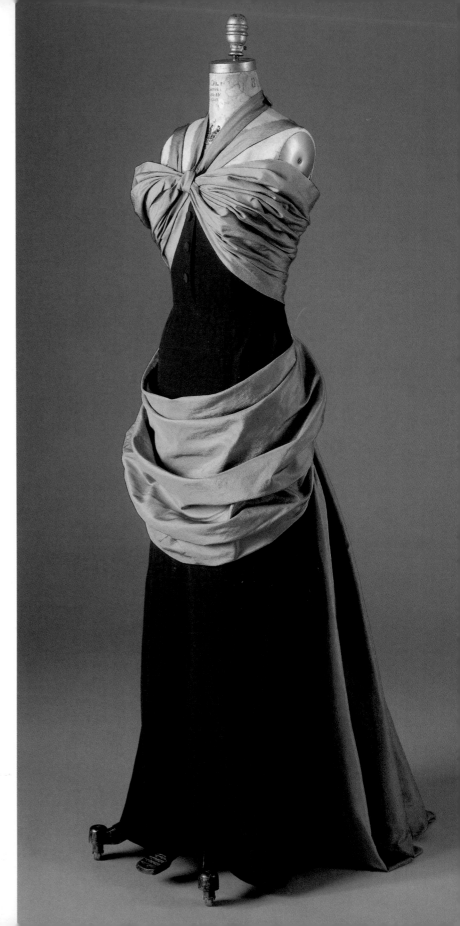

In the post-war years, as new developments
in fibre technology made available wider ranges
of fabrics with properties unlike their natural
counterparts, Balenciaga worked closely with
the silk manufacturer Abraham of Zurich, from
whom he commissioned silks for his fashion
house. By 1953 Abraham was manufacturing
ranges of textiles specifically for Balenciaga –
successfully so, for in the late 1950s Balenciaga
happily tried out his new synthetics, including
fabrics using Lurex, a yarn with a synthetic
metallic finish. Balenciaga obligingly pioneered
the use of a silk weave with a black metallo-
plastic finish.[34] His summer collection of 1964
revealed just how highly he esteemed Abraham:
32 textiles came from Abraham, 22 from Sache,
17 from Besson, 16 from Dognin and the rest
from his other 48 suppliers.[35] In the late 1960s
the couturier and the manufacturer worked
together on creating the firm silks gazar and
supergazar, which suited his stark modernist
aesthetic. Balenciaga also established a good
working relationship with Zika Ascher and he
consistently patronized the silk merchants of
Lyons, notably Bianchini-Férier, Bucol,

36. (FAR LEFT) **Bill from Balenciaga for the clothes ordered by Mrs Sybil Harrington in spring 1950.** This bill reveals the prices paid by couture clients for Balenciaga's clothes, both when he supplied the fabric and when the client supplied the fabric. The first seven items include fabric and making and were presumably made up as shown in the season's mannequin parades, while the last two items are payments for the making alone. Presumably, Mrs Harrington supplied the fabric.
Courtesy of Phoenix Art Museum.

37 & 38. **Black silk crêpe evening sheath with grey taffeta drape, spring 1950 (front and detail of drapery).** In the November 1950 issue, American *Harper's Bazaar* drew attention to the dramatic role that huge sashes of taffeta played in Balenciaga's sheath dresses. The dresses evidently had 'an impeccable flare at the bottom of the skirt' which meant they were easy to walk in. The drapery was inspired by 17th–century Spanish artists. This dress was worn by Mrs Sybil Harrington, a civic leader and philanthropist who founded the Fashion Design Department and the Arizona Costume Institute at the Phoenix Art Museum, to which she donated parts of her wardrobe. She bought this dress (*robe du soir de crèpe noir drapé de faille grège*) for 157,000 francs. It was the most expensive of the nine models she purchased that season. See above for the bill.
Courtesy of Phoenix Art Museum.

Ducharne and Staron, and the embroiderers of St Gall in Switzerland.

Balenciaga also received accessories designers. Percy Savage, recently graduated from the École du Louvre, for example, met him at a reception at the Spanish Embassy and subsequently presented him with designs for scarves:

At the time I was very influenced by a Russian painter called Poliakoff . . . and I did abstract designs for Balenciaga, and, and basically they were heart shapes, I think there were about five different coloured hearts on a dark background. And then once I'd done the original, Balenciaga wanted . . . what they called different colour ways, so I had to do different coloured backgrounds and different coloured hearts. So, that was a lot more work to be done, but it was, that was the way they did it in those days, all done by hand, of painting on paper and so on.[36]

Apart from indicating his desire for different colour ways, Balenciaga did not interfere in the actual appearance of the designs. He merely sent the designs off to his contacts in Lyons to be printed on to silk.

From the beginning of each collection (after 1948), Balenciaga worked with his secretary Gérard Cueca and his assistants Ramón Esparza and Fernando Martínez. All three were Spanish speakers, which undoubtedly facilitated communication. Esparza was responsible for designing the hats, while Martínez helped with the other models. Balenciaga defined the changes in his line, chose the colours and fabrics for each model, and then Martínez sketched from his instructions. The fabric samples for each complete outfit (matching coats, dresses, belts and hats) were attached to each sketch so that the whole effect was clearly visible. From hundreds of sketches, Balenciaga chose the 200 to 250 models that were to feature in his collection. Thereafter, he created fabric patterns (*toiles*) of each selected models and fitted them on the appropriate house mannequin. The importance of the relationship of his models to his mannequins, who were often the inspiration, should be emphasized. Most sketches that survive in the archives of the house bear two names: the name of the workshop head, who was responsible for supervising the making of the garment, and the name of the mannequin, who would present the model to prospective clients. The colourings and styles of different models suited different mannequins, and thus theoretically sold more clothes.

Once the *toiles* were complete and perfect (Balenciaga had no compunction about ripping apart unsatisfactory work at any stage of its creation), work could begin on cutting the actual fabric in which the garment would appear and making it up in the appropriate workroom, dressmaking (*flou*), tailoring (*tailleur*) or millinery (*modes*). Balenciaga inspected work in progress. According to Salvador, one of the tailors, he checked each model at least four times: once to see that the fabric was satisfactory and three times to see that the design was perfect. To go by the quality of finish on garments with the Balenciaga label in museum collections, his workrooms in Paris maintained a consistently high standard. Every garment was hand-finished and all fastenings were disguised, unless they were meant to dazzle, like the buttons on some of his suits. Typical of couture were the hooks, eyes and press-studs carefully covered in buttonhole stitch to prevent the metal from damaging the fabric; the hand-done overstitching of the seams and round the hem. Other details included the carefully calculated stiffening under full skirts, the padding on shoulders and facings in jackets. Such features were typical of haute-couture production, but not all couturiers' workrooms consistently turned out such high quality.

The whole process, from conception to completion, from sketches to final mannequin parade, lasted about two months. At the end, fashion journalists judged the collection from their precarious gilt chairs in the salon. Films of the parades from the 1960s show that each mannequin walked down the salon carrying a number, which identified the model she was wearing.[37] She neither smiled nor made eye contact with her audience, but rather walked on like a robot, unbuttoning and removing jackets or coats to show the detail below. There was no backing music and the whole atmosphere was

exceptionally austere. Balenciaga did not waste time or energy inventing romantic names for his models like some of his rivals. Instead, he made sure that attention was focused on the clothes. After the shows, the workrooms made up private and commercial orders, most within the first month. Thereafter, reproductions appeared in the stores in most countries at about one-third to one-quarter of the price of the original.[38] Private clients, however, could continue to order right up until the next season's collection, attending the house for a minimum of three fittings per outfit.

Design Sources

The line of Balenciaga's clothes developed gradually over the forty-odd years of his professional life, and many motifs reappeared time and time again in different guises. In 1971 he acknowledged his debt to French couture, in particular to Chanel, Vionnet and Louiseboulanger. His styles followed their lead in the 1920s and '30s before his arrival in Paris, and continued in their tradition until the Second World War. It was Vionnet herself who questioned whether Balenciaga really needed to copy her designs. In the late 1960s, at the age of 92, she remembered Balenciaga's visits to Paris in the early 1930s and revealed that he was already capable of designing clothes beautifully himself. She had queried his need for models, but Balenciaga just replied, with his usual courtesy, 'Your clothes, Madame, inspire me.'[39] He must have known, too, that his Spanish clients demanded Paris fashions.[40]

Only Chanel was to re-emerge after the war, in 1954, to challenge Balenciaga's domination of Paris fashion, his accent on suits and gradually evolving style. Her self-publicity (and the subsequent reworking of her suits by her house under the direction of Karl Lagerfeld) has resulted in the widespread impression that the 'Chanel suit' was the only one. In reality, the contemporary press delighted in both Chanel and Balenciaga suits. Their character was quite different, in keeping with the characters of the two designers: Chanel's suits were trimmed with startling braid and accessorized with costume jewellery, gold chains and buttons; Balenciaga's were understated, and more varied in their manifestations. Their trimmings were simple and seldom deliberately eye-catching. They reveal a much underestimated second influence on his work – tailoring.

Anny Latour, the fashion journalist, spotted this important component of his design. She contrasted Balenciaga's approach with that of three French couturiers active at the time, in the 1950s: 'Dior designed, so do Fath and Balmain, but Balenciaga tailors. He is said to spend days on a single dress, pulling it apart again, recutting and altering until he is satisfied.'[41] Her observations are in line with the opinions of María Pilar del Comín, former fashion editor of *La Vanguardia*, who insisted that Balenciaga's debt to English tailoring was an essential part of his work. She suggested that besides working for a tailor in Madrid as part of his apprenticeship, he also worked for a store called New England in San Sebastian.[42] This store concentrated on the production of ready-made garments long before ready-to-wear became widespread in Spain. They were in many cases based on traditional English tailoring techniques. Significantly, in 1919 Balenciaga called himself a tailor (*sastre*), whereas by 1934, when he set up in Madrid, he chose to call himself a dressmaker (*modisto*).[43]

The development of San Sebastian as a centre of 'Spanish Brummelism' was noted by visitors to Spain in the early 1950s, and tailoring was a fundamental trade in the town. Writing in 1955, H.V. Morton said: 'I have never seen so many shops for men in a town of its size; I should think that they outnumber women's shops by about three to one. In this masculine Paris I came every ten yards to a window full of men's clothes and shoes.'[44] Spain's reputation for tailoring extended to women, for in 1951, in French *Vogue*, Kitty Lillaz recommended to her female readers on holiday in Spain: 'If you have the time, go to a Spanish tailor for a made-to-measure garment. Spanish tailors are excellent and half as expensive as in France.'[45] In the light of this information, it is interesting to note that

Balenciaga chose to go to London before moving to Paris in the mid-1930s, and that he continued to visit London thereafter. His handling of tweeds and woollen cloths and his obsession with creating the perfect sleeve relate to the tradition of tailoring rather than dressmaking, which depends on the manipulation of finer fabrics. The firm but supple synthetics and woollens of the 1950s and '60s provided sought-after volume, and, not surprisingly, in those decades Balenciaga emerged as the most dominant force in French fashion.

Strangely, the British photographer Cecil Beaton did not mention this debt to English traditions, although he spotted the 'refinement of France and the strength of Spain' in Balenciaga's fashion.[46] Perhaps the Spanish references in Balenciaga's work were easiest to isolate for non-Spanish contemporaries, because they were the most exotic. Recognizable to the casual observer were examples of clothes from the heavily tourist-orientated regions: the flamenco dress of southern Spain with its brilliant colours, many flounces and embroidered silk shawls; the lace concoctions of the gala dress of the inhabitants of the Costa Brava and the Balearic Islands; and the bullfighting boleros of the toreadors. According to Bettina Ballard, Balenciaga did not enjoy bullfights and only accompanied her out of courtesy. Whatever his feelings on the subject, growing up in Spain and resident there for periods of the year throughout his life, Balenciaga could not have escaped the visual and material impact of bullfighting. It had been a prominent part of commercial culture since the late eighteenth century, and by the late nineteenth century posters and newspaper reports drew attention both to the fights and the personalities. San Sebastian, like most major cities, had its own bullring, which hosted *corridas* in August each year, the month that the court summered there. In the 1950s Balenciaga's overseas clients were increasingly aware of Spanish culture. Indeed, in 1951 and 1952 French *Vogue* began to devote some coverage to Spain, featuring in particular the picturesque traditions such as the Holy Week processions and bullfighting.[47]

39. (LEFT) **Henry Clarke, three-quarter-length jacket,** *Album du Figaro* **(April–May 1950).** This sporty jacket for spring–summer 1950 reveals Balenciaga's mastery of simplicity in cut, beautifully set sleeves and the use of suitable textiles to create the necessary volume and drape. It is only one of many loose-fitting jackets and full-length coats that featured in his collections in the early 1950s. It was described by the journal as 'Four-fifths length coat in sable wool over a black dress, very young, a little masculine, with very linear form'. It reveals his debt to a tailoring apprenticeship, and possibly an engagement with the values associated with that very British tradition.

Henry Clarke, Coll. Musée Galliera, Paris, ADAGP, Paris and DACS 2007.

40. (RIGHT) **Henry Clarke, velvet jacket, autumn–winter 1950,** *Album du Figaro* **(December 1950).** This dressy velvet jacket in different shades of brown velvet is a sharp contrast with the more sporty woollen jacket opposite, showing skill and luxury often associated with French dressmaking or couture. Its loose fit echoes many other jackets of this date and the full sleeves demonstrate another of Balenciaga's interests, which he developed in a range of different ways. This jacket was suitable for dressy wear in the afternoon. The magazine described it as: 'High collar, arrogant sleeves, on this coat of brown velvet streaks. Balenciaga brings out the volume via a tiny hat with pendant beads'. The Fashion Institute of Technology in New York have an example of this garment. It was model no.117 in the autumn–winter collection of 1950, made in the workshop of the tailor Denis for the mannequin Huguette in velvet by the Lyonnais manufacturer Staron.

Henry Clarke, Coll. Musée Galliera, Paris, ADAGP, Paris and DACS 2007.

Balenciaga was not alone in deriving pleasure from the most colourful elements of this spectacle, the suit of lights (*traje de luces*), for other couturiers took up Spanish motifs at intervals, too. The regional dress of more recondite parts of Spain, however, also attracted Balenciaga's attention, particularly the red or brown and black stripes of much Basque and Castilian costume. Foreign collectors and artists had paved the way for appreciation of the 'picturesque', 'foreign' elements of Spanish culture. From the Napoleonic Wars onwards, they had amassed paintings from Spain's Golden Age, painted charming compositions of gorgeous women in regional dress, and some had even brought home examples of that dress, which they donned for their portraits or as fancy dress. In the 1950s this tradition continued, as the likes of Henri Cartier-Bresson and Inge Morath captured in black-and-white photographs glamorous bullfighters and their bold female fans, sombre seminarians and lace-clad altar servers.[48] The Franco regime aided them in its promotion of popular traditions, while anthropologists drew attention to the dying arts of traditional communities.[49]

Balenciaga expanded his repertoire through Spanish art of the seventeenth to nineteenth centuries. The references to regional or peasant dress in Balenciaga's œuvre overlap with those to costumes in paintings by old masters, because many of the regional garments were fossilized fashions of the past. The works of Velázquez, Zurbarán and Goya attracted him, and all of these artists were represented in the fine collection of Spanish art in San Sebastian, in the Prado in Madrid and in the Louvre in Paris. Thus, the lace mantilla of Granada or Cádiz turned up as nineteenth-century fashionable dress in Goya's well-known portraits of *Queen María Luisa of Spain* (painted 1798–9) and in Balenciaga's mantilla of 1945. The square skirts and basqued jackets of Las Palmas appeared full-length in many of Velázquez's court paintings, such as *Las Meninas* (1656), and in Balenciaga's Infanta dresses of 1939. No doubt, Balenciaga was particularly lucky to have set up in business in Paris just before the big exhibition of

41. (LEFT) **Regional woman's dress from the Valle del Pas, Santander, Spain.** Santander is the province next to Guipúzcoa in the north of Spain, a rival for the attention of aristocratic tourists at the beginning of the 20th century. Balenciaga was undoubtedly familiar with its regional dress, which was similar in its use of bands of colour to most Castilian dress. This copy of original garments of 1908 was made in 1935, the materials being lightweight wool and velvet, the styles deriving from 19th-century fashionable dress. It comprises a shirt, skirt, jacket and apron (the garment with the bands of wool and colour), worn with stockings, slippers, overshoes and elaborate filigree jewellery. The colours belong to a palette with which Balenciaga had much sympathy throughout his life.
Courtesy of the Museo del Traje, Madrid.

42. **Bernat Klein, sample of mohair and velvet ribbon textiles bought by Balenciaga in 1964.** Balenciaga's taste for optical illusions, the play of different textures and colours, drew him to this 'velvet tweed' in 1965. Designed by Bernat Klein on the Scottish borders, it reached Paris via an agent and the designer did not realize it had been bought until he saw it in the press. The combination of mohair (hairy, light) and velvet ribbon made this an exceptionally lightweight fabric, far removed from the heavy tweeds traditionally made in the borders. It followed in the wake of a number of attempts to innovate in materials and textures, late 1950s couture being dominated by 'frothy' little suits and dresses, often in British fabrics.
Courtesy of the Textile Archive, Heriot Watt University, Edinburgh.

Spanish art held in Geneva in September 1939 – an exhibition that clearly had an effect on many French couturiers of the time.

The impact of religion and Spanish religious art on Balenciaga's work has not been explored beyond his borrowings of images from certain paintings, notably by Zurbarán. As noted earlier, religion was a fundamental part of his life, even in Paris. Although the draped garb of Zurbarán's saints or clerics affected Balenciaga's experimentation with fabrics, the processional sculpture and vestments he saw in church contributed to his feeling for the mass of fabrics and their sculptural possibilities, and to his cutting of garments in very simple forms, based on circles, semicircles and tunics – flat shapes, not figure-hugging or revealing ones. Shapes could be made by gathering and belting rather than by darting and seaming. His later collections, in particular, owed a debt to liturgical vestments – the gazar wedding dresses and the evening dresses of the late 1960s are positively ascetic in their austere simplicity (see Conclusion).

Practical experience of making vestments probably affected Balenciaga's work. The soutane he had made for the parish priest at Igueldo was familiar to him from his tailoring apprenticeship in Spain, where he probably also learnt to cut and construct ecclesiastical dress. The fact that the Basque country produced a disproportionately high number of priests before and during the Franco regime suggests that a young apprentice tailor in San Sebastian had plenty of practice in the cut and construction of vestments – a relatively simple task given that such garments had remained more or less the same for centuries. Balenciaga's apprenticeship probably differed little from that of his Guipúzcoan predecessor Juan de Alçega, author of one of the first Spanish tailoring books in 1580. Such books included patterns not only for men's fashionable dress but also ecclesiastical vestments, bishops' mantles and amices, clerical cloaks and soutanes.[50] These garments, like those of the sixteenth century, are still based on simple t-shapes and circles. The piecing of a full circle or semicircle from a narrow fabric was often a feature of Balenciaga's ball gowns, as of their ecclesiastical models. Vestments were usually cut by tailors, made up and, where appropriate, embroidered by nuns or professional craftsmen, whose needlework skills were renowned for their high quality.

Balenciaga's storehouse of ideas was not limited to three countries in Western Europe. He travelled widely, visiting other parts of Europe (Austria, England, Italy and Switzerland) and the USA. He also produced designs inspired by non-Western traditions: the Kabuki coat of 1955 and the sari dresses of 1963–5 derived from Japanese and Indian design respectively. Indeed, recently Miren Arzalluz has argued that Balenciaga's gradual move towards abstraction may have begun with an interest in the kimono and its depiction in artwork, the barrel line (1947) and the baby doll (1957) being early manifestations of the impact of Japanese modes of dress and aesthetic values on his work. Oriental imports were common in San Sebastian, the city having long traded with the Philippines and evidently

hosting more than its fair share of oriental emporia.[51] In addition, Balenciaga's heroine Madeleine Vionnet had a fine collection of Japanese artwork and artefacts. His contact with Indian design is rather less easy to pin down, but undoubtedly reveals his openness to material from any source.

Although Balenciaga turned overtly on only rare occasions to non-Western sources, he often dipped into the past and drew inspiration from history. His own collections of historic costume and textiles, and of nineteenth-century fashion plates, were both the outcome of this interest and the source of many ideas. The textile collection that Balenciaga gave to the Musée de la Mode et du Costume (Galliera) in Paris comprises both historical garments and flat textile fragments, with Spanish regional items and European fashions from the mid-eighteenth century to 1930. The bulk of the collection covers the mid- to late nineteenth century and includes many embroidered, brocaded and beaded items. Black and white predominate, although an old pink-and-beige striped taffeta polonaise of about 1870 and a mantle of puce-coloured taffeta with three flounces, embroidered and edged with fringes, dating from about 1845, recall Balenciaga's fascination with pinks and purples. The textile fragments reflect his curiosity about different types of fabrics, trimmings and their treatment. His collection enabled him to study closely the detail and effect of different textile techniques, the juxtaposition of colours, especially black and white, and also the construction of nineteenth-century garments. His work bears testimony to this study.

Balenciaga's interests in history did not prevent him from gradually developing away from late nineteenth-century modes of dress and construction. In retrospect, he seems to have made an immense leap from his lines of the late 1930s and '40s to the very individual lines of the 1950s and '60s, from a comfortable place among the mainstream couturiers to a position from which he could offer an alternative to their lines. Already successful in Paris before the Second World War, Balenciaga

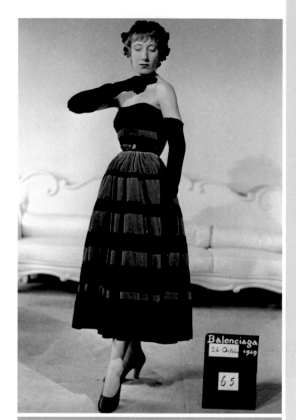

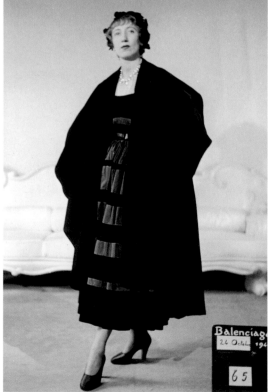

43 & 44. **House photograph of ensemble and dress, autumn–winter 1949, no. 65.** These house photographs give some impression of how the designer himself wanted the garment to be seen. This ensemble of winter 1949 clearly owes much to regional Castilian dress in its use of contrasting bands of colour. Balenciaga, however, turned it into a glamorous short evening dress by creating a fully rounded bustier style, to be worn with a dark silk coat and hat. He chose a silver necklace alone as additional adornment, and black shoes as accessories. The use of a blond mannequin with a 'disagreeable air' removed some of the potentially stereotypically 'Spanish' overtones.
Courtesy of the Archives Balenciaga, Paris.

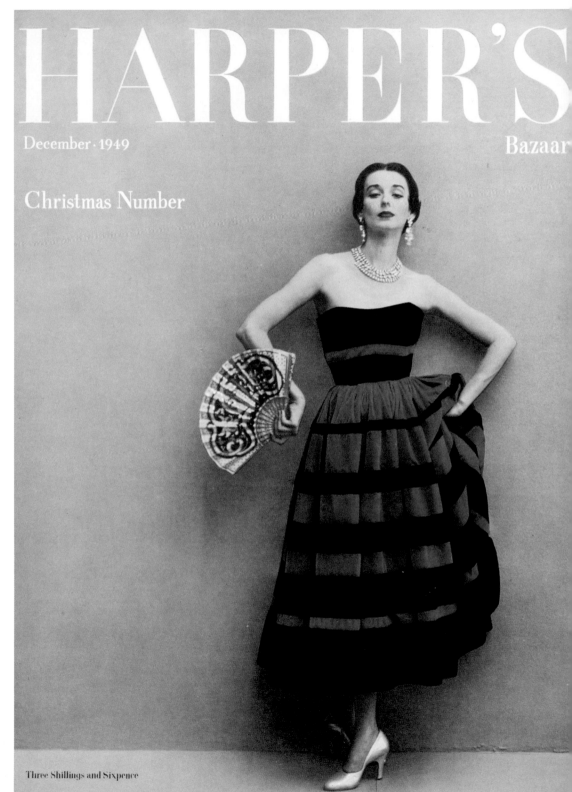

HARPER'S

Bazaar

December · 1949

Christmas Number

Three Shillings and Sixpence

45. Richard Avedon, *Dorien Leigh in Balenciaga, Harper's Bazaar* (December 1949). In contrast to the house photograph, Richard Avedon set up the shot that featured on the Christmas issue of a high-class fashion magazine in quite a different way. He – or the magazine's fashion editor – selected a mannequin and accessories that would emphasize the glamour of the dress, worn without gloves or coat or hat. The end product was a thoroughly festive image, posed as if the mannequin might suddenly shift into flamenco dancing. Dark-haired Dorien Leigh, one elegant foot on the ground in a silver high-heeled court shoe, held a large silver fan in her right hand and bunched up her skirt with her left. Her necklace was complemented by chandelier-like earrings, reminiscent of the heavy filigree jewellery of traditional Spanish dress of different regions.
Photo: Richard Avedon. Courtesy of Richard Avedon Foundation.

really emerged in the late 1940s as the main
rival of the favoured designers of the period –
Fath from 1937 until his death in 1954, Dior
from 1947 until his death in 1957, Chanel from
her comeback in 1954, Givenchy from 1956
and Yves Saint Laurent from 1959. The only
competition to throw a very real shadow over
Balenciaga came from his own workrooms, from
his former apprentice Courrèges, who shocked
the mature and delighted the young with his
Space Age collection of 1964. Ironically, it may
have been Balenciaga's fascination with the
fossilized traditions of regional and ecclesiastical
dress that led to his most abstract designs –
and paved the way for Courrèges.

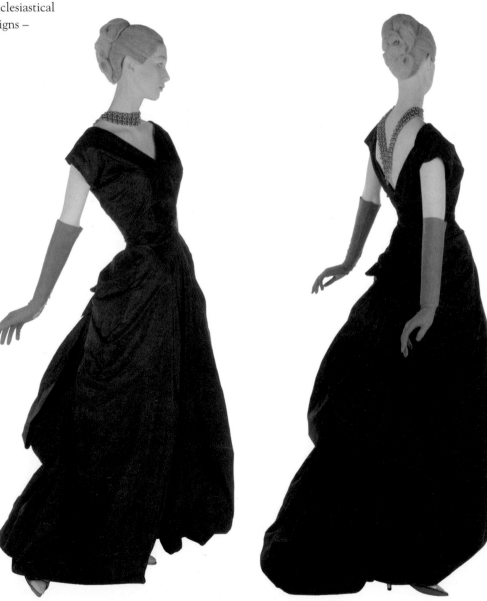

46 & 47. (LEFT) **Evening dress of red silk taffeta (back and side).** This gown is a good example of many of the immense draped and flounced dresses of the 1950s, some reminiscent of late 19th-century bustle effects. In this dress Balenciaga confined the bouffant drapes to the back, while retaining a simple smooth front with a v-neck and a straight, very narrow skirt at the front (with a slit in the hem to ease movement). The back consists of a swathed, drawn-back skirt with a double tier of enormous triangular flounces (formed by looping and gathering) topped by a large bow. The flounces are wired to keep their bouffant shape. The dress is mounted on a boned and padded foundation, which fastens at the centre back with a zip.
V&A: T.427-1967.

48. (RIGHT) **'The Ladybird'** *(La coccinelle)*, **1962.** The evening ensemble *La coccinelle* revealed Balenciaga's continued love of spots and manipulation of puffs and swags. It comprises a short dress worn with a ballooning cape with a frilled border. The dress itself is bustier in style, like the one in Plate 30, but tubular rather than waisted, with an enormous frill right down the length of the left-hand side of the body. The hem is also frilled. The red taffeta was warp-printed with black spots, and manufactured by the Lyons silk manufacturer Ducharne. This particular outfit was purchased from the house by Madame Antenor Patino, a very wealthy cosmopolitan Portuguese client.
Courtesy of the Musée Galliera, Paris.
Photo: Chantal Fribourg.

3

COMMERCIAL CULTURE

His [Balenciaga's] *life is his work, which at times leaves him hungry and empty, at other times filled with anger and a sense of great injustice when he sees ruthless copying of poor quality. It rarely seems to give him a feeling of fulfilment, as it never reaches the perfection he so desires.*[1]

Bettina Ballard

In Balenciaga's years in Paris certain fundamental changes in couture took place. Harry Yoxall, former Managing Director of British *Vogue*, describes in his autobiography the transformation of the industry from a dependence 'entirely on a cosmopolitan private clientele' to one on 'department store and wholesale buyers'. The Second World War was critical in breaking down the original couture system. As private fortunes dwindled, the cost of couture became impossibly high for many erstwhile clients, and wholesalers responded by producing accessible adaptations of couture models at a moderate price. The emergence of fashion news in the daily and Sunday newspapers also affected the availability and accessibility of high fashion.[2] These changes were all part of a process of commercialization that had, in fact, begun before the war. One of the consequences of the Wall Street Crash of 1929 was the increase in export tariffs on made-to-measure garments. This increase encouraged French couturiers to export the patterns for their models as *toiles* to avoid a 100 per cent mark-up on their prices.[3] Such a move meant that the actual models were made or manufactured outside the couture house and not directly under the supervision of the couturier. This situation was not very far removed from *prêt-à-porter*, ready-to-wear designed by couturiers but produced by commercial manufacturers - the main development in the post-war years.[4]

To survive in couture, therefore, couturiers had to adapt, and Balenciaga did. He established his first documented dressmaking house in 1919 in San Sebastian, under the old system of couture, making individual garments for individual clients.[5] He made biannual trips to Parisian couture houses, where he bought models to take back to Spain to adapt for his Spanish clientele. He thus understood this system; its emphasis on fine craftsmanship remained his ideal. When he opened in Paris in 1937, Balenciaga was not a novice. He was over 40 years old and had already weathered difficult times in Spain, including the bankruptcy of his second house in San Sebastian in the early

49. **Image of Balenciaga from French *Vogue* (February–March 1948).** A feature in French *Vogue* in 1948 used M.G. Peltier's new map of Paris to introduce the locations and buildings of some of the most important couturiers. The photograph placed on the map reveals that the House of Balenciaga already had two long signs attached to the second-floor balconies of the building. The hoarding over the shop window indicates the imminent arrival of Balenciaga perfumes. This was the year that Balenciaga launched his first two fragrances, *Le Dix* and *La Fuite des Heures*. Couturiers had begun diversifying into perfumes well before Balenciaga arrived in Paris.

Honeyman © *Vogue* Paris

1930s. He had relaunched himself, and successfully run houses in three major Spanish cities simultaneously. This chapter investigates how the House of Balenciaga functioned commercially, the ways in which it emulated and differed from its competitors in Paris. It does so by considering various facets of commercial culture: the formation and financial basis of the house, the location and public façade of its premises, its internal layout and structure and, finally, its approach to its product and publicity.

Commercial Realities

When Balenciaga established himself in Paris in 1937, he did so having temporarily left behind his houses in San Sebastian, Madrid and Barcelona.[6] Subsequently, after the Spanish Civil War, he reopened each of these businesses, apparently managing them independently of the Parisian concern. Balenciaga himself kept an eye on their affairs; many of the garments followed his Parisian models; and many of his crucial employees either began their working life or were sent for a spell of training there.[7] The Paris house was, therefore, only one component of Balenciaga's business affairs; largely invisible to most Balenciaga clients were the three couture houses that traded under the Eisa label.[8] Although their exact fiscal nature is still not fully known, nor the contribution they made to Balenciaga's solvency, they should not be forgotten because at the end of his career Balenciaga had a combined total of 219 employees in Madrid and San Sebastian, as compared with 500 in Paris.[9]

In Paris, Balenciaga relived his first experience of forming a partnership, in San Sebastian in 1919. He became the key player in a house that carried his name and depended upon his talents. Yet he invested considerably less capital in the business than his partners and could not have set up on this scale without backing. In San Sebastian in 1919, the shopkeeper sisters Benita and Daniela Lisazo Landa put up 60,000 (£2,537) of the 67,372.25 pesetas (£2,849) capital in order to form *Balenciaga y compañía*. The partnership was to last for six years, in line with the short-term nature of many such arrangements in the luxury sector. Should Balenciaga die unexpectedly, the partnership would be dissolved. The undertaking in Paris in 1937 was much smaller: Nicolas Bizcarrondo and Vladzio Zawrorowski d'Attainville put up 95,000 (£762) of the 100,000 francs (£803), Balenciaga 5,000 francs (£40).[10] This sum was less than the minimum amount needed to set up as a couturier in that year, as Fig. 1 demonstrates.

The intended lifespan of the business meant that changes in investment and value were likely. Growth and diversification into perfumes, as well as the death of one of the partners, played a role in the redisposition of the funds. In 1946 the amount of capital was increased to 2,000,000 francs (£4,167): 1,425,000 francs (£2,968) belonged to Bizcarrondo, 380,000 (£792) to d'Attainville and 25,000 (£52) to Balenciaga, who was still

Fig. 1 Couture businesses that opened in 1937/8 and were still active in 1955

Couturier	Nationality	Number of partners	Address	Initial capital (francs)
Jacques Fath	French	6	32 rue de la Boëtié	25,000
Madeleine Bultez	French	4	7 Avenue Rouget de l'Isle	50,000
Claude Rivière	French	2	75 rue du faubourg Saint Honoré	50,000
Balenciaga	**Spanish**	**3**	**10 Avenue Georges V**	**100,000**
Pierre Clarence	French	2	9 rue St Florentin	500,000
Jean Dessès	Greek	1	37 Avenue Georges V	610,000

Sources: Archives Nationales, F12 10.505 Declarations Couture-Création and Archives de Paris, Registre de Commerce.

the minority partner.[11] After d'Attainville's death at the end of 1948, Balenciaga bought d'Attainville's share from his heirs.[12] The following year a further increase in the capital took it to 30,000,000 francs, and in 1955 Bizcarrondo gave up 0.35 per cent of his share to four new partners: Renée Tamisier, *directrice* of the house since 1945; Ramón Esparza, the hat designer; Juan Tomás de Bareno, who marketed the perfumes; Marcel Leyrat and Étienne Hommey.[13] Subsequently, the business changed its status from a limited company (SARL) to a Société Anonyme (SA), indicating that it had gone to the stock exchange for finance.[14] The final increase in capital occurred in 1957, when the sum rose to 150,000,000 francs (£14,148). A year later the perfume franchise became separate from the couture house, the two merging again only in 1972 after Balenciaga's death. Thus, the couture house, which dealt in 'couture and all feminine attire' ('couture et toute la toilette feminine'), initially acted as an umbrella for the perfumes; subsequently, it garnered profits from them.[15]

While these figures suggest substantial growth, they do not reveal the annual turnover of the house. Rumour had it that at the end of the 1950s Balenciaga's house made the greatest profits in Paris. *Women's Wear Daily* speculated that they amounted to about $1,500,000 (£533,807).[16] Not surprisingly, the house operated from prestigious premises located in a propitious part of Paris, and had a very particular modus operandi.

Location, Location, Location...
Balenciaga SARL, later Balenciaga SA, was located from its foundation at 10 Avenue Georges V in the eighth *arrondissement*; during Balenciaga's life all activity took place here, from creation to sales. This location had several advantages. It was in the Parisian quarter in which wealthier members of the Spanish immigrant community congregated (Pont d'Alma), and more precisely, directly opposite the fashion house set up by Balenciaga's fellow Spaniard, Rafael López Cebrián. Having Gallicized his name, Raphael had worked from

3 Avenue Georges V since moving from Madrid in 1930, and in the 1950s had his own perfume and furs counter. Although little known today, he featured consistently and prominently in French fashion magazines throughout the 1950s, and was most frequently and highly praised for his tailored garments.[17] This address was just around the corner from the home of the Basque engineer Nicolas Bizcarrondo, next-door neighbour to Balenciaga and his other partner, who was an interior decorator.[18] Avenue Georges V was also in the heart of the Golden Triangle, the area of Paris given over to the luxury trades since the late nineteenth century. While Raphael (and subsequently Givenchy) was across the road, Mainbocher was next door at number 12, in premises that Balenciaga subsequently added to his empire. Jean Dessès opened in the same year as Balenciaga at number 37. He moved round the corner into rue Rabelais after the war, to join other major couturiers who worked in adjacent streets: Jacques Fath in Avenue Pierre 1er de Sérbie, Jacques Heim in Avenue Matignon, Pierre Balmain in rue François 1er and Christian Dior in Avenue Montaigne.[19] The buildings and environment were particularly appropriate for the pursuit of couture businesses, whose whole ethos revolved around an elite clientele. Some of those very clients had apartments in similar buildings in the same area, and decorated them in similar taste.[20]

The parallels between Balenciaga's previous – and subsequent – Spanish premises and the couture house in Paris are striking. The physical location and nature of the buildings in each city reveal the profile that the house sought and Balenciaga's awareness of the difference between the clients he was likely to attract in each city. The houses of San Sebastian, Madrid and Barcelona were built in a similar conventional European architectural style and located in the most lucrative and fashionable cities in propitious streets for luxury consumption: San Sebastian was the official retreat of the government in the summer recess and a popular seaside spa town; Madrid was the Spanish capital and centre of government; and

Barcelona was the country's largest city and home of the textile industry.

In San Sebastian, where his main clientele were summer visitors, Balenciaga took space in the Avenida de la Libertad. It was the major shopping boulevard, at the heart of the city, running directly from the Plaza de España to the esplanade and lined by many tailoring and textile establishments. Number 2 was right at the end nearest the magnificent bay of La Concha. In this area, the fashionable, elite visitors promenaded, only a stone's throw from the best hotels (those listed as first and second class in tourist guides to the city) in which they resided. As in Paris, Balenciaga's dressmaking establishment was on the first floor, and remained at the same address throughout his career.

In Barcelona, the house that he rented was much more discreet, tucked away in what had probably been built as a family home in 1851, in a narrow street just behind the main new shopping centre of the Paseo de Gracia, which has been described as the 'showplace of the new bourgeoisie triumphant where clothes and people exhibited themselves'.[21] It was therefore round the corner from the impressive Art Nouveau (*Modernista*) and historicist style family homes of the wealthy Catalan bourgeoisie and aristocracy, extremely accessible for his most likely clients, who were renowned

for their industry and discretion rather than their flamboyance. Renovated in 1942, the premises comprised commercial and living space, the former mainly on the ground floor, the latter on the first floor. On either side of the entrance were two small salons (*sala*), bordered on the right by a large salon and on the left by stores (*almacén*). Beyond were offices, space for the models (*modelos*) and for haberdashery. The changing rooms were on the first floor, as were a kitchen, bathroom, drawing room, dining room and bedroom. A large terrace or balcony took up a proportion of the back of the first floor.[22] There is no indication that Balenciaga called attention to his business on the exterior in any way that required planning permission. Again, Balenciaga retained these premises throughout his career.

Only in Madrid did Balenciaga move premises, although he did not move district. His establishment there was located at the heart of the most recent developments in the construction of the shopping area, before the Civil War in the calle Caballero de Gracia (number 42) and after the war just round the corner in the Avenida José Antonio (Gran Vía) at number 9 on the first floor. This impressive street was the main artery through the city, the height of fashion, and his business looked directly across at the most fashionable

50. **Ground plan of Eisa at calle Santa Teresa 10, Barcelona, 1942.** Balenciaga sought permission from the city authorities to renovate the two-storey house in Barcelona in 1942. In particular, he widened some of the doorways on the ground floor which was where the public viewed the shows. The fitting rooms were on the first floor, as was living space of a terrace, kitchen, bathroom, drawing room, dining room and bedroom. Courtesy of Archivo Administrativo de Barcelona.

rendezvous, the café Chicote, which was patronized by the cosmopolitan rich and famous, among them Ernest Hemingway and Ava Gardner.[23]

Clients of the Chicote could not have missed Balenciaga's house, since he believed in sensibly placed and simple publicity to attract attention in the busy urban landscape. In Madrid, one of his first moves in 1934 was to apply for permission to erect a neon sign on the first-floor balconies that corresponded to his premises. These signs read 'Costura Balenciaga B.E. Costura' (Couture Balenciaga B.E. Couture) and occupied the width of four balconies on the façade.

In Paris, the potential of the exterior was exploited even more: there were signs on the second-floor balconies and also above the shop windows. There, the other eye-catching element of the façade was the window display. At ground-floor level, three windows offered scope for amazing passers-by or attracting prospective clients into the shop (*boutique*). By 1952 Balenciaga had found Janine Janet, the sculptor who was to collaborate with him in creating the impression he sought. In contrast to his peers for whom she already worked, he wanted exceptional windows with exquisite sets that would last (one particularly satisfactory window even remained *in situ* for a year and a half). He was willing to provide the best materials, from the stocks reserved for his couture gowns, if necessary; and he brooked no hint of sordid commercialism.[24] Free to experiment, Janet undertook sustained research and used unusual techniques and precious materials for her compositions, her one objective being to 'suggest a three-dimensional effect equivalent to the luxury of the collections'.[25] She drew inspiration from historic sources (engravings from the seventeenth and eighteenth centuries) and from natural materials, some of which she already used frequently in her work – feathers, shells, coral, sheaves of wheat. The only product of the house permitted in the window displays – discreetly presented – were perfume bottles. The grandeur of their surroundings masked their existence to some extent.

51. Architectural drawing for the proposed neon sign for the first-floor balcony of calle Caballero de Gracia, Madrid, 1934. Balenciaga opened Eisa B.E. Costura in Madrid in calle Caballero de Gracia in 1934, according to trade directories for the city. The house remained there until 1936, by which time Madrid was under siege from the Falangist forces. In 1934 Balenciaga applied to the city authorities for permission to erect a neon sign on the first-floor balconies of the house. This is the architectural drawing showing what he intended. Note the Modernist nature of the font he was using for the name of the business.
Courtesy of the Archivo de la Villa, Madrid.

In 1952 Janet's first windows housed trophies representing Air, Earth and Water. Feathers and arrows cascaded over sculpted birds; sheaves of wheat complemented straw hats and wreaths of flowers; an anchor was draped with fishing nets and reeds. The grandiose three-dimensional results recalled the patterns by silk designers and weavers such as Philippe de Lasalle (1723–1804).[26] The following year Janine Janet made references to the centuries-old tradition of the Parisian luxury trades in three figures, The Perfumer, The Dressmaker and The Milliner, abstracted figures carrying the attributes of their trade. These particular displays were so successful that Balenciaga's representative in the USA wished to exhibit them there. Subsequently, Janine Janet erected exotic grotto-like installations of Mermen and Mermaids, fabricated from cockle and mussel shells, perfume bottles nestling in shells in the hollow of their hands. It is not surprising that photographers took the opportunity to record house fashions against the backdrop of the window displays. Thus, the conspicuous air of luxury of the windows contributed to the spirit of the garments, and the references to a long tradition of luxury. Janet's reputation benefited greatly from her association with Balenciaga and its results, as the report in *Vogue* on the trappings for the eighteenth-birthday party of the daughter of one of Balenciaga's important clients revealed. While mother and daughter dressed in Balenciaga, the *mise-en-scène* drew on Janet's skills.[27]

Structure of the House: Space, Staff and Clients

Internally, similar attention to detail was evident. Balenciaga eventually occupied two floors of 12 Avenue Georges V and three of 10 Avenue Georges V. Spaces were accessible to different constituencies of employees and clients, some being public spaces, others semi-public (by invitation or introduction only), and others private (for the running of the business). The layout was not dissimilar to that of other couture houses, and the spaces were decorated according to their function. Certain elements of

52. (LEFT) **Photo of the Balenciaga boutique, decorated by Christos Bellos.** On the Avenue Georges V the window displays drew attention to the shop. They contained artistic sculptural creations, sometimes perfumes, but never garments or prices. Often these displays were in place for more than a year at a time, a continuity that reflected his interest in gradually evolving fashion and longevity in styles. *Courtesy of Balenciaga Archives, Paris.*

53. (LEFT, BELOW) **Seeberger frères, fashions posed in front of the shop windows designed by Janine Janet, Autumn 1962.** *Courtesy of Bibliothèque Nationale de France.*

54. (RIGHT) **Janine Janet, *Shop-window Display for Balenciaga*, 1953. *The Perfumer*.** Janine Janet began designing windows for Balenciaga in 1952 and continued to do so until 1968. In this instance her design sources were probably engravings from the time of Louis XIV, a reference to the luxury trades that the king sponsored and which became so important to the Parisian economy. The other two windows had similar figures, representing the Dressmaker and the Milliner. The figure has a glass hat, head and hands, paper epaulettes, and the chest has shelves displaying Balenciaga perfumes. *Courtesy of Michael Tayals.*

the atmosphere were, however, idiosyncratic, according to former employees and clients. The proprietor's presence was austere and demanding, and he exerted control over every aspect of activity.

On the ground floor was the boutique, theoretically accessible to all. Redecorated in 1948 by Christos Bellos, it did not change thereafter. In it, perfumes and accessories were sold. The shop acted as an entrance to the premises, a through-route to the famous lift that took private and trade clients to the salons on the first floor. Clustered around the lift on the first floor, by the 1950s, were the cloakrooms, the *vendeuses'* room, two salons (one big enough to show the collections to professional customers and the press; the second more intimate, more appropriate for private clients wishing to view the models) and fitting rooms for private customers, as well as changing rooms for the mannequins. The Grand Salon overlooked the street, while the blue salon was on the main internal courtyard. The rest of the building was given over to workshop space and offices, the tailoring workshops, the design studio and the offices on the first floor. The dressmaking and millinery workshops and one of the tailoring workshops were on the second floor.[28] Balenciaga's own office was located in a far corner of 12 Avenue Georges V, right next to the management's staircase, between the design studio (Fernando Martínez) and Salvador's tailoring workshop – surrounded by Spanish speakers.

The staffing structure of the house was basically the same as that of other couture houses. At the top of the pyramid were Balenciaga and his business partners, Vladzio d'Attainville, who designed the hats until his death in 1948, and Nicolas Bizcarrondo, the sleeping partner who had provided the initial finance. Below them were the employees who collaborated in the design process. Ramón Esparza took over the designing of the hats after d'Attainville's death and Fernando Martínez helped with the designing of many of the models. He was, in fact, a more skilled draughtsman than Balenciaga and produced

many drawings to Balenciaga's specifications. The two apprentice couturiers, Courrèges and Ungaro, figured at this level also, contributing both ideas and drawings, as well as learning the skills of cutting and sewing. The *directrice*, Renée Tamisier, who managed the premises, had a powerful role amongst all these men, as her shareholding from 1955 suggests.

At a lower level, yet still immensely important to the couturier, were the tailors and cutters who brought their work to Balenciaga for approval. The tailor Salvador remembers that all models had to be submitted for inspection four times: once to check that the fabric was correct, and three times to review the design. On the next rung down on the ladder of employees actually involved in the making of the models was the *premières d'atelier*, who presided over the workrooms. One specialized in hats, one in dresses and one in tailoring. Balenciaga's cutters were substantially better paid than the *premières d'atelier*, whereas in other houses the differential was minimal (see

55. (LEFT) **The Boutique** In 1948
Christos Bellos designed the interior
of the boutique on the ground floor
of 10 Avenue Georges V. He chose
flooring and furnishings in keeping
with the couturier's Spanish
background: black and white tiles,
heavy dark furniture and imposing
high-backed chairs of red Córdoba
leather. In this environment scarves
and other accessories were sold, as
well as the house perfumes.
Courtesy of Balenciaga Archives, Paris.

56. (RIGHT) **Eric [Carl Erickson],
drawing of mannequin in the lift at
Balenciaga, wearing a dress
designed by the house, published
in British** *Vogue* **(November 1948).**
The lift at Balenciaga was famed. It
was lined in red leather and
decorated with brass studs and
evidently moved at a very slow and
stately pace. It acted as the
threshold between the public and
private world of the couture house,
only the initiated being allowed into
the first-floor salons. Private clients
arrived by invitation, as did the
press and commercial buyers.
Responsible behaviour was
expected and serious attention to
the clothes.

Appendix 4). This emphasis on cut is not surprising, given the sculptural perfection of much of Balenciaga's work and its deviation from traditional methods of cut and construction.

The seamstresses completed the main behind-the-scenes staff. In 1953 the house employed 244 seamstresses, and there were probably ten workrooms: four for tailoring, four for dresses and two for hats.[29] Balenciaga also engaged staff who dealt with the public: the ten house mannequins, the *vendeuses* who attended to individual clients, the window-dresser, the boutique attendant, the receptionist and the doorman. In the backrooms were the mannequins' dressers, the storeroom staff and the accounting department.

Balenciaga's house mannequins attracted much attention. They were, according to Fernando Martínez, all different female types, and of different nationalities and races, reflecting the international message of the house.[30] Many people remarked on their very

special method of presenting the clothes and on their unsmiling, remote demeanour as they progressed down the catwalk. Bettina Ballard averred that she had never been able to catch the eye of a mannequin at Balenciaga's. The really important factor behind their special training was their role as clothes-horses. They were there to show the clothes to their best advantage. Nothing about them should therefore detract from the clothes. The mannequins in the Spanish house in Madrid were subject to a similar discipline. The journalist Josefina Figueras recounts that Balenciaga watched the shows from behind a curtain. The shows lasted for exactly an hour, but if Balenciaga was not happy with a mannequin's passage round the salon, he ordered her back into the room in front of the same audience, carrying the same number and wearing the same model.[31] Balenciaga trained the mannequins himself – another sign of his control over his workforce – and he attempted to insist that fashion photographers use his

Commercial culture **71**

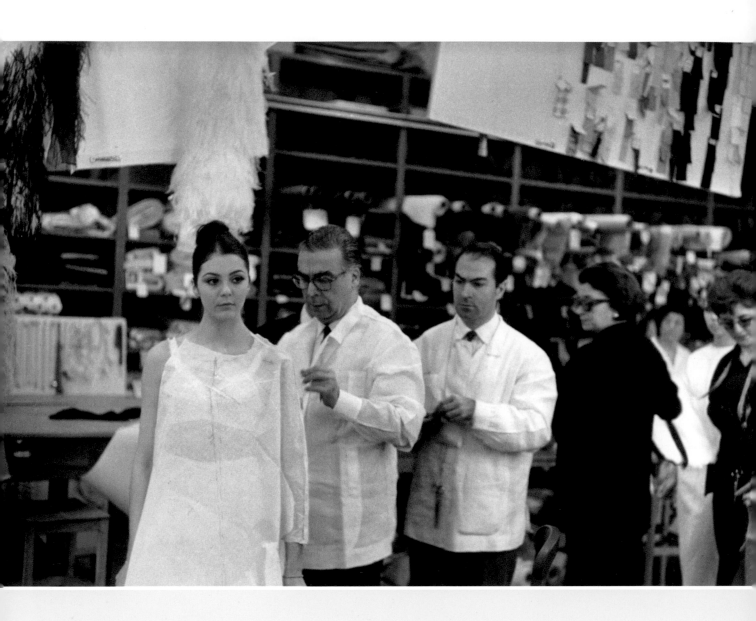

59. **Henri Cartier-Bresson,** *Balenciaga at Work*, **1960s.** The workrooms were very simply furnished with workaday wooden accoutrements as befitted their function: charts showing the models and textiles in use hung from racks on which rolls of textiles were stored. Staff working on the making of garments wore protective white coats while workshop heads or *vendeuses* dressed in black. In this image Balenciaga fits one of the of the house mannequins as his assistant Ramón Esparza looks on. The shadow of underwear glimpsed below the toile reveals that substantial foundation garments were worn under Balenciaga's models in the 1960s – even though his 'easy' styles purportedly let the body breathe.
© Henri Cartier-Bresson/Magnum Photos.

in-house staff for their photographs. This insistence partially explains why in some magazine fashion spreads the heads are cut off, since the mannequins were chosen for their carriage rather than their photogenic faces. Balenciaga was not completely successful in this respect, as is evident from some of the well-known faces on magazine covers.

Product, Pricing and Diversification

Balenciaga's 'good healthy instinct for being paid justly for what he creates' was well established by the time of his arrival in France, as were certain ideals and standards.[32] He believed in using the best and most up-to-date materials and already had good working relations with French textile manufacturers, some of whom were to collaborate with him in the creation of new fabrics (see Chapter Two). His experience, knowledge, high standards and business sense were a firm foundation and enabled the house to develop a reputation for quality and reliability. Such reassuring attributes benefited the business and its employees. Outsiders recognized both customer and employee loyalty.

In the absence of firm documentary evidence about the internal financing of the firm, its pricing and self-presentation are the only basis for assessing its strategy. The costing process for garments involved complicated accounts, which took into consideration maintenance and insurance of the property, expenditure on fuel, on staffing and materials, on publicity and shows.[33] Textile manufacturers who dealt with the house vouch for efficiency in the ordering of fabrics. Evidently, Balenciaga knew precisely which fabric he wanted and in what quantity, and he never needed more than requested. His calculations for the same model in different sizes required infinitesimal differences in quantity of fabric, according to Pierre Ducharne.[34]

Dependent on the quantity and type of fabric and trimmings, the hierarchy of prices rose from the simplest to the most complex garments: from blouses and day dresses to suits and evening dresses, which were often very elaborately embellished. In 1947, however, one

of the order books shows that small garments could be very expensive, an embroidered satin bolero (*bolero brodé satin*) costing substantially more than a woollen suit. A gaberdine raincoat was in the same league as the suit, but an evening dress in black wool was more expensive and a jersey day dress less so.[35] Prices also varied according to the purpose of the buyer. The house operated a rising scale for private customers, department stores and wholesale buyers. The single commission for private consumption was least expensive, the model for reproduction in small numbers cost more, and the model for wholesale reproduction cost most. In 1954, for a woollen suit, a private client paid 130,000 francs (£130), whilst a department store paid 265,000 francs (£270). Wholesalers paid as much as £1,000–£1,500 for the same item, because they were permitted to attend the shows only if they contracted to buy two outfits.[36] The British ready-to-wear manufacturer Frederick Starke noted in 1965 that the price of an original Balenciaga was about £600, but that the entrance fee to the Balenciaga show cost £1,500, and was essentially a contract that committed the ready-to-wear manufacturer to buy two models, which were not necessarily exclusive. These conditions compared with £200 at Christian Dior for a paper pattern of any Marc Bohan design. Starke suggested that this was one reason why more copies of Dior than of Balenciaga were seen on the streets.[37] These prices were therefore expensive by the standards of other couturiers. Balenciaga was sensitive to the worth of his models, believing that he designed a quality garment and should be paid accordingly. As a result, he refused to sell his models in the form of paper patterns, because such patterns showed neither how the garment was constructed nor the quality of the components, such as fabric and trimmings, interlinings and paddings, buttons and other fastenings.

Naturally, the house also paid attention to inflation and to the rising cost of maintenance. Between 1947 and 1968 the price of a woollen suit for a private client rose from 43,600 old francs (£90) to 4,005 new francs (£340).[38] In

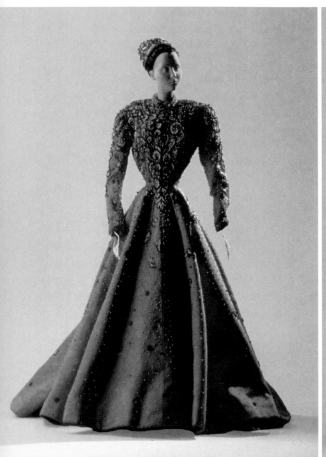

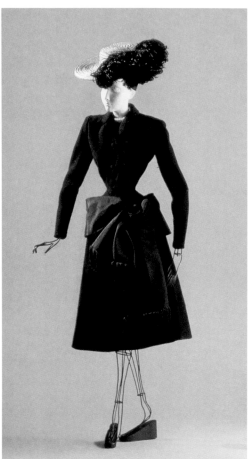

60 & 61. **Figures from the *Théâtre de la Mode*, 1945.** Metal wire, clothed in textiles, 70cm high. The black wool suit and the raspberry-red evening gown reveal the same austere line: square shoulders, fitted bodice, tiny waist and full skirt. The skirt of the suit emphasizes the width of the hips with a large stole of black faille, which tied over the skirt and ended in a silk fringe. There was no relief to the matte black wool other than the accompanying cream straw boater with its large black drooping ostrich feather. The evening dress was also simple, relying on its colour and lavish embroidery for effect. White pearls and red cabochons encrusted the bodice and gradually petered out into the skirt. A matching beaded pillbox hat added the finishing touch. The suit was illustrated in French *Vogue* (Summer 1946).
Courtesy of the Maryhill Museum of Art, Goldendale, Washington, DC.

addition, the house was unsentimental about the models worn by its mannequins, selling them off at a reduced price at the end of the season.[39]

Although it may look as if every service had its price, numerous anecdotes reveal that some services had no price *chez* Balenciaga. Fernando Martínez, Balenciaga's associate, tells the story of a big American wholesale firm that wanted Balenciaga to alter one of his designs for them. The garment in question was an embroidered lace evening gown with a two-metre train. The firm asked for the train to be shortened to one metre. Balenciaga refused, choosing not to compromise his design. Martínez also relates how Balenciaga received a commission to design a Spanish hidalgo costume. He was happy to accept, until he learnt that it was intended as the uniform for the client's *maître d'hôtel*.[40] Again, he was prepared to lose a

valuable commission in order to retain his good name. This uncompromising behaviour worked to the advantage of the house and its reputation only because Balenciaga judged each case on its own merits. When manufacturers commented on the bagginess of the sack line in the mid-1950s, and the fact that it would not reproduce well and would appeal to few women, he listened. His next collections reduced the fullness whilst retaining the original proportions. These moves made good business sense and did not adversely affect his designs.[41]

In the post-war years Balenciaga also saw the advisability of bringing out a range of perfumes and accessories. His first scent, 'Le Dix', named after the couture house at 10 Avenue Georges V, came out in 1948. 'La Fuite des heures' (1948) and 'Quadrille' (1955) followed. The range of accessories included scarves and

handbags. Three brands of stockings named after his perfumes were also launched by T. B. Jones in Britain in September 1960, their names corresponding to the names of the perfumes.[42] Such less expensive products spread the name of the house in the same way as wholesale reproductions without compromising the couturier's reputation. Despite his acknowledgement that times had changed, Balenciaga did not adapt any further. He chose not to design any ready-to-wear collections of his own, and not to license his name to any large manufacturing concern. In this he differed from most of his fellow couturiers. By 1953 Dior was designing de-luxe ready-to-wear collections as well as couture, and by 1971 Givenchy was designing not only two couture collections per year but also ready-to-wear and boutique collections. In 1985 the diversification had reached such an extent that Ungaro, Balenciaga's ex-apprentice, was producing ten collections, only two of which were couture collections.[43] Aware of the implications of his choice not to create ready-to-wear collections and not to desert his mature clients, Balenciaga retired in 1968 at the age of 73. He did, however, confide in the Marquesa de Llanzol: 'I regret not being younger, as I would create amusing but tasteful ready-to-wear as the times we live in demand. For me it is too late.'[44]

Balenciaga was true to his own beliefs about fashion. His business practice followed his design in this respect, and when he realized he could go no further he was astute enough to stop. But the halt to his activities was only partial and only really focused on his couture operations. The Parisian house closed in 1968 after the spring collections. The branches in Madrid and Barcelona followed suit later, in 1969 and 1973 respectively. The house, however, continued to manufacture scarves, hosiery, handbags and perfume, a profitable source of revenue. According to Prudence Glynn, even in 1971 Balenciaga was also involved in a fashion project in Spain, although he was reluctant to talk about it.

Advertising and Publicity

Many biographical accounts give the impression that Balenciaga eschewed publicity entirely. He certainly managed to restrict his contact with the media and appeared not to subscribe to the view of the dynamic young Jacques Fath, that in the post-war period: 'You don't understand haute couture at all today if you don't realize firstly that it is based on advertising . . . advertising has changed radically our working condition.'[45] However, he did join in with communal attempts to attract attention to Parisian couture in the immediate post-war years. To the Théâtre de la Mode in 1945, the first couture showcase presented in the United States after the Liberation of Paris, Balenciaga contributed four miniature garments: a black wool day suit, a white broderie anglaise day dress, a white satin cocktail dress with black velvet trim, and a striking raspberry-red satin evening dress and matching beaded skullcap.[46]

Restraint was the key to Balenciaga's management of his public image. The house did not splash out money on advertising, although it did use the media to inform the public of its existence and whereabouts, and its different products. Most houses took out advertisements in the glossy fashion press at least once a year, in French, British and American editions. Balenciaga seems to have favoured a more localized approach for his couture house, with advertisements appearing in French *Vogue* just before the collections. In 1938 and 1939, for example, he took them out in July and March. The house had only just opened – the first collection had been in August 1937 – and these advertisements placed strategically at the front of the magazine were more an announcement of its existence and location than a promotional effort. The simple uncluttered format drew attention to the bold black letters at the top of the page. In the post-war years, the announcement was even more laconic, with a stark white page featuring the name and address of the house centre page, and the fact that it dealt in *Couture* and *Parfums*. Such announcements continued until the mid-1950s.[47] The name of Balenciaga did, however,

figure in other sorts of publicity, for example, in tie-ins with reputable textile manufacturers. In 1949, for example, the prestigious silk manufacturer Bianchini Férier promoted their silk faille and silk velvet via a model by Dior and one by Balenciaga, and in 1950 Porter, Bennett and Gaucherand showed a model in one of their wool crêpes. In Britain, the French Perfumery Co. advertised Balenciaga perfumes along with other couturier scents. These perfumes had become profitable enough by the late 1960s to keep going when the couture house closed.

Although wholesalers were not allowed to use the name of Balenciaga to advertise their goods, department stores were. In Britain, Harrods announced the arrival of its couture models for the Model Department each season in the newspapers, *Vogue* and *Harper's Bazaar*. From their first orders from the house in 1938, they included dresses, suits and coats 'inspired by Balenciaga' or 'adapted from an original Balenciaga'. It is impossible to calculate the effects of such publicity, but it inevitably brought the name of the house to the fore. Balenciaga's other source of publicity was editorial space. His clothes appeared twice a year in features on the Paris collections, and at other times in articles devoted purely to fashion. They also appeared on the backs of his wealthiest clients in the society columns – at the races, in the ballroom, at exhibitions, at official events. Finally, they appeared in features on the lifestyles of particular women. The international profile of Balenciaga's business thus spread via his clientele.

In 1956 Balenciaga made the headlines with his decision to postpone his showings to the press. Disgusted by the piracy of his designs, he decided that the press should see his collections four weeks after private customers and commercial buyers. He hoped in this way to protect the legitimate buyers of his models from competition with cheap copies pirated from press photographs and sketches. His loyal disciple Givenchy joined him in this crusade for a fair deal from buyers. The month between the two showings allowed for the making up and

delivery of orders taken after the first showing. Thereafter, the press could publish whatever it wanted. In this plan of campaign, American journalists were most likely to suffer, since they had farthest to travel and had to spend extra and expensive weeks in Paris if they wished to publish news from all the collections, including Balenciaga's. By this stage his mastery of his craft was famed and he could not be omitted. Here again was an instance of his belief in value for money and a fair price for his own work.

To take the sting out of the move and soften the blow to American buyers, Balenciaga and Givenchy made a smart, if expensive decision that first year of their boycott: they took their spring collections to New York for a flying visit in April. As American *Vogue* put it: 'Something new in New York: the showing here of the spring collections of Balenciaga and Givenchy. The fashions came by the plane-load, showed themselves for one night at the Ambassador Hotel for the benefit of the American Hospital in Paris and flew back.'[48]

The press remained fretful – vocally so – for some years. Eugenia Sheppard, Fashion Editor of the *Herald Tribune*, risked publishing material from buyers' reports. Balenciaga banned her from his house temporarily. Four years later in 1960, Ernestine Carter of the *Sunday Times* exploded at yet another delaying tactic:

This year, adding, if not insult to injury, at least complication to difficulty, Balenciaga and Givenchy have ignored the official release date [determined by the Chambre Syndicale] of March 1st and set instead independent (and different) dates for the publication of photographs from their collections. The whimsicality of their gesture is underlined by Balenciaga's choice of April Fool's Day.[49]

Since models were already available in London, she decided to risk publishing sketches.

Balenciaga and Givenchy probably benefited from their strategy: they certainly did not disappear from the pages of the fashion magazines. Indeed, they gained their own exclusive space in American *Vogue* and *Harper's Bazaar* for the month of May, and in the British edition for April, in other words a month after the other couturiers. They also received much

62. Advertisement, French *Vogue* (February 1950). It is often claimed that Balenciaga did not advertise at all. This was not the case, although it does seem that the advertising he took out was localized, and aimed at directing clients to his house. The text was always very simple, usually just the name and the address. Here he uses the labels that were sewn on to his garments, black on dark garments, white on light-coloured ones.

publicity in the form of screams of outrage from journalists.

The commercial culture of Balenciaga's house was similar to that of many of his couture colleagues, but it differed in certain respects. A generation older than all the other couturiers who had established themselves in Paris in 1937–8, Balenciaga began from a solid financial basis. Unlike them, he chose to follow the practices of an older, pre-war generation, not involving himself in ready-to-wear ventures or in extravagant publicity. He exerted considerable control over the image of his house, its product and presentation. He chose carefully his premises in all four cities at the outset and remained in the same location throughout. By not courting publicity, by employing discreet and loyal staff, and by feeding that base with injections of new blood from outside the French couture system, he differentiated himself from the Parisian post-war generation. The existence of his houses in Spain, and his continued contact with Spanish society, may well account for his ability to avoid modernizing. Even if most of the employees were French, the management structure was firmly Spanish. Up until Franco's death in 1975, the regime in Spain promoted traditional values and upheld social structures that had collapsed in northern Europe and America. Thus, sending crucial employees to Spain to 'rub off their rough edges' was tantamount to sending them to another world in which modernization and social change were not at the same stage as in northern Europe. Moreover, women's role in Spain was only just beginning to change; they were still tied to the home and had time to spend with their dressmakers.[50]

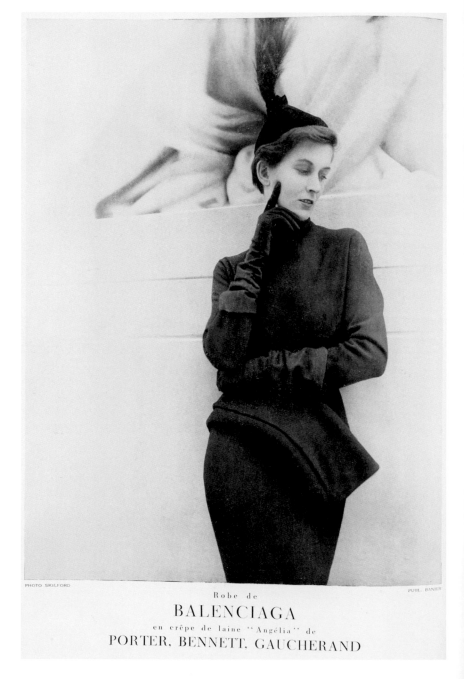

PHOTO SKILFORD PUBL. BANIER

Robe de
BALENCIAGA
en crêpe de laine ''Angélia'' de
PORTER, BENNETT, GAUCHERAND

63. (LEFT) **Tie-in advertisement, Balenciaga and Porter, Bennett and Gaucherand, French** *Vogue* **(October 1950).**

64. (RIGHT) **Tie-in advertisement, Balenciaga and Schiaparelli in Tissus Bucol, French** *Vogue* **(October 1948).**

Like other couturiers, Balenciaga often featured in advertisements that tied particular textiles to his models. In these cases, the silk firm of Bucol, which pioneered the use of man-made fibres after the war, and the woollen firm of Porter, Bennett and Gaucherand gained publicity for their products, while Balenciaga showed off his models. 'Tie-in' advertisements sometimes used the premises of the couturiers as the location for the shoot, but at others preferred locations in Paris or simple unadorned backgrounds. The images are therefore particularly pointed in the way that they stress the symbiotic relationship between textile manufacturers and couturiers. French *Vogue* in the immediate post-war years was keen to focus on French manufacturers in its editorial space, and until the early 1950s it was only in advertising space that overseas manufacturers found their voice.

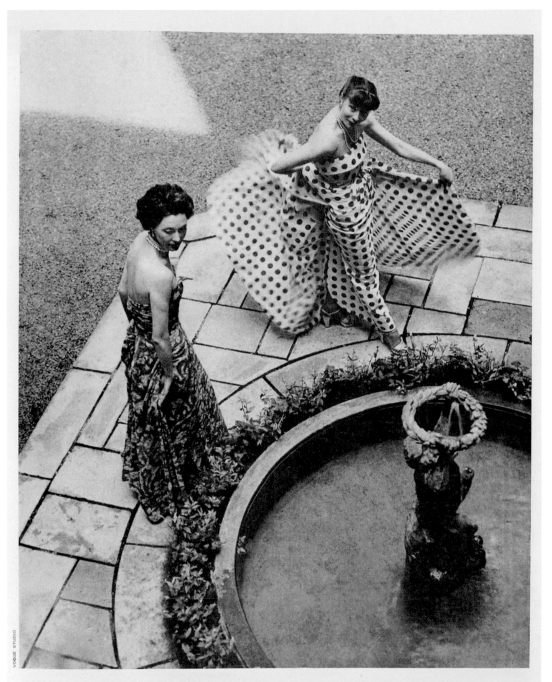

SCHIAPARELLI
Robe du soir en VOILNYL (Procédé Bté S. G. D. G.)
imprimé de ballerines blanches sur fond beige

BALENCIAGA
Robe du soir en CRACKNYL (Procédé Bté S. G. D. G.)
à pois rouges sur fond blanc

TISSUS DE **BUCOL**

4
CLIENTS AND CLOTHES

One man who takes no interest in this commercial roundabout is Balenciaga – a great artist: the designer's designer, his clothes are practically untranslatable into 'wholesale'. He does not care a hoot about the Press – in fact, he makes difficulties for its representatives and is far from eager to have his clothes photographed: he has such a rich, respected and completely Balenciaga-minded clientele that he needs no publicity.[1] Charles Creed

Steady client demand ensures the success of couturiers and the survival of their businesses, and, as the British-born, Paris-based couturier Charles Creed intimated, by the mid-1950s Balenciaga's clients were numerous enough, voracious enough and loyal enough to allow him to eschew the more extreme forms of advertising practised by his contemporaries. While the newsworthy private customers from the glamorous, press-worthy international 'jet set' were important during Balenciaga's career, the wider customer base who bought directly or indirectly from the house was perhaps more significant than Creed implied. It is still not clear whether private clients did indeed dominate the house's activities or how many were able to buy and discard a new wardrobe every season for a hectic social life.[2] Most publications on Balenciaga focus on the couturier and his innovations (production), rather than those on whom he depended for his livelihood (consumption). Four pioneering exhibitions have, however, opened up the way for a more rounded analysis, introducing private clients, each with a very different profile: two were glamorous, wealthy and cosmopolitan women (Mona Bismarck and Claudia Heard de Osborne), two were quite different upper-class Spanish women (the dazzling and fashion-conscious Spanish aristocrat, the Marquesa de Llanzol and a well-connected but modest Spanish client of the *franquista* high bourgeoise, Señora de Mayer Anderea).[3] Starting from this base, this chapter offers a glimpse – no more – of Balenciaga's relationship with his clients, as stimulus for reflection on who wanted and could afford to buy his clothes, how they acquired and adapted or customized them, and the possible implications for the couture house.

Of course, documentation of couturier-client relations is hard to come by, because it is preserved in the notebooks and memories of the saleswomen who attended customers and in the memories, correspondence and account-books of far-flung private clients and commercial buyers. Couture houses do not keep these kinds of records, and are – rightly – reticent about divulging confidential details about their

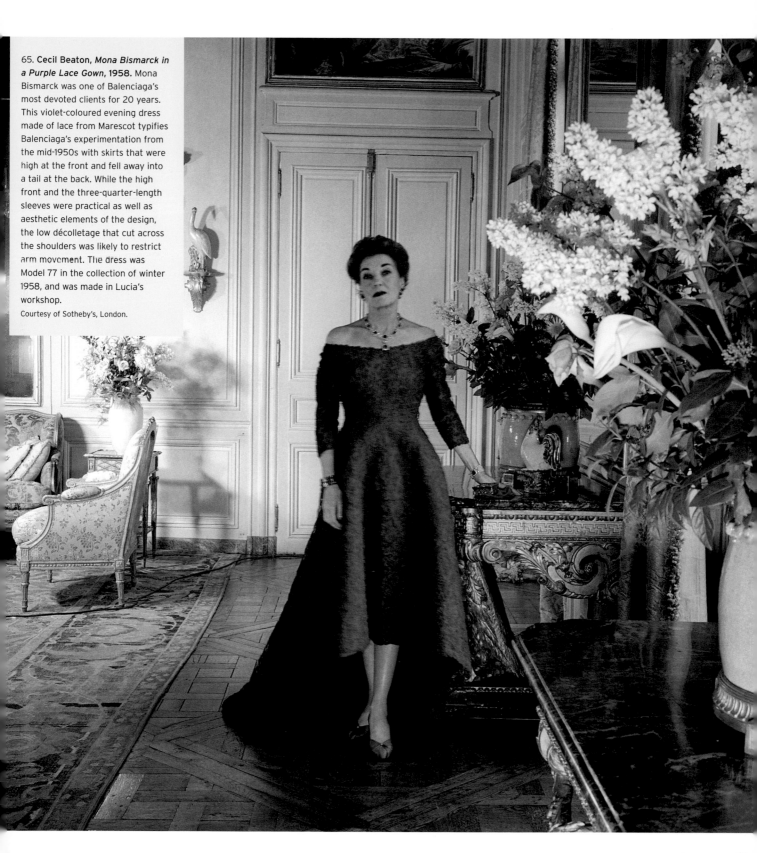

65. **Cecil Beaton,** *Mona Bismarck in a Purple Lace Gown*, **1958.** Mona Bismarck was one of Balenciaga's most devoted clients for 20 years. This violet-coloured evening dress made of lace from Marescot typifies Balenciaga's experimentation from the mid-1950s with skirts that were high at the front and fell away into a tail at the back. While the high front and the three-quarter-length sleeves were practical as well as aesthetic elements of the design, the low décolletage that cut across the shoulders was likely to restrict arm movement. The dress was Model 77 in the collection of winter 1958, and was made in Lucia's workshop.

Courtesy of Sotheby's, London.

clients; couture clients have not consistently recorded or spoken of the rounded experience of acquiring, living with or transforming Balenciaga clothes. Yet, to gain a balanced view of how a successful couturier worked, some insight into their demands and values is essential. Balenciaga made very careful strategic decisions about his clients in choosing a particular modus operandi for his business. The needs of his clients were embedded in his philosophy of fashion; while distant with many clients, he evidently struck up lasting friendships with some. What they chose to buy from his collections was not necessarily the ground-breaking styles promoted by journalists.

Affording and Acquiring Balenciaga

Balenciaga's clients came from across the Atlantic, from Australia and from Europe; they belonged to the governing, aristocratic and wealthy classes, the world of entertainment, the arts, fashion and commerce; they were young, middle-aged and old; some were consistently loyal over twenty to thirty years, others intermittently or once only. In Paris, for example, the veteran couturier Madeleine Vionnet, an early mentor, remained a loyal customer at the age of 92. In 1967 she was pleased to reveal publicly that she was happiest in 'a quilted trouser suit in pink printed silk, and a long camel-hair *robe de chambre*' made by the master.[4]

It was, however, the combination of private and professional customers that assured Balenciaga's reputation well beyond France and Spain, as well as the longevity of his business in the post-war years. Prospective consumers of Balenciaga could buy his garments – or designs – in a variety of ways: direct from the couture house in Paris, if they had an introduction; direct from the couture houses in Barcelona, Madrid and San Sebastian; via department stores across the world; via high-calibre ready-to-wear manufacturers who bought models legitimately from the house; and second-hand, from department stores, agencies and charity sales.[5] The mode of purchase dictated the likely price, second-hand being cheaper than new.[6]

66. (LEFT) **Robert Doisneau, Madame Weisweiller and her daughter Carole in Balenciaga dresses, 'Pour les dix-huit ans de Carole', French *Vogue* (October 1960).** Madame Weisweiller was a special client, a French society personality for whom Balenciaga made theatrical costume and fashionable dress. In this photograph, she is wearing a dress specially designed for her – and for her alone – for the 18th-birthday celebration of her daughter Carole. Madame Weisweiller's dress is made of pale pink organza, embroidered with ribbon work. It is now in the V&A dress collection (26 and 27). Carole is also wearing Balenciaga, but a dress and cape from his collection of that year. In Spain, Carmen, daughter of the Marquesa de Llanzol, acquired that same dress.
Robert Doisneau © *Vogue* Paris

67. (RIGHT) **Juan Gyenes, The Marqueses de Llanzol with their Daughters Carmen and Sonsoles, 1960.** All three women in this image are wearing evening dresses made by Balenciaga, Carmen wears the same model as Carole Weisweiller, while Sonsoles wears a light pink shantung gown, embroidered with silver metallic threads and appliqués of semi-precious stones and pearls in a floral motif. The choice of white is interesting, revealing that clients could order up colours other than those shown in the collection. In the collection, this was shown in a deep pink.
Photo: Juan Gyenes, Sonsoles Diez de Rivera Collection, Cristobal Balenciaga Museum Archives.

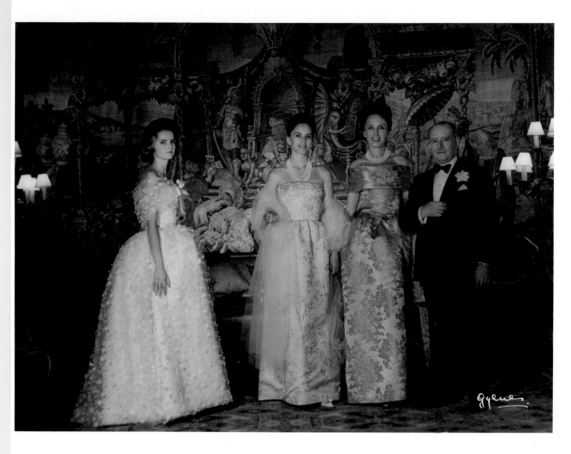

In the mid-1950s, when the house was at its height, Balenciaga showed just over 200 new designs (models) per season.[7] The first shows were for commercial buyers, the second for private clients and the third for the press. The models were made up first for private clients, who received advice from their *vendeuses* about when and where not to wear them in order to avoid the embarrassment of meeting someone else in the same dress. Often the *vendeuses* dealt with clients from the same geographical areas who met at the same social events. It was less likely, for example, that French and Spanish clients would meet. Thus, the extravagant dress chosen by Carole Weissweiler for her 18th birthday party in Paris in 1960 and by Carmen Díez de Rivera for her social calendar was unlikely to lead to a major social blunder.

The number of garments that Balenciaga's workshops made to measure each season was relatively small: only about 2,325 garments for private customers in 1954.[8] In the absence of detailed financial accounts, this quantity suggests that couture output alone did not bring in sufficient income to keep the house at 10 Avenue Georges V in business. What kept it going was revenue from wholesalers and retailers. Balenciaga certainly had a loyal following of customers in this category: Christopher Carr-Jones, a British wholesale manufacturer, suggested that about 200 buyers attended the shows, although it is not clear if he was referring only to European buyers or incorporating Americans in the number. Both groups had separate showings.[9] Whatever their nationality, Balenciaga charged wholesalers and retailers more than his private clients for each garment and he imposed conditions on his sales (see Chapter Three).

Only occasionally did Balenciaga design and make special commissions, such as dresses for rites of passage (birthdays, weddings, etc).[10] Whatever he made was reputed to command the highest prices in Paris. In 1950 the scale of

costs was as follows for the winter: the making of a dress and of a suit (in the client's own fabric) 75,000 francs (£76.50); the fabric and making of a day dress 80,000 – 88,000 francs (£82 – 90) according to the textile; a woollen suit cost 110,000 francs (£112), a faille coat the same amount, a dress of spotted taffeta 112,000 francs (£114) and an evening dress of black crêpe with a satin drape 157,000 francs (£160).[11] The faithful woollen suit was still a far cry from Elizabeth de Gramont's 'black velvet gown entirely embroidered in silver', which cost 800,000 francs (£815) in 1952, at a time when the average male wage in the UK was only £431 per annum.[12] The extent of couture purchases among those for whom money was no object is perhaps best epitomized by expenditure by the Woolworth heiress Barbara Hutton, who bought nineteen dresses, six suits, three coats and one *déshabillé* in a single season, and was rumoured to have paid $15,000 (£5,376) for a fancy-dress costume for the Beistegui eighteenth century ball in 1951 – an exaggeration, perhaps.[13] She went dressed as Mozart, in a suit of heavily encrusted dark-blue velvet, three-cornered hat and matching accessories.

In addition to the basic Parisian rate for couture, Hutton would have had to contend with high import taxes if she took her clothes back to the USA. Those taxes may not have affected her ability to buy couture, but they must certainly have inhibited many non-French customers who wished to take the garments out of France or to use French textiles in the production of copies. Percy Savage hints at one practice that probably avoided such taxes – rather costly in its own right:

. . . the main people in the fashion world or the beauty world, like Elizabeth Arden, in those days, and Helena Rubinstein, Helena Rubinstein was a, a big client of Balenciaga, and she used to come to London after she had bought from Balenciaga, and she used to go to a little Australian couturier in Beauchamp Place, who would copy stitch for stitch and bead for bead the jackets and suits and dresses that Balenciaga had made for her. And she, you know, she told everybody that she did it, everyone knew that she had copies of them . . .

and she'd leave the copies in London, so, when she travelled she didn't sort of travel much with clothes. Wherever she went, when she went back to New York, she had copies of clothes in New York too.[14]

There were other ways of acquiring Balenciaga couture more cheaply than it sold in Paris. At times when the exchange rate was favourable, Balenciaga models made in his Spanish houses cost about half the price of their Parisian counterparts, a fact advertised by Fodor's travel guides to Spain in the 1950s and '60s.[15] Tourists might therefore acquire their 'Balenciagas' safe in the knowledge that only they knew that the label inside the garment bore the word 'Eisa' rather than 'Balenciaga. 10 Avenue Georges V, Paris'. On the other side of the Atlantic, bonded couture offered access to more affordable Balenciaga. 'Bonded' garments were essentially second-hand. They had been imported to the USA on a temporary licence to be used in mannequin parades or to be copied. Before the licence expired, the importer had to re-export the garments. Often the quickest and cheapest way to do so was to sell them to South America or Canada rather than to return them to Paris. Department store buyers in Canada acquired them with a view to fitting them to particular private clients, even though the Parisian house models had not been made to measure for the clients originally and had already been worn several times. Such models were evidently prized, could be altered, or copied. Department stores also sold their own copies of Balenciaga, and his reputation was such that a reproduction of one of his garments cost more than an original 'bonded' garment from a lesser-known house. In 1955, for example, the department store Creeds of Toronto charged about the same amount for a copy of a Balenciaga or Balmain model as it did for an original by less famous names, such as Maggy Rouff, Jacques Heim and Raphael.[16]

Customers' Attitudes and Tastes
Just as Balenciaga entertained a variety of clients, so too did he encounter a variety of attitudes to his clothes. Retrospectively, at his

68. Cecil Beaton, *Mona Bismarck in a Satin Deshabillé,* **1955.** Mona Bismarck chose a large number of garments from each collection, from the most formal evening gowns through day dresses and suits to shorts for wearing on her yacht and when gardening. Here she poses in her home at the Hôtel Lambert in Paris (residence of the philosopher Voltaire two centuries before), surrounded by furnishings of her taste, most dating from the 18th century. This was an extremely appropriate setting for this particular gown, which echoes the sack backs of that century. Made of pale blue satin from the Swiss manufacturer Abraham, it falls in soft pleats to the floor.
Courtesy of Sotheby's, London.

69. Cecil Beaton, *Mona Bismarck in Shorts,* **1967–8.** As a friend of Mona Bismarck, Cecil Beaton visited her at her country homes, where she let him photograph her in less formal attire. Here she poses at the Villa Fortini in Capri in a white linen top and garden shorts made by Balenciaga. To patronize a couturier for such 'necessities' was surely only normal for the extremely rich among whom Bismarck counted. Her first husband, Harrison Williams, had been one of the richest men in the USA. With such close and personal contact with her couturier, it is no wonder that she was deeply upset when she learned of his death from Diana Vreeland, who was visiting her in Capri at the time.
Courtesy of Sotheby's, London.

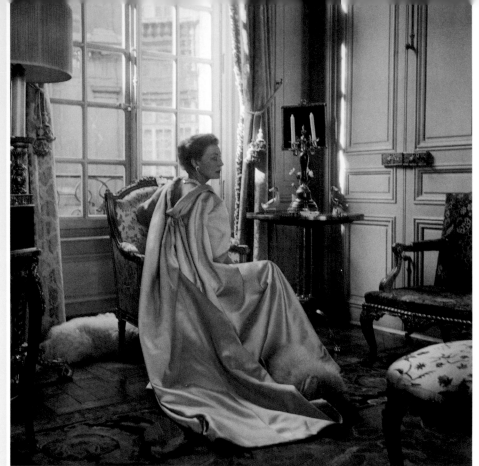

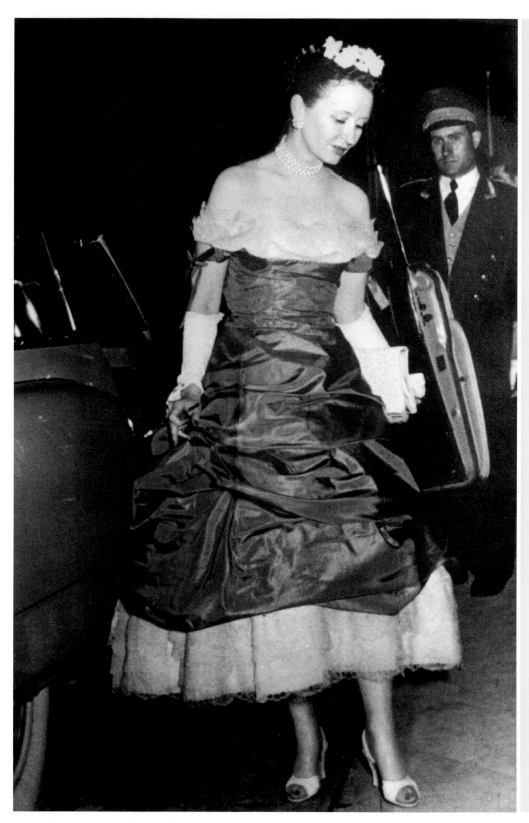

70. **Claudia Heard de Osborne stepping out of a car in Paris, 1955.** Mrs de Osborne acquired this gown from Balenciaga's spring collection and subsequently gave it to the Texas Fashion Collection in 1981. Both its style and colours are strikingly Spanish – cerise silk taffeta with white lace, worn over a crinoline-style petticoat. Sonsoles Díez de Ribera bought the same style from the house in Madrid, hers being made of the same taffeta but finished off with white broderie anglaise. Mrs de Osborne wrote when she gave it away: 'Dear Lord! I hope you appreciate this as I think it is the most glamorous ball gown he ever made. Do not call it a cocktail dress. IT IS NOT . . . I wore it to La Scala in Milano and to a very elegant opera ball afterwards. My gown caused a sensation in our box and again at the ball . . . I wore shoulder length white gloves and a crown of fresh gardenias. My husband is furious I am giving this up [twenty-five years later]'.

Courtesy of the Texas Fashion Collection, School of Visual Arts, University of North Texas.

retirement and after his death, a few private clients sang his praises and demonstrated their loyalty – and taste. Some had patronized the house intermittently, others consistently over many years, and yet others set up a family tradition of patronage, passing the baton from mother to daughter and even to granddaughter (in Spain). For regular clients, Balenciaga's departure from couture was a major loss. Diana Vreeland rather enjoyed the melodrama of the situation. When the news arrived, she was staying with one of the wealthiest women in the world, Mona Bismarck, in Capri (Consuelo Crespi felt it important enough to phone through from Rome). According to Vreeland, the effect on Mona Bismarck was dramatic: 'Mona didn't come out of her room for three days. I mean, she went into a complete . . . I mean, it was the end of a certain part of her *Life!*'[17] More pragmatic and coolly extravagant, Mrs Barbara (Bobo) Rockefeller was 'ordering frantically' from the Avenue Georges V salon, now inundated with orders. She explained to *Newsweek*: 'To wear a Balenciaga dress gives you a sense of security . . . It's too bad this will probably be my last.'[18] Even the wealthy and apparently confident, it seems, needed the psychological support of the right clothes. Balenciaga clearly provided both goods and service.

If news of Balenciaga's retirement had a traumatic effect on some clients, the memory and experience of his work left a profound mark on others. Pauline de Rothschild dressed at his house for 23 years and considered it a privilege: 'I knew and liked other couturiers; I also understood them. But the mystery . . . belonged to Balenciaga . . . His creations were not intellectual but made with great spontaneity to last forever. They offered voluptuousness, spirit and rigour.'[19] The Marquesa de Santa Cruz, wife of the Spanish Ambassador in London after the war, wrote in 1990:

I well remember the sketch by E. Carter [in the *Sunday Times* in the mid-1960s]. I still have and wear the Balenciaga *tights*. First tights to be seen. They were black-white and burgundy (*not* maroon) like my Chanel suit lined and trimmed in red-burgundy jersey, and the tights were fine wool mixed with fine cotton and something that made them stretch – I'll be delighted to be in the book about Balenciaga. Such a real and good find of mine.[20]

These comments suggest different patterns of consumption among couture clients. The Marquesa de Santa Cruz did not confine her purchases to a single couturier and saw the combining of Balenciaga accessories with a Chanel suit quite natural – which might not have been Balenciaga's view, given that he was known to believe in 'head to toe' loyalty and he able to distinguish whether or not a woman was wearing the complete 'look' of his competitors or had coordinated an outfit herself.[21] In contrast, Mona Bismarck patronized Balenciaga almost exclusively over thirty years, buying about 50 to 80 garments per season, including occasionally a mannequin-worn model that was reduced in price. Even her gardening shorts came from the house.[22] Significantly, before Balenciaga's arrival in Paris she had patronized one of his mentors, Vionnet, and subsequently she turned to one of his disciples, Givenchy. She did not throw or give away all outdated clothes, although she could afford to do so: in her life-time she donated pieces from her pre-1968 wardrobe to the Smithsonian Institute, the Metropolitan Museum of Art, the Museum of the City of New York, Kent State University and the Brooklyn Museum and gave other items to friends such as Cecil Beaton and Hubert de Givenchy in the early 1980s, thus ultimately benefiting the V&A and the Fundación Balenciaga in Guetaria respectively.[23] Her actions suggest an enduring sentiment for her clothes and their aesthetic qualities. In similar vein, her compatriots, the Texan oil heiress Claudia Heard de Osborne and the film star Ava Gardner, kept their Balenciaga garments of the 1950s and '60s and eventually donated them to museums. Claudia Osborne's arrived in the Texas Fashion Collection while Ava Gardner, before her death in 1990, specified that the V&A should select what the Museum wanted before the rest was sold at auction.[24] British clients were similarly attached to their clothes. Elsa Bonsack, wife of the well-known

Mayfair interior decorator, 'discovered' Balenciaga in the 1950s and remained a devoted client until the close of the house in 1968. By the time of her death, vintage couture was valued and in 1995 her wardrobe was sold to benefit the Institute of Cancer Research.[25] A one-off client, Margaret Lane, also kept her single unexpected Balenciaga purchase, a faithful black and white lace cocktail dress. Introduced by chance to the San Sebastian salon by an American in the mid-1950s, she bought the model used by one of the mannequins and then wore it throughout the late 1950s to cocktail parties in London. The lace may well have been made in Spain since it does not match the original model in Brivet lace, and the motifs are very 'Goyesque' in style. She disposed of the dress only in 1990.

Such attachment to Balenciaga garments suggests that they did not become outdated immediately, that they could be worn after their original season of purchase without shame, an aspect of couture that sits well with Balenciaga's output and principles, because of his philosophy of fashion, the 'timelessness' of his styles, their gradual evolution and the high quality of their materials and construction.[26] He was the only couturier mentioned by name in Geneviève Dariaux's A Guide to Elegance (1964), recommended for those who wished a suit that would last for at least five years,[27] and Bettina Ballard noted in her memoirs that Balenciaga thought it quite normal that she should wear a coat he had made for her ten years previously.[28] Other clients, too, rewarded his continuing research by wearing their outfits until they fell apart, or until they had to wear one surviving part with something else in their wardrobe.[29] At the time of the major retrospective exhibition in New York in 1973, Baroness Philippe de Rothschild was quite happy to reveal to Newsweek that she was still wearing the coat that Balenciaga had made for her from his last collection seven years before. It had stood the test of time – and her willingness to discuss the matter presumably indicates that she was well aware and proud of her foresight in patronizing the couturier.[30] Mrs John Simms Kelly allowed

herself to be photographed for Vogue wearing two outfits that were not conceived in their entirety by Balenciaga. For daytime, she wore a black wool Balenciaga dress beneath a white wool Givenchy coat, and for relaxing at home she wore the black brocade tunic originally designed by Balenciaga as a two-piece set over a pair of narrow silk trousers (designer unknown).[31] In Britain, Mrs Laurie Newton Sharp remembered cutting off the sleeves of a dress at the elbow, where they were threadbare, just so that she could go on wearing the dress.[32] Even clients who could afford to buy new clothes, managed their wardrobes carefully, a certain kudos being attached to this aspect of their social performance – a foretaste of the current vogue for 'vintage couture'.[33]

These examples of clients' customization of well-worn outfits reveal that, contrary to popular wisdom, Balenciaga did not have complete control over his clients and how they treated his designs. Indeed, even at the stage of taking their orders, he did not. In 1967, for example, Mrs Gloria Guinness combined an embroidered tunic that Balenciaga had shown worn over a skirt with a pair of trousers from the same collection.[34]

Legal Reproductions

In Britain, as elsewhere, not many women could actually afford a made-to-measure wardrobe from Balenciaga, but some could afford exclusive department store adaptations that cost about one-quarter of the house price, and others could afford ready-to-wear adaptations made by reputable houses from the London Model House Group. Commercial buyers were therefore very important clients of the house, intermediaries between Balenciaga and their own clients. Balenciaga's shows for the trade took place before those for private clients (and before those for the press).[35] They understood the tastes of their own clients and selected what would sell in their marketplace.

The fact that Balenciaga was two or three steps ahead of trends was so well acknowledged by the end of the 1950s that British wholesalers tended to take the lead from his collections. As

71. **Frederick Starke suit, copied from Balenciaga model, 1951.** Frederick Starke Archive, V&A Archive of Art and Design. This semi-fitted style was one of many pioneered by Balenciaga from the late 1940s onwards, offering an alternative to the figure-hugging, hour-glass, corseted figures proposed by his main rival Dior. The Balenciaga original in black wool by Chatillon-Mouly-Rousel appeared in L'Officiel in September 1951 and this copy by Frederick Starke in Fashion and Fabrics (November 1951). Starke also made a version in black barathea. The copy shows certain economies, for example, the reduction of the number of buttons from ten to five.

a result, in 1958 British ready-to-wear manufacturers were three months ahead of French couturiers in adapting and producing the Empire line, much to the delight of British fashion journalists. The 'directional' nature of Balenciaga's fashion was helpful to the firms that formed the London Model House Group; they could use his patterns more than once, since many elements in his designs continued for two or three seasons. Although the ready-to-wear companies also bought from Dior, these collections represented a 'flash in the pan' or 'fashion-victim' approach to fashion, which resulted in 'here today, gone tomorrow' styles and were not such a good business proposition.[36] Speaking of Balenciaga's models, Christopher Carr-Jones, son of the founder of Susan Small, suggested that each had about eight to ten derivatives and each of these would be reproduced about 400–500 times. Balenciaga's continuity was an impressive and important part of his strategy, yet his designs were often not openly publicized because he did not allow manufacturers to use his name in their advertising.

From 1938 British commercial buyers attended the shows and bought from the house alongside their transatlantic counterparts. Lydia Moss, Fortnum and Mason, and Harrods rubbed shoulders with the Americans Hattie Carnegie, Henri Bendel, Bloomingdales, I. Magnin, Nieman Marcus, Saks and Bergdorf Goodman, and the Canadians Creeds, Holt Renfrew and Simpsons.[37] Just like the private dressmakers, department stores had their own salons that provided a made-to-measure service. They reproduced each Parisian model up to 40 times for private clients and allowed customers to examine the original model alongside their made-to-measure reproduction.[38] In contrast, wholesale manufacturers such as Frederick Starke, Susan Small, Dorville, Spectator Sports and Harry B. Popper, all members of the London Model House Group, reproduced models in their hundreds rather than in tens. They were still exclusive in comparison with mass-produced clothes.

The New French Room

Our new French Room on the first floor, which is specially planned for the woman who demands originality and exclusiveness in her clothes, has specialised workrooms to design and make gowns and suits to her own personal requirements.

Here, too, she can buy ready-to-wear clothes—models straight from the Paris couturiers and leading London houses.

72. (LEFT) **'The New French Room'** **at Harrods after refurbishment in** **1950.** Advertising the exclusive quality of the newly redecorated French Room, this image draws attention to perfectly clad customers, mannequin parades and an opulent setting with chandeliers. Little niches were built into the room to allow a certain amount of privacy for client and *vendeuse*, as would have been desired in any couture house. The design of the room recalls images of couturiers' salons that appeared in French *Vogue* in the early 1950s. The design harks back to 1930s 'modern'; the items on display are those traditionally exhibited in the boutique of couture houses – small items or accessories such as gloves, scarves and handbags.
Courtesy of Harrods Archive, London.

73. (RIGHT) **'Designed by Balenciaga** **– Copied Exclusively for Harrods in** **"Terylene"/Worsted Herringbone',** *Harrods News* **(Easter 1966).** Harrods continued to patronize Balenciaga into the late 1960s. This coat made in one of the man-made fibres pioneered in the 1950s was doubtless appreciated at the time for its simple cut and uncrushable qualities. Much of Balenciaga's work from the mid-1950s onwards boasted practical seven-eighths sleeves. Formality in dress is still evident – despite the jaunty pose – in the wearing of hat and gloves.
Courtesy of Harrods Archive, London.

STRIPES ARE RIGHT
for the Younger Set

(YS. 269). Lamé for Cocktail wear. Alix sponsors the new cartridge trimming on this delightful model in striped or novel self design. Self flowers soften the neckline. In olive-green, dark delphinium, marron, wine-grape, black/silver or black/gold. Hips 35, 39. 4½ Gns

YS. 263

YS. 269

(YS. 268). From Ballanciaga this dramatic period Dinner Gown in striking two-tone striped taffeta. In dark delphinium/powder, duck-egg/heather, nattier-blue/heather or raspberry/bois-de-rose. Hips 35-40 4½ Gns

Younger Set Gowns, First Floor

Page 2 *HARRODS NEWS*

74. **'Stripes Are Right for the** **Younger Set',** *Harrods News* **(October 1938).** Harrods started purchasing Balenciaga models for reproduction from the second Parisian collection in autumn 1938. The striped dinner gown illustrated was part of a range of garments in which Balenciaga experimented with stripes. It is interesting to note that Balenciaga, often considered a couturier of matrons, was regarded as Paris's new 'young' designer at this time, and this design was thought suitable for Harrods' younger customers.
Courtesy of Harrods Archive, London.

ONE WOMAN'S WARDROBE
This week — Mrs Laurie Newton Sharp

Mrs Newton Sharp is News Editor at Harrods, which involves directing publicity, handling entertainment and arranging receptions. Apart from the Press coverage, Mrs Newton Sharp is not associated with fashion, but she does not deny that a good dress sense has helped her in her career. She believes that women are ageless, and proves it by wearing the same type of clothes today that she did at the age of 20 – for example, her Molyneux dress. Now, some of her tips for elegance – good grooming, simplicity, cut and fabric all balancing, and important, choosing clothes that suit you, rather than following extreme fashion. Accessories are also very important and Mrs Newton Sharp will buy expensive gloves and shoes and the best stockings obtainable. She adores hats and never feels an outfit is complete without one. Although

she does not think that Paris influences fashion as it used to, she still prefers to buy original models. Her favourites are Balenciaga and Yves Saint Laurent, but she also likes Italian clothes. She has no fur coat, but loves fur-lined coats and matching coats for evening. Her most coveted fur is sable. Much of her life is spent entertaining, and for this she wears long, flowing hostess gowns. But at weekends she likes trousers and tailored shirts.

In private life Mrs Newton Sharp is the wife of Dr P E Thompson Hancock, Director of Clinical Research at both the Royal Marsden Hospital and the Institute of Cancer Research, and apart from her full life at Harrods she is vice-chairman of the Ladies' Association of the Royal Marsden Hospital, a vice-chairman of the British Empire Cancer Campaign for Research and on the advisory committees of three art colleges.

Top: Palest blue wool hopsack suit by Balenciaga, from Harrods. **Above:** Ice-pink and white woven nylon evening coat worn over silk zibbeline dress. Original French models from Harrods. **Below:** Gabardine navy coat by Balenciaga with enormous bat-wing sleeves and trimmed with gold buttons. Worn with navy Balenciaga hat. From Harrods.

Above: Ripe apricot Indian silk trouser-suit from Harrods Shalimar Shop

Top: Brown lace over black crepe strapless cocktail dress by Castillo. Large black organza rose hat by Dolores. From Harrods. **Above:** Brown linen and rayon dress with flat pique bow at neckline, by Molyneux. Huge coffee-coloured straw hat by Balenciaga. From Harrods. **Below:** Navy wool suit with white overcheck by Balenciaga. The navy felt hat is also Balenciaga. From Harrods.

Report NORMA MORICEAU Pictures PETER AKEHURST

75. 'One Woman's Wardrobe', *London Life* (27 October 1966). This feature on Mrs Laurie Newton Sharp, News Editor for Harrods and best-dressed woman of the year, reveals her love for Balenciaga's designs. She was not only an excellent advertisement for the store, but also indirectly for the couturier, conforming to the slender models from whom he took inspiration.

In London, the most prestigious store for women's fashion was undoubtedly Harrods, whose buyers bought models for their different departments, which targeted customers with different budgets or of different ages: for the upper-end French Room (Model Department), which was renovated in 1950 to create a suitable environment of luxury for its customers, for the Inexpensive Gowns department and for the Younger Set. According to budget, Harrods made reproductions in the fabric used by the couturiers or in a cheaper fabric. Harrods was a loyal customer over thirty years. In 1938 the store began its association with the house by buying three models, two evening dresses and one two-piece day dress. Two appeared in Harrods' own newsletter and a third was advertised in the *Sunday Times* on 16 October. A two-tone striped taffeta dinner gown in dark delphinium/powder, duck-egg/heather, Nattier-blue/heather or raspberry/bois-de-rose was available from the Younger Set Gowns Department on the first floor of the store at 4 guineas. The black moiré wide-skirted dance dress with pastel pink frills and fichu was also for sale all in white or in purple with fuchsia or emerald with cyclamen for 6 guineas from the Model Gowns Department. Both were dramatic dancing gowns based on Victorian models, much in line with the Winterhalter – or 'Little Women' – revival of the late 1930s. Balenciaga's brilliant colour combinations appealed to English buyers. Harrods' day dress of 1938 was duller by contrast. Made in matte rayon crêpe, it had a tailored bodice trimmed with buttons, a slim-fitting skirt and a contrasting velvet cravat. The choice of colours was sober: black, *marron*, verdigris green or wine grape. The cost from the Inexpensive Dresses Department was £3 9s. 6d. Thus, Balenciaga's influence infiltrated the London store at all levels of fashion, with dresses costing less than one-quarter of the price of the original model in Paris.[39]

Harrods remained faithful to Balenciaga, among other couturiers, until the end of his career in Paris. In March 1965 the *Times* reported: 'The French Room at Harrods, for example, will have five Balenciaga models, a

76 & 77. Page of samples of fabric by Abraham, autumn 1966. Copies of Paris couture models were made up in department stores or by wholesalers either in the same fabric as that used by the couturier or in cheaper alternatives. Books of textile samples dating from the 1950s and '60s in Harrods Archive show that many of the major names in Swiss and French textile manufacturing sent supplies to the store. Some are even annotated to show by which couturier they had been used – and thus for which copies they were destined. These samples from Abraham, one of Balenciaga's closest collaborators, carry descriptions of the fibre composition of the textile, as well as showing those that were entirely sold out (FIN = finished). Courtesy of Harrods Archive, London.

day and evening dress from Givenchy and a Molyneux outfit. Customers buying Balenciaga and Molyneux reproductions for 80–100 guineas will be able to compare them with the original flown in from Paris.'[40] They were also informed that Harrods had chosen the most outstanding two models from his collection, a black organza sleeveless dress and matching coat and a navy suit, which 'has the ease for which Balenciaga is famous'.[41] In September of the same year, the store bought 12 models,[42] including a shocking pink evening dress with matching feather boa that was placed for promotional purposes in the store's window – a fine bit of free publicity for the house. To coincide with this promotion, Winefride Jackson of the *Sunday Telegraph* interviewed Cecil Beaton about 'The Man Behind the Clothes', discovering that the photographer had first met the designer fifteen years previously when his mother had bought a suit from him in Barcelona.[43]

Harrods' chic News Editor, Laurie Newton Sharpe, was the public face of (and voice piece for) the store's approach to fashion. She chose Balenciaga as one of her favourite couturiers and urged the store to buy. In April 1966, for example, a navy-blue and white checked suit was available in different fabrics to suit different purses: in the wool by Nattier, originally used by the house for 176 guineas (£185); in a cheaper wool by Raimon at 78.5 guineas (£80); and in other fabrics from 49 guineas (£50), at a time when the average male wage in the UK was £20.30 per week.[44] Laurie Newton Sharp elected to pose in this model for a photograph that appeared in a feature called 'One Woman's Wardrobe' in *London Life* in 1966.[45] Voted one of the ten best-dressed women in Britain in the *Daily Telegraph* in the same year, she was surely a fine advertisement for Harrods and Balenciaga. She also wore a pale bird's-egg blue woollen suit, and a coat in stretch wool twill, the former using wool from Labbey, the latter from Racine, with cheaper versions in wool from Raimon or other manufacturers. By this date, the costs of the French fabrics imported by Harrods had just risen dramatically because of a new government levy of 3s. in the pound on

imported garments and cloths, so that 'Women ordering copies of Paris couture suits at Harrods are already feeling the pinch as every yard of the fabric is specially brought in from France to order'.[46] This claim is borne out by the books of textile samples conserved in the Harrods archive, in which many swatches from the major Swiss and French manufacturers feature, sometimes identified as having been modelled by one of the couturiers.

Ready-to-Wear at Last?

Harrods' emphasis on suits underlined Balenciaga's lasting contribution to fashion. Indeed, it was the suits made for one of his last clients that brought him into the limelight briefly after his retirement. They showed that official, 'establishment' clients – in this case, Air France – were still in his thrall, while younger consumers – the air stewardesses – were not. The director of transport wrote to the great couturier in January 1968 inviting him to take on the prestigious and challenging commission of designing the new range of uniforms for the airline's air stewardesses.[47] The results were possibly Balenciaga's longest-lived designs in production, since they were used and reproduced from the beginning of 1969 until 1978. Importantly, Air France, the biggest airline in the world at the time, had a tradition of commissioning uniforms from French couturiers, because they considered their stewardesses 'ambassadresses for French fashion'. The profession was one of high status in Europe, and its practitioners had to understand the niceties of social etiquette, remain fresh and unruffled as they moved seamlessly from one environment to another, offering polite service to well-heeled customers. Air France stewardesses had worn uniforms designed by the couturiers Georgette Renal from 1946 to 1951 and Georgette de Trèze from 1951 to 1962, when the house of Dior, with Marc Bohan at the helm, created the new 'look'. Balenciaga inherited the mantle from Maison Rodier, whose uniforms had been in use only since 1967. The short life of the Rodier uniforms was not the norm, presumably because large

78. **Sketches of winter and summer uniform, 1969.** These sketches were included in the press pack issued at the time of their launch. On the right is the basic suit as worn on the aircraft and in good weather conditions, accessorized with handbag and cap. On the left is a depiction of the ensemble for less propitious conditions: suit covered up by double-breasted raincoat, and cap kept securely in place by a regulation scarf. Courtesy of the Air France Museum, Paris.

79. **Photograph of mannequins posing in the two versions of the winter uniform, 1969.** Both mannequins wear the white cotton gloves that were standard issue. The same coat and scarf were worn over winter and summer uniforms as protection against the elements. Knee-high boots were an innovative aspect of Balenciaga's fashions in the mid-1960s.
Courtesy of the Air France Museum, Paris.

numbers of garments had to be made, an expense that the airline had to sustain. Air France was not therefore looking for 'flash in the pan' fashionable attire for its employees, nor was it looking for individually made-to-measure garments. It had already undertaken research into the practical needs of the air stewardesses by considering climate changes, the tastes of their clientele and the views of the air stewardesses themselves.[48] The design brief was set, therefore, and it was merely a question of choosing a major name in French fashion. Balenciaga was *the* major name.

Significantly, Balenciaga was familiar with the requirements of the clientele whom the airline transported as passengers: right through his career his private clients had been the kind of women who travelled regularly. Such women

often appeared in magazines such as *Vogue*, offering ideas about how to choose the perfect capsule wardrobe for air travel. Kathryn Bache, wife of the American theatre impresario Gilbert Miller, for example, was described as 'an experienced traveller who has learned to carry her famous chic in a near-microfilm state'. In July 1957 her three coats, one carried, one worn and one packed, included a 'red wool coat by Balenciaga'.[49] Advice books of the period also recommended strongly 'Materials which will co-operate . . . and crease as little as possible', a concept with which Balenciaga, that great connoisseur of textiles, was familiar.[50]

Balenciaga was not, however, familiar with making models that were to be manufactured in batches, ready-to-wear. In the first instance, some 1,300 air stewardesses were to sport these uniforms and about 1,000,000 were to be made (to accommodate changes and laundry). Naturally, the couturier could not make all these to measure, although he proposed setting up a section devoted to Air France in his workshops. C. Mendès, the high-class ready-to-wear manufacturer who made Jacques Heim's *prêt-à-porter* collection, was to make them in standard sizes. Aware of the financial and manufacturing constraints, Balenciaga took on the challenge with relish and his correspondence with the airline shows that early on he was thinking about how to achieve the best results via an unfamiliar medium.[51] His solution to achieving a good fit with all those individual measurements was to set up at Orly airport a 'finishing-off' workshop, in which each uniform could be adjusted on the body of its wearer. Thus, the first generation of Balenciaga uniforms benefited from the attention of the master, both at the design and the fitting stages.

According to the Air France press release of December 1968, the resulting uniforms conformed to the need for 'elegance, freedom of movement, adaptability to sudden changes of climate, and maintenance of a smart appearance even after a long journey'.[52] Both summer and winter uniforms demonstrated Balenciaga's knowledge of textiles and cut, and his devotion to practicality. The summer uniforms comprised

a two-piece suit in pale blue or pale pink Terylene, Terylene (*tergal*) being a synthetic polyester fibre popular from the second half of the 1950s onwards because it did not lose its shape; it was crease-resistant and easily laundered. It had been chosen for 'its qualities of freshness and suppleness'.[53] The jacket was double-breasted with a collar that turned down over a navy-blue grosgrain bow, and the skirt was slim fitting. The latter did, however, have two pleats to allow ease of movement; its hemline hovered just above the knee; and its pockets were built into the seams at side front – kangaroo-pouch style. A navy cap completed the ensemble, along with a navy-blue raincoat with two silver buttons, white cotton gloves, a navy-blue shoulder bag and navy-blue court shoes with 5-centimetre heels. This was evidently the optimum height for avoiding tired feet. Flesh-coloured stockings had to be worn with this and the winter uniform, and the company proscribed any jewellery other than a discreet watch, bracelet and two rings.[54]

In contrast, the winter uniforms comprised a seven-eighths-length rainproof navy-blue coat, a navy-blue suit and a white blouse. The coat and jacket had no collar, whereas the white blouse had a high collar. The jacket boasted four patch pockets, two on the chest and one above the elbow on each sleeve; the sleeves were three-quarter length. The skirt followed the same basic cut and principle as its summer alternative, pockets directly over the stomach allowing a certain amount of expansion without loss of elegance. The accessories were a blue hat to be worn under a blue silk scarf in windy conditions, fine navy leather boots or court shoes, a navy shoulder bag and the ubiquitous white cotton gloves. Silver buttons and clasps fitted in with the Air France symbol on the hat. The fabric used was practical: wool serge for the suit from Lesur (uncrushable) and Terylene for the blouse (uncrushable and washable).

Externally, the only details that betrayed these ensembles as uniforms were the Air France insignia on the cap and the chest, and the little tie at the neck. Otherwise, these outfits could have come directly from Balenciaga's couture

collections of the mid- to late 1960s, from among his timeless little suits that were in the process of becoming smart, slightly conservative fashionable dress. Internally, however, the quality of linings and attention to finish immediately mark out these suits as ready-to-wear, especially ones that dated to the second or later generations of production.[55] While on some levels this combination was both practical and smart, and suited to the job, on others it was not. The synthetic fibres were probably extremely uncomfortable in heat, and the jacket sleeves of the winter suit inhibited movement. Air France still adhered to traditional notions of social etiquette for their 'ambassadresses' and did not espouse the more functional and less

80. **Publicity cut-out of air stewardess in summer uniform, c.1968.** The air stewardesses were ambassadors for France both in the air and on land, since cut-outs of their photographed figures were used as announcement boards that could be put out in the street or in an airport lounge to advertise special offers. Notices were affixed to the circular board held by the air stewardess in her left hand. Courtesy of the Air France Museum, Paris.

formal attire that many American airlines favoured for their staff: air stewardesses did not remove their jackets or protect themselves with aprons, even on long-haul flights.[56]

The reaction of the press and of the air stewardesses to the uniforms was immediate, widespread and not altogether complimentary. In many respects, it revealed why Balenciaga was wise to close his house in the year of the commission. He was no longer in tune with the major social changes that had happened since the war, changes that the student revolution of the late 1960s was throwing sharply into relief. A new generation of designers was responding with new ideas for fashion. Philippe Bouvard, the correspondent in *Le Figaro*, objected not just to the uniforms, which he claimed the air stewardesses did not like, but also complained about the choice of 'a foreigner on the brink of giving up on his profession'. After all, 'The stewardesses do tens of thousands of kilometres per year, they are photographed everywhere, they are true ambassadresses for French fashion and, thanks to them, everyone knows the name of their couturier even as far as the antipodes.'[57] The trendy couturiers Pierre Cardin and Ted Lapidus were quoted as lamenting the fact that someone more modern and used to dealing with active life had not been selected, Lapidus saying of Balenciaga: 'His dresses are ravishing for getting out of a Rolls Royce or for going to a soirée but not for walking down the aisle of a Boeing. I wonder why Air France did not work with Courrèges.'[58]

The air stewardesses, too, were dissatisfied, the journalist revelled in reporting. They thought that their particular working conditions had been ignored. They needed to be able to move freely, and the pressure in the cabin made their waists and feet swell. The winter suit was particularly singled out for criticism both because of the weight of the material and because of its military style. Finally, the uniformity and lack of choice distressed them;[59] after all, they belonged to a new generation of baby-boomers with a desire for self-expression.[60] The public exchange was surely a sad finale to a long and rich career, and obscured the fact that

Balenciaga still had a faithful following – nowhere more so than in Spain, where social circumstances were only just beginning to change, partly as a result of consistent contact with tourists from further north.

Spanish Society

By the 1960s Balenciaga's Spanish salons may well have seemed an oasis in a fast-changing world. They attracted not only Spanish women but also tourists who were apprised of their existence via the bush telegraph and also via travel guides to Spain. These guides described different mores from those of America or northern Europe, mores that still encouraged patronage of old-fashioned couture. According to the journalist Poppy Richard, writing in the early 1950s:

... The wealthy Spanish woman is chic ... with time on her hands to be soignée. Out of doors she wears English tweeds and is immaculately tailored in very nice suits. She has lovely bags and wonderful shoes ... It is the perfect clothes of Balenciaga which set the pace for the smart set. This very shy and exclusive designer – who carries more weight in Spain than Dior – draws more visitors to Madrid than the Prado gallery ... which is saying a lot, for the Prado museum picture gallery is one of the best in the world.[61]

Several years later in a *Woman's Guide to Europe* (1959), Jocelyn Bush made several observations about the different way of life and approach to clothing. She noted that Spain was not a woman's country, Spanish women for centuries having 'played a secondary role in the nation's intellectual and professional life', and only now beginning 'to emerge from their salons, nurseries and kitchens to take jobs, go to universities and plunge into business. In Spain's provinces, however, women still lead a strictly home life and are rarely seen in public'.[62] Although they undertook philanthropic work, the notion of a career girl was anathema, and women of good families were clearly expected to spend their time absorbed in social events, entertaining and dress.[63] Evidently,

Spanish women spend a tremendous amount of time on their clothes. They pass hours in shops

searching for just the right kind of material they happen to want, hours running to some out of the way, clever and inexpensive *modista* or dressmaker, hours trying on hats or picking out shoes and hours at the hairdresser or *peluquería*. And, after all, what could be more fun for any woman?

Unsurprisingly, a large number of dressmakers (*modistos* and *modistas*, mostly female) catered for these women with time on their hands: in Madrid, 585 *modistos* on the eve of the Spanish Civil War, 807 in 1945 and about 472 by 1958; in Barcelona, about 670 *modistos* in 1945.[64] Of these, only a dozen or so featured as high-class operators in the post-war years, only Balenciaga and Pertegaz being big enough to become Sociedades Anónimas (limited companies). By the 1960s, Spanish *alta costura* was born, a reflection of new aspirations as well as changes in habits of acquisition. Gradually, ready-to-wear was replacing made-to-measure except for the wealthy. By 1966 Madrid boasted two couturiers and Barcelona six, dressmakers having lost their place in trade directories for the country as a whole. Balenciaga/Eisa was still in business at this level.[65]

Before the 1960s few Spanish *modistas* or *modistos*, however, emerged as international names, or afforded Balenciaga serious competition. Pedro Rodriguez (1895–1990) and Manuel Pertegaz (b. 1918) were his main peers in the 1950s, familiar with Parisian fashion and acknowledged when the fashion establishment started to pay attention to what was going on in Spanish fashion. Rodriguez had been a mentor to Balenciaga prior to the Civil War, active in the same three cities, whereas the younger Pertegaz worked only in Barcelona and Madrid. Pertegaz, however, headed a much bigger enterprise, breaking into the American market early on, in 1952, dubbed the 'young Balenciaga'. He was even considered a credible possible successor to Christian Dior in 1957.[66] According to Enrique Loewe Lynch, of the Catalan textile manufacturing dynasty, Pertegaz gradually weaned women of the Catalan bourgeoisie from their trips to Paris to Balenciaga (presumably during the closure of the houses in Spain):

Women from the Catalan high bourgeoisie used to dress in Balenciaga . . . Twice a year, in Spring and Autumn, they went to Paris so that the King would consent to enhance their bourgeois beauty and convert them into dream princesses. They came home 'embalenciagadas' from head to toes, a fancy for which their husbands paid handsomely, buying and selling cotton on the black market.[67]

This last observation is a crucial reminder of the situation in Spain from the late 1930s to the end of the 1940s: most of the population experienced great hardship due to shortages of all sorts, while a minority profited from the situation and enjoyed spending the rewards of their speculation. Most French couturiers found new customers among the female relatives of black marketeers during the Second World War, although the Spanish contingent has not been singled out for commentary in recent fashion histories.[68]

Balenciaga had, of course, clothed the aristocracy and governing classes since the 1920s, and in some cases using his house became a tradition through two to three generations of the same family: the Marquesa de Casa Torres passed the mantle to Fabiola de Mora y Aragón, a granddaughter who wore Balenciaga for her wedding to the king of Belgium in 1960 (a gown of white satin trimmed with white fur). Spain's first lady, Doña Carmen de Franco, a patron of the house from before the Civil War, watched her granddaughter walk down the aisle in the last wedding dress designed by Balenciaga in 1972 (and completed by his colleague Felisa). Her first known Balenciaga gown and that of her granddaughter were made more than thirty years apart, and contrast in style and colour. Yet they share a common love of dignified simplicity and fine but substantial materials. The first was a simple bias-cut dress in black faille worn for the ceremony at which her husband assumed command of the Balearics in 1935,[69] whereas the latter was a flowing figure-hugging white satin gown decorated modestly with several rows of sparkling stones down the front. Both are now in the Museu Tèxtil i de Indumentária in Barcelona.

81 & 82. Juan Gyenes, (LEFT) *The Marquesa de Llanzol and Sonsoles at the Wedding of One of the Daughters of the Marqueses de Valterra*, St Barbara Church, Madrid, June 1955. (RIGHT) *The Marquesa de Llanzol and Sonsoles at the Wedding of the Romanones*, August 1955. Balenciaga launched his 'tunic line' to great acclaim in 1955, and the Marquesa and her daughter took it up immediately. These two photographs show their attire for a similar event three months apart in the summer of 1955. In tune with the era, despite the generation gap, mother and daughter wear the same formality of attire. In June, they both chose a three-quarter-length tunic worn over a narrow skirt, the Marquesa's with a round neck to reveal her pearls and three-quarter-length sleeves, Sonsoles with a higher 'boat' neck and short sleeves (a stole around her shoulders providing some protection). Sonsoles retained the stole for her outfit for the August wedding, at which mother and daughter opted for quite different styles. In Spain's high summer, the Marquesa chose a sophisticated lace two-piece, Sonsoles a full-skirted, sleeveless printed dress. Despite the likely heat, they both wore hats and gloves as the etiquette of the time demanded. Courtesy of Fundación Balenciaga, Guetaria.

One of Balenciaga's most consistent customers, the Marquesa de Llanzol, became not only patron but also friend to Balenciaga, and her friendship carried on through her daughter, Sonsoles Díez de Rivera, now an important patron of the Fundación Balenciaga in Guetaria. According to her daughter, the friendship began in a strange way:

... [my mother] was pregnant with one of my brothers, and she tried to get them [the saleswomen] to give her a substantial discount at the Fashion House in Madrid because of her bulky figure, which would prevent her from using this dress later on ... As they flatly refused, my Mother, as bold as brass, saw Balenciaga walking along the corridor, blocked his way and asked him to knock down the price of the dress ... as she was expecting. Balenciaga looked at her over his glasses, and said, *'Why should I have to give you a discount on a dress just because you are expecting? I'm not the one to blame.'* My Mother found this remark really funny, and from then on they were close friends until Cristóbal died.[70]

This anecdote reveals that wealthy customers sometimes expected special treatment, and perhaps also that they thought cautiously about their expenditure.

The marquesa dressed in EISA till the early 1970s. Photographs by the society photographer Juan Gyenes capture her immediate adoption of Balenciaga's most fashionable lines as they developed in day and evening wear. She was so up-to-the-minute and savvy that she even chose the model that appeared on the front cover of French *Vogue* for November 1953. But she did also on occasion reuse a dress a decade or so after it had been made, a sign of the care she took with her appearance and figure. Her height, slim contours and graceful demeanour suited well even Balenciaga's most outré designs. Many of those garments – of exquisite quality – have been preserved by her daughter, whose own friendship began early in life, her First Communion dress being made by Balenciaga. Subsequently, it became an heirloom, worn by both her daughter and granddaughter before being donated to the Fundación Balenciaga. As an adult, Sonsoles Díez de

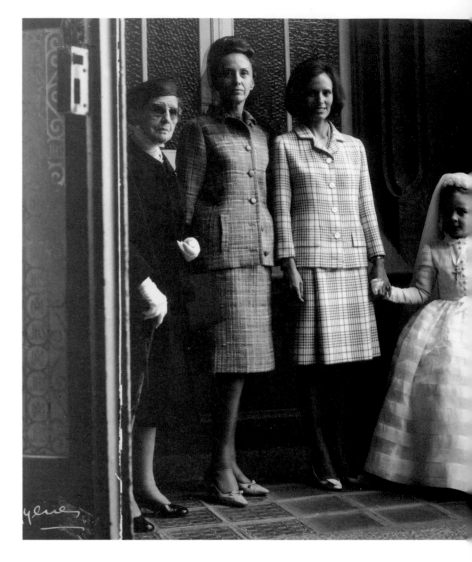

Rivera wore his dresses for the many fashionable society events. The one dress designed as well as made specifically for her was her wedding dress.[71] Now she dresses at Spain's only department store, the Corte Inglés, in both designer and non-designer labels, confident that elegance is not contingent on couture fashions.[72] With much the same confidence, as a young mother, she resisted Balenciaga's desire to rip out the sleeves of her shop-bought clothes and reset them.[73] Nonetheless, the sway that the house of Balenciaga had over the family was impressive: in the most extreme instance, four generations of women of the family appeared at family events in clothes made in one of his

83. Juan Gyenes, *Four Generations in Balenciaga*, 1966.
It is likely that all garments in this photograph were from the House of Balenciaga: certainly those of the Marquesa, her daughter and granddaughter were. The white organdie First Comunion dress made for Sonsoles Díez de Ribera in 1945 is worn by her daughter, while she herself wears a suit of red and white checked wool twill (both outfits are now in the Fundación Balenciaga in Guetaria). The Marquesa wears a woollen worsted suit, while her mother is clad in classic Spanish black. Changes in etiquette are noticeable here, as the two older generations still sport gloves and hats, while Sonsoles is bareheaded and handed. In Britain, the suit that the Marquesa wears attracted the attention of Harrods, too. The store advertised it in *Harrods Autumn Fashion News* (1965) as 'The "Long, Lean Look" of Balenciaga'. At £37 16s, it cost about one-third of the price of an original from Paris.
Courtesy of Fundación Balenciaga, Guetaria.

Spanish houses – grandmother, mother, daughters, granddaughter, mother-in-law.

While most of Balenciaga's clients at EISA were Spanish, some came from further afield. As in France, some were consistent and voracious consumers, while others were occasional customers. Marrying into or falling in love with Spain could be fatal, clothing-wise. After the Texan heiress Claudia Heard (died 1988) married the Spanish sherry merchant Rafael de Osborne in 1948, she spent her life mainly between the Ritz in Paris and the Ritz in Madrid. Her 'passion for fashion' led her to Balenciaga's salons in both cities and she became a faithful and avid customer until the house closed; for the remaining 15 years of her life she patronized Givenchy, Yves St Laurent, Felisa (a former colleague of Balenciaga), Pucci and finally Lacroix.[74] Her preference was to attend the Paris shows, but she was often fitted in Madrid – in her own apartments rather than at the house; autumn 1967 was the first time she did not make the collections in Paris, and Balenciaga accommodatingly supplied her with 200 of the photographs taken for his archives. As she wrote to a friend, 'They never show these photos as they are not for the public to see, but I am used to them and I can always tell about the dress from the photos'.[75] Like the Marquesa de Llanzol she had a special relationship with the couturier, socializing with him and extending her contact through the next generation: her daughter's First Communion dress made by Balenciaga in 1958 echoes that of Sonsoles Díez de Rivera made in 1948, and is now in the Metropolitan Museum of Art.

Another American client, whose dark beauty echoed that of so many Spanish women, was Ava Gardner, whose film career initially took her to Spain for the filming of *Pandora and the Flying Dutchman* in 1950. She fell 'head over heels in love with the place from the first moment'. In December 1955, when she left the USA for good, initially she chose Spain as her place of residence. In her autobiography she explained the attraction graphically: 'It was so unspoiled in those days, so dramatic, so historic – and so god-damn cheap to live in that it was

almost unbelievable. Combined with the fact that living abroad exempted me from paying domestic income tax, the whole package definitely appealed to the frugal side of my nature.' Interestingly, she was also well aware that she 'represented everything they [the Spanish] disapproved of. I was a woman, living alone, divorced, a non-Catholic, and an actress'.[76]

Sadly, in her autobiography, she does not mention that Balenciaga caught her attention, but he did – and the prices at his Spanish house may well have appealed to her 'frugal side'. Many of her clothes from the 1950s and '60s carry the EISA label, although some carry the Parisian label. Black dominates her surviving 'Spanish' wardrobe – a colour so beloved of Balenciaga that he made a single black dress with his own hands for each of his collections.[77] Black was traditional in Spain, in festive, mourning and religious dress. As Jocelyn Bush warned in 1959:

Spain . . . still clings to definite traditions. Its women still wear much black, since, not so many years back, any woman sporting colors was considered just that. So let's go dining at Madrid's Jockey Club in a very sleek short black dinner dress, which we'll wear dancing afterwards. You can discard the microscopic Parisian evening hat; look, no hats here. Spanish women have never got over the tall, amber comb idea, and their heads remain one of the few crowned glories of our time . . . You can wear colors, naturally, it's just that black seems to be the smartest thing for evening.[78]

Ava Gardner's black 'rags' often had dramatic trims (diamante bands of decoration on one garment from 1967, feathers on another) or were teamed with a striking contrast such as the ecru lace evening coat. Her wardrobe therefore embraced certain Spanish 'institutions': the bolero, lace and heavy embroidery.

Balenciaga's designs and service attracted a diverse private and professional clientele, some of whom were faithful to his house from the time of its establishment in Paris until its closure. Many clients did not desert the house in the 1960s, because the social etiquette of the pre-war years still governed their lives (their couturier may have moved with the times in

creating mini-skirts and trouser suits, even if
some, such as Claudia Heard de Osborne, were
cautious of such innovations); nor did they
necessarily throw away their clothes. There was
undoubtedly, however, a shift in emphasis in the
fashion world in northern Europe and America
as the baby-boomers became a significant
market. Ironically, Balenciaga, whom these
young people did not understand, laid the
foundations for meeting their requirements:
he trained Courrèges, whom he supported
materially in the setting up of his own house;
he even recommended that certain of his own
clients patronize the new house.[79] When
Balenciaga retired, others – mature and faithful
– knew where their natural home lay. It is sad,
therefore, that *Newsweek* noted:

> . . . The craze for the youthful look that
> Courrèges did so much to launch put Balenciaga
> customers into a panic about looking matronly
> . . . As hip young designers catapulted into
> headlines, Balenciaga's own flair for fun fashion
> . . . was overshadowed.[80]

Five years later, with the advantages of
hindsight, Fraser Kennedy summed up
perceptively the issue from the consumer's point
of view in her review of the 1973 retrospective
exhibition of Balenciaga's work:

> It is not that the Balenciaga clothes could
> never be worn by young women but, rather, that
> they could clearly be worn with great distinction
> by those who were no longer younger. This failure
> to exclude middle age is today a striking and
> unfamiliar quality. Here are clothes for women
> with hips and bosoms, even the odd bulge or
> two. ('M. Balenciaga *likes* a little stomach' one
> of his fitters said.) Many of his inventions
> distinctly benefited the older woman.
> Waistlessness was flattering to her, as was
> the blouse-back sheath, which concealed the
> lower back, whose curve is attractive only
> in the very young.[81]

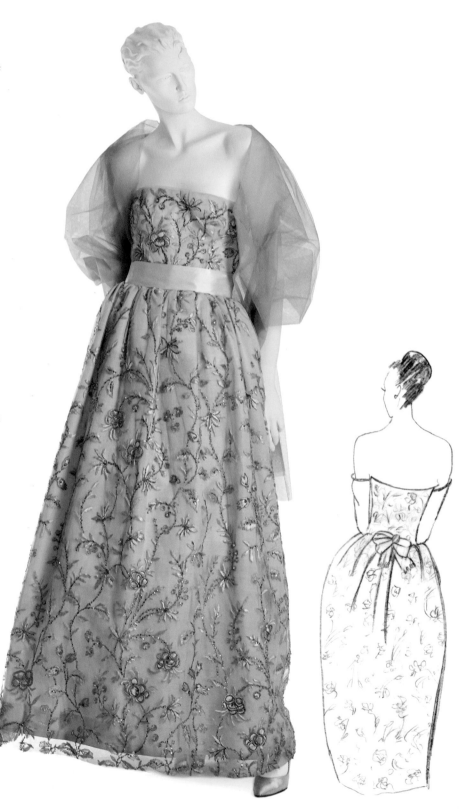

84 & 85. (LEFT) Evening gown of pale pink tulle, c.1958. Sketch of the same dress. This evening dress with embroidery by Lesage was one of Claudia Heard de Osborne's favourite dresses from Balenciaga: 'I especially loved the pale pink evening gown, all embroidered. Balenciaga made this for me to wear to a ball that Barbara Hutton gave in her famous house in Tangiers.' Living and visiting across countries and continents required regular packing and Mrs de Osborne commissioned the accompanying sketch (among others) from the house so that her maid could refer to it when packing.
Courtesy of Texas Fashion Centre, University of North Texas, Denton

86. (RIGHT) Ava Gardner arriving at a function in a black evening gown and ecru lace-crochet evening coat, late 1950s. Ava Gardner arriving at a function in black evening gown and ecru lace evening coat, c.1960. Gardner acquired this coat in Spain in the late 1950s or early 1960s, and it was donated to the V&A in her memory after her death (V&A: T.294-1990). Made of machine-made lace stitched to an organdie lining, it is decorated all over with strips of net which have been chain-stitched on to the base fabric in the shapes of flowers; the edge of the sleeves and the body are scalloped. Some time after this photograph was taken, a trimming of ostrich feathers was added round the sleeves, attached in a rudimentary fashion. This model cannot be matched to a Parisian equivalent so may be an example of a Spanish adaptation.
Courtesy of Camera Press.

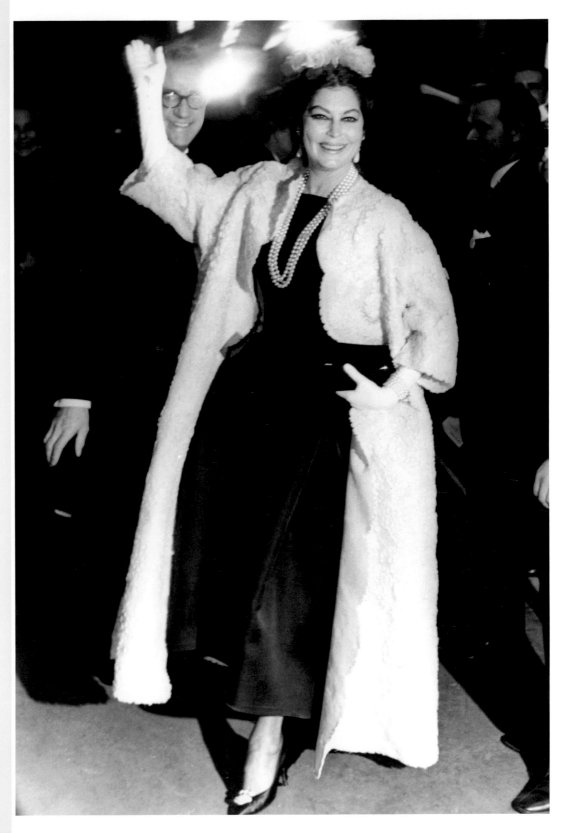

CONCLUSION

There is one brief, pithy Spanish word, cursi, that Balenciaga uses to describe what he hates most in fashion: vulgarity and bad taste. Of these he has never, ever, been guilty. Almost since the first day he launched his salon in 1937 he has been acclaimed as the great leader in fashion; what Balenciaga does today, other designers will do tomorrow, or next year, by which time he will have moved on again, out in the forefront of true elegance and chic. But because of his obsessive shyness, his dislike of Press publicity . . . his elusiveness . . . a kind of mystique has been built up around him, which makes some people wonder if there really is a Balenciaga at all.[1] British *Vogue*

Balenciaga's rise from 'rags to riches', from seafarer's son to world-famous couturier, has fed the imagination of generations of fashion designers. His concentration on his work and rejection of personal publicity shrouded him in mystery, focusing press attention on his clothes. The impressive array of his clients and their allegiance to him, the quality of his clothes and the respect of his fellow couturiers, turned him into a legend in his own lifetime. Without attempting to delve into Balenciaga's personal life, this book has considered some of the formative experiences that led to the founding of his house in Paris and the evolution of a small fashion empire, which extended to three major Spanish centres. Since the early 1990s, more reliable factual information on his family background, the financing of his businesses and their particular internal 'culture' has led to a more nuanced impression of his achievement. They locate him firmly within his time and its values, and underline even more strongly than before the need to consider two geographic and political contexts: Spain and France. They also emphasize his dependence on others for initial financial backing as well as the length of time it took him to build his empire (he was about 60 at its height in the mid-1950s).

The House of Balenciaga adhered to the well-established formula of 1930s haute couture, and depended on both Spanish and French social and political developments. The dictatorship of Franco created conditions that kept Spain in a time warp throughout Balenciaga's life, ensuring the continuation of traditional roles and occupations for men and women. The local dressmaker or tailor was becoming obsolete in more 'advanced' parts of Europe, but in Spain Balenciaga's services were as necessary as ever. In fact, high fashion was restricted to a small elite until the 1980s, when a new breed of Spanish ready-to-wear began to emerge. In Paris, the advent of ready-to-wear and youth fashion threatened elite couture much earlier, contributing to Balenciaga's decision to retire. This decision was timely. The world of the late nineteenth and early twentieth centuries had virtually vanished by the time of his death.

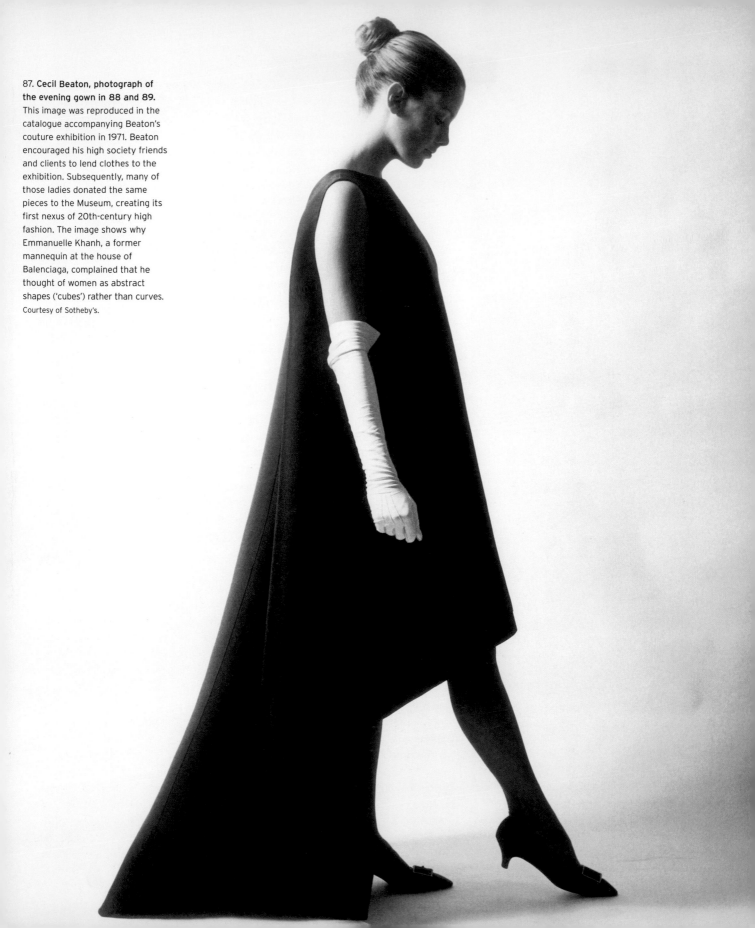

87. **Cecil Beaton, photograph of the evening gown in 88 and 89.**
This image was reproduced in the catalogue accompanying Beaton's couture exhibition in 1971. Beaton encouraged his high society friends and clients to lend clothes to the exhibition. Subsequently, many of those ladies donated the same pieces to the Museum, creating its first nexus of 20th-century high fashion. The image shows why Emmanuelle Khanh, a former mannequin at the house of Balenciaga, complained that he thought of women as abstract shapes ('cubes') rather than curves.
Courtesy of Sotheby's.

In many ways the fashions created by Balenciaga reveal characteristics typical of design in Spain during the Franco regime: a sense of what one historian has called *desfase*, the tension between traditional popular design relentlessly promoted by the regime and the modernist idiom prevalent in the rest of Europe.[2] But even this simplification underestimates the importance of Spanish influences on his work. Balenciaga did rely on Spanish popular design, national dress and 'typically' Spanish colours for many of his models. In the world outside Spain, these constituted a 'remarkable' phenomenon that could be promoted as 'different' among the small circle of truly Parisian designers. Many other elements in his design were considered innovative, modern and hence truly international. He pared away superfluous ornament and championed pure, simple, sculptural lines. Even this classic paring-away owed much to historic and timeless modes of Spanish dress. Ecclesiastical and clerical clothing based on simple shapes and austere styles lent itself to modernist interpretation outside Spain.

This analysis does not deprive the work of Balenciaga of its potency, but rather situates the man realistically within the traditions with which he was familiar. His design and his business practice were in keeping both with the times in which he was living and with his rigorous upbringing in early twentieth-century Spain. In a profession that looks for heroes, and often praises too easily with no critical edge, Balenciaga stood out – and still stands out – on account of both his personal qualities and the unerringly high standard of his work. These qualities are not all fashionable today. Yet, the designers who have most recently taken on his mantle in the House of Balenciaga at the very least pay tribute to the values of their illustrious predecessor's perfectionism – attempting to understand his methods and output.

88 & 89. (LEFT) **Front and back views of black evening gown and cape of silk zibeline by Staron, Paris, 1967.** The sleeveless dress has a high round neck, and flares from the shoulders – to the knee at the front and to the floor at the back. It reveals Balenciaga's expertise in cut as it is made with a single seam. The cape echoes this line, being shorter and fastening at the front with two large buttons covered in the same fabric. Worn by Gloria Guiness.
V&A: T.39-1974

90. (RIGHT) **Francisco de Zurbarán. *Fray Francisco Zúmel, c.1630.*** This portrait of a Mercederian monk reveals how closely timeless monastic dress may be equated with the simple modernity of Balenciaga's later designs. The white wool of the monk's habit is unadorned, voluminous in its folds, and envelopes the body without hugging its contours. Many of Balenciaga's silk gazar evening dresses and capes of the mid- to late 1960s were similar in concept, though made in quite different materials and with different intent. The dress of monks and priests in paintings of the Golden Age of Spanish art (from El Greco to Goya) was all too familiar to Balenciaga and his Spanish contemporaries, who saw it on a daily basis in the streets.
Museo de la Real Academia de Bellas Artes de San Fernando.

91. **Inge Morath, *Two priests in the Gran Vía*, Madrid, 1955.** Inge Morath cleverly captured 'old' and 'new' Spain in this image taken in the street in which the house of Balenciaga was located. The two traditionally clad priests, in flowing soutanes and cloaks and wide brimmed hats, walk away from the queue of ordinary citizens, anxious to enjoy the sophistication of an American movie. Such a scene was not uncommon right up to the end of the Franco regime.
© Inge Morath/Magnum Photos.

POSTCRIPT: LEGACIES

The fashion world worships Nicolas Ghesquière. During his tenure at Balenciaga, the designer has taken a classic house and made it his own: a thing of chic, edgy, intellectual beauty. But for Ghesquière it is the label's creator, the great Cristóbal Balenciaga, who remains the ultimate fashion icon.[1] Harriet Quick

Until the second half of the twentieth century, couturiers did not expect their couture houses to survive them.[2] They anticipated that their apprentices would go out and establish their own houses, just as Balenciaga's apprentices Courrèges and Ungaro did.[3] When Balenciaga and his partners set up in 1937, however, they allowed a 50-year life for the house, a life that these mature men knew would come to its natural end well after their deaths. The house has survived even its original planned demise, thanks to the late twentieth-century obsession with brands. Yet, there seems to have been no succession planning in order to ensure that it continued after Balenciaga's retirement and death. It is no longer, of course, a couture house. After a quiet period between the late 1960s and mid-1990s, it has become once again a major player in high fashion (ready-to-wear), receiving many plaudits from fashion journalists. The press invokes the spectre of the original founder on all possible occasions; the house itself acknowledges consistently its debt to the master; and the current designer, Nicolas Ghesquière, put his weight behind the major retrospective exhibition at the Musée de la Mode et du Textile in Paris (May 2006–January 2007). Indeed, he co-curated the exhibition, permitting the museum to finish off the display with clips from some of his own catwalk shows and actual examples of his recent pieces – stunning in much brighter lighting than the subdued levels required for historical preservation in the earlier sections. The result is impressive, but also suggests that nothing happened between 1968 and 1998.[4] This postscript steps into the breach, to reveal briefly how the house kept alive until its recent much publicized renaissance and where it stands now.

The Invention of Tradition

The reputation of Balenciaga has been crucial to the business, as has the increased interest in collectable couture over the last twenty years. Since the early exhibitions in New York and Madrid just after Balenciaga's death (1973 and 1974), biographies and exhibitions have proliferated, bringing the designer's name and

92. **Francesca Galloway,** *ES: The Evening Standard Magazine* **(February 1992).** Francesca Galloway, formerly of Spinks, deals in second-hand couture. In the *Evening Standard* in 1992 she wears a black Balenciaga evening gown that she bought in France in the 1980s. She still owns this gown.
Courtesy of the *Evening Standard*.

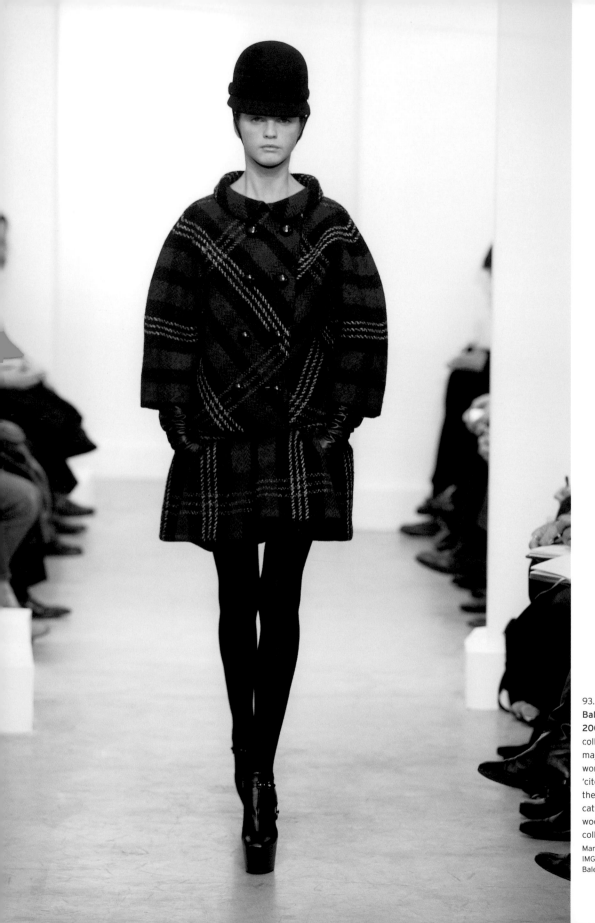

93. **Nicolas Ghesquière for Balenciaga, autumn/winter 2006–7.** In the most recent collection, which coincided with the major retrospective of Balenciaga's work in Paris, Nicolas Ghesquière 'cited' the master in every one of the garments that went down the catwalk. This suit is based on a woollen suit from the couture collection of Winter 1960, no. 1364. Mannequin: Jieisa Chiminazzo. Agency: IMG Models. Courtesy of the Archives Balenciaga, Paris.

work to a wider audience and stimulating interest in his clothing (see Bibliography and Appendix 1). Various designers have fuelled this interest through homage to him. Not only do fashion journalists invoke Balenciaga as a standard, but certain novelists have looked to him for 'authenticity'. How better to position an American débutante of the first half of the twentieth century than to refer to her wardrobe by Poiret and Balenciaga? How better to create a plot around a mysterious designer who will not come out of her workshop and face the cameras, than to explain that her mother trained as a seamstress chez Balenciaga?[5] More recently chic lit' has also used the house's new design ethos to position its protagonists, with Sam Baker's fashion journalist novice encountering the excitement of Ghesquière's collections.[6] In similar vein but in real life, Lisa Armstrong noted that the 'elegant, educated and staggeringly rich . . . [and] glamorous' Russian ladies of London 'melted at the sight of Nicolas Ghesquière's sculpted poufs for Balenciaga' at Harrods this season, reporting that the sales associate was particularly thrilled because these women want the 'most challenging catwalk pieces', not the selling collection.[7] Clearly, Balenciaga is a name the fashion cognoscenti will know, but so too will many a casual reader.

In the commercial sector, second-hand couture has contributed to an awareness of the fashion greats of the first half of the twentieth century. From the mid-1980s the sale of couture garments took off in London, initially via Spinks and subsequently through Christie's and Sotheby's.[8] The demand for vintage fashion and the death of couture clients of the first half of the twentieth century – some extremely famous – have fuelled this market. Balenciaga was crucial to Francesca Galloway's pioneering idea that the London auction house Spinks should sell couture. Visiting the important retrospective exhibition of Balenciaga's work at the Musée des Tissus in Lyons in 1985, she was struck by 'the sculptural quality of the dresses [which] gave them a fascination beyond their superficial appeal'.[9] Subsequently, Spinks

opened their Costume Department, which concentrated primarily on nineteenth- and twentieth-century couture. The department not only dealt in designer clothes but also held two exhibitions (1988 and 1990), which both included Balenciaga models. According to Francesca Galloway, Balenciaga's evening dresses of the 1950s and '60s were popular items in the 1990s, their prices ranging from several hundreds to several thousands of pounds. Today the dealer Kerry Taylor confirms that Balenciaga still sells well, a classic suit fetching somewhere between £500 and £800, evening wear starting at £400 and reaching as high as £7,300 (but most typically a good black lace gown sold recently for £4,200). When a splendid gown has a sound provenance, then the price escalates. At present, Balenciaga daywear is on a par with that of Yves St Laurent or Christian Dior, but their evening gowns tend to be more expensive. The market is, of course, affected by exhibitions, the most recent one at the Musée de la Mode et du Textile in Paris fuelling interest, and Kerry Taylor predicts that the opening of the Museo Balenciaga in Guetaria next year will have the same effect.[10]

At these prices, second-hand couture offers an interesting alternative to both of Balenciaga's present-day ready-to-wear collections – especially if the wearer is intent on displaying fashion know-how. Meredith Etherington-Smith noted in an article in the *Evening Standard Magazine* in 1992 that 'unlike what you buy in the high street, second-hand Balenciagas and Chanels not only have a third-hand resale value, but also give the wearer the cachet of clever chic'.[11] All illustrated garments were by Balenciaga, worn variously by the journalist Meredith Etherington-Smith herself (in a tweed suit that had belonged to the redoubtable Fern Bedaux, awarded the Légion d'honneur for her services to French fashion); Francesca Galloway, in a black gazar cocktail dress, bought in Paris ten years previously; Hamish Bowles, then style director of *Harper's Bazaar* in a pre-war velvet cloak from his collection; and Lucy Ferry, at that point wife of the singer Bryan, a customer of Christian

Lacroix, in a mid-1960s geometrically cut, shocking pink, full-length silk dress.

The advent of collectable couture coincided with designers in couture houses drawing on the traditions (and archives) of the house in order to create 'signature' collections. Early in the game, from his first collection for Chanel in 1983, Karl Lagerfeld championed Chanel's legacy, while more recently John Galliano has taken the Dior archives as a starting point for his collections. At the House of Balenciaga, the same occurred with the arrival of the designer Michel Goma in 1987, and, of course, Nicolas Ghesquière made capital out of his own access to the 'Keys to the Kingdom' in 2002, the kingdom being the archives.[12] Indeed, Goma's two archive-based collections of the late 1980s led to acclaim for his work at Balenciaga. Rather than reduce Goma's creative input to nothing, the house devised the plan of dividing the collections into two sections: one for designs inspired by the archives and one for pure Goma models. By the time of the collections of July 1990 reports were improving, as an article in *Amina* indicated: 'The last Haute Couture presentation of Balenciaga was a real success . . . The great Cristóbal Balenciaga would not have disowned this Haute Couture collections . . . This collection conceived and realized by Michel Goma, remains in the tradition of the great Balenciaga.'[13]

Goma's division of labour and retention of his own personal input anticipated Ghesquière's situation. At the start Ghesquière did not have access to the archives, so any resemblance to Balenciaga styles came from his familiarity with the photographs of Irving Penn or his visits to exhibitions. All changed once he had established himself as chief designer and had access to the archives. In 2002 Amy Spindler explained:

. . . what designers like Ghesquière at Balenciaga and Tom Ford at Gucci do is imagine a full vocabulary. They try to evoke a familiar feeling without the design being directly copied. It's an infusion. An essence. A reduction. It's like looking at a photo of a beautiful, exotic creature and inventing the language she might speak . . .

Ghesquière himself admitted that 'integrating and forgetting' had been his general attitude toward Balenciaga's work before he entered the archives, and that 'It might not be so easy now that directly beneath his office the archives are open to him for the first time',[14] a premonition borne out by his most recent collections. One response was the launch of the Edition collection in 2004, defined by its designer as comprising 'original designs reworked and reissued to suit the mood of fashion'.[15] Not only are the styles respected but every effort has been made to use original suppliers to the house, or to find acceptable substitutes who are able to make similar textiles.[16] In the autumn of 2006, the archive was fundamental to Ghesquière's collection, since 'to tie in with the retrospective, I thought, here we go! I wanted every outfit to be a citation, to have a direct link with Cristobal Balenciaga – the fabric, the hat, the print . . . To make a collage of Balenciaga.'[17] He succeeded, offering instantly recognizable Balenciaga tweed suits of the 1960s accessorized with jockey caps, platform-soled boots and riding whips – quintessentially Ghesquière and absolutely in tune with the way in which the market has changed.

Balenciaga Changes Hands

The corporate story of Balenciaga is much the same as that of competing houses. It has ceased to be an independent business and is now one of a stable of houses belonging to a major conglomerate with interests in branded luxury goods. Originally, after Balenciaga's death in 1972, the house passed into the hands of his nephews and nieces, who kept the perfumes and accessories going. In 1978 they sold the business and its name to the German group Hoechste, which was responsible for launching the first ready-to-wear collections. In October 1986 the French perfume group Jacques Bogart, under the directorship of Jacques Konckier, bought Balenciaga SA, and began upgrading the image 'to work in the Balenciaga tradition'. American and Hong Kong branches, Balenciaga Inc. and Balenciaga Hong-Kong, were set up at the beginning of his reign in 1987. By 2000 Balenciaga was still not exactly an outstanding

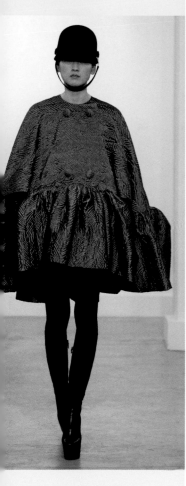

94. (ABOVE) **Nicolas Ghesquière for Balenciaga, autumn–winter 2006–7.** This grey cape, in silk cloqué, was based on no. 195 of Balenciaga's summer 1963 collection. It is a direct reference to the original cape but the cloqué has a very different quality from the original gazar.
Mannequin: Hye Park. Agency: City Models. Courtesy of the Archives Balenciaga, Paris.

95. **White gazar cape, February 1963.** This white cape remains from an ensemble worn by Mrs Gloria Guinness, exhibited in Beaton's 1971 couture exhibition and subsequently given to the Museum.
V&A: T.31-1974.

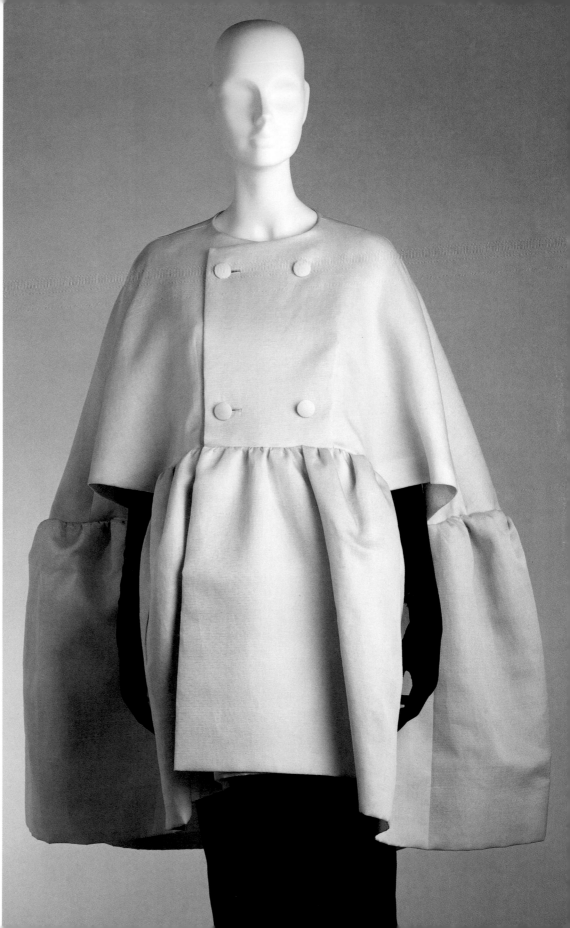

business. Perfume accounted for the majority of sales, as it does for comparable houses.[18]

Nonetheless, in 2001 Gucci bought the brand, to the amazement of many – with majority rather than unanimous approval from the conglomerate's shareholders. Chief executive Domenico De Sole and Texan designer Tom Ford expressed the intention of developing it as a global luxury brand, focusing on ready-to-wear, accessories and perfumes.[19] Balenciaga thus joined Gucci's other prize businesses: Yves Saint Laurent ready-to-wear, the Italian leather goods makers Bottega Veneta (handbags and shoes) and Sergio Rossi (shoes), Boucheron jewellery, and the newer names they were to support in setting up their own labels, Stella McCartney (now, five years later moving into profit) and Alexander McQueen. Gucci thus became the main competitor of LVMH (Louis Vuitton Moet Hennessy), owner of Lacroix, Givenchy, Pucci and Louis Vuitton. The acquisition did not instantly bode well; since the value of Gucci shares dropped, possibly a sign of the instability of markets for luxury goods in the face of crisis in the Japanese economy and deceleration in the USA and Europe.[20] Not all members of the business community knew the name of the original Spanish designer or had hopes of success for the business. In Spain, the journalist Lola Galán explained Gucci's surprising move:

> **For some time they [De Sole and Ford] had noticed the talent of the new 'strong man' at Balenciaga Nicolas Ghesquière (formerly at Callaghan). Gucci had courted him for months without getting the desired yes.**
>
> **Finally, they reached for the cheque book and opted for taking on the whole firm. Ghesquière will maintain 9% of Balenciaga and will continue as the artistic director. 'Nicolas has enormous talent and all luxury businesses have propositioned him', Domenico de Sole declared in order to justify an action that not all shareholders in Gucci approve.[21]**

The timing of this acquisition was impeccable, since Ghesquière walked off with the award for best international designer at the Council of Fashion Designers of America Awards in the same year.[22]

96. Balenciaga boutique in Paris, 2003. The design of the boutique has always been an important indication of the nature of the business, accessible as it is to a wider public than the salon. During Balenciaga's life-time, the house effected a major transformation in 1948 which may have looked dated twenty years later. Most recently, the house has been upgraded in a contemporary style.
Courtesy of the Archives Balenciaga, Paris.

The physical image of the house has also changed since Balenciaga's time, although it remains upmarket. Andrée Putman, one of the foremost interior designers in Paris, redesigned the shop at 10 Avenue Georges V in 1989. Chosen for her reputation and experience (the house had noted her legendary salon designs for Yves Saint Laurent and Karl Lagerfeld), she was the epitome of the standards the company wished to maintain. Her simple black and white interior offered a suitably timeless alternative to the previous heavy Spanish-style boutique. It was discreet but modern. The window displays, however, were altered to a stage far beyond Balenciaga's subtle suggestions for the shop behind the façade. They contained examples from the current ready-to-wear collections, usually on minimalist stands or pieces of furniture, with accessories and perfumes by Balenciaga. The interior of the shop was just visible through the screens at the back of the displays. All items bore prices. Nothing was left to the imagination. In 2003 the shop was

undergoing further renovation, to designs by Nicolas Ghesquière in association with the French artist Dominique Gonzalez-Foerster. They seek a 'futuristic and luxurious environment' to suit Ghesquière's collections, 'a landscape to wander through and discover':

The stores feature a mix of natural, raw and artificial materials. The light changes in the artificial sky, giving an impression of climatic, seasonal and time changes – from sunrise to noon, from cloudy to sunny, a concept developed by Benoit Lalloz. White modular display structures, made of metallic lacquered poles, are placed throughout the landscape. Common elements of designs include the artificial 'black asteroid' used as cash register, and the 'iceberg' used as an accessory display.[23]

The shop is no longer the entrance to the fashion shows, which now take place in a trendy venue on the Left Bank in rue Cassette. In addition, there is a store in New York, opened in the meat-packing district in 2003, the interior design then comprising raw rocks and primeval rocks on its walls.[24] The geography of fashion has shifted since Balenciaga's time and the clients that Nicolas Ghesquière attracts are ever so slightly different – younger, certainly, and some *cursi* by Balenciaga's standards.

During Goma's time, the house attracted custom again from old faithfuls such as Bergdorf Goodman in New York and Nordstrom in the southern states (from 1991). These stores were chosen carefully by the management, and the range was exclusive and not available from any of the other big American department stores. The target audience was a particular clientele: professional women who could afford such high prices, and were mostly in their late twenties to early forties. The willingness of such women to buy ready-to-wear indicated the general shift away from couture to a high-class, expensive alternative. Since Ghesquière took over, a wider range of retail outlets has succumbed to the Balenciaga charm, and customers now include Harrods, Selfridges and a number of celebrities (not just 'ladies who lunch'): by 2001 they included Charlotte Gainsbourg, Madonna,

Siobhan O'Connor, Françoise Hardy and Chloé Sevigny and by 2005 Jennifer Connelly, Maggie Cheung, Nicole Kidman and Jemima Khan. With the cost of an ivory silk cocktail dress commanding £3,000, the market for original ready-to-wear Ghesquière is limited.[25] It may even compete with second-hand couture by the master himself.

The fate of the perfumes has been different from that of the ready-to-wear. According to James McArthur, Executive Vice President of Gucci Group and President & CEO of Balenciaga, after the sale in 2001, Gucci Group allowed the vendor of Balenciaga, the French fragrance group Jacques Bogart, to continue manufacturing and distributing Balenciaga fragrances under licence for a limited number of years. No new Balenciaga fragrances were launched during this period and the fragrance activity quietly reduced in scale and visibility. That licence expired at the end of 2006, and today only residual stocks of Balenciaga fragrance may be found.[26] Thus, now the name of Balenciaga is no longer linked to out-moded fragrances but rather to prestigious upmarket fashion items, including the House's famous ready-to-wear and bags.

Time will tell what will become of Balenciaga: where Ghesquière's imagination will lead the house; and what part the archives will play in the future. At the moment, Ghesquière's star is in the ascendant. But will his reign in contemporary fashion match that of his illustrious predecessor, will he achieve the lasting respect of his peers, and will these ready-to-wear garments (multiples) become iconic statements as their couture ancestors have done? Such are the questions that future generations of fashion historians will ponder.

REFERENCES

Foreword to the Second Edition
1 *Pertegaz* (Madrid, 2004), p.53.
2 Didier Grumbach, *Histoires de la Mode* (Paris, 1993), p.82, citing Marie-Andrée Jouve and Jacqueline Demornex, *Balenciaga* (London, 1989).
3 Grumbach, *Histoires de la Mode*.
4 Alexandra Palmer, *Commerce and Culture* (Vancouver, 2002).
5 Co-curated by Pamela Golbin, curator of twentieth-century fashion at the museum, and Nicolas Ghesquière, chief designer at Balenciaga. Accompanying publication: Pamela Golbin, *Balenciaga Paris* (Paris, 2006).
6 Suzy Menkes, 'Temple to a Monk of Fashion: Museum to Open in Basque Designer's Birthplace', *International Herald Tribune* (24 May 2003); www.fundacionbalenciaga.com.
7 *Cristóbal Balenciaga*, Museo Nacional de Escultura, Valladolid, 2000.
8 www.fundacionbalenciaga.com.
9 Co-curated by Jouve and Pierre Arizzoli-Clementel, then director of the museum.
10 *Mona Bismarck, Cristóbal Balenciaga, Cecil Beaton* (Paris, 1994).
11 Golbin, *Balenciaga Paris* (separate versions in French and English are available); Myra Walker, *Balenciaga and his Legacy* (New Haven and London, 2006).

Introduction
1 Cecil Beaton, *The Glass of Fashion* (London, 1954), p.259.
2 *L'Officiel* (1938), p.1.
3 *Woman's Journal* (September 1939), p.17.
4 *Silk and Rayon* (November 1949), p.1462.
5 Georgina O'Hara, *Encyclopaedia of Fashion* (London, 1989).
6 Diana Vreeland, *DV* (New York, 1985), p.139.
7 *Le Figaro* (11 September 1990), p.34.

Chapter One: A Spaniard in Paris
1 Vreeland, *DV*, p.139.
2 Prudence Glynn, 'Balenciaga and *la vie d'un chien*', *The Times* (3 August 1971), p.6. Hereafter, all references to Glynn and Balenciaga in conversation are from this article; only direct quotes are footnoted.
3 Quoted in Guillaume Garnier, *Balenciaga* (Tokyo, exhib. cat. 1987), p.86.
4 Quoted in Jouve and Demornex, *Balenciaga*, p.96.
5 Percy Savage, 'Balenciaga the Great', *The Observer* (13 October 1985), p.51.
6 Anny Latour, *Kings of Fashion* (London, 1958), p.260.
7 More than half a million died in the Civil War and a further half-million were in exile. Thousands more died in post-war repression. Adrian

Shubert, *A Social History of Modern Spain* (London, 1990), p.206.
8 'La Semaine sainte en Espagne', French *Vogue* (March 1951), p.82.
9 For example, ibid.; and André Villeboeuf, 'Bientôt La Temporada', French *Vogue* (April 1952), pp.127ff. Information for brochures for this period in Thomas Cook Archive.
10 Raymond Carr, *Modern Spain, 1875–1980* (Oxford, 1988), p.157.
11 *Guía comercial de Madrid* (Madrid, 1934, 1935 and 1936); he appeared under his own name as a *modisto*, c/Caballero de Gracia, 42; Archivo de la Villa de Madrid (henceforth AVM), Extracto del empadronamiento municipal quinquinal de habitantes de diciembre 1935, registered as Cristóbal Valenciago Eisaguirre (mis-spelt), but applied to have a neon sign put up on balcony of house with Costura EISA B.E in 1934. AVM 45-122-14, Inv. 746. On 26 December 1941 reopened on the first floor of Gran Vía José Antonio, 9 and company renamed EISA S.A. in 1946. AVM 28-385-51 and 36-268-12.
12 Félix Luengo, 'En la memoria cercana, 1936–2000', in *Historia de Donostia San Sebastián*, ed. Miguel Artola (San Sebastian, 2000), pp.406–7.
13 Madge Garland, *The Changing Form of Fashion* (London, 1970), p.112.
14 Shubert, *A Social History of Modern Spain*, p.211.
15 This was Pertegaz's experience and he gradually supplanted Balenciaga in the post-war years as the Spanish bourgeoisie's favourite designer. *Pertegaz*, p.104.
16 Until Manuel Pertegaz got established, according to Enrique Loewe Lynch's testimony, ibid., p.111.
17 AVM, 28-385-51. *Licencia* applied for on 26 December 1941 and granted on 30 April 1942 to establish himself in Avenida José Antonio. He was in the telephone directory for Barcelona in 1937, but not 1940, and requested planning permission from city authorities in 1942. *Guía telefónica de Cataluña* (1937 and 1940); Arxiu Municipal Administrativo, Barcelona, no. 6.687A.
18 Jouve and Demornex, *Balenciaga*, p.22.
19 Glynn, 'Balenciaga and *la vie d'un chien*', p.6.
20 Garland, *Fashion*, p.81; and *Woman* (15 February 1947), p.6.
21 Grumbach, *Histoires de la Mode*, pp.48–53. See too Lesley Ellis Miller, 'Perfect Harmony: Textiles, Textile Manufacturers and French Haute Couture, 1947–57', in *The Golden Age of Couture* (forthcoming).
22 Ducharne, cited in Florence Charpigny, 'L'étoffe de la mode: soierie lyonnaise et haute couture, l'example de la maison Ducharne', in *Mode: Des parures aux Marques de Luxe*, ed. Danielle Allérès (Paris, 2005), p.31.
23 Golbin, *Balenciaga Paris*, p.18.
24 Bettina Ballard, *In My Fashion* (London, 1960), p.111.

25 Jouve and Demornex, *Balenciaga*, p.23.
26 AVM, Extracto de Empadronamiento Municipal Quinquenal de Habitantes de Diciembre 1935; Inspección de rentas . . . , 1945.
27 Ballard, *In My Fashion*, p.110.
28 Ducharne, cited in Charpigny, 'L'étoffe de la mode', p.29.
29 Lucien François anecdote.
30 Golbin, *Balenciaga Paris*, p.24.
31 Ballard, *In My Fashion*, p.111.
32 Ibid., pp.116–18.
33 Percy Savage in conversation with Linda Sandino, National Life Story Collection in partnership with the London College of Fashion, 11 July 2004.
34 Although a list of what exactly the family owned has not been traced.
35 Commission for Infanta dress from Madame Bemberg for the Beaumont Ball in 1939 in red velvet and white organdie; Jouve and Demornex, *Balenciaga*, p.40.
36 His father was José Balenciaga Basurto (1862–1906), his mother Martina Eisaguirre Embil (1864–1944); his older siblings were his sister Agustina Balenciaga Eisaguirre (1888–1966) and his brother Juan Martín Balenciaga Eisaguirre (1889–1955), who became the father of ten children. Golbin, *Balenciaga Paris*, p.30. His mother's earliest surviving bill is reproduced on the same page.
37 On the Spanish education system, see Shubert, *A Social History of Modern Spain*, p.182.
38 In 1959 the population was 1,518, inhabiting 144 residences. *Diccionario geográfico de España*, vol. 12 (Madrid, 1960), pp.146–7.
39 *Guía oficial de San Sebastián y de la Provincia de Guipúzcoa*, ed. El Sindicato de Iniciativo y Propaganda (San Sebastian, 1924–5), pp.115–16. He owned works by El Greco, Zurbarán, Goya and Rodin. Miren Arzalluz, 'Cristóbal Balenciaga: The Making of a Work of Art', unpublished MA dissertation, Courtauld Institute of Art, University of London (2004), p.9.
40 *Censo de España* (Madrid, 1897); *Diccionario geográfico de España*, vol. 12, pp.316ff.
41 Montserrat Garate Ojanguran and Javier Martín Rudi, *Cien Años de la Vida Económica de San Sebastián, 1887–1987* (Donostia-San Sebastian, 1995), pp.269–311.
42 *Guía ilustrada para el forastero en San Sebastián* (San Sebastian, 1913), p.7.
43 For example, ibid., p.64; *La Voz de Guipúzcoa* in various issues sampled for June to August 1919, the year Balenciaga set up on his own. For example, La Perla Vascongada advertised textile novelties of all kinds, 'Sastrería . . . Taylor', on p.36.
44 Thomas Cook Archive, Holiday brochures for 1930s–1960s.
45 Captain L. Richardson, *Things Seen in the Pyrenees* (London, 1928), p.122.

46 His mother's earliest surviving bill is reproduced in Golbin, *Balenciaga Paris*, p.30.
47 Ballard, *In My Fashion*, p.112.
48 Latour, *Kings of Fashion*, p.259.
49 Georgina Howell, *Sultans of Fashion* (London, 1990), p.3.
50 Quoted ibid., p.3.
51 Glynn, 'Balenciaga and *la vie d'un chien*', p.6.
52 Jouve and Demornex, *Balenciaga*, p.370.
53 Ibid., p.99.
54 Ballard, *In My Fashion*, p.113.
55 Quoted in Howell, *Sultans of Fashion*, p.3.
56 Percy Savage in conversation with Sandino.
57 Alison Adburgham, former fashion journalist, in a letter to the author, 9 March 1991.
58 Musée Historique des Tissus, *Hommage à Balenciaga* (Lyons, 1985), p.39.
59 Ballard, *In My Fashion*, p.113.
60 Beaton, *The Glass of Fashion*, p.267.
61 This is the title of an article in the catalogue for the exhibition *El mundo de Balenciaga* held in Madrid in 1974.

Chapter Two: From Cloth to Collections
1 Celia Bertin, *Paris à la Mode* (London, 1956), p.229.
2 Zumsteg (1968), cited in Musée Historique des Tissus, *Hommage à Balenciaga*, p.38.
3 Jouve and Demornex, *Balenciaga*, p.78.
4 Nor does it chart conception to completion as the House of Balenciaga now reserves the use of sketches of the collection for its own purposes. For a much more detailed year-by-year breakdown, seen through the eyes of international journalists and examples of the sketches, see Golbin, *Balenciaga Paris*.
5 For a good description, see Dominique Veillon, *Fashion under the Occupation* (Oxford, 2002), chapter 5.
6 *Harper's Bazaar* (April 1947), p.29.
7 *Draper's Record* (13 August 1955).
8 'The Paris Designers Must Have Hearts of Flint', *Evening Standard* (3 September 1955), p.11. She rang Adrienne Corri, Moira Lister, Mary Ure, Margaret Leighton and Mrs Laurie Newton Sharp. Mrs Newton Sharp had seen the potential of the new style immediately: 'She intends to buy a late afternoon dress and wear it with one of the new three-quarter length-coats. She says she could then go to an informal dinner in the dress and wear it with the coat for lunch.'
9 *Draper's Record* (12 August 1950).
10 *Daily Express* (31 July 1958).
11 American *Vogue* (15 October 1957), p.68.
12 In Christian iconography, St James the Great, patron saint of Spain, is depicted in long flowing (shapeless) robes, with a wide, brimmed hat with a cockleshell badge on it.
13 Fake fur jacket, winter 1967. Musée Galliera, Inv.No.MMC 90.12.5. Acquisition of the City of Paris from Mme Roux.

14 *L'Officiel* (September 1938), p.102.
15 *Harper's Bazaar* (October 1938), p.49.
16 *Woman's Journal* (September 1938), p.17.
17 Beaton, *The Glass of Fashion*, pp.265–6.
18 Ibid., p.226.
19 *WWD* (23 August 1990).
20 Ballard, *In My Fashion*, p.120.
21 Fraser Kennedy, *The Fashionable Mind* (New York, 1987), p.84.
22 Beaton, *The Glass of Fashion*, p.267.
23 Musée Historique des Tissus, *Hommage à Balenciaga*, p.31.
24 'Rounding off this remarkable success enjoyed by Bernat Klein in the Paris autumn collections – his fabrics were used by 13 couturiers – comes the news that Balenciaga has also included one of his sensational new "velvet tweeds". Balenciaga used a velvet ribbon in dark brown interwoven with uncut mohair loop threads in black.' *Drapery and Fashion Weekly* (4 September 1964), cited in Bernat Klein and Lesley Jackson, *Bernat Klein: Textile Designer, Artist, Colourist* (Selkirk, 2005), p.15.
25 Cited in Musée Historique des Tissus, *Hommage à Balenciaga*, p.31.
26 Vreeland, *DV*, p.139.
27 Cited in Charpigny, 'L'étoffe de la mode...', p.32.
28 Archives Nationales de France, F^{12} 10.505, *Déclarations d'acte de candidature Couture-Création*, 1953 and 1954; also Jouve and Demornex, *Balenciaga*, p.74.
29 The thickness of the thread – measured in deniers – became important to the fashion-conscious after the war once nylon was readily available and rationing over – 15 denier was very fine, 30 medium-fine, and in Britain by 1950 stockings came in 45, 48, 51, 54, 60 and 66 gauge in plain mesh or lace knot. In other words, Balenciaga's 10-denier stockings were exceptionally fine. In the 1960s stocking became thicker again because of the mini-skirt, and in the middle of the decade Balenciaga's black seamed lacy stockings sat in the middle of the market at £1 10s. 6d, as compared with 9s. 6d for ribbed stockings by Corah and £4 10s. for hand-knitted stockings from Women's Home Industries. Jeremy Farrell, *Socks and Stockings* (London, 1993), p.79, citing *Vogue* (January 1965), p.59. *Daily Express* (20 August 1965).
30 Glynn, 'Balenciaga and *la vie d'un chien*', p.6.
31 Miller, 'Perfect Harmony: Textiles, Textile Manufacturers and French Haute Couture, 1947–57'.
32 As much as one-third of some collections used fabrics from Abraham. See Jouve and Demornex, *Balenciaga*, p.107, and Golbin, *Balenciaga Paris*.
33 Pierre Ducharne, cited in Charpigny, 'L'étoffe de la mode', p.30.
34 James P.P. Higgins, *Cloth of Gold: A History of Metallised Textiles* (London, 1993), p.98.
35 Danielle Slavik, cited by Golbin, *Balenciaga*

Paris, p.21, note 22.
36 Percy Savage in conversation with Linda Sandino.
37 Tom Kublin filmed shows from 1960 onwards, thus providing a record of the collections.
38 See Chapter Four.
39 *Harper's Bazaar* (1 October 1967), p.135.
40 Evidence from *El Hogar y la Moda*, based on a sampling of issues from the 1950s and '60s.
41 Latour, *Kings of Fashion*, p.261.
42 María Pilar del Comín in conversation with Montse Stanley, Barcelona, Autumn 1991.
43 See Chapter Four.
44 H.V. Morton, *A Stranger in Spain* (London, 1955), p.205.
45 Lillaz, 'La Semaine sainte en Espagne', p.113.
46 Beaton, *The Glass of Fashion*, p.263.
47 For example, Lillaz, 'La Semaine sainte en Espagne', pp.82ff., and Villeboeuf, 'Bientôt La Temporada', pp.126ff. It included a fabulous image of up-and-coming hero toreador, Luís Miguel Domínguez (who was briefly Ava Gardner's lover).
48 See, for example, *El Greco to Goya: The Taste for Spanish Paintings in Britain and Ireland* (London, 1981); Marisa Oropesa, *Pintores románticos ingleses en la España del XIX* (Zamora, 1999); *Manet Velázquez: la manière espagnole au XIXe siècle* (Paris: Musée d'Orsay, 2002); Jean Clair, *Europeans: Henri Cartier-Bresson* (London, 2001).
49 Miren Arzalluz makes a strong case for Balenciaga's absorption of the Spanish popular and elite culture that surrounded him during his formative years and his probable assimilation of the work of artists such as his fellow Basque Ignacio Zuloaga: 'Cristóbal Balenciaga: The Making of a Work of Art', pp.5–15. Deborah L. Parsons comments on the mixture of popular and modern cultures in the metropolis from the late nineteenth century until the Civil War in *A Cultural History of Madrid: Modernism and The Urban Spectacle* (Oxford, 2003). The Hispanic Society of America sponsored Ruth Mathilda Anderson's work, best known through *The Dress of Extremadura* (New York, 1954), and collecting for the Museo Antropológico (now Museo del Traje) in Madrid was under way by the 1920s–1930s.
50 Juan de Alçega, *Geometría y traças pertenecientes al oficio del sastre* (Madrid, 1580).
51 Arzalluz, 'Cristóbal Balenciaga', pp.15–32.

Chapter Three: Commercial Culture
1 Ballard, *In My Fashion*, p.115
2 Harry Yoxall, *A Fashion of Life* (London, 1966), chapter 7. Palmer, *Commerce and Culture* gives the fullest description of the North American experience.
3 Janine Hénin, *Paris Haute Couture* (Paris, 1990), p.61.
4 For a good overview, see Grumbach, *Histoires de la Mode*.

5 Extract from contract forming Balenciaga y Compañía Sociedad Mercantil in San Sebastian in 1919 reproduced in Pamela Golbin, *Balenciaga Paris* (Paris, 2006), p.26.

6 He appears for first time in Madrid trade directories in 1934, in the section 'Dressmakers' ('Modistos y modistas'), mis-spelt as Balciniaga, c/Caballero de Gracia 42. Bailly Baillere, *Guía comercial de Madrid* (Madrid, 1934). He had reopened after the Civil War by the time the directories resumed publication in 1944, this time as EISA, Gran Vía José Antonio 9, and continued at that address. He was in Barcelona by 1937, and returned in 1941 to the same address, calle Santa Teresa 10. He is not listed in the *Guía de comercio general de España*, vol. II (Madrid, 1935), but is in that of 1945 (vol. II); he was in the *Guía telefónica, Cataluña* of 1937, but not in that of 1940; he was back in Barcelona by 1941 (Arxiu Municipal Administrativo, Barcelona, Año 1942 Reforma Cristóbal Balenciaga).

7 At least two collaborators and seven employees according to details given in Golbin. *Balenciaga Paris*, p.24.

8 In the pre-Civil War years garments bore the label EISA B.E, thereafter simply EISA. It is more than likely that B.E. was merely an abbreviation for his full name 'Balenciaga Eisaguirre', since these letters do not correspond to any specific legal business terminology – although his great nephew suggests that the EI came from his mother's name and the SA was for Sociedad Anónima. Walker, *Balenciaga and his Legacy*, p.13.

9 Barcelona is not mentioned in the newspaper reports of the Spanish closures at the end of 1968. 'Cierre definitivo de la firma de alta costura "Casa Balenciaga"', *Voluntad* [Gijon] (13 November 1968); 'Balenciaga cerró ayer sus talleres dejando sin trabajo a 219 mujeres', *Baleares* [Palma de Mallorca] (13 November 1968).

10 Inscripción en el registro de comercio de Guipúzcoa (15 January 1919) and Enregistrement au greffe du tribunal de commerce de la Seine de la Société Balenciaga (7 July 1937). Golbin, *Balenciaga Paris*, p.26. Both documents of formation are reproduced here, sadly not in their entirety. Bizcarrondo (75,000 pesetas), d'Attainville (20,000 pesetas).

11 Achat, acte notorié July 1949. Cited in Golbin, *Balenciaga Paris*, p.26.

12 Bizcarrondo 74.65 per cent, Balenciaga 25 per cent, Renée Tamisier 0.05 per cent, Juan Tomás de Bareno 0.1 per cent, Ramón Esparza 1 per cent, Marcel Leyrat 0.1 per cent and Étienne Hommey 0.05 per cent. Augmentation du capital (27 June 1950). Cited ibid., p.26.

13 Ouverture du capital de la société Balenciaga à de nouveaux actionnaires (6 July 1955). Cited ibid., p.27.

14 I am grateful to Serge Chassagne for explaining to me the implications of the change in status. In theory, the annual turnover should therefore have been deposited at the Stock Exchange subsequently.

15 Création de la Société à Responsabilité Limitée 'Parfums Balenciaga', 1958. Cited in Golbin, *Balenciaga Paris*, p.27.

16 Ibid., p.21, note 3.

17 Archives de Paris, Registre du commerce de la Seine, no. 71 388, registered 27 December 1930. Couture pour hommes, dames et enfants, fourrures, fabrication et ventes. Still there in 1955. Archives Nationales, F¹² 10.505 Questionnaire relatif à la classification couture création. See the magazine for these years, both editorial and advertising space. Born in Madrid in 1900, probably the son of a dressmaker, since three dressmakers by the name of Cebrián were active in Madrid before the Civil War; Baillere, *Guía Comercial de Madrid* (1934), p.953: Jerónima, Josefa and María Cebrián in calles Porvenir, Gal. Portlier and Torrijos respectively. Only Josefa was still active at the same address in 1945; ibid. (1945), p.726. She had moved to calle Hermanos Miralles by 1958; ibid. (1958), p.926. See, too, the biographical sections in *50 Años de Moda en España* (Madrid, 1990).

18 Archives de Paris, Registre de commerce, Bizcarrondo at 26 Avenue Marceau and Balenciaga and d'Attainville next door at no.28.

19 Archives Nationales, F¹² 10.505 Déclarations Couture-Création, 1953–5.

20 For example, Mona Bismarck, whose house was Avenue of New York on the banks of the Seine.

21 Carles Carreres i Verdaguer, 'L'evolució del centre comercial de la ciutat', in *Els Barris de Barcelona*, ed. Ramón Alberch i Fugueras, vol. I (Barcelona, 1999), p.66; Lluís Pernanyer, *Historia del Eixample* (Barcelona, 1990), p.114.

22 Arxiu Municipal Administrativo, Barcelona: Año 1942, Ayuntamiento de Barcelona A. No. 6.687ª Comisión de Ensanche: Expediente de permiso a Don Cristóbal Balenciaga para reformar casa en la calle de Santa Teresa, no. 10, including plan of the building, Barcelona, April 1942. The cost of work was to be 25,000 pesetas; the rent was 400 pesetas per month.

23 Still in business today at number 12 and selling itself on its past history as Madrid's most famous cocktail bar 'with the same 1930s interior design it had when the foreign press came to sit out the Spanish Civil War, although the sound of artillery shells along the Gran Vía could be heard at the time. Long a favorite of artists and writers, the bar became a haven for prostitutes in the late Franco era.' www.frommers.com/destinations/Madrid/ N3065 (accessed 2 November 2006).

24 Jouve and Demornex, *Balenciaga*, pp.57–8. Claude d'Anthenaise, *Janine Janet: métamorphoses* (Paris, 2003), pp.36–47, 56–7,

64–9, 87.

25 Ibid., p.38.

26 V&A: T.187–1931 Panel of brocaded silk, probably designed and manufactured by Philippe de Lasalle (1723–1804).

27 'Pour les dix-huit ans de Carole', French *Vogue* (June 1960), pp.142–5.

28 Based on the very useful floor plans presented in Golbin, *Balenciaga Paris*, pp.22 and 24.

29 Glynn, 'Balenciaga and *la vie d'un chien*'. Certainly at its height, the house had ten workrooms. See, too, Goblin, *Balenciaga Paris*, and Appendix 4.

30 Musée Historique des Tissus, *Hommage à Balenciaga*, p.41.

31 Josefina Figueras, *Moda española: una historia de sueños y realidades* (Madrid, 2003), p.44.

32 Ballard, *In My Fashion*, p.123.

33 Ginette Spanier explains the costing system at Balmain in *It Isn't All Mink* (London, 1959).

34 Musée Historique des Tissus, *Hommage à Balenciaga*, p.49.

35 I am grateful to Florette Chelut for this information, which she passed on through Marie-Andrée Jouve, former archivist at Archives Balenciaga, Florette's notebooks, 1947.

36 Ibid., 1947–68; and confirmed by Christopher Carr-Jones. See Chapter Four.

37 'Paris Copies', *The Times* (1 March 1965).

38 Florette's notebooks, 1947–68.

39 Evidence for this practice in Paris in the notebooks of sales of the Countess of Bismarck, displayed at the exhibition in 1994, not reproduced in the publication *Mona Bismarck, Cristóbal Balenciaga, Cecil Beaton*; for Spain, Margaret Lane in correspondence with the author in 1990.

40 Musée Historique des Tissus, *Hommage à Balenciaga*, p.42.

41 Beaton, *The Glass of Fashion*, p.267.

42 'Quadrille is a fully-fashioned 10-denier 66 gauge style. *Dix* is seamless, 10-denier 474 needles, while *Des Heures* is a 15-denier micromesh.' *Draper's Record* (17 September 1960), p.23.

43 Glynn, 'Balenciaga and *la vie d'un chien*'; L. Perschetz, *W: The Designing Life* (New York, 1987), p.64.

44 'Je regrette de n'être pas plus jeune, car je créerais un prêt-à-porter amusant mais de bon goût ainsi que l'exige l'époque à laquelle nous vivons. Pour moi c'est trop tard.' Musée Historique des Tissus, *Hommage à Balenciaga*, p.29.

45 Cited in Valérie Guillaume, *Jacques Fath* (Paris, 1993), p.58.

46 Edmonde Charles-Roux et al., *Le Théâtre de la mode* (Paris,1990), cat.nos 5 and 161, pp.148 and 160; Golbin, *Balenciaga Paris*, p.53 (Archives Balenciaga, Paris: 1945E000-PA01 day dress in white broderie anglaise). In the exhibition curated by Golbin and Ghesquière, the second figure

owned by the Archives Balenciaga was also displayed: a white evening dress in duchesse satin with black velvet trim (1945E058-PA01).

47 In French *Vogue*, annually in October.

48 American *Vogue* (1 May 1956), p.128.

49 *Sunday Times* (6 March 1960), p.19.

50 For a good overview of sexual politics in Spain and how they changed after 1975, see John Hooper, *The Spaniards* (London, 1990), chapters 15 and 16.

Chapter Four: Clients and Clothes

1 Charles Creed, *Maid to Measure* (London, 1960), p.202.

2 Alexandra Palmer's pioneering work, *Couture and Commerce*, on couture in North America and Canada is a crucial model for re-evaluating this approach. I follow her lead in the way I try to break down how Balenciaga's clothes were consumed and by whom, as a method that could be attempted more exhaustively through museum collections and private records.

3 *Mona Bismarck, Cristóbal Balenciaga, Cecil Beaton*; Walker, *Balenciaga and his Legacy*; Fundación Balenciaga, *Cristóbal Balenciaga y la Marquesa de Llanzol* (Guetaria, 2004); Fundación Balenciaga, *Balenciaga: el lujo y la sobriedad* (Guetaria, 2006). Palmer, *Couture and Commerce* also uses private clients, as did a recent exhibition at Phoenix Museum of Art in 2002.

4 American *Vogue* (October 1967), p.135.

5 See Palmer, *Commerce and Couture*. In the UK, sales of couture models worn by mannequins were advertised at the back of *Vogue*; usually their labels were removed first.

6 A second-hand couture model did not become collectible or wearable 'vintage' until the late 1980s. Francesca Galloway, quoted in Meredith Etherington-Smith, 'Saving Graces', *ES: The Evening Standard Magazine* (February 1992), pp.36–9; Alexandra Palmer, 'Vintage Whores and Vintage Virgins', in *Old Clothes, New Looks: Second Hand Fashion*, ed. A. Palmer and H. Clark (Oxford, 2005), pp.197–213.

7 He made 212 for Spring/Summer 1954 and 209 for Autumn/Winter. Archives Nationales de France, F^{12} 10.505 Déclaration Couture-Création, 1954. See Appendix 4.

8 AN F^{12} 10.505 Declaration forms for classification as Couture-Création, 1954. Dior and Fath made more than double this number.

9 Golbin, *Balenciaga Paris*, p.17.

10 'Pour les dix-huit ans de Carole', French *Vogue* (June 1960), pp.142–5.

11 Handlist for an exhibition held at Pheonix Art Museum, November 2001-February 2002, bill accompanying exhibit 16. My thanks to Dennita Sewell for drawing my attention to this excellent research tool. Golbin offers the following breakdown: in 1937 an outfit for daytime or a coat

cost 4,500 francs (£36); in 1943 a coat cost 5,500 francs (£31); in 1963 a simple day suit cost 4,900 francs (£357), an evening dress 6,000 to 10,000 francs (£437–£729). Golbin, *Balenciaga Paris*, p.21, no.5.

12 Elizabeth de Gramont cited in Musée Historique des Tissus, *Hommage à Balenciaga*, p.33. See note on wages at front of book.

13 Cited in Golbin, *Balenciaga Paris*, p.17; Christie's sale, London, 2 July 1991, p.15, lot 114.

14 Percy Savage in conversation with Linda Sandino.

15 *Fodor's Woman's Guide to Europe* (New York, 1960), p.373-4.

16 The authority on bonded models is Palmer, *Couture and Commerce*; this example is from p.214.

17 Vreeland, *DV*, p.111.

18 *Newsweek* (3 June 1968), p.59.

19 Musée Historique des Tissus, *Hommage à Balenciaga*, p.24.

20 Taken from a letter written by the Marquesa to Laurie Thompson Hancock, June 1990.

21 *Pertegaz*.

22 There were 88 outfits in 1963, 144 over the next two years. Jouve in *Mona Bismarck, Cristóbal Balenciaga, Cecil Beaton*, p.57; the *vendeuse*'s notebooks exhibited revealed the purchase of mannequin garments at reduced prices.

23 Ibid., p.58, and www.fundacionbalenciaga.com.

24 See Appendix 3. Sotheby's sold the remaining items.

25 She then patronized Givenchy, and also bought from Courrèges, Cardin and Philippe Venet. *Textiles, Aubusson Designs and Costume including the Balenciaga Wardrobe of Mrs Godfrey Bonsack*, Christie's South Kensington, 6 February 1996, pp.26–33, lots 226–63, 276, 278, 279, 280, 281, 286 and 287.

26 On this point regarding couture in general, see Palmer, *Couture and Commerce*, pp.218ff.

27 Geneviève Dariaux, *A Guide to Elegance* (originally published in 1963; reprinted London, 2003), pp.181–2: 'if you take care to select a model that is in the long-range general fashion trend rather than a passing fancy, a well-made suit is often wearable for five years or more – especially the Balenciaga models, which are at the same time in advance of the mode and independent from it'.

28 Ballard, *In My Fashion*, cited in Palmer, *Couture and Commerce*, p.220.

29 Vreeland, *DV*, p.151.

30 *Newsweek* (2 April 1973), p.33.

31 American *Vogue* (15 March 1960), pp.98 and 100.

32 Laurie Thompson Hancock in conversation with the author, summer 1991.

33 For other examples, not necessarily related to Balenciaga, see Palmer, *Couture and Commerce*, chapters 5–7.

34 V&A: T.128&A–1982 (a black and white tweed suit, 1954) and V&A: T.128&A–1970 (a brown, black and cream tweed suit, 1951).

35 Christopher Carr-Jones, son of the founder of Susan Small, in conversation with the author, autumn 1990.

36 Christopher Carr-Jones has remarked to the author that this was so, and Anny Latour made a similar comment at an earlier date: Latour, *Kings of Fashion*, p.261.

37 The main source of these names is fashion magazines such as *Vogue*.

38 Stephen de Pietri and Melissa Leventon, *New Look to Now: French Haute Couture, 1947–1987* (New York, 1987), pp.23ff., and Jouve and Demornex, *Balenciaga*, p.67.

39 Jouve and Demornex, *Balenciaga*, p.33. Harrods' choice was, incidentally, totally different from the models selected by *Woman's Journal* and *The Scotsman*.

40 'Paris Copies', *The Times* (1 March 1965); also reported in *The Guardian* by Phyllis Heathcote on 27 February 1965.

41 The reasons cited for Harrods choosing his couture in *The Queen* (7 April 1964).

42 *Weekend Telegraph* (24 September 1965).

43 Winefride Jackson, 'The Man behind the Clothes', *Sunday Telegraph* (26 September 1965).

44 British *Vogue* (15 April 1965), p.97.

45 'One Woman's Wardrobe', *London Life* (27 August 1966).

46 Serena Sinclair, 'The Great Price Tag Mystery', *Daily Telegraph* (2 November 1964).

47 Florence Müller, *Élégances aériennes: une histoire des uniformes d'Air France* (Saint-Herblain, 2004), p.63. This book gives an excellent introduction to how Air France uniforms fitted with social change from 1946 to 2004.

48 Air France, 'The New Air France Uniform', Press Release for the new Christian Lacroix uniform, April 2005.

49 American *Vogue* (July 1957), p.50.

50 Madge Garland, 'Travel', in *The Intelligent Woman's Guide to Good Taste*, ed. Susan Chitty (London, 1958), p.66.

51 The letter dated 27 March 1968 is reproduced in Golbin, *Balenciaga Paris*, p.152.

52 Air France Press Release, *Description du nouvel uniforme des hôtesses d'Air France*, 9 December 1968.

53 Ibid.

54 Müller, *Élégances aériennes*, p.75.

55 Deduced from examination of suits at the Air France Museum, Paris, with the help of Mary Brooks.

56 Personal communication from Pascale Monmarson-Frémont, Archivist, Air France Museum.

57 Philippe Bouvard, 'L'uniforme des hôtesses d'Air France supporte-t-il une fermeture?', *Le Figaro* (6 November 1968).

58 Ibid.

59 'La tenue des hôtesses navigantes: image de prestige ou vêtement de travail?', *Le Monde* (25 December 1968), cited in *Élégances aériennes*, p.75.

60 Up to 1963, air stewardesses had to retire when they married; thereafter they could work until the age of 50 after 1968. Müller, *Élégances aériennes*, pp.45 and 63. On the rise of the birth rate in the 1950s, see J.-P. Rioux, *The Fourth Republic* (Cambridge, 1989), chapter 17.

61 Poppy Richard, 'Femme du Monde', *Woman's Journal* (October 1953), p.56.

62 *Fodor's Woman's Guide to Europe*, p.373.

63 Ibid., p.374.

64 Bailly Baillere, *Guía comercial de Madrid* (1935, 1945, 1958).

65 Ibid.; Bailly-Ballere-Riera, *Anuario general de España*, vol.II (1945, 1966).

66 *Pertegaz*, p.62.

67 Percy Savage in conversation with Sandino.

68 Testimony in *Pertegaz*, p.111.

69 Veillon, *Fashion under the Occupation*.

70 Museu Tèxtil i de Indumentária, Barcelona. Inv.No.109.922 and Inv. No.109.848.

71 *Cristóbal Balenciaga y la Marquesa de Llanzol* (Guetaria, 2004), p.11.

72 Cristina Torres (interview with Sonsoles Díez de Rivera, Patrona de la Fundación Balenciaga), 'Hay que destacar, porque la multitud es penosa', http://servicios.elcorreodigital.com/vizcaya/pg050 818/prens/noticias/Cultura_VIZ/20 (accessed 29 January 2006).

73 Ibid.

74 *Four Decades of High Fashion: The Wardrobe of the Late Mrs Heard De Osborne*, Christie's South Kensington, Tuesday, 21 June 1994, p.4.

75 Walker, *Balenciaga and his Legacy*, p. 45.

76 Ava Gardner, *Ava: My Story* (London, 1992), p.247. At the beginning of the 1950s, the American film industry discovered the benefits of using Spain as a location for many films which did not necessarily have a Spanish content. It would be instructive to explore whether American film stars gave the Spanish fashion industry a boost and encouraged Spanish designers to seek patronage abroad.

77 Jouve and Demornex, *Balenciaga*, and Golbin, *Balenciaga Paris*.

78 Musée Historique des Tissus, p.31. *Fodor's Woman's Guide to Europe*, p.39.

79 Musée Historique des Tissus, *Hommage à Balenciaga*, p.13.

80 'A Retiring Master', *Newsweek* (3 June 1968), p.59.

81 Fraser Kennedy, *The Fashionable Mind* (New York, 1987), p.84.

Conclusion

1 British *Vogue* (1 October 1962), p.89.

2 Guy Julier, *Spanish Design* (London, 1990).

Postscript: Legacies

1 Harriet Quick, 'Saint Nicolas', British *Vogue* (October 2006), p.324.

2 Valérie Guillaume. 'Haute couture: reconquête et «new look»', in *Paris, 1944–1954: artistes, intellectuals, publics: la culture comme enjeu*, ed. Philippe Gumplowicz and Jean-Claude Klein (Paris, 1995), p.96.

3 The possible exception was Worth, whose sons carried on in the trade, and whose names clearly suggested some continuity.

4 The same is true of the useful publication that accompanies the exhibition: Golbin, *Balenciaga Paris*.

5 Sara Paretsky, *Black List* (London, 2003), pp.26–7. 'The next family news was a clipping welcoming Geraldine home from Switzerland in the spring of 1931', this time in a white Balenciaga suit, 'looking interestingly thin after her recent illness'. Sadly, the Balenciaga dress is attributed to 1931, an unlikely purchase by someone who had been in Switzerland at finishing school! Sally Beauman, *Danger Zones* (London, 1997), pp.236–7. My thanks to Mary Brooks for drawing my attention to Beauman's novel.

6 Sam Baker, *Fashion Victim* (London, 2005), p.95.

7 Lisa Armstrong, 'The Ladies of Londongrad', *Vogue* (November 2006), p.235.

8 Christie's will be holding two whole sales this year, 2006.

9 *Country Life* (5 October 1985), p.180.

10 I am grateful to Kerry Taylor (of Kerry Taylor Auctions) for responding to my request for this information so generously in November 2006.

11 Meredith Etherington-Smith, 'Saving Graces', *ES: The Evening Standard Magazine* (February 1992), pp.36–9.

12 Amy M. Spindler, 'Keys to the Kingdom: A Fashion Fairy Tale Wherein Nicolas Ghesquière Finally Inherits the Throne', *New Yorker Magazine*, Style section (14 April 2002), pp.53–8.

13 *Amina* (July 1990).

14 Spindler, 'Keys to the Kingdom', pp.53–8.

15 Harriet Quick, 'Saint Nicolas', p.326.

16 Information from Documents de la Presse of the Archives Balenciaga.

17 Quick, 'Saint Nicolas', p.326.

18 Lola Galán, 'La escalada Gucci llega a Balenciaga', *El País* (15 July 2001).

19 Julia Finch, 'Gucci Liked the Designer So Much It Bought Balenciaga', *The Guardian* (7 July 2001).

20 By 3.6 euros in Amsterdam. Galan, 'La escalada . . . '. Japan and South East Asia represented 65 per cent of all Balenciaga accessory sales in 1990, according to *Gap* (October 1990).

21 Ibid.

22 Finch, 'Gucci Liked the Designer . . . '.

23 www.balenciaga.com (accessed 11 November 2006).

24 www.dilpreetbawa.com/historyoffashion/ balenciaga.html (accessed 24 May 2003), p.4.

25 Quick, 'Saint Nicolas', p.326.

26 www.escentual.co.uk/balenciaga/cristobal_elle (accessed 11 November 2006).

SELECT BIBLIOGRAPHY

This bibliography comprises secondary and printed primary sources only. Archival and museum sources are referenced in the endnotes.

Aguirre Franco, Rafael, *Carteles en Guipúzcoa* (San Sebastian, 1984)

Alçega, Juan de, *Tailor's Pattern Book 1589*, facsimile, ed. J. L. Nevinson, trans. J. Pain and C. Bainton (Bedford, 1979)

Adburgham, Alison, *A View of Fashion* (London, 1966)

Anderson, Ruth Matilda, *Spanish Costume. Extremadura* (New York, 1951)

Artola, Miguel ed., *Historia de Donostia San Sebastián* (San Sebastian, 2001)

Arzalluz, Miren B., 'Cristóbal Balenciaga: the Making of a Work of Art', unpublished MA dissertation, Courtauld Institute of Art, University of London (2004).

Ballard, Bettina, *In My Fashion* (New York, 1960)

Baroja, Julio C., *Los Vascos* (Madrid, 1986)

Beaton, Cecil, *The Glass of Fashion* (New York, 1954)

Beaton, Cecil, 'Balenciaga: The Man Behind the Clothes', *Sunday Telegraph* (26 September 1965)

Beaton, Cecil, *Fashion: An Anthology by Cecil Beaton* (London, 1971)

Berges, Manuel et al., *Moda en sombras* (Madrid, 1991)

Bertin, Célia, *Paris à la Mode: A Voyage of Discovery*, trans. Marjorie Deans (London, 1956)

Carr, Raymond, *Modern Spain, 1875–1980* (Oxford, 1988)

Carter, Ernestine, 'Are We Women or Are We Mice?', *Sunday Times* (6 March 1960)
 'Reign of Spain', *Sunday Times* (20 March 1960)
 'How It Crumbles, Kooky-wise', *Sunday Times* (17 September 1961)
 'New Names in Fashion', *Sunday Times* (24 September 1961)

Clapés, Mercedes &. Martín i Ros, Rosa María, *España. 50 años de moda* (Barcelona, 1987)

Comín, Pilar, 'Balenciaga ha muerto en España', *La Vanguardia* [Barcelona], (25 March 1972), pp.1, 7, 8

De Marly, Diana, *The History of Haute Couture, 1850–1950* (New York, 1980)

Dent Coad, Emma, *Spanish Design and Architecture* (London, 1990)

de Petri, Stephen, and Leventon, Melissa, eds., *New Look to Now: French Haute Couture, 1947–1987* (New York, 1989)

Emerson, G., 'Balenciaga, the Couturier, Dead at 77', *New York Times* (25 March 1972)

Figueras, Josefina, *Moda española. Una historia de sueños y realidades* (Madrid, 2003)

Garate Ojanguren, Montserrat and Martín Rudi, Javier, *Cien años de la vida económica de San Sebastián, (1887–1987)* (San Sebastian, 1995)

Glynn, Prudence, 'Balenciaga and *la vie d'un chien*', *The Times* (3 August 1971)

Guillaume, Valérie, 'Haute couture: reconquête et "new look" in *Paris: 1944–1954. artistes, intellectuals, publics: la culture comme enjeu*, ed. Philippe Gumplowicz and Jean-Claude Klein (Paris, 1995), pp.96–105

Grumbach, Didier, *Les Histoires de la Mode* (Paris, 1993)

Hooper, John, *The Spaniards: A Portrait of the New Spain* (London, 1987)

Howell, Georgina, 'Balenciaga the Magnificent' in *Sultans of Fashion* (London, 1990)

Ironside, Janey, *Fashion as a Career* (London, 1962)

Jouve, Marie-Andrée, *Balenciaga* (New York, 1989)

Jouve, Marie-Andrée, *Balenciaga* (New York, 1997)

Julier, Guy, *Spanish Design* (London, 1990)

Kennedy, Fraser, 'Balenciaga' in *The Fashionable Mind: Reflections on Fashion: 1970–1982* (Boston, 1982)

Latour, Anny, *Kings of Fashion*, trans. Mervyn Savill (London, 1958)

McDowell, Colin, 'Maestro', *The Guardian* (24 July 1989)

Martí, Octavi, 'Maestro Balenciaga', *El País* (1–2 July 2006).

Martin, Richard and Koda, Harold, *Flair. Fashion collected by Tina Chow* (New York, 1992)

Mendes, Valerie, *Ascher. Art, Fabric, Fashion* (London, 1987)

Mendes, Valerie, *Black in Fashion* (London, 1999)

Menkes, Suzy, "Temple to a Monk of Fashion: Museum to Open in Basque Designer's Birthplace," *International Herald Tribune* (23 May 2000)

Miller, Lesley Ellis, *Cristóbal Balenciaga* (London, 1993)

Montesinos, Francis, *Carta de amor a Cristóbal Balenciaga* (Valencia, 2002)

Mower, Sarah, 'Balenciaga: The Master Touch', *The Look. Canada's Fashion and Beauty Quarterly* (Summer 2006).

Müller, Florence, *Élégances aériennes: une histoire des uniformes d'Air France* (Saint-Herblain, 2004)

Oropesa, Marisa, *Pintores románticos ingleses en la España del XIX* (Zamora, 1999)

Palmer, Alexandra, *Couture and Commerce: The Transatlantic Fashion Trade in the 1950s* (Vancouver, 2001)

Palmer, Alexandra, and Clark, Hazel, eds., *Old Clothes, New Looks: Second Hand Fashion* (Oxford, 2005)

Parsons, Debora, *A Cultural History of Madrid: Modernism and the Urban Spectacle* (Oxford, 2003)

Pasalodos Salgado, Mercedes, 'Balenciaga en el Museo Nacional de Antropología', *Anales del Museo Nacional de Antropología*, no. VIII (2001). pp.199–216

Savage, Percy, 'Balenciaga the Great', *The Observer* (13 October 1985)

Shubert, Adrian, *A Social History of Modern Spain* (London, 1990)

Shubert, Adrian, *A Social History of the Bullfight* (Oxford, 1999)

Smith, Paul Julian, *Contemporary Spanish Culture: TV, Fashion, Art and Film* (Cambridge, 2003)

Spindler, Amy M., "Keys to the Kingdom: A Fashion Fairy Tale Wherein Nicolas Ghesquière Finally Inherits the Throne." *New Yorker* (14 April 2002), pp.53–8

Steele, Valerie, *Paris Fashion: A Cultural History* (Oxford, 1988)

Thurman, Judith, 'The Absolutist: Cristóbal Balenciaga's Cult of Perfection', *The New Yorker* (3 July 2006).

Walker, Myra, *Balenciaga and his Legacy* (New Haven and London, 2006)

Walton, John and Smith John, 'The first Spanish Seaside Resort', *History Today*, vol. 44 (August 1994)

Walton, John & Smith John, 'The First Century of Beach Tourism in Spain: San Sebastian and the "playas del norte", from the 1830s to the 1930s', in *Tourism in Spain: Critical Issues* (Wallingford, 1996)

Zuloaga, *Desde la Barrera* (Museo Taurino de Bilbao and Museo San Telmo de San Sebastian, 2003)

Exhibition publications on Balenciaga
(in chronological order)

Metropolitan Museum of Art, *The World of Balenciaga* (New York, 1973)

Palacio de Bellas Artes, *El mundo de Balenciaga* (Madrid, 1974)

Musée Historique des Tissus, *Hommage à Balenciaga* (Lyons, 1985)

Fondation de la Mode, *Cristóbal Balenciaga* (Tokyo, 1987)

National Gallery of Victoria, *Balenciaga: Masterpieces of Fashion Design* (Melbourne, 1992)

Mona Bismarck Foundation, *Mona Bismarck, Cristóbal Balenciaga, Cecil Beaton* (Paris, 1994)

Museo Nacional de Escultura Policromada,

Cristóbal Balenciaga (Valladolid, 2000)
Kutxaespacio del Arte, *Cristóbal Balenciaga* (San Sebastián, 2001)
Fundación Balenciaga, *Cristóbal Balenciaga y la Marquesa de Llanzol* (Getaria, 2004)
Fundación Balenciaga, *Balenciaga: El Lujo y la Sobriedad* (Getaria, 2006)
Musée des Arts Décoratifs, *Balenciaga Paris* (Paris, 2006)
Meadows Museum, Texas, *Balenciaga and his Legacy* (New Haven and London, 2006)

Contemporary periodicals
Draper's Record (later *DR*), 1938–68, 1986–90
El Hogar y la Moda, 1934, 1937, 1956, 1965
Harper's Bazaar, 1938–68 (English, French and American editions)
Harrods News, 1938–68
L'Officiel, 1938–50
Silk and Rayon, 1938–62
The Scotsman, 1937–50
The Times
Vogue, 1938–68 (English, French and American editions)
Woman's Journal, 1938–1968

Oral history
NATIONAL LIFE STORY COLLECTION, in partnership with the London College of Fashion, Percy Savage interviewed by Linda Sandino, June–July 2004

Trade directories
Bailly-Ballère-Riera, *Anuario general de España*, vol. II, 1935, 1945, 1946, 1966
Bailly Baillère, *Guía comercial de Madrid*, 1933–6, 1944–6, 1950, 1958
Guía telefónica, Barcelona, 1937, 1964–77

Travel guides
Guía ilustrada para el forastero en San Sebastián (San Sebastian, 1913)
Guía oficial de San Sebastián y de la Provincia de Guipúzcoa, ed. El Sindicato de Iniciativo y Propaganda (San Sebastian, 1924–5)
Fodor's Woman's Guide to Europe (London, 1959)

Websites
www.balenciaga.com

APPENDIX 1
CHRONOLOGY

Despite the relatively recent demise of Balenciaga, the source of many of the 'facts' about his life remain rather vague. Where I have incorporated 'facts' from unreferenced secondary sources, they are marked with an asterisk.

1895 Cristóbal Balenciaga Eisaguirre born on 21 January in Guetaria, Guipúzcoa, northern Spain

1912 Sent to Paris by his patron, the Marquesa de Casa Torres, to meet Poiret, Reboux and Cheruit while head of the Magasin du Louvre in San Sebastian (Donostia)*

1914 Begins to buy Paris models to adapt for Spanish clients*

1914–15 Opens the House of Balenciaga in San Sebastian with about thirty employees*

1919 Registers business formed on 15 January 1918 under the title Balenciaga y compañía in San Sebastian, for six years. Partners: Benita and Daniela Lizano Landa; capital 67,360 pesetas (£2,929), of which 7,360 pesetas (£320) from Balenciaga.

1922 In San Sebastian, working from first-floor premises at number 2 Avenida y Vergara

1927 Business in San Sebastian based at number 2 Avenida de la Libertad

1931 Decline in business caused by the fall of the Spanish monarchy, resulting in Balenciaga's bankruptcy*

1934 Opens house in the centre of Madrid in 42 calle Caballero de Gracia, on the first floor, becoming one of 310 dressmakers (*modistos*) active in the Spanish capital (recorded in trade directory), population about 600,000; employs Elena Gurunchaga as manageress; requests permission to erect a neon sign on first-floor balcony with the wording *Costura Eisa B E Costura*

1935 Opens house in Barcelona in 10 calle Santa Teresa, under an abbreviated form of his mother's name, Eisa (first concrete evidence of this business in *Guía Telefónica: Catalunya*, 1937)

1936 Leaves Spain for London; outbreak of the Spanish Civil War

1937 Registers business partnership under the name of Balenciaga SARL in collaboration with Vladzio d'Attainville and Nicolas Bizcarrondo; presents first collection in Paris at 10 Avenue Georges V in August

1938 Designs costumes for Hélène Perdrière for the film *Trois de Saint-Cyr* by J.P. Paulin

1939 End of Spanish Civil War; beginning of

Second World War. Probably reopens house in Madrid at the new address of Gran Vía José Antonio, 9 under name EISA, though first record is in 1941; designs costumes for Marie Déa in the film *Pièges* by Siodmak, starring Maurice Chevalier; presumably takes over 12 Avenue Georges V after Mainbocher's departure for USA

1940 Designs costumes for Alice Cocéa and Suzet Maïs in *Histoire de rire* by Armand Salacrou at the Théâtre des Ambassadeurs

1942 Shows collection in Lyons, despite the German Occupation;* in Barcelona makes alterations to the building that required planning permission

1945 Contributes to the *Théâtre de la Mode*, which toured Europe and the USA, showcasing Parisian haute couture

1946 Launches his first perfume, 'Le Dix'

1948 Begins redecoration of the ground floor of 10 Avenue Georges V, employing the interior decorator Christos Bellos; launches new perfume, 'La Fuite des Heures' (Fleeting Moment); death of Vladzio d'Attainville in Madrid in December

1950 Designs costume for Lucienne Bogaert, a regular client, for *Pas d'amis, pas d'ennuis* by S. Teyrac at the Théâtre de l'Œuvre

1951–68 Develops pioneering window displays with the aid of the sculptor Janine Janet

1952 Visits New York to discuss the distribution of his perfumes and the problems of licensing*

1953 Designs costumes for Hélène Perdrière and Lise Delamare in *Aux innocents les mains pleines* by André Marois at the Comédie Française

1955 In France Balenciaga SARL becomes Balenciaga SA; launches a new perfume, 'Quadrille'

1956 Begins to show his collections one month after the official opening of the couture calendar; designs costumes for Marie Daems in the film *L'air de Paris* by Marcel Carné, for Ingrid Bergman and Mao-style tunics for Yul Brynner in the film *Anastasia* by Anatole Litvak

1958 Awarded the title of Chevalier de la Légion d'honneur by the French Government for his services to fashion; designs costumes for Hélène Perdrière and Javotte Lehman in *Domino* by Marcel Achard at the Comédie Française

1959 Designs costume for Madame Weissweiller in the film *Le Testament d'Orphée* by Jean Cocteau

1960 Designs the wedding dress for Fabiola, granddaughter of the Marquesa de Casa Torres and future queen of Belgium

1962–4 Designs costume for Marie Daems for *Les Foches* by F. Marsan at the Théâtre des

Nouveautés; designs black sequinned dress and cloak for Christiane Barry, who plays the part of Death in *Orphée* by Jean Cocteau at the Compagnie des Tréteaux, Paris; designs sports outfit for Annie Ducaux in *Comme des Chardons* by Armand Salacrou at the Comédie Française; launches 'Eau de Balenciaga' for women

1968–9 Receives and executes commission to design new uniforms for Air France, the largest airline in the world

1968 Announces his retirement after the summer collections, closing the houses in Paris but retaining the perfumes in production; closes the houses in Madrid and San Sebastian

1970 Gustave Zumsteg, textile manufacturer and friend, organizes at the Musée Bellerive in Zurich the first retrospective exhibition of Balenciaga's work

1971 Balenciaga makes his last public appearance, at Chanel's funeral; 'Holang', a fragrance for men, launched

1972 Completes his last commission, the wedding dress of the future Marquesa de Cádiz, granddaughter of Spain's dictator, General Francisco Franco; dies in Jávea (Alicante) on 24 March

1973 Diana Vreeland organizes the retrospective exhibition at the Costume Institute of the Metropolitan Museum of Art, New York, shown in Madrid the following year; 'Eau de Lavande' for men and 'Cialenga' for women launched

1974 The last reference to EISA in the *Guía Telefónica* of Barcelona, although his nephew M.J. Balenciaga Perez is still listed as living in the city in the following year; first retrospective of his work in Spain in Madrid at the Palacio de bibliotecas y museos

1978 Hoechste buys the house from Balenciaga's nephews and nieces and launches ready-to-wear collections, the first designed by Ramón Esparza

1979 'Michelle' fragrance for women launched

1980 'Portos' fragrance for men launched

1981 Marie-Andrée Jouve begins the task of cataloguing the archive of the house; over the next twenty years she enlarges the collection to 600 garments and curates several exhibitions

1985 The house contributes to the retrospective of Balenciaga's work at the Musée Historique des Tissus (later called Musée des Tissus) in Lyons, with an emphasis on the textiles used in his garments; Spanish Government establishes the Balenciaga Prize for Fashion Design

1986 The perfume group Jacques Bogart buys the house and re-launches it under the management of Jacques and Régine Konckier; 'HoHang Club' fragrance for men launched

1987 Michel Goma presents his first collection under the Balenciaga label; first menswear collection launched and Balenciaga Uniformes; the Spanish Ministry of Industry and Energy launches the Cristóbal Balenciaga National Fashion Prizes

1988 'Rumba' and 'Prelude' fragrances for women launched

1989 Andrée Putman employed to redecorate the salon and shop; *Clothes Show* presents feature with the vice-president of the house; contract signed with Sekitei in Japan for the opening of 15 boutiques within six years, and the Country Club Balenciaga near Tokyo founded

1990 'Balenciaga pour Homme' and 'Balenciaga pour Femme' launched

1992–7 Mechior Thimister is head designer

1993 Retrospective exhibition at the Powerhouse, Sydney, Australia

1994 'Talisman' and 'Talisman Eau Transparent' fragrances for women launched

1998 Nicolas Ghesquière's début collection for the Balenciaga label; 'Cristobal' for women launched

2000 Spanish government establishes the Fundación Balenciaga in Guetaria, injecting $3.2 million into the project in order to 'to foster, spread and emphasize the transcendence, importance, and prominence that Don Cristóbal Balenciaga has had in the world of fashion' through the construction and development of a museum in Guetaria, the establishment of an international centre for design training, the foundation of a research and documentation center, the publication of a fashion periodical, and the development of touring exhibitions about Balenciaga, fashion design and haute couture'; 'Cristobal' for men launched

2001 Gucci Group buys the house, adding it to its portfolio, which includes Yves Saint Laurent, Sergio Rossi, Boucheron, Roger et Gallet, Bottega Veneta, Bédat & Cie, Alexander McQueen, Stella McCartney; Ghesquière enticed to stay via a 9 per cent share in the business; Ghesquière wins the International Designer of the Year Award from the Council of Fashion Designers of America

2003 Opening of shops in New York (February) and Paris (April), designed by Nicolas Ghesquière and Dominique Gonzales-Foerster

2005 Opening of shop in Hong Kong (October)

2006 Retrospective exhibitions at the Musée de la Mode et du Textile in Paris and the Meadows Museum, Southern Methodist University, Dallas, the former co-curated with Ghesquière.

basque a short skirt sewn on to the bodice of a dress or jacket, sometimes called a peplum

Brummelism fastidious attention to dress, usually among men. Derived from the name of the Regency dandy Beau Brummel (1778–1840), who was one of the first to introduce the notion of elegant simplicity, cleanliness and perfect fit as crucial elements of men's dress

chenille a furry yarn that resembles a caterpillar and is used in weaving, knitting and embroidery

cloqué a silk (or synthetic) fabric with a raised pattern. The term comes from the French word for blistered

faille a soft, glossy silk with a cross-wise ribbed effect in the weave structure. It drapes well

gazar a firm silk fabric created by Abraham of Switzerland for Balenciaga. Its successor, super-gazar or zagar, was an even more sculptural form of the original fabric

Infanta refers to the crown princesses of Spain, and in the 1930s most evidently to the styles of dress worn in the many portraits of the daughters of Philip IV of Spain, painted principally by the king's painter Diego de Velázquez in the second half of the seventeeth century. In these paintings, full-length, wide-skirts were worn with close-fitting bodices, the shoulder line being emphasised through adept use of trimmings. The textiles used were more sophisticated (silks etc.) than those for *Little Women*.

lamé a thin fabric containing metal yarns, which may be added as decoration or woven in as the warp or weft thread

Little Women refers to the novel written by Louisa May Alcott (1832–88), *Little Women* (1868) based on her own experiences growing up in the mid nineteenth century on the eastern seaboard of the USA. An immediate success, it became a favourite with subsequent generations of girls, first being made into a film in 1933 and subsequently and notably in 1949, 1978 and 1994. In dress terms, the styles were long, full-skirted and 'home-spun'.

Lurex trademark of the Dow Badische Company for its metallic fibre yarn, which was introduced during the 1940s. Woven or knitted with cotton, nylon, rayon, silk or wool fibres, Lurex is made into dresses, cardigans and sweaters

matelassé a fabric with a pouched or quilted effect; a double or compound cloth in structure

moiré a finish that creates a wavy, watermark effect on the surface of the fabric, mostly used on silk

nylon the first fully synthetic fibre, made from petroleum, natural gas, air and water; developed in 1935 by the US chemist W.H. Carothers and his associates, who worked for Du Pont; used increasingly for clothing from 1940s onwards, nylon stockings being the first major use from 1941

paillette a sequin or spangle

piqué normally a cotton fabric with a small raised pattern on the surface in ribs, squares, diamonds, etc., the effect created in the weave structure

rayon regenerated cellosic fibre, sold as artificial silk until the name 'rayon' was adopted in 1924; now known in Europe as 'viscose'. Rayon was produced as a filament fibre only until the 1930s, when it was discovered that broken waste rayon could be spun into a yarn

Terylene trade name for a synthetic polyester fibre produced by the chemicals company ICI; the first wholly synthetic fibre invented in Britain by the chemist J. R. Whinfield of Accrington in 1941; bulk production began in 1955. Fabric made from Terylene keeps its shape after washing and is hard-wearing

Winterhalter Franz Xavier Winterhalter (1805–1873) painted many portraits of European royalty, including Queen Victoria and her family and the Empress Eugénie. The so-called Winterhalter Revival in the late 1930s consisted of neat-waisted, full-skirted evening dresses. The fashion press alternatively called them 'Little Women' styles or related them to the Spanish *infantas* of the late seventeenth century

zibelline a heavy coating fabric with a long, shaggy nap, usually woollen

CONTEXT FOR COLLECTION

Many major museums in large cities in Europe, North America, Japan and Australia have strong holdings of Balenciaga couture, acquired from or donated by the wearers of the garments, or bought at auction: in Australia, the Powerhouse, Sydney; in Japan, the Costume Institute, Kyoto; in the USA, the Brooklyn Museum, the Museum at the Fashion Institute of Technology, and Costume Institute at the Metropolitan Museum of Art, New York, Los Angeles County Museum, Philadelphia Museum of Fine Art, Texas Fashion Center, Denton, the Phoenix Art Museum, The Fine Arts Museum of San Francisco; in Europe, the Musée de la Mode et du Textile, Paris and the Musée Galliera, Paris; the Museu de Indumentária i Tèxtil, Barcelona and the Museo del Traje, Madrid, the Fundación Balenciaga, Guetaria, and the Victoria and Albert Museum in London. Many smaller national and regional museums own one or two pieces: in the UK, the Museum of Costume in Bath, the Gallery of Costume in Manchester, Hampshire Museum Service, and Royal Scottish Museum in Edinburgh. These garments bear one of three possible labels, according to where and when they were made: BALENCIAGA 10 AVENUE GEORGES V PARIS (if made in Paris between 1937 and 1968); EISA B.E. (if made in Spain between 1934 and 1937); EISA (if made in Spain after the Spanish Civil War). Black lettering on a white ground was used for light-coloured garments and the reverse for dark-coloured garments. If the garment was made for a private client, there is a second label behind the main woven label; on it there is a hand-written number.

THE NATURE OF THE COLLECTION

The Victoria and Albert Museum in London has the largest collection of Balenciaga garments in the UK (just over 90 ensembles and 30 accessories – mainly hats), most made in Paris, a few made in Spain. The first Balenciaga garments to enter the museum did so as a result of *Fashion: An Anthology*, the exhibition put together by the high society photographer and designer Cecil Beaton in 1971. He showed a range of garments by many couturiers active in Paris, London and New York. In the exhibition 25 outfits represented Balenciaga. Designed and made post-war (between 1948 to 1968), the majority had been worn in the 1960s; it now seems that some may have been bought from fashion shows in the 1950s and worn over several years, possibly worn in new combinations when original parts wore out. Evening dresses or coats dominated the 'Beaton'

group, with only four garments representing day wear or the British tradition of tailoring. Other acquisitions and donations have enhanced the collection; all items date to the 1950s or 1960s. While some are suits and coats, evening and cocktail wear still dominates. Most of the clothes are made of natural fibres (wool, silk and linen), although some are decorated with new synthetic materials. Textiles are plain and patterned: decorative components are the result of brocading, machine lace, printing, and embroidery. Balenciaga's styles evolved gradually, so it is often difficult to date his garments precisely and not all of this collection has yet been definitively dated.

SIGNIFICANT PIECES IN THE COLLECTION

The most significant pieces from Balenciaga's oeuvre in the collection are all black and are illustrated in V. Mendes, *Black in Fashion* (London, 1999), with the exception of an evening coat made of layers of black lace and called evocatively 'Le mouton noir' (T.18-1974). Comparison of the black wool sack (T.234-1982), the black lace baby doll dress (T.334-1997), and the 'monastic' evening outfit (T.39-1974) encapsulates Balenciaga's versatility in different materials and forms of construction. Brilliant 'Spanish' colours are represented by a flamenco inspired evening dress (T.26-1974) and three outfits from the 1960s, embroidered with melanex (T.23-1974, T.24-1974, T.38-1974). The Museum now owns one of the important sari dresses (T.348-1997), and suits that demonstrate both inset and magyar sleeves. Some garments arrived with accessories, most did not. The recent donation of a black felt hat arrived in its original Harrods hat box (T.19:1-2006). Significant, too, is an example of a one-off dress designed for Madame Alec Weisweiller (T.17-2006), evidence that the designer did sometimes make special pieces for favoured clients. The Museum's website under 'Search the Collection' gives access to some pieces in the collection.

CUSTOMERS REPRESENTED

Just before Beaton's exhibition, Catherine Hunt and two unknown donors had the foresight to offer the Museum outfits. Subsequently, Cecil Beaton collected from friends from high society and the arts, in particular, Madame Miguel Angel Carcano, Mrs Ian Flemming, Mrs Loel Guinness, Mrs Charlton Henry, Mrs Paul Mellon, Mrs Gilbert Miller, Mrs Stavros Niarchos, Princess Stanislaus Radziwill, Baroness Alain de Rothschild, Baroness Philippe de Rothschild. In recent years, the wardrobes of women from similar circles include: Mrs Fern Bedaux, Countess Mona Bismarck, Miss Ava Gardner, Mrs Susan Hammond, Mrs Opal Holt, Belinda, Viscountess Lambton, Mrs Alec Weisweiller, and Rita Wolberg-Reiss.

APPENDIX 4
THE HOUSE OF BALENCIAGA, PARIS, 1951–54

Title of company: Balenciaga
Date of establishment: 24 June 1937
Type of company: SARL (Ltd)
Address: 10 Avenue Georges V
Partners: Nicolas Bizcarrondo and Cristóbal Balenciaga
Designer: Cristóbal Balenciaga

	1951	1953	1954
Number of full-time employees:	???	???	???
ouvriers	217	244	246
cutters	2	3	3
workshop heads	3	3	3
mannequins	10	10	10
Average monthly wages (in francs):			
cutter	109,450	119,700	138,188
workshop head	94,785	94,785	97,823
Number of models created and presented:			
Spring/Summer	176	181	212
Autumn/Winter	173	189	209
Other lines:			
Boutique, gloves and perfumes			

Nota (1951): This current questionnaire does not Include information concerning millinery.
Source of information: AN F^{12} 10.505

Balenciaga in context, 1954–55

The following data on Balenciaga and five of his fellow couturiers puts his operation into context for the period spanning Spring 1954 to Spring 1955. His house ranked high in number of designs, but lower in number of garments made and sold. Dior's figures do not include his boutique collections, Givenchy had opened two years before and Chanel had only just reopened.

Couture house	No. of models designed	No. of garments made and sold
Dior	712	5,154
Heim	701	2,250
Balenciaga	**607**	**2,325**
Fath	556	4,140
Dessès	448	1,494
Givenchy	441	628
Chanel	222	300

Source: AN F^{12} 10.505

INDEX

References in italics refer to illustrations